True Colors

True Colors

The Real Life of the Art World

Anthony Haden-Guest

The Atlantic Monthly Press
New York

Published simultaneously in Canada
Printed in the United States of America

FIRST EDITION

Library of Congress Cataloging-in-Publication Data
Haden-Guest, Anthony.
 True colors : the real life of the art world / Anthony Haden-
Guest. — 1st ed.
 p. cm.
 Published simultaneously in Canada.
 Includes index.
 ISBN 0-87113-660-0
 1. Art, American. 2. Art, Modern—20th century—United States.
3. Art—United States—Biography. 4. Art and society—United
States—History—20th century. I. Title.
N6512.H28 1996
709'.73'09045—dc20 96-28423

Design by Laura Hammond Hough

The Atlantic Monthly Press
841 Broadway
New York, NY 10003

10 9 8 7 6 5 4 3 2 1

Contents

Introduction 1
The Birth of the Contemporary Art Market at the Scull Sale,
Sotheby Parke-Bernet, New York, on October 18, 1973.
The Avant-Garde and Its Enemies

One / Racing Demons 21
Joseph Kosuth Has an Idea; Dennis Oppenheim and Michael Heizer
Head for the Wild Blue Yonder; Chris Burden and Bas Jan Ader Go
Boating; Piero Manzoni Goes to the Bathroom. And Other Adventures
in the Last Days of Modernism

Two / I'm Painting, I'm Painting Again 51
Surviving in the Lean Time and Back to the Easel

Three / New Spirits 83
Julian Schnabel Leaves the Kitchen and America Discovers Europe

Four / The Heat & the Cool 119
Wild Style; Jean-Michel Basquiat, Keith Haring, and the Lower East
Side; Cindy Sherman Is Not Quite Herself; the Selling of Jeff Koons

Five / Boom 161
Jasper Johns and Vincent van Gogh meet Saddam Hussein

Six / The Dark Side 207
The Bombing of Rob Scholte

Seven / More 239
The Anger of Donald Judd

Eight / The Saviors 271
*Damien Hirst Bisects a Cow; Matthew Barney Climbs the Walls;
Janine Antoni Loses Important Body Parts; and
Other Next Big Things*

Nine / Ends 301
James Turrell's Volcano and Other Millennial Signs

Introduction

Even the catalog is a collector's item nowadays. The cover
reads *A Selection of Fifty Works from the Collection of Robert C.
Scull* and shows a splendidly insolent Jasper Johns, the painted
bronze cast of a couple of Ballantine's Double XX ale cans photo-
graphed against a ripe yellow background—the same ripe yellow, it
happens, as the Scull's Angels taxicab fleet from which Robert Scull
had made his spending money in the first place. It gives the auction
date, October 18, 1973, and the venue, Parke-Bernet on Madison
Avenue. Sotheby's, the London auctioneers, had snapped up the New
York house in the mid-1960s, but this had created so much ill feeling
that the London-based company still used the venerable American
name.

The Scull sale was the first devoted to a single collection of
Contemporary art, so it was guaranteed of footnote status in art his-
tory even before it happened. "Contemporary" artists were so described
to distinguish them from the Moderns. In practice, it means artists
whose careers got going after the end of World War II. The auction
houses had looked on this untried market with suspicion and had
usually tacked recent stuff on to the end of a sale of the Moderns. But
James Mayor, the son of a London art dealer, who was at Sotheby's at
the time, had promoted the notion that the field was rich in possibilities.

In 1970, when Mayor was twenty-one, he had secured some
pieces from the Contemporary collection of Don Factor, the movie-

producer son of cosmetics magnate Max Factor, and put them into a
sale. The results had been satisfactory enough for Sotheby's to create
a separate Contemporary department, and Mayor was put in control.
Not for long. After a bibulous lunch with Sarah Picasso, a daughter-
in-law of the artist, the couple were photographed in Little Italy dur-
ing the Festival of San Gennaro. The picture was run as an ad in the
September 1971 issue of *Artforum* with the caption: "Parke-Bernet Is
Having Another Auction . . ." Ms. Picasso is smiling demurely. James
Mayor is holding a dildo. So it was that James Mayor was soon a pri-
vate dealer and John Tancock, who had come from a Philadelphia
museum, was in charge when Robert Scull decided to unload a tranche
of his collection.

There were problems and promise. Noxious clouds were fum-
ing over the art world. The fraud case against the Marlborough Gal-
leries following Mark Rothko's 1970 suicide was one cloud. Also, the
Metropolitan Museum had been caught preparing to sell off some
"weak" paintings to fatten up its acquisitions fund in 1972. The de-
ceptively humdrum word for this practice — not allowed by European
museums — is *de-accessioning*. Among the merchandise being de-
accessioned were a Manet, a van Gogh, and a "Douanier" Rousseau,
the latter two being earmarked for Fiat magnate Gianni Agnelli. Deal-
ings were aborted, but not before propaganda hay had been made
of them by the terrorist Red Brigades. Art collectors are inclined to
groupthink, and shabby goings-on within the art world can make them
scamper like rabbits. The promise seemed greater than the problems,
though. The economy was clambering out of a slump, and their pri-
vate conversations — with dealers, collectors, museum curators — sug-
gested that the Contemporary market was gearing up for action.

Tancock got cracking in early summer. "I quickly discovered that
Mrs. Scull's name was not to be on the catalog," Tancock says. Auc-
tions are usually triggered by the three D's — death, divorce, and di-
saster — and in this case it was the second. "I was divorcing him because
he was crazed with drink and drugs," Ethel told me later. She had been
angered by her husband's decision to sell, but she was in pain from a

back injury sustained while gathering shells in Barbados a couple of years before and had let her husband prevail even though Jasper Johns's *Maps*, for instance, was actually inscribed "For Ethel."

The fifty pieces chosen included part of the Pop collection— Rosenquist, Warhol, Tom Wesselmann—that had made the Sculls famous. There were also a number of canvases by Abstract Expressionist predecessors Franz Kline, Barnett Newman, Cy Twombly, and Willem de Kooning. The work was illustrated in what was a lavish catalog for the time, though it would not compare with the thumping-great albums to come. High and low estimates were not then printed—indeed, were divulged to interested parties with exquisite reluctance. John Tancock says, "We only gave them out five at a time. It's as if we weren't encouraging people to bid."

As a first roll of the drum, the collection was flown to a grand hotel in Zürich, the Baur au Lac, and shown on walls that had been built for the event. It returned briefly to New York en route to Los Angeles. "This was one of the first of such tours, which have since become *de rigueur*," Tancock says. There was a downpour of rain while the art shipment was sitting on the JFK Airport tarmac, and the crates were drenched. The work was flown on to Los Angeles, where the paintings were laid out all over Sotheby's (then) premises on Beverly Boulevard, and as many fans were switched on as the wiring could take. There were no casualties. If the Sculls' collection had included work by Pop's contemporaries, the Color Field artists—the feathery washes of Morris Louis, say—the outcome could have been different. The work was shown to the L.A. cognoscenti, then flown back to New York for the main event.

Robert and Ethel Scull had prided themselves that they collected on the leading edge of art making. They supported art that was sometimes "difficult" and that could still be described, without irony, as avant-garde. Indeed, the Sculls were players in the process that has

enabled the avant-garde to become what it is today—a mighty industry worldwide.

A long, strange trip it has been. The phrase the *avant-garde* was first used in this sense by the savant Saint-Simon. Claude-Henri de Rouvroy, Comte de Saint-Simon, fought for the American Colonists as an artillery captain at Yorktown. He returned to France, bought up land cheap at the beginning of the Revolution, and survived the Terror, but squandered his wealth on party giving. Saint-Simon spent the remainder of his life elaborating a system of Christian socialism (which was admired by Karl Marx's collaborator, Friedrich Engels).

In 1825 Saint-Simon wrote a dialog between an Artist and a Scientist. The Artist uses a military metaphor. "It is we, artists, who will serve you as the avant-garde," he says, adding, "What a most beautiful destiny for the arts, that of exercising over society a positive power, a truly priestly function, and of marching forcefully in the van of all the intellectual faculties, in the epoch of their greatest development! This is the duty of artists, this is their mission . . ."

Gustave Courbet, Saint-Simon's countryman, marched further down the revolutionary road. Courbet was thirty-one when he came to the attention of the 1850 Paris Salon; he was praised for the realism of his painting but attacked for its "ugliness." Courbet co-wrote a book, *Art and Its Social Significance*, with the anarchist Pierre-Joseph Proudhon and joined the Paris Commune when it grabbed power. After the defeat of the Communards, the painter was accused of helping to topple Napoléon's column in the Place Vendôme and charged 323,091.68 francs to put it up again. He fled to Switzerland. Courbet was modern in many ways, not all of them endearing. He declared that contemporary history was the only interesting history there was. Asked what school of art he belonged to, he said: "I am a Courbetist, that's all. My painting is the only real stuff. I am the first and unique artist of the century; the rest are students and cretins."

The avant-garde has also had less moralizing antecedents. One icon, Thomas Chatterton, was an impoverished orphan, the son of a British schoolteacher. He started writing poetry at fourteen and arrived

in London in 1770, hoping for glory and bearing a trove of poems by a fifteenth-century monk, Thomas Rowley. That August 25, Chatterton was found dead in his garret, torn scraps of paper around him. He was seventeen and a half years old. There was arsenic in his body, and the coroner brought in a verdict of suicide.

The Romantic movement of the next generation found in Chatterton a perfect emblem for the alienated artist, the victim of a cloddish society. Coleridge wrote a poem about him. So did Wordsworth, who addressed him as "the marvellous Boy." The poet Alfred de Vigny paid him homage in France, as did the sculptor who wrought a *Death of a Misunderstood Man of Genius,* a statue now in Lyons and described by the critic Linda Nochlin as "one of the many crosses which French provincial museums seem destined to bear." The British academician Henry Wallis made an 1855 painting of Chatterton on his deathbed, which became hugely popular. (Wallis used George Meredith, the poet, author of *Modern Love,* as his model, and later decamped with Meredith's wife.)

The thing is this: Chatterton was a fraud.

He wrote "Rowley's" poems himself, on parchments from the archive room of a parish church, in garbled Old English. But the fraud was part of the mystique, because there was another notion about the role of art, and it had nothing to do with the long march to a better world. Théophile Gautier wrote in his 1835 novel *Mademoiselle de Maupin* that there was no relation between art and morality. Writers of the Decadence, most famously Oscar Wilde, elaborated upon this. The movement's doctrine was Art for Art's Sake. Provoking the bourgeoisie was the artist's glorious duty.

In painting, the most articulate voice of the Aesthetic movement was certainly James McNeill Whistler. A former West Pointer, Whistler, who had arrived in London by way of Paris, was greedy for notoriety. He gained it perhaps less through his work than through his acid turn of phrase and foppish dress. (Degas, with whom Whistler was generally on cordial terms, expressed the "serious" avant-gardist's distrust for the theatrically bohemian when he said, "Whistler, you

behave as if you have no talent.") In 1880 Whistler exhibited a canvas, *Nocturne in Black and Gold: The Falling Rocket,* in London's Grosvenor Gallery.

It was seen there by the best-known British critic of the day, John Ruskin, an earnest believer in the moral mission of art, who saw the state of the arts as a "visible sign of national virtue." He was also by then crotchety and unstable. His much-repeated critique of Whistler can stand one more repetition. "Sir Coutts," wrote Ruskin, alluding to the gallery owner, "ought not to have admitted works into the gallery in which the ill-educated conceit of the artist so nearly approached the aspect of wilful imposture. I have seen, and heard, much of Cockney impudence before now: but never expected to hear a coxcomb ask two hundred guineas for flinging a pot of paint in the public's face."

Whistler sued for libel.

A play, *The Grasshopper,* opened in London soon before the trial. A canvas by an "artist," a caricature of Whistler, was brought onstage. It was called *Dual Harmony in Red and Blue.* One way up, it was the desert at noon; the other way, sunset at sea. Whistler was amused. He was less so when the case began and his *Nocturne* was brought into court the wrong way up. This was just part of a painful process. Sir Edward Burne-Jones, a Pre-Raphaelite, until then a friend of Whistler's and testifying reluctantly under subpoena, said he felt the canvas was "very unfinished." William Powell Frith, a Victorian realist painter whose *Derby Day* was one of the most admired images in nineteenth-century Britain, was cross-examined by Whistler's attorney on the subject of the painter J. M. W. Turner. "Is Turner an idol of Mr. Ruskin's?" Frith was asked.

"Yes, and I think he should be an idol of everybody."

"Do you know one of Turner's works at Marlborough House called *The Snowstorm*?"

"Yes, I do."

"Are you aware that it has been described by a critic as a mass of soapsuds and whitewash?"

"I am not."

"Would you call it a mass of soapsuds and whitewash?"

"I think it very likely I should," the Royal Academician said merrily. "When I say Turner should be the idol of everybody, I refer to his earlier works, but not to his later ones, which are as insane as the people who admire them." It was recorded that there was laughter in court.

Whistler won his case but was awarded only a farthing in damages. He was ruined. To that extent, it was an avant-garde catastrophe. To the extent that Whistler—to say nothing of the late Turner—has triumphed over egregious academics like Frith, it was a triumph.

The curious thing is this: The culture at large still judges art according to categories that would be familiar to Whistler or Ruskin. Most feel that it is the job of art to be beautiful. Many feel that art should be moral or socially useful, too. This is a problem, because contemporary artists do not necessarily feel a need to be either.

Seating at the Scull sale was the province of Francine LeFrak. Ms. LeFrak had begun as a collector when the outside world paid little attention to auction houses. "I remember Nelson Rockefeller buying up a whole sale of green celadon. There was nobody there," she says. The daughter of Sam LeFrak, who had made a fortune in cheap housing, she had been put in charge of a new division, the "customer services department," the year before. "Our image has become too exclusive as a result of all the stories about glamour sales, such as the one where Elizabeth Taylor bought a million-dollar diamond," explained John Marion, president of the American end of the business, at the time. "We want to attract the average buyer." In fact the idea behind the customer services department was clearly that the rich would rather be serviced by their own than by scholarly types who looked as if they would be at home behind a library desk, and Ms. LeFrak set a sleek standard that Sotheby's has stuck to ever since.

The seating required finesse. "I couldn't seat the Germans next to the Japanese," Ms. LeFrak says, explaining that the former allies were anything but friendly in the salesroom. In the event, it wasn't too

big a problem, since the Japanese were thin on the ground. "They had dive-bombed sections of the market a few years before. When the recession struck, they found they couldn't get their money back on their second-rate Renoirs," Liz Robbins, then a Sotheby's publicist, explains briskly. There was one major Japanese presence, though—the Tamenaga Gallery, an operation much beloved by European and American dealers because of its lust for work that had bottomed out elsewhere, like hackwork by that failed savior of the École de Paris, Bernard Buffet.

At any rate, the showing in the salesroom that evening, October 18, 1973, can be read as a diagram of the Contemporary Art market in that significant moment. Among the dealers were Sidney Janis, André Emmerich, and, of course, Leo Castelli. A fastidiously tailored and unfailingly polite man in his early sixties, Castelli had been very friendly with the Abstract Expressionists, indeed a member of their famous "club," but he had elected to show Pop when he became a dealer. De Kooning had grumbled, "That son of a bitch could sell two beer cans!" This had been repeated by Robert Rauschenberg to Jasper Johns, who had promptly cast the cans. Castelli had come through, selling them to the Sculls for $960. Castelli now represented most of the major Pop artists and was content. "By 1972 my lineup was complete. I didn't want to take on anybody new," he told me later.

Ivan Karp of O.K. Harris was also there. Karp, who showed up with headphones so that he could catch a ball game, had formerly managed Castelli's gallery. O.K. Harris, though, had taken to showing artists who, mainstream opinion had decided, were tainted with kitsch. So O.K. Harris remains financially successful to this day, but as far as reviews and respectable avant-garde attention go, Karp scarcely exists.

Ambitious younger dealers on the scene included Arne Glimcher of Pace and Larry Rubin of Knoedler. Eugene Thaw, who unlike his fellows plied his trade mostly among the old money, was present, as were Richard Feigen and William Acquavella, who were as active as anybody in new art but didn't count as cutting edge because they trafficked in the work of other periods, too. Dealers from abroad included

Denise René from Paris, who had her eye on works by Barnett Newman and Franz Kline.

Another inscrutable presence was Frank Lloyd, whose Marlborough Galleries was arguably the richest dealing operation in the world. Lloyd, who was making an excellent job of acting as though the Rothko case were a minor squall in the corner of some distant landscape, had not yet dabbled his toes in the art of the sixties. With Lloyd was Irving Blum, who had given up his Los Angeles gallery to oversee Marlborough's promised move into this new area. Also present were some important collectors, like Burton and Emily Tremaine and a young gun, Peter Brant. It was a sign of the modishness of the occasion that the architect Philip Johnson sat in the fourth row with Lee Radziwill and that the couturier Halston had seats plumb in the middle of row one.

The Sculls, who wanted no such prominence, had settled for fifth-row seats. They were wired up beforehand by Geoff Vaughan, a moviemaker who was documenting the event, and they set off, hardly trying to mask their mutual bitterness. The weather was rotten. "I remember looking out my window as I changed to go," says Barbara Guggenheim, then an intern at the Whitney Museum and living in an apartment on Madison and Seventy-seventh Street. "There was sleet, and this stream of people. It was astonishing. I had never seen so many people going to an auction." Martin Stansfield, a Sotheby's publicist, says, "There was this enormous riot scene outside. We made a bad mistake in not having a more secure gate. The whole of SoHo came. We had seventy real journalists and at least seventy fake ones."

Joseph Hirshhorn, shortly to found his own museum in Washington, D.C., and not a man famous for his patience, was heard repeating, "I'm Joe Hirshhorn! I'm Joe Hirshhorn!" to the wall of flesh, with little effect. Several cabbies made their feelings about Scull's Angels' pay rates clear by brandishing placards that read NEVER TRUST A RICH HIPPIE and ROBBING CABBIES IS HIS LIVING, BUYING ARTISTS IS HIS GAME. Hugh Hildesley, Sotheby's expert in the High Renaissance, who

had been assigned the freight elevator, advised that the precinct be asked to send along a few more cops.

It wasn't just the cabbies who felt mutinous. There is one art world, which is occupied by dealers, collectors, and curators, and there is another one, which is lived in by working artists. Hildesley remembers that "some artists had bought snow shovels from the hardware store and were selling them as artworks outside." The anti-art-market mockery was an homage to Marcel Duchamp, whose best-known "ready-made" was a *pissoir*, but who had exhibited a snow shovel too. There was also a group of women artists, calling attention to the fact that only one woman had work in the auction: Lee Bontecou, a remarkable artist of the sixties, who had shown little since she had married an artist of no particular reputation and moved to Long Island.

Artists are rare birds at sales, so it came as a surprise when Robert Rauschenberg put in an appearance. He was tanned — in a suede-cloth suit, his shirt unbuttoned — and emotional. Roberta Gratz quoted him in the *New York Post*. Of his relationship with the Sculls, Rauschenberg said that it "was only love. This is the divorce." Thanks to the auction, "all the intimacy of the work is gone." Years later I asked Rauschenberg if he had been wholly sober at the time. "Probably not," he said.

There were reasons beyond the quality of the work for Sotheby's to feel some covert optimism before the sale, one being that the Sculls were stars, and not just in the art world but in the wider world, too. For instance, they had been featured in a two-part article by Tom Wolfe. This was printed in 1967 in Clay Felker's weekly magazine in the *New York Herald Tribune*, which survived the newspaper to become *New York* magazine. Wolfe's piece was a lampoon, both of the Sculls themselves, called "Bob" and "Spike," and of the work they were championing.

Wolfe's article was part of a tradition of ridiculing the artsy much older than the avant-garde itself. It was not Ruskinian, an episode of

internecine art-world warfare. It was an attack on the perceived pretensions of the art world from the squirerarchy of Plain Common Sense.

Few indeed have put more elbow grease than Tom Wolfe into attacking the avant-garde art world. In some respects this is curious, since his prose is "radical" enough and his armor of foppery brings Whistler, if not Salvador Dalí, to mind. The Scull piece, at any rate, was a warmup for a longer piece, "The Painted Word," which was first published in *Harper's* magazine, and then as a book in June 1975. Wolfe's thesis, succinctly expressed by his title, was that artists had taken to doing just what critics told them to do. He noted the collapse in the prices of the Abstract Expressionists when Pop took off—"in general, this type of painting was depreciating faster than a Pontiac Bonneville once it left the showroom"—but seldom seemed to eyeball his quarry, and even then without much pleasure, as when he noted that Barnett Newman "spent the last twenty-two years of his life studying the problems (if any) of dealing with big areas of color divided by stripes."

Wolfe also had a passage dealing with corporate Modernism, which concluded: "This led to the Container Corporation's long-running advertising campaign, the Great Ideas of Western Man series, in which it would run a Great Idea by a noted savant at the top of the page, one of them being '"Hitch your wagon to a star"—Ralph Waldo Emerson.' Underneath would be a picture of a Cubist horse strangling on a banana."

It was a comical image, but it is also clear that the horse Wolfe wanted his readers to chortle over wasn't any old humdrum horse but the central figure from Picasso's *Guernica*, and any doubts on this score should have been dispelled by Wolfe's own cartoon that accompanied the text. Time has been unkind to "The Painted Word," both as to detail—canvases by the Ab Exes outperform used Pontiac Bonnevilles these days—and to the general thesis. Indeed, in October 1984, when Wolfe returned to the field, again in *Harper's*, with "The Worship of Art," he conceded as much, noting, "I can't think of a single influential critic today." But the cartoon horse indicates that whatever the

writer's targets of opportunity, he didn't have much time for the Modernist enterprise from the beginning.

In this Wolfe is at one with much of the culture. This might, at first, seem a peculiar statement, given the uplifting statistics. Three New York museums, for instance—the Guggenheim, the Museum of Modern Art, and the Metropolitan—pooled resources to study the economic impact of four major exhibitions in the fall and winter of 1992–93. The shows were Matisse at MoMA; the Russian and Soviet avant-garde at the Guggenheim; and two shows at the Met, Magritte and—the only non-Modernist—Jusepe Ribera. It was found that one and a third million people, mostly out-of-towners, had visited the four shows, spending over $600 million, including $60 million in state and city taxes. *The Arts as an Industry,* a study undertaken jointly by the Port Authority and the Alliance for the Arts for that same period, noted that there were 114,000 "employed artists"—a broad category, including photographers, dancers, and so forth—in the New York metropolitan area and that a majority of people moving to the city mentioned its cultural life as a lure. All this, just when the art world was wallowing in a slump.

These were Moderns, though. History. The present-day successors of Matisse, Magritte, and the Russians are accorded no such dutiful reverence. The makers of the New Art are thoroughly professional. Even the most extreme of them tend to disdain the term *avant-garde.* They show in hundreds and hundreds of galleries nationwide and are celebrated in a gleaming flow of monthly magazines. Internationally, fairs, expos, seminars, and museums have so proliferated that the art calendar has blackened, like burned toast. The avant-garde art world is just that: a world.

It is, though, a world very much to itself. When government money, funneled through the WPA, was creating the conditions that made the New York School possible, the outside world was as conservative as it is today. There wasn't enough money to make art a target. The eighties changed all that. Morley Safer, a splendid reporter when he knows what he is talking about, did a *60 Minutes* segment on con-

temporary art at the zenith of the Boom. Here Safer, a self-described "Sunday painter," is talking to the collector Elaine Dannheisser about the white urinals made by artist Robert Gober.

Dannheisser: They look like urinals, but they really aren't.
Safer: I know, because there's no plumbing attached to them.
Dannheisser: Yes.
Safer: But beyond that, does it comment on society in some way, do you think?
Dannheisser: I think it comments on things that we take for granted and that we really don't see. That is Robert Ryman.
Safer: That is . . . it's a white rectangle.
Dannheisser: Right. And Ryman has reduced painting to its very essence, and a lot of people don't understand that but—
Safer: I confess I'm among them on this one.

What is interesting here isn't Safer's certainty that the art world is made up of pretentious clowns or even his assumption that his mass audience would agree with him. What is interesting about Safer, as indeed about Wolfe and art's other intelligent enemies, is the intense irritation that seems to smolder beneath their mockery. After all, many people don't understand the fundamentals of such-and-such a sport or discipline of science, either, but they don't get particularly *annoyed* about it. Art has rules, too.

It has become normal, though, to find that just the sort of people who once might have been expected to show some interest—readers and people who go to "good" movies and keep abreast of current affairs— will treat new art with resentment, mockery, or indifference. It is partly that few things in the world worry smart people more than a fear of being taken as rubes, and artists are often to blame, being overweening and pretentious (if hardly more so than writers, say, or rock musicians). But it simply hasn't gotten through that artists (a) are serious and (b) that they don't always take themselves that seriously. "Above all, the hilariousness of it," de Kooning said of *Woman I*. John Baldessari, a

Conceptualist, made a 1971 print that consisted of the sentence I WILL
NOT MAKE ANY MORE BORING ART, repeated, like a schoolchild's pun-
ishment. Just why do so many otherwise informed people seem to believe
that some Arts Establishment is conspiring, with *Protocols of the Elders
of Zion* cunning, to perpetrate a hoax, a fraud, a scam?

It was my bafflement at this lack of communication between the
art world and a wider world that decided me to enter on the researches
that have led — slowly, and unsystematically — to this book. It is the fruit
of several years of talking to artists and to others involved in the busi-
ness of art, sometimes in formal interviews, at least as often in ordi-
nary encounters. I wanted to paint a picture of the art world from
within. It has been my intention not just to document the main suc-
cessive waves but to give a sense of the ocean, with its currents, its deeps
and shallows, its occasional fierce storms.

Artists, like everybody else, are subject to political and economic
forces. They tend to be at least as ambitious as politicians. They en-
dure rejection and failure. They survive success. The final product is
the art that ends up in a gallery, a museum, a public space, in the hands
of a private owner, or only as a documentented memory. I have hoped
to show how this may sometimes have come about.

The sale started an unprecedented half hour late. The sixth lot
was de Kooning's *Police Gazette*, which the Sculls had put up for sale
eight years before — when they were moving into Pop — but had kept
when it failed to get a higher bid than $37,000. This now went for
$180,000, a record for the artist. "It was like the room heaved a sigh,"
a dealer says. The first Jasper Johns was lot fourteen. It was one of the
famous *Target* paintings. The Sculls had bought it for $5,000. It fetched
$125,000. Astonishing.

Next up was another Johns, *Double White Maps*, a thoroughly
painterly, indeed Expressionist, canvas, except that it shows two maps
of the United States, with the states' names stenciled in. The Sculls

had paid $10,200 for it. Bidding soon ping-ponged past that for *Target*. One of the bidders was the New York dealer and collector Ben Heller. This caused a subsidiary buzz. Ben Heller was basking in the glow of having sold his Jackson Pollock, *Blue Poles*, to the Australian National Gallery in Canberra, a deal with just the sort of pedigree the room was hoping to see repeated in Parke-Bernet that night. Sidney Janis, Pollock's dealer, had originally sold the painting to a Connecticut doctor in 1954 for $6,000, of which Pollock had received two-thirds. This was a good price in those days, the highest in the painter's lifetime. In 1956, some months after Pollock's death, Heller had bought it from the doctor for $32,000.

The Australians had just paid Heller $2.2 million for it, making it the highest price ever paid for an American artwork. The outrage had been immense. *Blue Poles* would play its part in a process that ended up with Gough Whitlam, the prime minister who had approved the purchase, being tossed out of office later that year.

Ben Heller bought the Johns. The price was $240,000—a different record: This was the largest sum for the work of a *living* American artist.

But there was no unleashing of energy in the room. The mood was intense, watchful. One dealer compared it to a casino when the house or one of the players may or may not be beginning a run. Next up was lot sixteen, the cast cans of Ballantine's ale by Jasper Johns. It should be pointed out that the technology that now makes art auctions as silky-smooth as any other commodity trading were not yet in place in 1973, so computer screens did not display dollar sums translated into global currencies; telephone bidding lay in the future; and artwork that was about to go under the hammer did not appear on a turntable but was transported into the room by employees, this evening by black men wearing white gloves.

The ale-cans piece was awkward—a bit too heavy for one man to carry, a bit small for two. According to Andrew Terner, a young dealer at practically his first sale, the employees walked the piece in "with tiny baby steps. And one of the guys knocked an ale can over.

There was this hush. An absolute dead silence. He picked it up. And there was this wild applause. Crazy insanity! It lasted about half a minute. That was the turning point. The tension was gone. After that, it was like another auction."

James Mayor, who was celebrating his return to his former place of employment by wearing a Xandra Rhodes caftan, bid on the piece, but it went to a German for $90,000. From then on things went swimmingly. Barnett Newman's *White Fire II* was bought for $155,000 by the Basel Kunstmuseum. Another record. Other auction records were set for Cy Twombly, Warhol, and Rosenquist. Robert Rauschenberg watched as *Thaw,* which Scull had paid $900 for in 1958, fetched $85,000 and *Double Feature,* which Scull had paid $2,300 for the following year, went for $90,000.

At the auction's end, Rauschenberg approached Scull. "I've been working my ass off just for you to make that profit," he said.

"It works for you, too, Bob. Now I hope you'll get even better prices," Scull said.

What happened next was caught by Geoff Vaughan's camera but has an ambiguous quality all the same. Ethel Scull insists Rauschenberg punched her husband hard in the stomach. If so, the camera missed this. What it captured was Rauschenberg's expression, a half smile, as if the artist wanted both to slug the collector and to hug him but settled for an angry shove.

The two never spoke again.

There were some other changes in the wake of the sale. Frank Lloyd of Marlborough hadn't made a move. "He sat on his hands," Irving Blum says. So Blum left Marlborough and went into partnership with another out-of-towner who had been at the sale, St. Louis collector Joe Helman. Geoff Vaughan was so disgusted that he never returned to documenting the art world again. But for most it would be business as usual, only *changed.*

The night's take—$2,242,900, a record for Contemporary art—meant that Sotheby's would start taking the market seriously, whatever it privately thought about the actual art. (Linda Silverman, one

of the rare zealots for the New there, remembers John Marion's reaction when he spotted a gray felt suit by the German shaman Joseph Beuys hanging in her office. "He said, 'What's that? Did somebody forget their dry cleaning?'" Silverman recalls.)

Elsewhere there was no doubt about the significance of the event. André Emmerich, then president of the Art Dealers Association, says, "In my life there have been very few watershed sales. One was the Goldschmidt sale, which I attended as a very young dealer." This had been the 1957 auction of eight Impressionist paintings in London that had, in one intense evening, propelled Sotheby's from being barely even a second fiddle to Christie's, just a place to dispose of a library or to buy Roman coins, right into the vortex of the art market. Emmerich says, "The Scull sale was a comparable watershed. I felt awe and shock—that pictures could be worth that much money. And a certain embarrassment—that the Sculls should have to sell in this way." Indeed the easy-come, easy-go nature of the new collectors was yet another lesson of the Scull sale.

It was also important that the Sculls had mostly collected New York art. The hegemony of New York had been established by the Abstract Expressionists. Proclaimed by texts such as Irving Sandler's *The Triumph of American Painting*, it had only been strengthened by such attacks as *How New York Stole the Idea of Modern Art*, a vivid book, lightly marbled with paranoia, by a French-Canadian critic, Serge Guilbaut. European contemporaries of the New York Ab Exes— painters like Italy's Alberto Burri and Lucio Fontana, France's Pierre Soulages, the Spaniard Antoni Tàpies, and Britons such as Patrick Heron and Peter Lanyon—might as well, so far as most Americans were concerned, have gone flying with Amelia Earhart. As for Europe's figurative artists—painters like Balthus, Francis Bacon, and Lucian Freud—they were curiosities, far from the mainstream of history. That was the way the record had read, and what the Scull sale added to it was this: Rauschenberg, Johns, and the Pop artists were the Abstract Expressionists' legitimate successors. The hegemony of America—and New York in particular—endured.

There were lessons to be drawn from this. Rauschenberg was forty-eight at the time of the sale, and Johns, four years his junior. Pieces they had sold for hundreds or a few thousand were now worth tens of thousands, hundreds of thousands. For collectors it was not a complicated message:

Buy.

For artists, though, the message was more complex. Leo Castelli had a bottle of champagne delivered to Jasper Johns, who was in Los Angeles working on prints at Gemini GEL. Johns told me years later that he had seen the auction figure as just another statistic. By then, he intimated, he had gotten used to press, both good and bad. "When the Sculls bought the ale cans, there was a story that some lunatic had paid $900 for this. It was in some slick magazine," he said.

Warhol's reaction to the sale was Warholesque: elation at his own price, and pique that others had done better. He hauled a soup-can painting from the early sixties from under his bed and put it on the market at $100,000. Another painter whose work did well at the sale was Dan Christensen, a leader of a movement called Lyrical Abstraction. They were seen as a third wave—after Abstract Expressionism and Color Field—and doughty competitors to the dour Minimalists. Christensen described the effects of the sale on his career as "catastrophic." Collectors who had bought his pieces for a few hundred dollars quickly popped them into salesrooms, causing a glut. "The prices started dropping. I suddenly started having a very bad time," he says. Lyrical Abstraction was reappraised as "academic." It suffered a quick death.

As for Rauschenberg, he saw the scuffle with Scull not as an end but as a promising beginning. He decided that artists should have a contractual right to a share in profits from resales of their work—15 percent, he felt—and got into discussions with his business manager, Rubin Gorewitz, who had campaigned for such rights for several years (a draft contract already existed, named for the lawyer who had drawn it up: the Projansky Agreement.)

Rauschenberg's effort got nowhere, but he had many supporters among artists—James Rosenquist, for one, and three artists who hadn't

had work in the Scull sale: Carl Andre, Sol LeWitt, and Hans Haacke. Carl Andre was, at least, consistent. In 1971 he had priced pieces at a show according to the income of the buyers. A leading figure among the Minimalists, he made his work from metal plates, sometimes scrounged off the street, or from un-arty prefabricated components, like cinder blocks and Styrofoam planks. The year before the Scull sale, London's Tate Gallery had bought *Equivalent VIII*, a rectangle of 120 firebricks, for $650. The British press had not as yet noticed this, but when it did, the transaction would generate paroxysms of mockery beside which the Australian press treatment of *Blue Poles* would seem a butterfly kiss. Indeed, Andre's brick piece would remain the most regularly mocked artwork in the British tabs until the coming of Damien Hirst.

Sol LeWitt was also a Minimalist. A characteristic LeWitt might consist of a grid penciled onto a wall. Hans Haacke's art was outspokenly political. The year before the Scull sale, he had called for an artists' boycott of the Guggenheim Museum for refusing to let him execute a piece there. The piece was a written denunciation of one of the Guggenheim trustees as a slum landlord.

Which is to say that Rauschenberg's allies in his attempt to wrest a slice of profits from the collector were three of the more rigorous adherents to the influential credo of the art world of the time: Traditional painting was dead. Sculpture too. The Scull sale had shown that the Contemporary art market was all dressed up and ready to go but that the most highly regarded artists wanted out. The mood was anti-museum, anti-dealer, and, above all, anti-collector.

That was the direction that art had been taking, but the art world is a landscape, not a highway. The landscape is peopled with curators, collectors, academics, critics—who often spend as much energy sniping at one another as at art's vigorous and well-armed enemies—and, of course, with artists, who often regard one another balefully, and sometimes with incomprehension.

The writer Orville Schell has noted that during dynastic times, Chinese scholars divided historical writings into two genres. There

were *zhengshi*, the authoritative, official histories, and *yeshi*, literally "wild histories." Schell describes these as "derived from the eyewitness accounts, personal remembrances, popular lore, rumor," etcetera. Official histories are written by the winners to record—and, sometimes, update or revise—their victories. Wild histories are more fluid, catching life on the wing. What follows are a few wild histories of life and death at the edge.

One / Racing Demons

The July 29, 1968, issue of *Newsweek* featured an eight-page look at what was stirring in the art world. *The New Art: It's Way, Way Out* focused on twenty artists, themselves in their twenties, and it was an attempt to make their work as lapel-grabbing as Pop had been (a photograph of Claes Oldenburg made the connection). Given the times, it is no surprise that every artist described was a man and that the magazine did not feel this required comment.

Newsweek had a punchy cover ready. It showed Joseph Kosuth, a twenty-three-year-old enfant terrible, looking Warholesque, with lank fair hair and ink-black granny glasses. He was wearing a white shirt, white tie, and what looked like a white lab coat, and behind him was one of his pieces: the definition of the word *idea*, taken from a dictionary, enlarged and printed in negative. But before the magazine went to press, the tanks of the Soviets and the Warsaw Pact countries squelched the Prague Spring. The art piece ran, but Czech leader Alexander Dubček got the cover. As was only right. Art was out on the social margins again.

What margins they were, though. The feature by Howard Junker caught the sense that the artists were pelting off madly in all directions, like nineteenth-century explorers racing toward the Pole or the source of the Blue Nile. That onward motion was crucial. There were paradigmatic examples, like Matisse's set of increasingly abstracted bas-reliefs of a woman's back in MoMA's sculpture garden

and the sequence of drawings in which Piet Mondrian turned a plane tree into a linear grid.

Not everybody accepted this as a game plan for art, least of all disgruntled former Modernists like the painter, writer, and pamphleteer Wyndham Lewis. Lewis had founded Britain's only native avant-garde movement, Vorticism, which was snuffed out by World War I, but in the fifties he published *The Demon of Progress in the Arts*, a ferocious attack on the movement toward abstraction. Lewis was seen as backsliding. The best artists of a new generation simply *had* to up the ante on their predecessors. That was holy writ, what the critic Harold Rosenberg would call "the Tradition of the New."

When Frank Stella made his black "pinstripe" paintings in the early sixties, he described them as "a flat surface with paint on it— nothing more." He had shot the swan of allegory. You couldn't go back again. These were the "Last Paintings." Stella's contemporaries, the Minimalists—like Donald Judd, Carl Andre, Sol LeWitt, and Dan Flavin—made objects from which the fat had been boiled, and they were competitive about this. Carl Andre said to an interviewer, "Donald Judd is a fine sculptor, but he deals with materials in an almost painterly way." No compliment intended. "My sculptures are masses and their subject is matter."

Sol LeWitt made geometrical line drawings on walls, usually leaving the execution to other hands. Like André, Dan Flavin worked with industrial units—fluorescent tubes. In case anybody got the wrong idea, he wrote, "No time for contemplation, psychology, symbolism, or mystery." This was utterly American in its nuts and bolts. Note that Flavin didn't even bother to list beauty among the undesirables. Beauty has been the guilty secret of art, a byproduct at best, during the Endgames of Modernism.

It is a tribute to the grip the Minimalists exerted on the American art world that the movement didn't just wash away, the way Abstract Expressionism had. It was as if there was so much repressed energy in those obdurate shapes that they had to explode. In a brief, extraordinary period toward the end of the 1960s the art world went

off like one of those fireworks that send other fireworks zinging on-
ward in all directions. To describe the time, you have to follow the
trajectory of one story, return to the point of explosion, follow another,
go back, and so on, until you are done—one of the most rarefied tra-
jectories being that of the Conceptualist Joseph Kosuth.

Kosuth grew up in the Midwest. He came to Manhattan in his
late teens and went to an art school to learn how to draw and paint.
Useless learning, he decided. Frank Stella's black canvases had an-
nounced the Death of Painting. So why was Stella still at it? Kosuth
decided that this was a "weakness." He decided to make work that was
pure idea. He made *One and Three Chairs* in 1965. He was twenty.
In the middle was a real chair. A photograph of the chair was on one
side of it and a blown-up dictionary definition of the word *chair* on
the other. As a postscript, he took the brushes with which he had made
his own "last painting," stuck them in a can, and wrote DEAD on the
front. This piece, which is on a shelf in his loft, alludes to the Jasper
Johns cast of a Savarin coffee can, likewise holding paintbrushes.
Painting might be dead, but art history was alive and kicking.

Kosuth had stipulated that the chair in *One and Three Chairs*
could be any chair and could be photographed by anybody, but it
remained an object all the same. It could be bought, traded, collected.
So Kosuth began just picking words from the dictionary and photo-
stating the definitions. That was his Art. Soon, though, Kosuth found
that people were keeping the stats. They were objects, too. Renounc-
ing the Photostat machine, he turned his Art Ideas into small ads and
began to place them in magazines. They had become "completely
valueless as collectors' objects," he gloated, "abstractions of abstrac-
tions." As the End of Art approached, Joseph Kosuth could be forgiven
for feeling that he could hardly be out-Ended.

It is one thing to make extreme work. Getting it taken seriously
is quite another. "I was being dealt with as an eccentric. And that made

me very unhappy," Kosuth says. "I thought I had a new agenda for art. But I realized nobody would listen to me unless I had a movement around. Nobody would get the message." His Realpolitik was carefully planned. "I guess now I can say it so many years later," he says. "I'm a little embarrassed that was the way I really behaved. I knew the Conceptual artists in Denmark. I knew the Conceptual art in Yugoslavia. I knew the ones in Paris. And I knew those guys in England.

"So I went out and put together a group. It wasn't for career reasons. I wanted the art to be understood, and I needed concrete examples of the practice. Right? So I went out and phoned the artists. I converted many artists. Right? Lawrence Weiner was a painter. A very devoted one, working and playing with materials. Robert Barry was a painter. Doug Huebler was a sculptor."

This was the core group in the show of Conceptual art curated by art entrepreneur Seth Siegelaub at a gallery on New York's Upper East Side in 1968. The following year Kosuth published "Art after Philosophy" in *Studio International*, in which he bid Minimalism farewell, writing, "Pollock and Judd are, I feel, the beginning and end of American dominance in art . . . most likely due to the fact that nationalism is as out of place in art as it is in any other field."

The Minimalists were not grateful. "Oh, they were definitely threatened. Their radical thunder was being stolen from them," Kosuth says. Sol LeWitt wouldn't visit his studio. "He said, 'Joseph, I've heard what you're doing. And you have to know: *Ideas will never be art!*' Sol may be the grandfather of the movement, but he certainly isn't the father." After the publication of "Art after Philosophy," Kosuth claims, LeWitt and Carl Andre prevailed on Karl Fischer, the Düsseldorf dealer, to cancel a show of his work. "As a result, I didn't show in Germany until some years later," Kosuth says. "I can understand now. These guys had worked quite a while before they got any recognition. I was very young. I was twenty-three years old in 1968. No one knew my age. In those days people didn't take young artists seriously."

Also in "Art after Philosophy," Kosuth listed various followers, Lawrence Weiner being one. Weiner, a lanky, sardonic, powerfully

built man with pale eyes, beard, and ponytail, is known for printing words and sentences on museum and gallery walls. He handed me a white matchbook printed in red letters with STARS DON'T STAND STILL IN THE SKY and made it plain that the notion that he was a follower of Kosuth didn't sit particularly well with him. "I'm a New York person," he said. "I was here in the early Conceptual days. Joseph wasn't. He was wherever the fuck he was. He came here on a Fulbright.

"I'm not going to spend the rest of my life worrying about Joseph's fantasies. The point is that most of the things he did, he never showed. And everybody in New York saw *everything*. But if he wants Conceptual art, he's got it. *It's all his*. I always put myself down as a painter or a sculptor or whatever. Who the hell wants to be a Conceptual artist? Those guys were like boring schoolteachers."

When interviewees differ, it is awfully easy for the writer to become part of the process, like in a game of Chinese whispers.

Conceptual art was at the threshold of power, Kosuth still believed. Painting and sculpture were drizzling away into "visual Muzak." Kosuth felt he was successfully pressing the notion that putting paint on canvas "would block the ability of any individual artist to really say anything. That was what I was fighting for."

Meanwhile, though, the culture was focusing on wars that were muddier and bloodier.

In 1965 a full-page ad in the *New York Times* calling for an end to the Vietnam War was signed by five hundred artists, critics, and so forth. Thus the American art world plunged en masse into radical politics. The following year a "Peace Tower," designed by the sculptor Mark di Suvero, was erected by a hundred West Coast artists on a vacant lot in Los Angeles. It failed to find a home and was sold off piecemeal. Anti-war movements like the Angry Arts Coalition, co-founded by married artists Nancy Spero and Leon Golub, sprang up. In Chicago in 1968, the year of the Democratic Convention, a dealer,

Richard Feigen, put on a show attacking the heavy-handed mayor, Richard Daley.

Even more rigorous perhaps was the European art movement known as the Situationist International, a name that was not thriller-esque by accident. The S.I. was born at a meeting in July 1957 in Cosio d'Arroscio, a small town in Italy's industrial belt. The eleven people present were the total membership of three groups — the Psychogeo-graphical Society of London, the International Movement for an Imaginist Bauhaus, and the Lettrist International. Their merger cre-ated one of the most icily exotic art sects ever.

Guy Debord, the Lettrist who led the S.I., was one of those des-potic figures the art world sometimes throws up — like André Breton, boss of the Surrealists, and George Maciunas of Fluxus. Debord be-lieved the modern city no longer offered real experience and that ordinary citizens had become consumers of images. Debord, a super-lative phrasemaker, called this "the Society of the Spectacle." He believed this urban numbness could be dissolved, given the right situ-ations. Hence the movement's name.

Debord believed art could deliver the necessary shock treatment, but tossed out earlier models like spent shells. Duchamp's "drawing of a mustache on the *Mona Lisa* is no more interesting than the origi-nal version of that painting," wrote Debord and Gil J. Wolman, a fellow "Situ." The S.I. wanted to make work that could not be "recuper-ated" — their word — exhibited, published, bought, *collected*. One scheme was to dye the Venetian lagoon a bright color. This was aban-doned. Instead, they crashed a meeting of art critics — a group that included James Johnson Sweeney, former director of painting and sculpture at MoMA — in Brussels and distributed a communiqué, which concluded: "Disperse, fragments of art critics, critics of frag-ments of art. The Situationist International is now organizing the unitary artistic activities of the future. You have nothing more to say."

Guy Debord's hunger was unsatisfied. At the S.I.'s fifth confer-ence, the making of any art, however "radical," was expunged from the agenda in favor of political action. From then on, the movement's

principal visual production consisted of what were called "erotico-political comics," which were actual commercial comic strips, with Situationist aphorisms in the speech bubbles. In these, as in the movies of Godard—whom the S.I. detested—the allure of the Low rather overpowers the subversive intent.

Elsewhere in the art world, Richard Hamilton turned a TV image of the shootings at Kent State into a print. Oyvind Fahlstrom, formerly among the liveliest of Europe's Pop artists, made some wooden anti-Vietnam images. Erro, a Paris-based Icelandic artist, was acclaimed for *American Interiors*, 1968 canvases showing noble Third World guerrillas looming outside the French window of a suburban dressing room, planting a bomb in a bathroom, or wielding spiky weaponry in a bedroom. Alain Jouffroy, the Marxist author of *The Abolition of Art*, expressed doubts, wondering whether it was possible to make truly revolutionary paintings. "For it seems difficult to conceive of an 'illegal' painting," he wrote, "unless painters devote themselves exclusively to the production of revolutionary posters."

René Block, a Berlin dealer, found himself at a similar impasse. "Ulrike Meinhof used to visit my gallery. There were, for a short time, discussions about how the new artistic and political forces could work together," Block told the magazine *Art Press*. He added: "But soon it was clear that the political side was only looking at artists as poster designers and organizers of polit-happenings." Meinhof departed the art world. She co-founded the Baader-Meinhof group, took part in some famous kidnappings and died in jail, supposedly a suicide.

Artists could seldom be so single-minded. "A lot of artists had trouble. They couldn't work. They felt it didn't make sense," says Olivier Mosset, a Swiss artist and former assistant to the quirky junk artist Jean Tinguely. Mosset was in Paris, painting canvases that were blank except for a central disk image. Alain Jouffroy approved these, writing that Mosset had "put into practice the more or less conscious idea of abolishing 'art.'" Mosset puts a more art-world spin on it, though. "Donald Judd said anything could be art as long as it was interesting," he explains. "The idea was to do something that was not interesting."

The "red" or "Vietnam" room was the set piece at the Young Painters' Salon in Paris in 1967. In 1968 artists showed up at a Cultural Congress in Havana, Cuba, and closed down both the Venice Biennale and the Dokumenta, the influential art fair in Kassel, West Germany. In May 1968 slogans like L'IMAGINATION AU POUVOIR and SOUS LE PAVE, LA PLAGE bloomed on the walls of Paris. "The Imagination to Power!" "Beneath the cobbles, the beach!" These were the creations of the Situationist International. Jean-Jacques Lebel, the artist son of Robert Lebel, friend and biographer of Marcel Duchamp, led the storming of the Paris Opéra. The wave of revolution crested, and curled.

And vanished.

What happened? Olivier Mosset says, "It stopped. Everybody went on vacation."

The most cantankerous groupuscule was in New York. It was founded by Ben Morea, a short, slight man with dark eyes and black hair, who had taken up painting as art therapy in a drug-rehab program. The anarchist writer Murray Bookchin says, "His painting was very unusual. It consisted of *vast panels* of black. Swirling nebulae. Completely black." Morea, who lived on the Lower East Side and dressed likewise in black, was going to make revolutionary art, and soon had a cadre of followers. Morea's group was accepted by the Situationist International as a New York chapter. "He started by criticizing the more heinous figures of the counterculture, like Timothy Leary and Allen Ginsberg," Bookchin says. "He put up extremely pithy posters." No movement gets far without a name, but Morea abhorred Isms, so a phrase was taken from the first line of a poem by LeRoi Jones, who would soon Africanize his name to Imamu Amiri Baraka. They became the Up Against the Wall, Motherfuckers, and Morea changed his name to Ben Motherfucker.

The Motherfuckers were given the center pages of *The Rat*, a counterculture periodical, and created terrific agitprop—for instance, collaging a gun and a line of text from an art-school-enrollment ad: "We're looking for people who like to draw." They also did such street theater as chucking garbage into the Lincoln Center fountain to support a sanitation strike and a performance to applaud Valerie Solanas for gunning down Andy Warhol. But in November 1967 the Situationists sent Guy Debord's deputy, Raoul Vaneigem, to New York to make sure that their tributary groups were keeping to the party line. As is made plain in the fractured crystal prose of the *Situationist International Anthology*, the Motherfuckers did not come up to scratch. They were, to use the grim term the S.I. much enjoyed, duly "excluded."

The Motherfuckers were not crushed. In March 1968 they joined a group of Surrealists protesting "Dada, Surrealism and Their Heritage," a show at MoMA. "Suddenly the Motherfuckers were there, dressed as pirates. It was hilarious," Bookchin says. Jean-Jacques Lebel arrived in New York in the summer of '69. He and the Motherfuckers went to Woodstock together, "liberated" some food from a truck, and gave it to the soaked fans. Lebel then went onstage with Abbie Hoffman, who planned to make an address. Poor timing. The stage was occupied by The Who. The rock group had actually been launched with Pop Art trimmings—Pete Townshend had worn a Union Jack jacket; Keith Moon had a T-shirt with a target and POW! on it—but they had also been one of the few groups to insist on being paid before performing. Townshend whacked Hoffman with his guitar. Art and Revolution were pushed offstage by Rock. It was a hinge moment. Ben Motherfucker took off from New York soon after. "He was very paranoid. He was convinced that the FBI and the police were out to get him," Bookchin says. "He faded away."

Other radical art groups were less funky. In January 1969, Takis, a Greek artist, forcibly removed one of his own pieces from MoMA because it wasn't the piece he wanted to show. His issue was institutional disregard for the wishes of artists, and this was taken up by the

Art Workers Coalition, a group that was egalitarian, nonviolent, and remorselessly prosy and among whom a prominent presence was a blue-coveralled Carl Andre. Its preferred venue was Paula Cooper's gallery. "I wasn't invited because I was a gallery owner," Paula Cooper says. It rankled at the time, though, not least because, unlike certain of the Art Workers, she actually *worked*.

The Art Workers drew up a menu of demands for MoMA's director, Bates Lowry, one being that a segment of space be permanently assigned to black artists. None of these demands were acceded to, but Lowry resigned in May. The Art Workers also contrived to release a swarm of cockroaches when the trustees of the Metropolitan Museum were holding a black-tie dinner in a reconstructed Louis XVI banquet hall.

But the arts utopia was drifting out of reach. Things were darker, sourer, meaner. In April 1968 Hans Haacke wrote in a letter to *Artforum*: "Nothing, but absolutely nothing, is changed by whatever type of painting, or sculpture, or happening you produce. All the shows of Angry Arts will not prevent a single napalm bomb from being dropped. We must face the fact that art is unsuited as a political tool."

The balloon hadn't burst. It hung there, shriveling. The Performance artist Carolee Schneemann, says the American art world underwent "a collective nervous breakdown . . . couples separated. People flipped out on drugs. They went into communes. The buzzword was polarization. There was paranoia." Guy Debord moved further down his cold road. He decided that the success of the Situationists during *les événements* of May 1968 had made them part of the enemy, the Society of the Spectacle they were supposed to be attacking. In 1972, the Situationists made their last "exclusions"—themselves. According to the critic-curator Peter Wollen, this "brought to an end an epoch which began in Paris with the Futurist Manifesto of 1909—the epoch of the historical avant-gardes with their typical apparatus of international organizations and propaganda, manifestos, polemics, group photographs, little magazines, mysterious episodes, provocations, utopian theories, and intense desires to transform art, society, the world,

and the pattern of everyday life." A time, that is to say, when the future was young.

Things tend to move a bit slowly in London, and the British art world remained *engagé* longer that most places. Norman Rosenthal, now the exhibitions secretary at the Royal Academy, was at the avant-garde and politicized Institute of Contemporary Arts until 1976. "I left my blood on the walls when I left," he told me recently.

What actually happened? He looked at me as if maddened by my denseness, and repeated, "I left my blood on the walls when I left." He had been roughed up, he said, by militants.

I popped into the ICA and was shown a sheet of Perspex on the wall, preserving some brownish splotches. A penciled notation read: NORMAN'S BLOOD.

Others, like Dennis Oppenheim, were looking at different ways to skin the cat. Oppenheim was born in Electric City, Washington, the son of an engineer on the Grand Coulee Dam. He was at Berkeley in 1964 when the Free Speech Movement was in full spate, and went on to Stanford. First there was the ritual dumping on the establishment. "At Stanford we were targeting Minimalism as the movement to overthrow," Oppenheim says. "Minimalism, I felt, was very limited. I was groping for a way to lead me out of this zero point. Thinking about that over and over again led me to look at alternatives."

He tried making "bad paintings," just as Olivier Mosset was doing in Paris. It didn't work for him. Then Oppenheim read Robert Smithson, an artist of his own age. Smithson, an admirer of the British science fiction writer J. G. Ballard—whose stories are filled with hauntingly described artificial landscapes, like deserted airstrips—wrote in plain, urgent prose and tapped into the pent-up poetics of Minimalism, the way it connected to both the prehistoric and the futuristic (an oblong shape could be just an oblong shape, or it could be the oblong shape in Stanley Kubrick's 1968 movie *2001: A Space*

Odyssey). Oppenheim says, "Smithson brought sculptural ideas into the real world. It made me very happy to find a way out of the studio, which I thought was going to be a dead end. He didn't indicate exactly how some of these things were going to be done. But for me it was like reading my own thoughts." A 1967 Smithson article was illustrated with a map and a satellite photograph of California's Pine Flat Dam, which was then under construction, and noted, "When it functions as a dam it will cease being a work of art and become a 'utility.'"

That summer Oppenheim trekked through Oakland, California, until he found the right spot. "It was in a suburban area, not a rural area," he says. "I made a very small cut in a hillside. It was done with shovels, entirely by myself, and it had a kind of a wooden liner, so that the walls would not cave in." He called it *The Oakland Wedge*. Oppenheim says it was his first Earthwork. "*The Oakland Wedge* was never photographed," he says. "But I talked about it in interviews with Willoughby Sharp and other people. And I told Smithson and Heizer about it." Sharp edited *Avalanche,* one of the livelier art mags of the time. "And it was always mentioned. Because there was quite a bit of interest in who did what first," Oppenheim says. Yes indeed.

That same year, Walter de Maria, an artist of Conceptual bent and quicksilver temperament, wanted his Manhattan loft painted. In accordance with the protocols of the art economy, he hired Michael Heizer, a younger artist, to do the job. The paint job went well and de Maria chatted with Heizer. Michael's father, Robert Heizer, was an archaeologist, and as a boy Michael had been with his father on digs. He had already made a maquette for a piece he called *North, East, South, West,* — four geometric shapes, but negative spaces, dugouts.

A cartoonist would illustrate the conversations between Michael Heizer and Walter de Maria by showing a lightbulb going on.

"Walter de Maria had been making these Duchampian landscape drawings," Heizer says. "He had one that said *Two Parallel Lines in the Desert.* All his concepts were in a card file. So he had an affinity for the idea. I encouraged him to do this. As I encouraged Smithson very strongly."

Heizer is ferociously insistent that he preceded Dennis Oppen-heim. "I'll put it to you straight. The way it worked, I was the only guy doing it. I was real alone and real lonely. No one in the world was doing what I was doing . . . riding around on a Greyhound bus . . . hitchhiking, with a shovel and a water can. . . . These guys weren't doing that work. . . . I'm not sitting here and arguing for my historical position. I'm just telling you."

In 1968 Michael Heizer made some short-lived pieces in the Mojave Desert, using dyes and powders, and *Nine Nevada Depressions*, "a fifty-two-mile line of loops, faults, troughs, and intersections." He first showed in public in the early fall at a group show, "Earth Art," at the Virginia Dwan Gallery in Los Angeles. In 1969 he began work on a monumental piece in the desert, *Double Negative*.

The catalog of the Los Angeles Museum of Contemporary Art retrospective of Michael Heizer's work includes a chronology. It notes that *North* and *South*, his first two "Earthworks"—a term he hates, just as Judd hated "Minimalist"—were made in the Sierra Nevada, Cali-fornia, in 1967. William Seitz wrote in *Art in the Age of Aquarius* that Heizer's "early efforts remain unknown, but from the spring of 1968 on, he made careful photographic records." Seitz clearly missed the LAMCA catalog. It has a snap of *South*, dated 1967.

Dennis Oppenheim came to New York and got a job teach-ing art to ninth graders in a Long Island junior high. In early 1968, he and Michael Heizer were sitting in Max's Kansas City with dealer John Gibson. The dealer paid each artist a studio visit. He remembers that both had well-researched projects and were working on models, but he doesn't remember either one mentioning a completed piece. "I offered them both shows. But Heizer wasn't ready," Gibson says.

"Everything was very volatile, very competitive," Oppenheim says. "There was a lot of angst among the artists, a feeling that they were guarding secrets. These guys have survived because they were

really vultures. All of them! Richard Serra. I mean, it was like *the cat was out of the bag*. And everybody was guarding their positions. It was the year, and the summer. Things gelled so concretely during a three-month period. It was in the air—just ready to drop."

Oppenheim's first one-person show, "Earthworks," opened in May 1968. It consisted of scale models for unbuilt pieces, with houseplants standing in for the vegetation. While it was still up, Oppenheim worked on some small-scale projects in Connecticut and Pennsylvania. Younger artists offered to help, so Oppenheim decided to make a bigger piece in Maine, where his wife's family lived, and wrote to Robert Scull, asking for $350 to rent a snowmobile and a small tractor. "He actually came to my studio. I had a basement in Brooklyn," Oppenheim says. The collector came through. Oppenheim took off for Maine with his zealots and a cheap camera.

One project was on the Canadian border. They cut a line of more than a mile along the frozen St. John River where it forms the frontier. Oppenheim says, "I was very interested in the fact that my sculpture would be on the boundary. It was twelve o'clock on one side, one o'clock on the other. It was not an object. It was a *place*." They labored on in the bitter weather. In another piece Oppenheim replicated the growth rings of a tree trunk in the snow. In another he sheared lines through the black river ice. Who got to see the stuff? "Just a handful. My wife. A few assistants. Some Canadians," Oppenheim says.

Robert Smithson was from New Jersey, but Walter de Maria, Dennis Oppenheim, and Michael Heizer were from California. So too was James Turrell. His parents were Quakers. He says, "Quakers don't believe in art. They don't believe in decoration." Turrell went to Pomona College. Because he loved flying, he started reading about aerial phenomena. Texts on perceptual psychology taught him about a phenomenon called the *ganzfeld*, or "homogeneous field," a domain

of pure light. In the everyday world, the disorienting effects of a ganzfeld are most likely to be experienced in the form of a whiteout during a thick fall of snow.

Turrell's earliest realized pieces were begun in 1966. He used a quartz-halogen projector on a wall to create a seemingly solid cube of light. If approached, it dissolved. In 1968 he hooked up with another West Coast artist, Robert Irwin, and with Ed Wortz, a divisional head of a small aerospace firm that had been a subcontractor on NASA's *Apollo* program. Turrell was then living with his first wife in the Mendota Hotel in Ocean Park, a low-rent bohemian neighborhood not far from Los Angeles. There he began to make what he called the *Mendota Stoppages*. He cut openings into his walls, painted his floors and ceilings, hung scrims of insubstantial fabric, and filtered light through panikins of water or of gas. What with Video and Performance, to say nothing of John Cage's music, time was playing a part in the new art and it did so here, as the light moved through the Mendota, changing as the day progressed and with the nuances of the weather. Turrell played with it, like a painter squeezing pigments directly from a tube or mixing them on a palette.

Making stuff that was short-lived or keyed to time was another way of making stuff that resisted becoming an object of trade. It was also an implicit rebuke of Minimalism, which was irreducible to the point of seeming indestructible. There was a lead piece by Richard Serra in "Anti-Illusion," a 1969 show at the Whitney organized by a young curator, Marcia Tucker, that picked up on a lot of these tendencies. There were several pieces by a Californian, Bruce Nauman, including the fiberglass *Impressions of the Knees of Five Famous Artists*. (Nauman was then also making his first videos. Video was a form that had become widely available just that year. It was then Sony put out its Portapak, one of those commercial advances that have extraordinary impact on the practice of art, like the marketing of tubed paint in the 1840s.) Tucker's show also included a soft sculpture by Robert Morris, who cut gray felt into strips, and a "scatter" piece by Barry Le

Va, who took the revolt against form about as far as it would go, on this occasion by littering snippets of cut felt over the floor. There was a creepy piece by Eva Hesse, a metal box filled with quasi-intestinal latex tubing, and there was a photograph in the catalog of another artist, Lynda Benglis, tipping liquid latex onto the floor.

Benglis wasn't in the show — "I wasn't ready," she says — but it will be noted that both she and Hesse were women. No accident. Marcia Tucker was one of the first of a crew of feisty feminists to get into the structure of a major museum. Eva Hesse developed a brain tumor, which was at least aggravated by her art material of choice, before the show opened. Tucker took the catalog to her in the hospital. A few months later Hesse was dead.

The work made by the Anti-Form artists satisfied a prime requirement of any hot-wired new form: It didn't look much like art. The thinking, of course, is that if stuff looks like art, it is because it looks like other art, and something new should look alien at first. This is a good principle, if by no means always true. It was true certainly of Process art, another coinage of the time, whose principle was well expressed by Richard Serra, who wrote: "I want to show the results of actions taken. Folding, rolling, cutting or bending — not the illusion of those actions."

In 1969 Dennis Oppenheim made *Canceled Crop* and *Directed Seeding*, an enormous double work with farm machinery, in the wheat fields of an art-loving farmer in Finsterwolde, Holland. The project left the artist feeling both exhilarated and troubled. "The fact that I could use food and things like that interested me," he says. "But I saw I had expanded sculpture to such a degree that it included everything in the world. And I felt unable to carry that idea forward in any inspired way." Earthworks were getting too grandiose. Later Heizers "look like Nazi architecture," Oppenheim says. "I turned inward to my body." Soon Oppenheim was having daily conversations with another artist, Vito Acconci.

Vito Acconci is a New Yorker with the saggy, melancholic face of a spindlier Rembrandt and a voice like a collapsing mound of gravel. He began as a poet. His decision to become an artist without elementary training would not nowadays be worth a mention—in a certain sense *all* artists are self-taught these days—except that Acconci is quick to admit that he has few natural talents, and not even much of an eye. "I came at a time when that wasn't much of an issue," he says. "The time of *The Whole Earth Catalog*—the time of the blending of disciplines. You could take from wherever you could. You might not know how to do a particular thing. But you knew how to use the Yellow Pages."

In 1970 Dennis Oppenheim made a piece called *Reading Position for Second Degree Burn.* He was photographed lying on a beach with an open book across his chest. In a second photograph he is in the same position, but shrimp-pink, except for a pale oblong where the book had been. The photo had been taken at Jones Beach. "The Hamptons were not on the menu yet," he says. "I wasn't after severe burns. It was about commitment. And the formal color change." Another photograph taken later that year shows Oppenheim with an alarmed expression, standing beneath a tilted boulder. "The expression was real. The boulder might easily have fallen," he says. On later reflection, something troubled him more—the degree of theater in those pieces. "It seemed to me there was a touch of masochism there, exhibitionism," Oppenheim says. He realized that Body art had limits, too.

Acconci's first post-poetry pieces had been photographs. He started to use his own body in 1970, after seeing Oppenheim's first steps in that direction the previous year. *Seedbed* was in 1972. The artist was concealed beneath the false floor of the Sonnabend Gallery, which had recently opened at 420 West Broadway. Throughout the exhibition, Acconci lurked there invisibly, masturbating, with gallery-goers thumping or tippy-tapping overhead and listening to his grunts and muttered soliloquy on an intercom. "Sometimes I would strive to no avail," Acconci concedes. "But at that time authenticity seemed

really important. I wanted my stuff to be stuff that *anybody* can do. For me, Abstract Expressionism had meant the artist as priest. The use of my body was . . . well, everybody has a body. It backfired because as soon as a person is photographed, this person becomes as important as any Abstract Expressionist. But the original impetus had been that this could be anybody.

"We had the notion — the misguided notion — that this was really going to change the art world. This was a way of saying art is not a system of unique objects, therefore precious objects. We were going to provide things that were impossible to sell." Dennis Oppenheim, Acconci remembers, kicked up a bit of a fuss before Kynaston McShine's "Information" show at MoMA, one of the first public airings of this new work, upon learning that the artists' names were going to be affixed to their works.

Acconci gives a hoarse, knowing chuckle. "We didn't think hard enough. It was kind of interesting that the first year Sonnabend was there, they did a show of mine, they did Dennis Oppenheim, they did Gilbert & George. In other words, they were showing stuff which was obviously going to bring no sales but which was going to create a lot of interest.

"I don't know that this was a carefully thought out plot on the part of dealers. Sonnabend had been showing uptown with a very different kind of work. She was showing Robert Graham. I think this was more . . . feelers. We might not have provided things to sell, but we provided something that every business needs. We provided advertising, window dressing. If anything, I think we made the art gallery system stronger. They could say, 'Look, we can even deal with *this*!'

"By '72 or '73 I started to have my doubts. The concentration on self began to be exactly what we didn't want it to be — American Cowboy!"

Acconci and Oppenheim turned their attention to making objects. Body art would continue to be made for years to come, though, by others. "That was when the real nonsense began," Lawrence Weiner says acerbically. "The Brushing My Teeth piece . . . the Cleaning My Toenails piece . . . the Work About Thinking of Going to Work, piece

number three, variable number four . . . All movements become decadent after a while, don't they? It's the nature of movements."

In modes of art where the handiwork is less important than the idea, why you do something can be at least as important as what you do. Body art tended to be about downplaying the artist's ego in the United States. Elsewhere, showing off was much of the point. As early as 1959 James Lee Byars, an American whose work has always gone down better in Europe, would display himself in a room dressed as a Chinese mandarin. Ben Vautier, a Fluxus artist, designated himself a "living artwork." Piero Manzoni, a Milanese artist, upping the ante both on Vautier and on his principal rival, Yves Klein, who had "signed" the sky to make it his own artwork, signed other people, designating *them* as artworks.

In 1959 he started selling his breath in balloons. Manzoni's next step was described by a friend, the painter Enrico Baj. "In 1961, in an act of defiant mockery of the art world, artists and art criticism, which in unison treated him as though he were retarded, Piero Manzoni invented 'The Artist's Shit,'" Baj wrote in a sad-angry essay. "He performed the operation himself: produced it, put it in a box, sealed it, labeled it, numbered it, and signed it."

Manzoni made an edition of ninety cans. "This filthy gesture brought all his relationships — not only with the art world but also with his own former aspirations toward visual and conceptual purity — into crisis. He became increasingly restless; he started to travel and to drink heavily." This went on for only eighteen months. Baj wrote: "By the age of thirty he had drunk himself to death."

Killing art was a deadly serious business. It is the opinion of many art world cognoscenti that Manzoni's infamous cans in fact contain tomato paste. They are wrong.

In 1969 Gilbert & George gave their first public performance, *Singing Sculpture*, at the Lyceum, London. I saw it in Nigel Greenwood's

tiny gallery off Sloane Square the following year. Standing on a small square table, their faces slathered with metallic paint, they moved through a series of stiff poses with arms, legs, and canes while a venerable gramophone played and replayed a standard of the British music halls, "Underneath the Arches." The duo moved like automata, performing seven hours a day for a week, and it was said that some viewers left convinced that the pair were, in fact, cunningly constructed robots. During my own second visit, a well-tailored drunk was imploring them to "perform" at a party. They ignored him. The drunk was walked out, impotently waving a fistful of banknotes, a rare sight in an art gallery at the time.

George, the larger one, is British. He was pale, deceptively mild. Gilbert, a German of Italian extraction, was slight and dark. Each would answer questions carefully when we met some years later, but would then freeze, rather unnervingly, into an Art Pose. References to their "Edwardian" appearance did not go down well. "In general we don't take kindly to people saying we derive from other periods," said George, the spokesman, puffing fastidiously on a Gold Flake. "We hate it if somebody says something inappropriate to our work. We are not interested in the formal picture-making side of it. If we are ourselves with our art, and if the viewer is with us, what more can we want?"

"Their feelings can be as rich as ours," Gilbert observed.

Do they ever relax? Come off-line?

"We work very little," George said.

"The relaxing is the work," said Gilbert.

"The sculpture takes up a minute part of our time," said George.

They congealed simultaneously into poses of polite attentiveness.

The endurance that Gilbert & George had demonstrated on the table was taken elsewhere to the sort of limits abjured by Dennis Oppenheim after Jones Beach. In 1971 Gina Pane, a Paris-based artist then in her early thirties, made a contraption in her studio of lad-

ders with nails sticking from their rungs. She climbed it with bare hands and feet and stayed aloft until the pain had eased enough for her to make an equally unpleasant descent. She called this her *Escalade Non Anesthésiée* and explained it was "to protest against a world where everything is anesthetized." This launched Pane on a career of aggression against herself. At a 1975 peformance at L'Espace Cardin, for instance, she used boiling water from an electric kettle to raise a design of blisters on her arm. "I was so horrified that I pulled the plug," says the Filipino artist David Medalla.

In Paris also, Michel Journiac exhibited himself in the Biennale in a posture of crucifixion, with hypodermic syringes in lieu of nails. Franklin Aalders, a Dutchman—naked, as was the norm in these exercises—adhered himself with Krazy Glue to the underside of a lock bridge in Amsterdam, and rose and fell for several hours. Valie Export, an Australian, munched razor blades and cut ritual scars upon her face. Stelarc, another Australian, had himself hoisted aloft on meat hooks.

Part of art is keeping the child alive. Few descents into infantilism were as complete as those of the Austrian foursome Vienna Aktionismus—Hermann Nitsch, Gunter Brus, Rudolf Schwarzkogler, and Otto Muehl. Nitsch, the first to get attention, began *Orgies, Mysteries, Theater,* a sequence of performances he called a "drunken ecstasy of life," in 1962. A freshly killed beast would be trundled on and torn apart by Nitsch's cultish followers, after which the entrails and bucketfuls of blood would be smooshed over a naked youth, usually male. Photographs suggest that the broad-faced Nitsch was not so much in an orphic trance as having the time of his life.

Gunter Brus, who rather lacked Nitsch's *joie de mort,* would perform wearing a brassiere, garter belt, and black stockings, like the *Playboy* Femlin, but burlier. He would hack at himself until he bled, would vomit, shit, and so forth, and handle the residues. Rudolf Schwartzkogler would slice into his lower abdomen. David Medalla attended a performance. "I was invited by one of Schwartzkogler's patrons. It was in a castle somewhere," he says. The invited audience watched on a video monitor while the artist was maiming himself in

another room. Some months later the artist was dead. The widely believed report was that he had severed his penis during a performance and committed suicide.

This never happened. David Ross, director of the Whitney, says, "The thing was a fake. It was made out of clay. I talked to the photographer. He never cut himself." Schwartzkogler did commit suicide, but because he was very ill. His patron committed suicide not long after.

Anecdotal liaisons of Death and Art have been current in the murkier parts of the art world for many years. One piece is authenticated by David Ross. He was a director of the Long Beach Museum in southern California and organizing some Performances in the mid-1970s. "A guy fucked a corpse. He brought it with him from Mexico," Ross says. The corpse was female.

Feminist ire descended on the director. "I can't even remember the guy's name. I've repressed it," Ross says.

Was there documentation?

"Just audiotapes. You hear the sound of *squishing*."

Bas Jan Ader, a Dutchman, arrived in California in 1964 after a two-man voyage from Europe in a forty-five-foot ketch. He married an American girl, Mary Sue, whom he had met at Otis Art Institute. They moved to Claremont, thirty miles from Los Angeles, and he wrote an "Implosionist Manifesto," which, Mary Sue explains, was "intended to work against the notion of an art object." Both taught. "Making a living from art was never an issue," she says.

Bas Jan Ader began making a few carefully documented pieces. There was never an audience. "I was mostly the photographer," Mary Sue says. In *Fall*, serial photographs show him toppling off his roof and riding his bicycle into an Amsterdam canal. In a 1970 photograph, *I'm too sad to tell you*, tears streak his cheeks. The following year the twenty-eight-year-old told *Avalanche* magazine, "I do not make body

sculpture, body art or body works. When I fell off the roof of my house or into a canal, it was because gravity made itself master over me. When I cried, it was because of extreme grief."

A fresh notion seized him. He would shoot himself with a handgun. Not badly. In some fleshy part. Ader was working out the parameters when, much to Mary Sue's relief, a younger artist beat him to it—Chris Burden.

Chris Burden had still been a student at UC Irvine when he felt drawn toward an art of extreme situations. Students submit a piece to graduate as Master of Fine Arts, and Burden came up with an elegant, indeed Minimal, plan. He would submit a box with himself in it. "My big breakthrough came when I realized I didn't have to *make* a box," he says. "I decided to put myself in a locker for five days and to make that a piece of sculpture or a performance or what have you. I liked the idea that the box pre-existed. I activated it."

Burden crawled into the locker, which was one of a bank of lockers in a campus room, at nine on a Monday morning, April 26, 1971. It was two feet high, two feet wide, and three feet deep. It was padlocked. The news traveled, and people constantly drifted in to look. "At night I couldn't sleep and my knees hurt a lot," he says. He had fasted, so didn't need to excrete, and had a pipe coming from a five-gallon drum of bottled water in the locker above and another pipe going down to a drum below to take care of the liquids. At five in the afternoon on Friday, April 30, the locker was unlocked and the artist crawled out.

That November, he made *Shoot*, the piece that pre-empted Ader. A friend fired a gun from fifteen feet away at Burden's right arm, grazing his skin. The wound is documented by a photograph. On May 25, 1973, well-wishers dropped Burden off with a kayak and bottled water on a beach in San Felipe, Mexico. He paddled to an empty beach on the Sea of Cortés where the average daytime temperature was 120 degrees. On June 7 he paddled back to San Felipe again.

On April 23, 1974, Burden was in a garage in Venice, in southern California. Outside in an alley, resonantly called Speedway Av-

enue, waited fifteen of his friends. Burden had called them, but hadn't said why. There were four men in the garage with Burden, who stripped to his waist and stepped up onto the bumper of a pale-blue Volkswagen. He leaned backward, his arms outstretched, until he lay on his back on the Beetle's comfy curve. He had been—though this is not part of the literature of the piece—shot full of Novocain.

One of his companions—"actually, it was my attorney"—hammered a nail through the palm of each of his hands and into the car. The others opened the garage door, started the engine, and drove the crucified artist out onto Speedway. "It was like an apparition," Burden says. "It was sort of like *Shoot* . . . the motor is running full blast. It's screaming! I think I'm only out there thirty seconds or sixty seconds . . ."

What had he actually been thinking, I wondered.

A long pause. "Art. Making art, I guess," Burden says, finally. "The pieces were kind of mythic because they were so short. What the audience saw was only thirty seconds long. Or sixty seconds . . . You could have been riding your *bicycle* down this alley . . ."

The piece was called *Transfixed*. Chris Burden was making art truly impossible to own or sell. "I could carry all my work in a briefcase. Just a set of negatives and a typed thing," he says. An exemplary Conceptual career.

Tony Shafrazi, an Armenian of Iranian background, had been at a London art school in the sixties. Losing confidence in his own art making, Shafrazi determined to make a place for himself in the art world as an enabler, and left for New York. There he discovered the same burnout that had driven the Performance artist Carolee Schneemann to Europe. "The art scene had reached what Smithson used to call 'The Vanishing Point.' You know, a cul-de-sac for everybody," Shafrazi says.

He went west. In 1973 he was teaching in New Mexico when Robert Smithson showed up, demanding that Shafrazi take him to see

the collector Stanley Marsh, who had a ranch near Amarillo called the Hidden Art Ranch. "He kind of forced the idea of doing something on Stanley," Shafrazi says. "So Stanley flew us in a private plane over the land and Bob was seeing things in the landscape that was whizzing by. He knew he had it when he saw the lake."

What Smithson saw was a fortlike structure, and he had a name for it. He had thought of giving it a contemporary twist by calling it *The Watergate*, but settled on *The Amarillo Ramp*. Marsh said he would make the money and labor available. Smithson flew back to New York, got into a fierce argument with Joseph Kosuth, who thought Earthworks were much too material, and flew back out west. He sent Kosuth a postcard: a photo of a hearse. Smithson wrote HERE'S AN "IDEA" FOR YOU on the card.

Stanley Marsh had loaned a little house to Smithson, his wife, Nancy, and Shafrazi. They would stay up late, working on the plans. "Then he persuaded Stanley to rent the plane again to take more aerial views. I went up with him. It wasn't right for what they wanted to do, which was to tip over and have a look at the lake, 'cause the windows were above the wing and it was too fast," Shafrazi says.

"The feeling was really horrible. Yet Bob was sort of laughing and giggling. He would give these beady-eyed reptilian giggles. Smithson liked this—the whole thing of entropy, this experience of the stomach dropping. It was all part of his art. You know, Humpty-Dumpty." It is also worth remembering that LSD was Smithson's drug of choice at that time.

A second flight had been arranged for the following morning. Shafrazi declined. He had, he says, a horrible dream. "And in my dream I realized that I had to get up, wake up, and stop him from going. And I couldn't do it! I heard a voice. Now I'm sure that it was Bob, calling out, to see if I wanted to go. But it was impossible to go." The next thing he knew he was being woken by the Marshes. There had been a crash. Smithson was dead.

"I felt I was hallucinating," Shafrazi says. "Maybe it was all planned. A conspiracy. Some peculiar thing or other." A look at the site convinced him it was pilot error, and he went back to New York.

The art world was in shock. "There was a wake, and then a huge party. Sol LeWitt and people were saying, 'well, what are you going to do?'"

In the event, Shafrazi, Nancy Smithson, and Richard Serra went to Texas, drained the lake, and spent forty-five days building *The Amarillo Ramp* with heavy machinery. But as far as Shafrazi was concerned, no exorcism occurred. He returned to Manhattan. "It seemed that art was truly ineffective in this world of politics and chaos," he says. "This was the culmination of Watergate. Something had to be confronted.

"From October until that spring—five months—I concentrated on the idea of the written word, applying it to something else. Because it was meaningless on a piece of paper." The "something else" he had decided to write on were the greatest paintings in the Museum of Modern Art.

"In my head the great masters were looming like icons. The pictures I had in mind were from this century. From Malevich's *White on White* to Duchamp all the way to Jackson Pollock and Johns's *Flag*. All the noble examples. The idea to write on these paintings was tremendously terrifying. I felt I had to let the words speak, and speak the most terrifying message. Almost like a sneer." Shafrazi began scribbling phrases into notebooks. The one he chose came from Joyce's *Finnegans Wake*. It was: "Lies. All lies."

He arranged for a call to the Associated Press in enough time to report the action but not to alert the museum, and computed that this would leave him three minutes, which would not be time enough to deface all the paintings he had in mind. "I had to pick *one* painting," he says. "It didn't matter whether the subject matter was appropriate, but it was. It was *Guernica.* It was at the top of the stairs.

"I took a spray can. The most convenient thing, really. It was red. Cherry-red. There were about forty people looking at the painting, and I had to cross the invisible threshhold that's there. You never cross that! And once you do touch that surface, that tabooed surface, it's like you're a child and could be hit on the head.

"So I wrote LIES ALL. And then I had reached the end of the painting. So I went to the front. It was a matter of writing a clean sentence. So I wrote KILL."

Shafrazi, who had feared his action might trigger the guards, who might or might not be armed, stepped back from the disfigured canvas. "A guard approached and I hand him the can," he says. "Everything was in frozen stages . . . more guards came . . . and the head of security came and he was pretty obnoxious. I mean he really was . . . They took me into a men's bathroom and searched me. . . . I had my passport and travelers' checks. I was thinking from here I would go to prison.

"And as we came out, there were already four or five people in white coats cleaning it. And, oh, many, many press were there to ask my name, and how to spell it. I said, '*I am an artist!*'"

Richard Serra, the temporarily deranged Shafrazi's host, helped put up bail. Shafrazi did not leave the United States. *Guernica* would later do so. Its surface had been undamaged because of the speed with which it had been cleaned and because Shafrazi happened to have used a fairly harmless paint. *Guernica* — Tom Wolfe's banana-strangled horse and all — now hangs behind bullet-proof glass in the Prado, in Madrid.

By 1973 Bas Jan Ader came up with his most ambitious project to date. He called it *In Search of the Miraculous*. It was a triptych. The first leg was an exhibition in Los Angeles. On view were phototographs of Ader wandering around the city by night with a flashlight, actively in search of the miraculous. A choir sang sea chanteys at the opening. Bas Jan Ader only made a few hundred dollars in sales, but it was agreed that the show was a success.

For the second leg he was sailing alone to Holland in a boat small enough to get into the *Guinness Book of World Records*. The third leg would be an exhibition in Holland, which would consist of the Los Angeles show, augmented by documentation of the voyage. Ader cannot be blamed for feeling that *In Search of the Miraculous* would put him into Burden's league at the very least. The boat was a twelve-and-a-half-foot ketch. Ader called her *Ocean Wave*, after a

ditty. He equipped her with a desalination device, a distress signal, and three months' worth of provisions and set off from Cape Cod in late spring.

Mary Sue flew to Holland to await him, but when he hadn't shown up by September, she flew home. In light of Bas Jan's general mystery-mongering, she remained optimistic for a while that his no-show might be a part of some greater artwork. A Spanish fisherman found an empty boat early the following year and towed it ashore. By the time local officialdom located Mary Sue and she got to Spain, both the boat and whatever documentation Ader might have been preparing had vanished. "All I have of Bas Jan's last voyage are his sunglasses," she says. Chris Burden says wonderingly, "He just sailed off, never to be heard from again."

The Search for the Miraculous was over. So it was, in a sense, for Burden too. *Transfixed* was among his last pure actions. He had made objects at UC Irvine. In 1975 he decided to return to this. In 1976 he showed the leavings from his actions, which he called *Relics*, at the Ronald Feldman Gallery in SoHo. Artists—not dealers, collectors, writers—are the best guide to what is going on in the art world. Warhol and Jasper Johns each bought three *Relics*, with Johns securing the nails that had secured Burden's hands to the Volkswagen and his diary from the Sea of Cortés beach. A young dealer, Larry Gagosian, paid $500 for the padlock to the locker in UC Irvine. This told the knowing not only that Burden was an odds-on favorite for the history books but that the whole moment had lurched into the past. "There was a bunch of us trying to make art that couldn't be sold," Chris Burden says. "Vito Acconci . . . Dennis Oppenheim . . . we all knew each other. But we were fooling ourselves. I think all work is collectible. All of a sudden, photographs are being sold. Or films . . . documents . . . something. In a sense we were all really naive."

Two / I'm Painting, I'm Painting Again

—The Talking Heads, 1978

In 1948 Mme. Jean Walter bought Cézanne's *Pommes et biscuits* at the Galeries Charpentier for 33 million francs, the 1996 equivalent of about half a million dollars. *Fortune* magazine would date the beginnings of the Modern Art market to this sale. But it wasn't until a London lunch in the fall of 1967 that a way of showing this market at work was dreamed up. At lunch were the business editor of Britain's *Times* and Brigadier Stanley Clark, who handled public relations for Sotheby's. The idea they hatched was for a sort of Dow-Jones index of the art world. Geraldine Norman, a statistician with no arts background, was hired to put the brainstorm into practice. "After five or six weeks working on it, I decided it couldn't be done," Norman says. "I walked up and down all night thinking about it, wondering whether to tell them it was impossible."

Strictly, she was right. A pound of sugar is a pound of sugar, whereas a Picasso can be early or late, a revelation or a doodle, studio-fresh or a ruin. But Geraldine Norman did it anyway. The Times-Sotheby Index was carried by the *Times* (of London), the *New York Times*, and *Connaissance des Arts*, and it was a hit with readers. The jagged edges of its graphs seemed to show that somewhere in the swirling fogs of subjectivity reared a solid mountain range of verifiable fact.

Peter Wilson, the Sotheby's chairman, killed it off in February 1971 anyway, much to the annoyance of the London *Times*. "I read a filthy letter about it to Wilson from the editor. But the graph had started

to go down. Wilson simply couldn't stand the rate at which it was collapsing," Geraldine Norman says. The index hadn't bothered to cover Contemporary art. It hadn't seemed interesting. That was just before the blooming of SoHo.

SoHo had been Indian country when Wall Street actually was the settlers' protective wall. The heart of New York in the very early nineteenth century, it soon sank. The volume of *Valentine's Manual of Old New York* published in 1926, described it thus: "Builders of armor plate and iron clads, thrown out of work by the ending of the Civil War, were perforce turned to the arts of peace. The result was the erection of such a melancholy set of buildings that many persons thought it would have been less harmful to have the war go on. . . . Their original claim of being fireproof was soon proved a fallacy and dealt a severe blow to their popularity."

The *Valentine's Manual*'s horror of the cast-iron frontages—the style was called palazzo—seems quaint now, but the writer was right that they were vulnerable, and the district was ominously nicknamed Hell's Hundred Acres. It was deserted by the garment business before the First World War. Realtors called it the Valley and waited until times were good enough to flatten it and rebuild. Robert Moses came close to doing that with plans for an expressway that was to run from New Jersey to Queens. A 1962 study entitled "The Wastelands of New York" observed that "there were no buildings worth saving" on Mercer, Greene, Spring, and Broome Streets. It said they should be replaced by high-rises.

Artists had been living illegally in this industrially zoned area for decades, and more moved in when a loft-rich area to the south was razed to make room for the World Trade Center. Evictions were common and early art settlers describe their travails with a *nostalgie de maquis.* Christo and his wife, Jeanne-Claude, who moved to Howard Street in 1964, still have a lightbox lettered PHOTO-STUDIO—DO NOT

ENTER attached to their apartment door. It was kept permanently flashing. When the inspector called, they had breathing space to strew camera equipment over the dining room table, stuff the bedding into a cupboard, and attach photographs—"They were pre-taped at the corners," Jeanne-Claude says—to the walls.

Robert Hughes, *Time*'s newly appointed art critic, an Australian who had been living in London, moved into a floor of a former factory on Prince Street, also in the mid-1960s. It was still urban wasteland. At five o'clock on a Sunday afternoon a bunch of kids stole his Harley-Davidson. He was so enraged that he stalked out onto West Broadway, which was deserted, and discharged a shotgun. "It was totally safe. If I did it now, I would be a mass murderer," he says.

The trickle into SoHo was turned into a flood by George Maciunas of Fluxus. This group of American and European artists, which had flourished earlier in the decade, focused on the light, the jokey, the ephemeral. There was nothing of a joke about Maciunas, the group's Lithuanian capo, though. Even the artist Lucio Pozzi, a close friend, calls him a "Stalinist." Maciunas got into real estate as though making a raid into enemy terrain. A brochure explained: FLUXHOUSES were formed in 1966 as cooperatives consisting solely of artists, film-makers, musicians, dancers, designers, etc. Maciunas bought buildings on Wooster, Greene, Grand, and Prince, eight in all. Would-be tenants were required to cough up two dollars per square foot, plus three cents per square foot for mortgage, insurance, and maintenance. Maciunas pointed out that this also covered "legal fees"—the only reference to the fact that the Fluxhouses were outlaw dwellings and that investors risked finding themselves on the street.

The dismal plan to build an expressway lurched back to life at the end of the sixties. Artists' groups sprang up to fight for legalization of the loft spaces in what a local antiques dealer decided to call SoHo. This stood for South of Houston but was borrowed from the raffish London district, itself named for a hunting cry: "Sohoe! The hare ys founde!"

The first art gallery in the area was opened on Prince Street by Paula Cooper in 1969. She was followed by Max Hutchinson, an

Australian, and Reese Palley, who showed both the newest art and
Boehm china birds. Holly Solomon, who had been an actress and a
collector, opened up at 98 Greene Street shortly thereafter. "It was a
performance space. It cost $150 a month. It was designed by Gordon
Matta-Clark." Matta-Clark, the artist son of the Chilean Surrealist
Roberto Matta, was a force in the art world. He and the poet-critic
Peter Schjeldahl had a lot to do with goings-on at 98 Greene. "We
did giant poetry events . . . video," Holly Solomon says. "There was
real art activity in the streets. It wasn't about selling art. There was no
documentation.

"We were all very poor. We would eat at Fanelli's, and there was
a truckdrivers' place that smelled of Lysol where you could get ham
sandwiches for eighty-nine cents. Gordon opened a place called Food
to give young artists coming to New York a place to work. Every Sun-
day night an artist was invited to make dinner. It was an event."

The first SoHo Artists Street Festival was held in May 1970. The
killings at Kent State University had taken place a few days before,
but rather than call things off, the participants had a mourning pro-
cession. The media coverage was intense. Later that year loft dwell-
ings were legalized but with many restrictions, and George Maciunas
carried on with his illegal co-ops, evading arrest attempts. There was
an escape tunnel from his apartment, he had a "Flux-kit" of disguises,
and for many years he delighted in sending postcards to the attorney
general's office from spurious addresses or (supposedly) from foreign
parts.

The metamorphosis of SoHo had predictable side effects. "There
was the abuse of drugs. People were spiking drinks with LSD. A lot of
people got scared," Holly Solomon says. Gravitas arrived in 1971 in the
shape of Leo Castelli, who opened on the second floor of 420 Broad-
way. Ileana Sonnabend, his first wife, settled in above him, and John
Gibson moved to the third floor. The dealers were so unsure about how
they would fare in this new neighborhood that they gave their first open-
ings on the same evening. "We were worried about whether we would

get anybody," Gibson says. "Then we looked out and saw this . . . sea of people. We staggered our openings from then on."

SoHo was given landmark status on August 14, 1973.

The collapse of the Times-Sotheby Index notwithstanding, there was one compiler of art statistics, Dr. Willi Bongard of Cologne. In 1971 Bongard began publishing a fortnightly newsletter, *Art Aktuell*, a mixture of gossip and analysis subtitled "Confidential Information about the Art Scene." It consisted of four cheaply copied foolscap sheets, without illustrations, and Bongard sold some five hundred copies at $100 a year. Such was the anti-profit motive of the time that he was sometimes referred to as "the most hated man of the German art scene" or—his own preferred formulation—"the most maligned art commentator in the Western world."

Bongard would kick off with "Dear Art Lover" and then focus on the current reputations and prices of leading avant-gardists, of whom the oldest would be of the Jasper Johns generation and the youngest, the most talked about newcomer. Each year he published a *Kunstkompass*. This was a list of those he considered to be the world's most important artists, ranked from one to a hundred, according to a system in which auction prices played no part but points were awarded through a wondrously complex application of games theory to art careers.

Three hundred points, for instance, were awarded to an artist whose work was shown at New York's (then scalding-hot) Jewish Museum, as against a hundred for London's Hayward Gallery or a measly seventy-five for Paris's Musée des Arts Décoratifs. Dokumenta was far and away Bongard's preferred international art fair, and being chosen to show there earned an artist three hundred points, as compared with fifty for the biennials in Venice, São Paolo, and Tokyo. Further points were awarded for getting into specific publications, but

Bongard ignored single volumes on an artist's work as being gallery-subsidized exercises in career building. Bongard was savaged for the lack of critical content in the newsletter, but actually his critique was implicit in whom he chose to include—and not many of his picks have flamed out since.

The *Kunstkompass* for 1975, for instance, led off with Rauschenberg, who was awarded 20,370 points, followed by Oldenburg, Warhol, and Johns. Joseph Beuys was the first non-American. Indeed, fifteen of the top twenty places were nabbed by Americans; Arman, one of the remaining five, would move to New York shortly. Hans Haacke came in at number one hundred. There were five women on the list, among them Bridget Riley and Lee Bontecou.

Bongard also compiled a list showing that thirty top artists had vastly outperformed Europe's thirty leading industrial stocks between 1960 and 1975. He was, though, rather less gung-ho when I ran into him in 1975 in Sonoma County, northern California, in the lea of Christo's *Running Fence*, about which I was writing a piece for a magazine. "Things went better this year than last," he said. "People seem to be more optimistic. But there is confusion. Collectors don't know what to buy. What is going to make it? It isn't the market that's the problem. The *art* is the problem."

But the market *was* part of the problem. The creation of OPEC in 1974 and the coming of oil power had bashed the Western economy, the art-market portion along with the rest. Some hoped the problem might also be the solution. An article in the London *Times* said, "Help for Arabs: Mr Andrew Faulds, Labour M.P. for Warley East, a keen pro-Arabist, and former front bench spokesman for the arts, yesterday announced the formation of a purchasing panel to advise Arab countries . . . Their role is seen as the protection of the new buyers from the machinations of the international art market."

Even more willing to be helpful than Faulds was the London dealer Roy Miles, a flamboyant former hairdresser, who assembled a stack of British horse paintings and flew them to Kuwait forthwith. An emir

looked them over and asked the price of one. Miles gave it to him. "He told me he could have his best stallion flayed and hang the skin for less," says Miles. A lot of loose money had ended up in regions that were not unnaturally suspicious of the artifacts of Western culture.

On July 24, 1970, John Baldessari put together all his paintings and burned them. "I wasn't selling any of them. And I saw myself eventually getting suffocated by all of my own works," he says. He began printing photographs and text onto canvas instead. Joseph Kosuth thinks he was right to claim painting was dead and that his death notices had been found convincing. "The dealers believed those things," he says. "What happened was they said, 'Painting's dead! You're right!'" He mimes a smacking of the lips. "'Now! Who are the Last Painters?'" He adds, "The whole careers of Brice Marden, Bob Ryman, Mangold, etcetera are based on the dealers' belief that we were right. They were getting the 'Last Painters.'"

These three were surely operating on the edge. Robert Mangold made paintings that were often of a uniform matte color, upon which were limned stripped-down Classical motifs. Robert Ryman made "white" paintings, although other colors might be scumbled into the all-over whiteness, and the surfaces varied enormously, so that one might look spare as a drawing board while another would be as succulent as an albino Soutine. Ryman, who like many artists enjoys being provocative when describing his work, called himself a "realist," the reality being the paint. Sometimes his work thrums with a neurasthenic delicacy; sometimes he just seems like a guy who had One Good Idea. It is demanding work. (French moviemaker Claude Berri, who has several Rymans, won't allow smoking near them for fear of yellowing the paint.)

The most robustly austere of Kosuth's three "Last Painters" was Brice Marden. "I'm not concerned with being in the forefront. I'm

very conservative," Marden says. Which is true, and which makes it more striking that Brice Marden made his reputation with work in a tradition that seems fine within the art world but that from outside it seems either decor or a colossal put-on: the Monochrome. Brice Marden worked as Robert Rauschenberg's assistant for a while but never saw his Monochromes. Jasper Johns's gray paintings affected him deeply, though, as did the work of Kenneth Noland and Jules Olitski. By the mid-1970s Marden was painting double panels, with each panel an all-over color. The colors were the muted grays and greens of the natural world: rock; seawater; plants. The surfaces are sensual but cool, and bear witness to the time that went into their making.

It isn't just time that went into the making of Marden's canvases but emotion—and not pacific emotions, either. American artists and writers are peculiarly prone to vaunt "anger" in their work—often to the bafflement of Europeans—but with Brice Marden it has the ring of truth. At the end of the eighties, after he had gone on the wagon, he spoke to me of his drinking days, which began "several years before the legal drinking age. There was this angry thing. When I got drunk I was not the kind of guy to be around when I was angry. I was mean.

"I'm still very angry. And the paintings I make aren't happy little paintings, either. That's an important element in the paintings. For me. The paintings are layered. They are layerings of very specific situations. Each one of these paintings is different and not by any preconceived thought. When I'm painting there's an immediacy because I'm right there. It's that moment and it's coming out of me. I do it. Nobody comes in to do it for me. So I guess that makes me an 'expressionist,' in quotes. A lot of this emotional stuff is somewhere in there."

Can the Monochrome keep its power three-quarters of a century after the first shock? Well, for Marden, at least, shock was never the point. "Oh, sure," he says. "I mean, people are redoing and redoing figurative art. Why can't they redo and redo Monochromatic art? Somebody can come along and make it interesting."

* * *

It wasn't just the oil lords who didn't have much time for art. There wasn't much of a demand in the United States, either—especially for work by "difficult" artists. The artists had determined to be hard on the collectors, and their strategies had been a triumph. The collectors pushed off, and such interest as there was came mostly from abroad. Christo and Jeanne-Claude, for instance, had lived in SoHo since 1964, but ten years later, the artist was still making 80 percent of his sales to collectors in Europe. Artists accordingly took to the trade routes. There was a string of cities—like Ghent, Amsterdam, Turin, and Milan—that had galleries and a nucleus of collectors. The artist would arrive, make a show, hang out, make a little money, and move on to the next city. It was like being part of a bare-bones road show. Some artists would prospect further, setting up their own trade routes. "I first went to India in 1971. I set up a show there," says the Conceptual artist Keith Sonnier.

"I went to work in Japan. Nobody was buying work that much. It was a big shock if somebody bought a work. But things were much cheaper. You could fly cheaper. And there was a more active grant system." It had been a grant from the Smithsonian that took Sonnier to India. Things were cheaper back home, too. "I was living on Mulberry and Canal, right in the heart of Manhattan. I had three floors for sixty dollars a month."

European markets for the more demanding American art were serviced by an enterprising crew of dealers, mostly German, Swiss, or Scandinavian and in their twenties. They were nicknamed Der Kinder, the kids, and perhaps the most striking was Bo Alveryd, a Swede, who stood six-foot-seven and had a gothic sense of humor. "You're a Conceptual artist, aren't you?" Alveryd asked Les Levine upon their first meeting.

"No. Not really," said Levine.

"Well, you make *boring* art, don't you?" Alveryd said, and laughed fit to bust.

Alveryd had been a Stockholm law student. "I was thinking of becoming a doctor in expropriation. This is when the government takes

the land," he says. Instead, he joined up with a poet, a would-be art dealer. "But he couldn't sell art. So I had to come into that." Alveryd became a frequent visitor to New York in the early to mid-1970s. Levine recalls that artists were dazzled by the money bag hanging from Alveryd's neck. He would dip into it when offering to buy a piece—minute sums, but actual money—and he would clinch a deal with the flattering, unreliable line: "It's for my private collection."

Alveryd preferred to buy in bulk. "As with most commodities dealers, he is cautious about creating markets for commodities in which he doesn't have large holdings," observes Levine, who credits Alveryd and Der Kinder with an aesthetic sensibility floating around the zero mark. "We always knew that art dealing was also a business. They were the first people to make it completely about money," Levine says.

Among the most ardent European collectors of American art was Count Giuseppe Panza di Biumo, a lawyer and realtor. His country house in Varese, Tuscany, had been filled with canvases by Rauschenberg, Rosenquist, and Franz Kline, but he had become a convert to Minimalism and what followed. "You are having a renaissance period there, like Italy in the fifteenth century," he told an American reporter in 1975, by which time his country house was filled with Judd, Flavin, Serra, and Robert Morris. Panza flew James Turrell to Tuscany after visiting him at his volcano near Flagstaff. Turrell cut a *Skyspace* into the ceiling of an upstairs room. He was paid $15,000, plus expenses.

There were American collectors—like Stanley Marsh, the still-active Robert Scull, and Agnes Gund, for instance—and several couples, primarily Burton and Emily Tremaine, Teresa and Alvin Lane, John and Dominique de Menil, and Chimiko and John Powers. All of these were wealthy, but one of the most remarkable collecting duos, Herb and Dorothy Vogel, were as financially strapped as the artists. Dorothy, bespectacled, with straight brown hair, looked like an assistant librarian, which she was. Herb, who was dumpy and outgoing, worked for the postal service. In the summer of 1975 I visited their two-room midtown apartment, in which they had made room

for a couple of turtle-filled aquariums, six cats, and a plethora of "difficult" art.

Herb and Dorothy had begun buying haphazardly, the way noncollectors collect: Rauschenberg prints; a shopping bag signed by Andy Warhol. "The key thing came when we visited Sol LeWitt's exhibition," Herb said when I visited in 1975. "We got our first piece directly from Sol. It was the first piece Sol ever sold." He meant the first piece in the Vogel Collection proper.

The next piece they bought was a Judd. They plunged into this austere world in a frenzy. "We began buying more heavily," Dorothy said. They became celebrated for both their eye and their intensity, and the artists' chronic suspiciousness was lulled by the Vogels' promise: never ever to sell. The sums they paid for work were, in Dorothy's words "a very solemn secret," but they were exceedingly low. The collection, upon my visit, included a LeWitt drawing, executed by Dorothy in colored crayons on the bathroom wall, and a Christo package. There was a Richard Tuttle, a hexagon of white paper, pasted onto the living room wall by the artist himself, and a Richard Long photograph of a field of grass and daisies, with two intersecting lines swathing through to make an X. "This is his most major piece of the time—*Plucked Daisies*. We are very lucky to have it in this country," Herb said. Another photo-piece shows Vito Acconci stepping onto and off a chair. "It's an important piece because that's when Acconci became a body artist," Herb said, and added intently that he was going to show me something "historical."

"We have without a doubt the greatest piece of Conceptual art that was ever done in the world. We have the *Closed Gallery* piece by Bob Barry," Herb said. The piece consisted of three white cards in a single oblong frame, invitations to the galleries in Amsterdam, Turin, and Los Angeles to which the show had traveled. The invitations bore the dates and times of the shows and the following information.

DURING THE EXHIBITION THE GALLERY WILL BE CLOSED. Amsterdam.

FOR THE EXHIBITION THE GALLERY WILL BE CLOSED. Turin.

THE GALLERY WILL BE CLOSED. Most succinctly in Los Angeles.

The documentation is a sheet of yellow paper, signed by the artist, confirming that the Vogels were the owners of the piece. Barry's note concluded, sternly: *This Paper Is Not for Display.*

This raced beyond Yves Klein's famous opening in an empty gallery. *The gallery wasn't even there.* The Vogels looked at it, exhaled, and glowed. They paid Barry $250 for this piece, which is what they paid Christo for his package. They bought from Dennis Oppenheim's first show, where the pieces were supposedly priced at $500, but the Vogels got the only one that actually sold. For $100.

It was 1976 and Farah Diba, the empress of Iran, had been on a gambling spree. "She dropped a million pounds at the Salle Priveé in Monte Carlo," says Parviz Radji, then Iranian ambassador to the Court of St. James's. Alarmed at the bad press, Radji suggested they put some money into art instead. They bought twelve canvases at Christie's in London in November 1976 for £400,000, including £60,000 for a Degas, *Nue Allongée.*

If it was Parviz Radji who put the Peacock Throne into the art market, it was Kamran Diba, a first cousin to the empress, who brought them up-to-date. Diba had studied architecture in America, returned home, and decided that Teheran, like any thoroughly modern capital, required a modern art museum. By the late 1960s he had drawn up plans, but found closed eyes and deaf ears at the Ministry of Culture, which was mainly occupied with the upkeep of ancient monuments. "The plan was very ambitious. And it was not their baby," Diba says.

The shah, for all his famous modernity, wasn't much help. "He was more interested in foreign affairs," Diba says. The empress, though, had studied design at the École Normale Supérieure in Paris and had been involved in performing arts there. At the end of the sixties she had launched the Shīrāz Festival, and John Cage, Merce Cunningham, and Robert Wilson had presented work there. But Iran, though well-to-do by Third World parameters, was not so compared to the

industrialized West. Kamran Diba's chances of getting the financing for even a respectable provincial museum seemed slim. OPEC changed everything, because the shah was very intent on bringing Teheran up to full cultural speed. "We felt we had tremendous wealth. A lot of development money poured into Iran. Somehow the museum could be a reality," Diba says.

His brief was simple: He had to build up a museum of international quality, and quickly. He bought some Impressionists. He bought Moderns but quickly became aware that, petrodollars or no, he would be unable to assemble a four-star collection of Impressionists and Moderns from scratch, so he decided to focus on contemporary work. Accordingly, in 1975 he approached a professional: Tony Shafrazi.

Diba was aware of Shafrazi's unhappy recent past. "He was a good boy with an Iranian background. We decided to help him," Diba says. Letters went out. "Some dealers refused to cooperate because of his *Guernica* thing. The Weber Gallery sent a letter saying, 'Who is this man Shafrazi?'" Diba says. Other art worlders were simply startled. "This artist manqué suddenly reappeared, wearing a vicuña coat," says Barbara Jakobson. Andy Warhol also appeared for a show of his helium-filled silver balloons and took the opportunity to make a silk-screened portrait of Farah Diba. Dennis Oppenheim was tapped to do a project in the desert. The Peacock Throne, it seemed, was going to play the role that rich Americans had once played in Paris: supporters of the avant-garde.

The Teheran museum opened on October 12, 1977, with a three-day shindig celebrating the birthday of the empress. The imperial couple were at the opening, and the International Hotel had been taken over to put up incoming dignitaries, including the likes of Nelson Rockefeller. No director with international clout had been found because of the political unrest in the country, so the acting director was Kamran Diba himself. The museum was quickly a popular success. "I saw a mullah there with his wife and son. I thought that was a good sign," Diba says. "I gave them a tour. He must have been one of the progressive ones."

Tony Shafrazi meantime was opening a gallery in Teheran — his
first gallery. He was opening with a show of work by Zadik Zadikian,
an artist who had gotten out of Soviet Armenia in 1966 and had been
in Manhattan since 1973. One of his projects there had been gold-
plating bricks, and his Teheran project was an extension of this. Zadik
had had five thousand bricks fired and was gilding them with ten thou-
sand dollars' worth of 22-carat gold leaf. They were to be sold in
bunches of thirty-two.

It was actually a brilliant scheme. The bricks, first of all, were an
exotic riff on Carl Andre, made seductively collectible, and witty be-
sides. (Gold bricks. Get it?) This was just for openers, moreover.
"Kamran was building a new city in the south. And he wanted a couple
of buildings to be gilded. *Totally.*" Zadik says. He exhales, wistfully.
"Ahhhh! It was a visionary thing."

Domus magazine ran a cover picture of the new museum in
February 1978, just when the shah's troubles were deepening. "It was
like a storm. The smiles are not smiles. The sun does not have a glow,"
Diba says. The first thousand of Zadik's gold bricks were in Shafrazi's
gallery. "I was painting the place and putting up lights. And suddenly
there was martial law. I lost everything," Shafrazi says. He was still in
Teheran when the shah fled. The gold bricks vanished. Diba's gold
buildings and Oppenheim's *Star Skip* were unbuilt. "Movie theaters
were burned . . . liquor shops . . . travel agencies . . . stores with Ameri-
can Express accreditation. And yet nothing happened in the museum.
Nothing! Luckily at the time there was a show of calligraphy. All
Islamic," Kamran Diba says. "We had a good reputation. The mobs
were mainly students. They used to hang out in the museum."

Early fears that the ayatollahs might adopt a Red Guards approach
and incinerate the art faded. "A lot of dealers were in contact. But these
people are no fools," Diba says. "They know the art is very valuable,
but politically it is very complicated to sell. It was a big political thing.
These mullahs have never been to an auction house. They are scared
of being burned. Deep in my heart I am glad. The collection is still
there. In Iran."

It is a shame no cinematographer was around for a last incursion of hip art worlders before the shah's fall. A clutch of New Yorkers, including Joseph Kosuth, Sarah Charlesworth, Keith Sonnier, and Tim Rollins, stopped over in Teheran en route to Beijing in January 1978. "Tony picked us up. He took us to the bazaar, the mosque," says Sarah Charlesworth, a Conceptualist who works with photographs. So on to China. They were one of the first groups allowed in and were permitted to lecture but not to show their work. Sarah Charlesworth sees the trip as marking the end of the involvement by American artists in direct politics that had begun over a decade before.

Figurative art, too, was refusing to die the death the Endists were expecting. Alex Katz was making paintings as flat and urbane as those of Pop but of people who functioned in a world of flesh and blood. (Katz aptly was picked by *Time* magazine to make the cover portrait of another cool operator, John Updike.) Others, more oddly, came out of abstraction. When Paula Cooper met Jonathan Borofsky, he was a Conceptualist. "In my first show with Jon he did a computer number piece. That was in 1969," she says. In the early 1970s Borofsky began developing a whole vocabulary of eccentric forms, including a rabbit with erectile ears, a hammering smith, and a bevy of fleeing bowler-hatted figures.

The sculptor Joel Shapiro took basic Minimal oblongs, stuck them together, and set them hopping, skipping, and jumping like gingerbread men. (As another dig, Shapiro cast them in bronze, an intensely unfashionable material, as it was considered "arty.") The most all-out convert was Philip Guston, who had made his name as a latecomer Abstract Expressionist. In 1966 he had a show at the Jewish Museum on Fifth Avenue: big canvases put together with delicate blackish-gray strokes, like pigeon feathers. They were his last abstractions. "I got sick of all that Purity!" Guston wrote in *ARTnews* in October 1970. "I wanted to tell Stories!" His show at the Marlborough

that season told stories with cartoon characters, like hooded Klansmen, chomping on cigars, with gun-emplacement slits for eyes. There was a furor, much of it hostile, but Harold Rosenberg suggested in the *New Yorker* that Guston might "have given the cue to the art of the nineteen-seventies." He was only a few years off.

Neil Jenney, who had studied in Massachusetts, arrived in New York in 1963 and started making Conceptual sculpture. He first showed in 1967. "Richard Serra was in that show," he says. "Bruce Nauman . . . Mark di Suvero . . . Artschwager . . ." A year later he was a painter. "It was an economic decision," Jenney says. "In those days there were more sculptors than painters, I would say twice as many. It was plain that people wanted a Judd, a di Suvero, dah-dah-dah down the line, before they got to a Jenney."

It happened like this. In 1968 Jenney was offered a show in Cologne. "In those days the West German dealers arrived and everybody had a show in Germany," he says. "The line was, 'We can't afford to ship your art over, so we'll ship you and then you make your work here.' It was a way to get taken advantage of. So that's what everybody did. Anyway, when I got there, people looked at my work and they were saying, Beuys . . . Beuys . . . Beuys . . .

"I'd never heard of this guy Beuys. Then I saw some Beuys things in Düsseldorf. They were different from mine. They were crazy. Mine had a kind of logic to them, you know. But I realized that Beuys was killing my whole deal here—you know, confusing the issue."

Jenney began to make drawings of the forms he had developed for his sculpture. Then he decided that drawing even abstract forms was a sort of realism. "I realized, gee, I want to go into realism. That's where the painting should be." In 1969 he began to paint. The pieces were done so loosely that they looked like finger paintings. Jenney would place some homespun image—a wheelbarrow; a dog; a child lying down, dead or asleep—in the center of a lush green lawn. He used broad frames of brown wood and painted a title along the bottom to tell you what you were looking at. They were refreshingly plain.

The avant-garde mainstream, though, would dismiss such artists as sideshows, anomalies. But in the spring of 1975, *Art-Rite*, a cheaply produced small-circulation magazine of considerable influence, edited by Walter Robinson and Edit DeAk, devoted an issue to painting. The writer Paul Taylor said, "It was handed around like kids handing porn around a schoolroom." The all-type cover was designed by Robert Ryman. It is always chastening to look at archival copies of once up-to-the-moment magazines. This issue has its share of forgotten names, but there is a four-page conversation with Brice Marden and a two-pager about Neil Jenney; there are also single-page chats with Nancy Spero and a rakishly thin young artist, Julian Schnabel.

In 1976 Dennis Oppenheim made a piece at a gallery in Naples. Two eighteen-inch dummies, modeled after the artist, lip-synched mechanically to a taped lecture. It began with the real death of Robert Smithson and went on to describe various fictional deaths, including the suicide of Walter de Maria, the trampling of Michael Heizer, and the bombing of an airliner over Sweden that took out Carl Andre, Robert Morris, Bruce Nauman, Lawrence Weiner, Joseph Kosuth, Robert Barry, and William Wegman. SoHo became a ghost town, and 420 West Broadway was "the home of heroin addicts."

Oppenheim says the piece was about the Resurrection of Painting and the corresponding death of the American avant-garde. Something was stirring. "Taste somehow seems to obey the laws of compensation, so that with the negation of certain qualities of a period one almost automatically prepares the ground for its triumphant return at a later date," the conservative Modernist Hilton Kramer has written. "But it is never possible to predict exactly the schedule of taste. Its roots are in a deeper and more mysterious layer than mere fashion. I believe that what is at the core of every genuine change in taste is a biting sensation of loss, of existential pain—a feeling that something absolutely vital for the life of art has entered a state of unbearable atrophy."

A handful of artists have enacted these traumatic changes in their own lives and work, few more urgently than Malcolm Morley.

* * *

Malcolm Morley, the man Les Levine describes as "the Last Modernist," was born in an outer London suburb. He wound up in a Borstal, a reformatory for young offenders, at sixteen. He was released unreformed. "I was involved with the glamorous idea of a big gang of crooks," he says. "I wanted to pull off a big job. In a way it was the same kind of ambition as wanting to pull off a big painting. But I never did pull off a big job. I always got caught for petty things—stealing a lorryload of cigarettes."

For this he got three years in a real jail, Wormwood Scrubbs. It was there he read *Lust for Life*, Irving Stone's middlebrow best-seller about van Gogh and Gauguin. Morley says, "The idea of van Gogh put everything in another dimension somehow." He enrolled in the art class and took a correspondence course in illustration. "I became adept very quickly at watercolor paintings," he says.

Upon his release, Morley showed his work to his parole officer. The upshot was acceptance at Camberwell School of Arts and Crafts. He was twenty-two. The only "real" art he had so far seen had been in the old-fashioned magazine *Studio*, which his mother had sent him in jail. "All those fantastic watercolorists that used to do pictures of Waterloo Station with the smoke going up," Morley says. "They showed me a Picasso the first day in art school. And it was easy for me. I had no difficulty in understanding Picasso right away. At first glance.

"Because there's a certain primal power in things that one recognizes, I realized that the aggression I couldn't muster in jail I could somehow muster in painting. I felt I could replace Picasso. A very immodest thing to say. But I felt that I knew that thing, and had experienced it long before I knew it was called 'art.'"

Morley went on to the Royal College of Art. Some of the best of the British Pop artists—like Allen Jones, Peter Blake, and Richard Smith—were there, but to a Borstal boy they seemed posh kids with Italian scooters and sophisticated girlfriends. He hated his three years there. "I was an angry young man. A classic case," he says. He

moved to New York in 1958 and has been in the United States ever since.

Morley's first solo show in 1964 was of abstract paintings, but even while it was up, he was on to something different. Not a development. Different. He would pick a commercial image, like a postcard of an ocean liner, and pencil a grid onto the image. He would pencil a larger grid onto a canvas and paint in the squares, one at a time, more or less oblivious of the visual information, as though he were painting an abstraction. "I was very tense then. Very ego-pushy. Blazing," Morley says of that time. "In order to untangle the knot, I had to show that I could make a . . . perfect thing. A certain kind of perfection had to be achieved before the rough and raw started going."

It was a breakthrough. Morley had one problem—shared with many artists, like Roy Lichtenstein, say, but aggravated in Morley's case—which was that in reproduction, the works subside back into the source material from which they arose, like princes becoming frogs again. The word "Photo-Realism" was quickly applied to the work of Morley and a few other artists working in a similar vein. "I prefer to call them Hyper-Realism. Somehow or other, one of the proofs that you're doing something right is that you create a movement," Morley says.

Other Photo-Realists had their own image banks. Richard Estes, one of the better, specialized in streetscapes with glass windows and frumpy old neon signs. Others focused on glossy-flanked racehorses, glimmery chrome hubcaps, or equally glimmery silk underwear on the nether parts of pin-uppy young women. The artists sounded serious. "I don't enjoy looking at the things I paint, so why should you enjoy it?" Estes bleakly told a writer in 1968. Dealers loved the work, and a bevy of collectors who had missed out on Pop, Part I—especially European collectors like Daniel Filipacchi, the publisher of *Oui*—moved in. But even as the sales momentum was building, Malcolm Morley was preparing his adieux.

In 1970 he spent months on a canvas, *Race Track*. The original image was a photograph of a day at the races in Johannesburg, South

Africa, with pavilions and bright green grass. It was complicated. The political content—a *race* track—was simpler, and Morley completed his work by negating it, scrawling the surface with a red X.

His canvases grew progressively more turbulent, but the Hyper-Realist work was still on the market. On November 30, 1974, the Florists' Telegraph Delivery, a corporation that had invested in Contemporary art, put some of its holdings up at auction in Paris. Included were pieces by Tom Wesselmann, Larry Rivers, and Morley, who was represented by a painting of Buckingham Palace. Bidding on the Morley had reached 30,000 francs—say, $7,500—when the artist himself popped up and made his way to the front. With him was a camera crew, supposedly from a TV station but actually hired by Morley himself. In a voice made resonant by a drink or three, he boomed out at the crowd: "This place is a laundry and they're cleaning dirty money with my art."

"I had really got involved with changing that painting. Developing it further, and in public," Morley says. He had meant to write FAUX—false—on the canvas. Somebody had tipped off the auction house, though, and the painting was sheathed in plastic. Morley held off the guards long enough to nail a water pistol into the corner of the piece, and beat a retreat. He is elated by the action to this day. "Things were happening all the time. Like little sparks. I was a little bit off my head—I would have to be," he says. Malcolm Morley was now doing the work that makes him the godfather of Neo-Expressionism, but it was not stage devils that possessed him, but real ones.

The action had effects in the "real" world, too. A German dealer who had been planning to go up to $30,000 stamped furiously out, and the sale fell apart. But Morley's coup got plentiful coverage in the French press, and Bo Alveryd sniffed opportunity. He called "some Wall Street people who trust me" and bought fourteen artworks, the Morley included, for a quarter of a million dollars—fire-sale or water-pistol prices. As Morley learned, the harder you resist the market, the stronger it can sometimes become.

※　※　※

Malcolm Morley simply ignored the notion of the Death of Painting. Others mounted an articulate opposition—the Pattern & Decoration movement, for instance. P&D was sweet and reasonable. It was also perhaps the first movement in which women played an equal part. Their adversary was what one of their best painters, Robert Kushner, calls "the Old Boy Network of the Minimalists." P&D was determined to function as a mutual support system rather than a cyclotron for colliding egos. It should go without saying that P&D is reviled and execrated to this day.

The P&D artists took to looking for an alternative to the all-Americanness of the Minimalists in what might now be called World Art—African art, the Byzantines, and Islamic art in particular. "At this time the Islamic department at the Met wasn't even open. The Islamic collection had been in storage since 1912," Kushner says. P&D adhered to a set of principles of picture making. Flatness and repetition of motifs were among them. The project was beauty. "The implicit feeling that I run into is that if you make things that are beautiful, you're a little simple-minded," Kushner says. "But there's a huge decorative tradition out there. There are whole cultures that only make decoration and don't make art."

Kushner says that his dealer, Holly Solomon, would get uncomfortable with this line of argument. Indeed, Solomon would sometimes claim that P&D's ornamentality was a protest against Vietnam or whatever. Kushner won't accept this easy out. "I want something I can escape to, the way Matisse said art should be like an armchair. And that's a very unpopular position," he says. He extends his argument to Minimalism itself. "A tremendous amount of Minimalist art is decorative," he says. "The Donald Judd boxes. The serialness of them. I think Sol LeWitt is a wonderful decorative painter. I am not at all certain he would like that.

"We stepped on a lot of toes. Many people really hated what we were doing. They hated pink. It was that whole American Puritanical thing." In the mid 1970s the P&D artists showed some decorative panels. "There was a tremendous, tremendous hostility to what we were

saying. I remember somebody asking, 'How can you say your work is more interesting than wallpaper?' He was red in the face, he was so upset. We said, 'We're not saying that. If it's good wallpaper, that's what we aspire to.'"

In 1978 Kushner put up a show at Holly Solomon's gallery and went to India. He returned, ready to transfer the unsold work to a show in Washington, D.C. "Holly said, 'Surprise! I've sold everything. You have to make some new paintings.'

"What happened was we were picked up by a group of European dealers. Thomas Ammann was the first. He bought very judiciously. Bruno Bischofberger came in and bought a tremendous amount. For a while Charles Saatchi was buying them. The hot period for me was '78 to '81." With an odd, dispassionate mildness, he adds, "I had banked on it being for five years. I was rather surprised when it was only three."

What happened?

"It was the dealers, looking for the next thing. I think they made a mistake. Our work was overly promoted and in the wrong way. My agenda was to say, Listen, there's a big world out there. But it was promoted as This is the Next Step. But the decorative painters were kind of soft—in a positive way. We don't have the killer instinct. Then, as soon as the Mary Boone stable emerged, suddenly the dealers had a product they wanted to promote. A coalition formed.

"The truth of the matter is that we were all cream-puff-type people. It was never my goal to be a barracuda. I've heard Julian Schnabel say things like 'You have to be like that to make great art.' I don't agree. I don't agree philosophically. Anyway, what happened to this movement is that the European backing dropped. And I think Holly went through an extremely difficult period personally. It had to do with divorce and no longer being the star. There were long periods when Holly just wouldn't come into the gallery. I was in my late twenties when this was happening, so it was all rather confusing."

Charles Saatchi dumped his P&D holdings—a dress rehearsal for dumpings to come.

After the collapse, Kushner talked to Willi Bongard, the canny editor of *Art Aktuell*, in Cologne. "Did it never occur to you to approach Leo Castelli?" Bongard asked.

"No," Kushner told him. "It never even crossed my mind."

It wasn't just that the P&D artists were out-strategized by more Machiavellian talents. Kushner, at least, thinks the bulk of art is not transcendental or significant, that it isn't always painted philosophy or drenched with meaning, and that most artists—even "serious" ones—are often simply making pictures that will look good over the sofa. The art world loathed hearing this. It is not something ambitious artists are likely to say again soon.

"Fortunately, I'm still supporting myself very nicely," Kushner says. "The truth of the matter is all these artists are still working. There's another taboo about to come up. I think what saved me was meditation and spiritual practice. I just remembered that I was not making art to be a famous artist and running around the world. I'm making art for the joy of making art."

There was also the joy of making money. The Invisible Hand, Adam Smith's metaphor for the market, had twitchy fingers in the art world of the later 1970s and early 1980s. Investment syndicates, for instance, were heavily promoted as inflation shelters. Some were aboveboard, like Artemis and Modarco. Artemis was originally a private syndicate of the (mostly) British rich, funding the famous eye of the dealer David Carritt (who discovered a Tiepolo ceiling decorating London's Egyptian embassy). It went public, and did well. Modarco, which was funded by the Bank of Paris, deteriorated into a not wildly successful dealership, and was taken over by Martin S. Ackerman, a Manhattan lawyer, in early 1979.

The real bottom feeders in the auction houses were the "satcheleers," so called for the satchels they no longer carried. They would

buy an item at an auction, put down a deposit, and then try to sell it at a profit in the period—a week to ten days—allotted to coming up with the rest. If they failed, they would complain that the item was not as described in the catalog and demand their money back.

In the Contemporary Art world, the Invisible Hand was equally active. Texas slumped, in both oil and real estate. Such are the interconnections between economic and cultural heft that there was a waning of both local and national interest in Texas artists. Some artists—Robert Yarber; John Alexander—moved to Manhattan. Of those that remained, David Bates has maintained a prickly visibility; but the regionalist boom was over.

On the morning of June 11, 1980, Tom Armstrong, the director of the Whitney Museum, a man of Dickensian ebullience, and given to the wearing of showy bow ties, got a call from Arne Glimcher of the Pace Gallery. Glimcher said that *Three Flags*, a 1958 Jasper Johns and a pivotal work from the collection of Burton and Emily Tremaine, was for sale. The Tremaines were asking a whopping $1 million.

There was personal history here. Armstrong says, "I had wooed the Tremaines for years. They teased you." The Tremaines had once made some work available to the National Gallery in Washington— including a Bridget Riley—but the work had not been taken on the countrywide tour that they believed they had been promised. "They took this as a symbol that no museums are to be trusted," Armstrong says. The Tremaines decided museums didn't respect stuff they hadn't paid for, and big.

A million dollars was way beyond the Whitney's acquisitions budget, and Armstrong talked with the head of his board, Leonard Lauder. "Leonard realized there are moments when you have to go beyond your capabilities. He encouraged me. But he didn't help me raise money," Armstrong says. "We tried to raise it in large increments—$100,000, $150,000—and we got up to $700,000.

"The trustees had only been vaguely informed. I was in South Carolina at one of these getting-together-with-business-and-industry feel-good sessions when Grace Glueck called." Glueck, still then with

the *New York Times*, had heard about the Johns. "That panicked us," Armstrong says. The art world had stopped paying much attention to critics, but reporters were something else.

The Whitney got the $1 million together. Armstrong paid Leo Castelli a courtesy call to give him the unwelcome news that the museum was acquiring a piece by one of his artists through a rival dealer. Castelli's wife, Toiny, picked up that something was in the air. "Do not talk business. Not in the apartment," she told Armstrong. As soon as she was out of the room, though, Armstrong gave his news about the Johns. "Leo didn't want to hear," he says. "He told me, 'You'll never do it. I'm selling it to the Japanese.'"

The Whitney got it, of course. Attention was paid. A million bucks for a painting by an artist who was just fifty and still making ten paintings a year! Mary Boone says, "That was the sign. Speculators started going down to SoHo as if they were panning for gold."

It was no surprise that the Tremaines hadn't put the Johns up at auction. Both auction houses were in flux. Christie's had opened a New York branch on Park Avenue and Fifty-ninth Street in September 1977. By that time Sotheby's was twice the size of Christie's. In 1979 Sotheby's announced further expansion plans, partly to rub Christie's nose in it and partly because Peter Wilson, the chairman, was retiring, and they wanted to show that this was not going to let the air out of their balloon. The new building, a five-story behemoth, on York Avenue and Seventy-second Street, had been built as a cigar factory in 1922 and had been an Eastman Kodak service center since 1949. Here the house would sell estate furniture and so forth, while continuing to sell Fine Art on Madison Avenue.

"We are envisioning the York Avenue facility as more than 'just' an auction gallery," said Robert Woolley, the Decorative Arts capo. "We hope it will become an educational center and a focal point of the community."

David Bathurst of Christie's acted unimpressed. "We already expanded by coming to New York," he told me at the time. "We're not going to dash out and buy a new building. We both depend a lot on new buyers. I don't see them getting over to York. It's like going to Harlem. You need a tin hat to walk over there."

Inflation was rampant through 1979. On October 9 the Dow-Jones fell 26.45 points, its steepest drop in six years. Panic selling didn't really hit the art world, though. Indeed, some financial houses, like Salomon Brothers, were tracking art as an alternative investment for institutional clients. Sotheby's North American sales for the 1979–80 season, which ended in August, totaled $250 million. This was the first time New York had outdone London. Christie's traded just $113 million through New York in the same period. "We want to be Rolls-Royce to their General Motors," Bathurst said, bravely. Sotheby's opened its gargantuan gun emplacement of a building on York Avenue in September.

Christie's had two big sales in May 1981 and both were turkeys. Fewer than half of financier Saul Steinberg's collection of German Expressionists found buyers. "The yen is down," David Bathurst said afterward, calling the results "a hiccup." Indeed, Sotheby's did much better. On May 21, *Yo Picasso*, a 1901 self-portrait, was sold to Wendell Cherry, a Kentucky health-care magnate, for $5.3 million, becoming the fourth most expensive painting ever sold at auction and the most expensive artwork from the twentieth century. Auctioneer John Marion, Sotheby's American president, rammed the bodkin into Christie's, telling the crowd, "The two-day recession in the art market is now over."

It wasn't, and it wasn't a hiccup, either. It was a seller's market and the sellers were playing rough. The auctioneers were often forced to lower their 10 percent fee or sometimes to forgo it altogether, leaving them to make their profits off the buyers, who were themselves increasingly insisting on credit. Which was fine while the houses were in profit. "1980 was a very good year. 1981 was a very good year," says David Nash, who was director of Fine Arts at Sotheby's. "1982 was not a good year."

We were talking at the end of the 1980s in Nash's office in the York Avenue building. David Nash is a Briton who had seen employment as a grave-digger before applying for a job at Christie's twenty-five years before. Rejected, he had joined Sotheby's. His office was heaped with catalogs. The annual *Christie's Review* had been pressed into service as a doorstop. "That door will keep swinging shut," explained Nash, dryly.

Nineteen eighty-two was dire. Sotheby's share value plummeted to a half of its high the year before. Nash said, "In the summer of '82 we closed down California. We closed down Madison Avenue later that year. It was difficult. We had to let three hundred people go, and Madison Avenue was the center of the art world." For the traditional Madison art walkers, it was devastating. "It killed the stroll," says Gabriel Austin of the art bookstore, Wittenborn.

Things got yet worse. "We had enormous difficulty getting together a sale of any caliber that winter," Nash said. The sale they assembled was "pathetic," and that winter they reported their first trading loss for many years. "Christie's looked as if they were going to emerge dominant. That's when Cogan and Swid made their bid," Nash said. Marshall Cogan and Stephen Swid were scrappy New York entrepreneurs who controlled a company, General Felt Industries. They had taken over a most unwilling Knoll International, which manufactured the furniture of such designers as Marcel Breuer and Mies van der Rohe. Cogan and Swid had also become the largest single holder of Sotheby's tremulous stock. In December 1982 they attended a Sotheby's board meeting in London and let it be known that they wanted a degree of control. The room grew icy.

"Then Doris Havemeyer died," Nash said. This was the daughter-in-law of sugar baron Henry Havemeyer, who had bought Degas, Manet, and the Impressionists, sometimes on the advice of the American painter (and friend of Degas) Mary Cassatt. Many of the Havemeyer pictures were in New York's Metropolitan Museum. The sixteen works in the Doris Havemeyer estate were not the best on the market, but they were fresher than fresh, and resonant with history. "It was crucial for us to get the Havemeyer collection. There had been

articles in the *Times* about Sotheby's financial troubles for ten days in a row," Nash said.

The squad that sallied in to negotiate with the executors—who included Doris Havemeyer's son, Harry—consisted of Nash, Hugh Hildesley, and John Marion. By happenstance, Marion sauntered into Nash's office just as he was saying what transpired.

Their first meeting had been in an office of Morgan Guaranty and even Peter Wilson was there, briefly back from retirement to show the firm was in fine fettle. "Other people in the auction business were trying to make the case that we were insolvent," Marion said. "David Bathurst told me later that they hadn't been worried about Sotheby's at all. Their main fear was that a consortium of dealers would buy up the estate."

The squad performed smoothly. One particularly effective piece of business was the way Nash fussed over the art, which had suffered from neglect, the worst case being a Monet with paint peeling from the canvas. "The painting was laid out on the dining room table. Like a body," John Marion said. "David had the conservator come in. He was wearing white. He looked like the surgeon general."

Then the waiting. Despite Peter Wilson, Sotheby's truly was on the brink. There was a call from the executors in November, the same day that the "pathetic" sale actually took place. They wanted another meeting. Nash, Marion, and Hildesley huddled beforehand. "We speculated endlessly—what it meant that they were coming to see us. Wouldn't a single telephone call have done?" Nash said. "They arrived at two. The lawyer said to John, 'Have you had your lunch?' John said, 'Yes. But I haven't swallowed it yet!' They were trying to wind us up . . .

"Then Harry Havemeyer looked at his lawyers and said, 'Oh, for God's sake!' He told us, 'We want to do business with you.'"

Thus, with upper lips freshly stiffened, the Sotheby's crew set to beating off Cogan and Swid. At one London meeting the duo were told, "You are simply not our kind of Americans." The Establishment swung into support, and on April 28, 1983, there was a motion in the

House of Commons suggesting that the bid might "endanger London's preeminent position in the world's art market." Cogan and Swid responded with a full-page newspaper advertisement promising to "respect the name of the firm and the essential Englishness" of its culture. But the takeover was attacked in the House of Lords and was stillborn.

The Havemeyer sale took place on May 18. It was hugely successful, in terms of both money and public éclat. With the auction house backing away from the precipice, another suitor emerged—a group of American and European investors. The head of the group, A. Alfred Taubman, a Detroit shopping-center billionaire, and a crony of Henry Ford and on a bevy of museum boards, clearly was Sotheby's kind of American. He got control of the auction house in October 1983 for roughly $139 million, having told the British authorities that London would remain the headquarters and that the "traditional nature of the business and of the services offered would be changed as little as possible."

The cold facts were other. Many, many years before, Peter Wilson had gotten into a furious argument with Ralph Colin, then head of New York's Art Dealers Association, at a meeting in the Klaus Perls Gallery. Borrowing from Khrushchev's "kitchen debate" threat to Vice-President Richard Nixon, he had told the dealers' representative, "We will bury you!" Sotheby's would indeed wax stronger and stronger vis-à-vis the dealers. And New York would never again defer to London.

Not all of Peter Wilson's dreams worked out, though. "Soon there will be room for only one auction house, and I intend for Sotheby's to be it," he told Cogan, Swid, and Taubman, according to writer Jeffrey Hogrefe. Wilson died in 1985. That same year, David Bathurst resigned from Christie's after it became known that he had boosted the house's statistics by claiming that some paintings had been sold at a 1980 auction when this had not been the case. So, gentlemanly Christie's was capable of taking off the gloves, too.

Three / New Spirits

It is difficult in accounts of this sort not to let knowledge of what came after infect one's memories of what went before, so events seem programmed, as on-track as a bullet train hurtling toward a noble destination or an almighty screwup. The fact was that I didn't properly address the Julian Schnabel/Mary Boone phenomenon until the spring of 1982. It *was* a phenomenon, too. Schnabel put together his huge canvases, with their often stunning passages of abstraction, ambitious figuration, usually inert drawing, and attached detritus of velvet and broken crockery, as though the road down which the Last Modernists had been pushing was just a cul-de-sac. Arthur Danto, a professor of philosophy, actually took up regular art writing—as a reviewer for the *Nation*—as a direct consequence of Julian Schnabel. Danto says, "This shouldn't have happened next!"

There had been immediate, splashy consequences. The art world, in fact, had gone public for the first time since Pop. I was assigned to look over the furor by *New York*, a magazine that had been stingy with its coverage of the art world over the last decade. I went along to see Mary Boone in her gallery on West Broadway. Petite, she had olive skin and eyes like black enamel, doubtless owing to her Egyptian origins, and a sliver of a nose wholly owed to herself. "I didn't like my nose. So I bought a new one," she explained. She was in cashmere, with pale scaly shoes, chosen from "between 102 pairs."

This pair being made from what?

"Cobra."

Do I dwell on trivia? Trivia are not necessarily trivial. Those shoes were made for walking, and clean out of the bohemian ghetto.

Julian Schnabel's studio was on Twenty-third Street and Tenth Avenue. I wrote at the time: "Schnabel has somewhat of a Roman profile, and with his marble pale skin and rippling brown hair, lightly oiled, has the bravura of a second-century emperor." Schnabel showed us what he was working on. I had been expecting an ordinary studio visit, but it was oddly intense. "I feel very disoriented today. Some days you just go in and out of control," Schnabel said, then left my side abruptly and stuck his face close to the skin of a painting on the far wall.

"Even the most skeptical and disbelieving person I've brought here has been changed," Boone said. "The authenticity is so remarkable. They're gritty and passionate and completely committed. People who say they are invented are absurd." Her pique was real. "A hype!" she said.

The canvas Schnabel was looking over bore the central image of a woman in a shift. He returned, announcing, "Today I feel like throwing it in the garbage. I may feel differently tomorrow. The drawing's good." Boone said fondly, "It's the same crazy mind."

Schnabel revealed he had a way of dealing with his disoriented moods. It was all his own. "I go and look at other people's paintings and see how shitty they can be," he said, adding, "How horrible people are!"

Boone was right, though, about the ambient disbelief. "It's hype! The worst hype since the South Sea Bubble!" Robert Hughes of *Time* told me, resoundingly. "This hoo-ha in SoHo is a phenomenon of entropy. You think you can make a quick killing. That's the crucial thing about this flurry." Many Europeans were just as obdurate. Rudi Fuchs had very deliberately excluded Schnabel from Dokumenta that spring. Willi Bongard of *Art Aktuell* had launched a missile at Schnabel from the mass magazine *Stern*. "It's a very fashionable thing," he told me at the time. "But I do not trust its staying power. It does not fulfill

the basic requirement of good art. It is not new! I still believe in the tradition of the new . . ."

This, my first research, was to include a photo shoot in Boone's gallery. Shortly before, Boone had become so angry with her landlord that her nose had bled. The shoot looked like a goner. Within minutes, though, she was gleaming into the lens. The story ended with Boone presiding at a champagne party for her artists at the art restaurant of the moment, Odeon. She wound up on the cover of *New York*. It seemed as if the champagne would never run out.

Julian Schnabel was born in 1951. The youngest son of a Czech immigrant who had prospered in the meat trade, he grew up in a middle-class Jewish neighborhood in Brooklyn. He was high-strung, a nail biter, and plump, embarrassed at being outfitted in the "husky" department of clothing stores. When he was fourteen, his family moved to Brownsville, a small town in south Texas, across the Rio Grande from Mexico. According to the writer Marie Brenner, who also comes from Brownsville, "a small but significant number of the population truly believe that they have seen the Miracle Virgin of Guadalupe appearing in the clouds, on their tortillas, or, just recently, in the knot of a tree." "I felt like I was the only Jew in Brownsville," Schnabel has said. "I never joined any clubs at school, never had a date. I didn't even go to my senior prom."

Schnabel's life brightened as a fine arts major at the University of Houston. "There was a real art world there. Like Chicago and California. But nowhere else," says John Alexander, a Texas painter teaching there at the time. "Houston artists weren't interested in Color Field. They thought that was New York shit. There weren't any Texas Minimalists or Conceptualist artists." Instead, there was great interest in what would later be called Outsider art, Black art, and—most especially—the morbid belief-soaked imagery of neighboring Mexico. An older artist, Joe Glasco, had worked in Mexico in the 1940s. Glasco

was about as close as anybody could be to being Schnabel's mentor. Michael Tracy, a close friend of Schnabel's, drew on Mexican imagery for his fetishistic work. Alexander says, "This was a time when regionalist artists were getting some attention. We were getting into art magazines. Curators like Marcia Tucker were looking at the work. For young artists in Houston, it was a time of hope."

The unhappy truth, of course, was that the provinces only seemed to pulse with life because the art capital was afflicted with anemia, and Julian Schnabel had no intention of becoming a Texas artist. After his 1973 graduation he was accepted by the Whitney Independent Studies Program, moved into the loft of sculptor Joel Shapiro, which he painted in lieu of rent, and launched his preliminary assault on the art world. Schnabel soon became rather dificult to ignore in the art bars of the time, which were the Spring Street Bar, El Quijote, and, pre-eminently, Max's Kansas City, with his vocal insistence that he was going to be a Great Artist. Most young artists think they are going to be great, or at least damn good, but from very early on, Schnabel was able to project a shameless Maileresque egotism that forces the listener to contemplate the prospect—*somebody* has to be great, after all—that the boaster might be correct and that doubters would be left bobbing far behind in the swell.

Schnabel was accorded a full page in the 1975 "Painting" issue of *Art-Rite*. He was described as a "Dog Painter," and the page consisted of some paragraphs of his writing about dogs and a couple of snapshots of the artist with some paintings, one of which, *Hawk*, would be reproduced in his lushly produced memoir, *CVJ*. In that same memoir he revealed that his attention grabbing was not always favorably received and that a drunken Brice Marden had tried to punch him out in a studio. (Marden told me, years later, that he remembered it as a throttle hold, not a punch, and ascribed it to Schnabel's Kill-the-Father discourse. "He was after my ass. You have to do what you have to do. If you're strong enough," Marden said.)

Others were unbeguiled. Bruce Wolmer, then at MoMA, remembers a first meeting with Schnabel in "pink jelly glasses." Wolmer's

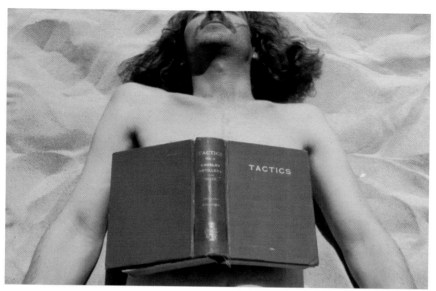

READING POSITION FOR SECOND DEGREE BURN
Stage I, Stage II. Book, skin, solar energy. Exposure time: 5 hours.
Jones Beach, 1970

Dennis Oppenheim Photograph: Phyllis Jalbert

Vito Acconci looking in a mirror, then shattering his own image in *See Through*, 1970. *Courtesy Barbara Gladstone Gallery, New York*

Michael Heizer in the Nevada desert. Behind him is *Complex I*, which is part of a colossal piece to be called *City*. *Photograph: Peter Lindberg*

Joseph Kosuth. *Photograph: Marcia Resnick*

John Baldessari. *Photograph: Marcia Resnick*

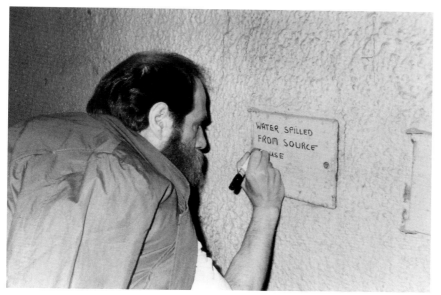

Lawrence Weiner. *Photograph: Ryzard Wasko*

Bas Jan Ader. In the boat that was part of his last unfinished artwork.
Photograph: Mary Sue Ader

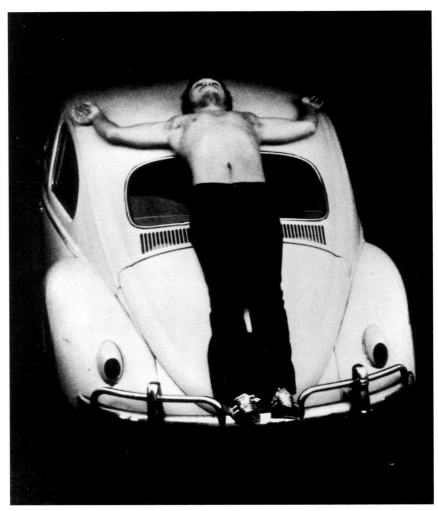

Chris Burden crucified on a Volkswagen for *Transfixed*, 1974.

Piero Manzoni, showing his work. *Photograph: Oje Bjørndal Bagger, courtesy of Herning Kunstmuseum, Denmark*

Gilbert and George, recreating *The Singing Sculpture,* their first success, at the Sonnabend Gallery, New York, in 1991. *Photograph: Rose Hartman*

date admired them. "Right away he offered to find her a pair. He was almost too obliging. I felt his hunger. I felt, I hope *he* doesn't get anywhere." Wolmer admits that he remembered Schnabel now and again, a bit smugly, because he did indeed seem to have disappeared. "I thought, Well, that's the last we'll see of *him*."

But Schnabel had just gone back to Houston. James Harithas, who had arrived at the Contemporary Art Museum from Washington, D.C.'s Corcoran in the summer of 1974, was giving seven local artists solo shows. Schnabel was one. The show flopped. "People hated it," Harithas says. Schnabel spent eight months in Texas, moved to Europe for a while, and then returned to Manhattan. Again, he took a job painting a loft. This time he was employed by an artist closer to his own age, Ross Bleckner, whose parents had bought him a house on White Street. "I hired Julian to help me fix up my place. After ten minutes I realized he wasn't the employable type. I was walking around, trying to boss everyone around for three dollars an hour. And he is looking at me like I'm crazy," Bleckner says. "I said, 'Listen. Just forget it.'"

Julian Schnabel's nonpainterly forte was cooking. Before going back to Texas, he had cooked at the Ocean Club. Now he took a job in an eatery owned by Mickey Ruskin of Max's Kansas City. Called the Locale, it was an artists' kind of place. Sherrie Levine waitressed there for a while, for instance. Schnabel's sous-chef was another young artist, David Salle.

Few artists could have seemed more unalike than the operatic Julian Schnabel and the cerebral David Salle, though there were similarities. Both came from Jewish families in parts of the country where this was not usual — Salle's father was in insurance in Wichita, Kansas — but there were deeper resonances too. "We were on the same wavelength for a while because we had overlapping interests and aspirations. And, in a weird way, some kind of overlapping history about being self-invented," Salle told me years later.

As to the overlapping interests, both were fascinated by certain artists who seemed to indicate ways of pounding through Minimalism's reductive walls—Rauschenberg, for instance. Both artists also looked carefully at the later work of Francis Picabia. Like several of the early Modernists—Kees van Dongen, Derain, Magritte, and, spectacularly, De Chirico—Picabia ended up making "bad" paintings. Picabia's, though, were so spectacularly tasteless that they suggested less a faltering talent than a sunburst of perverse energy. In the 1920s Picabia floated disjointed images over and alongside one another in a series of paintings he called *Transparencies*. In the 1940s he painted outright kitsch for a travel agency on the Riviera. "Bad" art began seeming to younger artists a wonderfully cranky compass for steering a course through the blinding whiteout of Endgame Modernism.

Picabia is very connected in art lore with his co-provocateur Marcel Duchamp. Just so Rauschenberg is seen as grappled in competitive friendship with Jasper Johns. David Salle is nothing if not history-minded, and was so given to referring to important older artists by their first names—"Roy," for example—that you half expected a mention of "Pablo" or "Marcel." It seemed clear he had cast himself as the self-contained Johns to Schnabel's boisterous Rauschenberg. "I can tell you what these competitive friendships are about," Salle said. "It's when one person has in abundance quality X and the other person has in abundance quality Y. And the person who has quality Y needs a little bit of X, and vice versa. And that's it! Julian was the bull in the china shop, and I was the intellectual. In the long run we couldn't use very much of each other. But we liked the proximity."

Salle had arrived in Manhattan in 1975. He commuted to a teaching job in New Jersey for a while, then took a job in the art department of a publisher on Fifth Avenue and Fifty-seventh Street. They put out the scuzzy magazine *Stag*. Salle's job was menial, but when he left, he bore off some 500 photographs, including variously spread-eagled female nudes. This trove became a staple in Salle's early canvases. The images are floated alongside and, later, over a repertoire of other sour-colored images that are recuperated from

High art, Low art, and yet opaquer sources in a way that seemed to taunt any viewer who tried to piece together something as dumb as a "meaning." For me, at least, the paintings delivered a frisson of nausea and disquiet, like sitting under fluorescents in a public space at four in the morning.

Salle's cooking was getting him by, but barely. "I didn't have enough money to go out. It sounds like a Dickensian sob story but it's true," Salle said. "I went to Studio 54 once. This is going to sound like a joke. Julian, Ross [Bleckner], and I went in a group. And somehow Julian with his big mouth talked us into the place. I don't remember paying the fifteen dollars or whatever it was. With his grand way, Julian just convinced the doorman that we were celebrities and we should be let in."

More typical was his presentiment upon watching a homeless man on the subway. "I remember feeling the line between me and that bum was so thin," Salle said. "I was so close to being that. I still get that terrible hair standing up on the back of the neck when I see a homeless person.

"But I was perhaps from the last generation of artists to take that for granted, for that to be absolutely normal, in no way onerous or punishing. It was just what you *did*. I was incredibly lucky to get a teaching position. Ten thousand dollars a year. That was at the University of Hartford."

Did he wonder if this would be his whole life? "Of course I thought about that. How long can you hold on? That was a very real consideration. I rented a place on Nassau Street. I loved that space. It was tiny but beautiful. I wasn't depressed. I was making paintings that were very, very dry."

Salle also got gigs writing for arts magazines. Holly Solomon remembers him using this as leverage to get her to pay a studio visit. "I told him, 'David, I will always pay a studio visit. In time,'" she says. Salle had more luck with the writer Robert Pincus-Witten. "He said, 'Look! Your work is really interesting and you're really intelligent and really good. But it's never going to happen for you in New York. Accept

it. Don't be bitter about it. You've got a teaching job. You're *lucky*,'"
Salle recalled. "That was the climate. Everybody said my work was
obscure. Anything the least bit difficult didn't have a chance."

But what David Salle, like Julian Schnabel, sensed was that a
major upset was brewing. Signals were beaming in from a part of the
art world to which New York had been indifferent: Europe. "The
generation that preceded mine did not see what they were coasting
on the legacy of. It wasn't political. It was just ignorance. *They just
didn't know*," Salle said. "They thought American art was on such a
roll. A decade of power! Why would they even suspect that there was
a radical prankster in Düsseldorf that they should be paying attention
to? Because everybody knew that American art was superior. And blah
blah blah."

The "radical prankster" was Sigmar Polke. Salle and Schnabel
would often discuss such "marginal" artists as Polke and Blinky
Palermo, German artists who had spent time in New York. Quite apart
from their work—and Polke was making layered images every bit as
"obscure" as Salle's—both artists had a certain heroic outlandishness.
Palermo, for instance, was born in Leipzig as Peter Schwarze. He was
at the Joseph Beuys Academy in Düsseldorf when he borrowed his
moniker from an American mafioso who was in the news at the time
and whom he supposedly resembled. He made quirky Monochrome
objects painted on circles of wood or poles, and he was a notorious
drunk, even in the notoriously drunk German art world. (After one
Palermo opening, another artist bowled one of his artworks down the
road, like a hoop.) Early in 1977 Blinky Palermo set off for the Maldive
Islands in pursuit of a girlfriend. He killed himself there with the bar-
biturates he was taking to kill his alcohol habit. He was cremated by
Buddhist monks, and the girlfriend smuggled his ashes back to Eu-
rope. Julian Schnabel made a painting, *Homage to Blinky Palermo*. It
would not be the last memorial work by Schnabel, who has a High
Victorian taste for grandiose sentiment.

Both Schnabel and Salle went to Europe fairly often in the later
1970s. One year Schnabel went as an assistant to the media artist Les
Levine. "Every time we would go into a museum he'd look at things

that close," Levine says, indicating about ten inches. "To a point where it was difficult for anybody else to look at the paintings. Julian is primarily interested in technique."

In New York the art world's vital signs were low, and a wary conformity prevailed. David Salle told me, "It doesn't take much for an artistic community to get the idea that if you follow a certain path diligently, one, you will be doing the right thing and, two, you will be rewarded for it. It's a kind of academicism. The work is good because it's like something else that is good.

"I mean, it was easy for somebody to come in from left field and take over the joint! To put it in corporate terms, it was ripe for take-over. These people were just honing their skills. It was *ripe.*"

That said, as late as 1977 or 1978 David Salle didn't know of a contemporary who had actually sold an artwork. *"You mean, they take the painting and give you money?* I didn't think it would ever happen." Julian Schnabel was less unconfident. Some might have treated the chef's job as a chore. For Schnabel it was a production, with the maestro emerging from the kitchen whenever art worlders worthy of attention were on the premises. "I introduced him to a great many people. Which he now seems not to remember," says Joseph Kosuth. A writer was startled by the apparition of the chef, in his whites, proffering a free helping of chips. "There was some suggestion that I write about his work. Which I had not seen," the writer says. "I pooh-poohed it. Which is not the most brilliant thing I ever did."

Schnabel was generous to artists to whom he took a liking, hanging their work in the place and inviting them to Sunday dinners. It was here that Ross Bleckner introduced Schnabel to a young dealer who was showing an interest in Bleckner's own work, Mary Boone.

Mary Boone had studied art at the Rhode Island School of Design. The artist Lynda Benglis describes Boone's later paintings as "balloony nudes." Boone took a job as an assistant at the Bykert Gallery, an admirable Minimalist gallery, which was named for Jeff Byers—who was

married to the daughter of Bill Paley, the overlord of CBS—and the writer/curator Klaus Kertess—who actually ran it. Kertess decided to leave in the spring of 1975. Boone says, "The gallery was at its peak. I think Klaus left because it was getting *too* successful. He tended to undermine things." Kertess asked Boone to take over. "I thought, Egad! Absolutely not! I'm an artist!" Boone says.

"In reality I was an art gallery person. But I couldn't make the transition quickly enough in terms of my own psychological makeup."

Kertess handed the gallery over to another dealer, Frank Hobert. "I was fired around my birthday in October '75," Boone says. By the time the gallery went under, she was dealing privately, representing such Bykert artists as Gary Stephan and Alan Uglow. Seven backers raised a six-figure sum and in April 1977 she opened in a minute space, formerly used for storage, on the ground floor of 420 West Broadway, where her upstairs neighbors, by no coincidence at all, included Ileana Sonnabend and Leo Castelli.

Before paying Schnabel a studio visit, Boone warned him that she would not have anything to say about his work straightaway. This proved not to be the case. "I was struck by the incredible physicality of the paint. It was lush. Holes were dug out of it," she says. "I was a bit nonplussed—both attracted and repelled. It wasn't what people were doing then. But I told him we would do something together."

Boone wasn't the only interested dealer. "Gordon [Matta-Clark] came in one day and said, 'There's this young kid who's doing these narrative paintings, these dog paintings. I like him and he's a good kid. He's a cook. Why don't you come and see him?'" Holly Solomon went around to see Schnabel, who was then in a loft on East Twentieth Street, picked out a couple of paintings, and hung one of them in a show called "Surrogate/Self Portraits." The painting, *Jack the Bellboy,* was a somber canvas, and Schnabel has said that its mood reflected a broken love affair. One segment, a wall-like surface gouged with se-quences of vertical slashes, suggested both close attention to the work of certain older Spanish artists, like Antoni Tàpies, and the way that prisoners record the passing of days. This alliance of pure painterli-

ness and dramaturgy would be Schnabel's forte. The canvas was priced at $2,000–$2,500, but didn't find a buyer, so Holly Solomon acquired it for the collection of her and her husband.

Solomon also learned that Schnabel's ambition went beyond the usual SoHo griping. He was furious at not having been included in the Whitney's "New Image" show. "I'll be number one. I'll never be excluded again," he told her. Solomon was impressed enough both by the work and the young artist's roiling energy to offer him a solo show. Mary Boone had only committed to including him in a group show, but quickly matched Solomon's offer. David Salle advised Schnabel against going with Holly Solomon. His reasoning was that Schnabel's use of kitschy materials, like velvet, would be seen in the wrong context in a gallery so identified with Pattern & Decoration.

That summer Schnabel returned to Europe, this time with Ross Bleckner. In Barcelona they studied the work of the Catalan architect Antoni Gaudi, who embellished the surfaces of his fantastical buildings with embedded china, the way peasants use shards to ornament freshly thrown clay pots. That night they ate in a seafood restaurant. Schnabel was nauseated in his hotel. He told Bleckner that he felt like churning everything into a painting—the plates, the cutlery, the regurgitated food.

Back in Manhattan, he cut a sheet of Masonite to the proportions of the closet of his Barcelona hotel room. He bought a crate of Salvation Army crockery, shattered it, stuck the shards to the Masonite with Bondo and dental plaster, and began to make some work. Then more, and more. "Julian called me one morning and said he'd done some extraordinary paintings," Mary Boone says. He told her he had been lying in bed all night listening to crockery breaking off the surfaces and splintering on the floor.

In time to come, some would suggest that Schnabel had learned not just from Gaudi but from the eccentric and well-to-do Long Island artist Alfonso Ossorio. If so, it seems irrelevant. Ossorio put his ceramic shards to a quirkily decorative use, whereas Schnabel had invented for himself a way of making a surface come uncontrollably

alive—like Pollock not touching the canvas as he whipped around his sticks, or the Conceptualists Robert Morris and William Anastasi making drawings with their eyes shut. Schnabel had qualms, though. Donald Newman, who had been at CalArts with Salle and Bleckner, was one of the handful of people to be shown the first "plate" painting. "Julian had it hidden in a sheet," he says. Such qualms would dissipate like mists in the glare of a rising sun.

Boone started doing her stuff. She was painstaking. "If I had to describe myself in a word," she once told me, "I would say I was a plotter." At least that was what I thought she had said. She gurgled with laughter when I repeated it. "No, not a plotter. A *plodder*," she corrected.

She set up studio visits by those collectors whose opinions created a buzz, and was making sales by the fall of 1978. Schnabel's first solo show, in February 1979, consisted of just four pieces. Each of these had been pre-sold for $3,000 to 3,500, which lent a sense of urgency, the notion that Schnabels were hard to come by. There were no plate paintings in that first show, although Boone had already sold a couple, at $4,500 apiece. "He was trained as a painter," she told a reporter, "and I didn't want him seen as some kind of fetish object-maker." Schnabel, though, claimed that not showing the plate paintings had been his idea. It seemed a minor divergence, but it was a hairline fissure all the same.

The show was hardly reviewed. "There was a big article on the art world in *Esquire* in 1979 that mentioned every gallery in 420 except mine," Boone says. But prices were a bit higher at a Boone-prompted show of Schnabel that June in San Francisco, and in November she showed four plate paintings in her gallery, each one pre-sold at $6,000. The show excited further attention and finally attracted a visit from Leo Castelli, who had not at first felt warmly about his new downstairs

neighbor. "One day the Hague people, who were art shippers and packers, announced they were going to devote part of their space to a new gallery," Castelli says.

"I said, 'Who?' They said, 'It's a new dealer, Mary Boone.' I said, 'Who is Mary Boone?' I felt very noncommittal about it." Gary Stephan had reassured Castelli that Boone wasn't going to degrade the neighborhood. Castelli was unprepared for his first sight of the Schnabels. "This was a *coup de foudre*," he says. "Like when I went to see Jasper in '57 or Stella in '59. I went in and I saw the clay paintings. And I was just bowled over."

Boone now had a roster of younger artists, including Ross Bleckner and David Salle. "I decided to take Julian right away. It was years before I took David," she says. Indeed, Salle's first solo show in New York had been in September 1979, in a short-lived gallery run by a Manhattan dealer, Annina Nosei, and a dealer from Los Angeles, Larry Gagosian. The show created no hoopla, but a few pieces sold. "Charles [Saatchi] bought three or four of those paintings. He still has them," Gagosian says. Boone asked Salle to join her gallery.

He did so, but was not on hyperdrive. "You have to understand that I was coming out of a period of intense rejection," he says. "I was much more of an outsider in a way than Julian was. I had already made my foray into the art world. I had shown in Europe. I had shown in Artists Space. I had had various people over to my studio—Ileana and so forth. A lot of people had been mildly curious, nibbling around the edges, but nothing had happened. Basically, I felt totally rejected and had more or less given up. I was just hanging in there without any great expectations.

"I thought the art world worked by some insider favor-trading kind of machinations. I thought it was about people who were sucking up to other people, doing little favors, and they were given little rewards. I had the most naive and cynical view of it.

"Then Julian comes along and just *assumes* he's going to take over the joint. He never had any doubt in his mind for a second. He

just assumed we were going to be famous. And I was . . . 'Oh, yeah? Sure, Julian!' . . . and when it started to happen, I was in the middle of getting divorced. I had been married young. So when it started to happen, I didn't believe it. I didn't trust it. I was really out of it."

Galleries that represent living artists are biospheres to be trod with caution. Egos bulge and nerves crackle. Castelli had wanted to take on Brice Marden, but hadn't, because he represented the older Abstractionist Ellsworth Kelly. "He thought Brice was a *vile imitator.* But of course he was completely different," Castelli says. (Castelli had humored Kelly, fruitlessly. Kelly moved on to Knoedler anyway.) When a gallery and its artists are young and sense that they are on a cresting wave, the air can sweat ambition.

The younger artists *had* taken over, too. By the time the Mary Boone Gallery started basking in wider attention, the Bykert Minimalists, with rare exceptions—like Stephan and Uglow—had faded. Truer to their aloof aesthetic than they perhaps intended, for a while at least they vanished from the record. "It was basically Julian and Ross who were the driving force," says the painter Donald Newman, who had been introduced to Boone by Julian Schnabel. "Julian wanted to do things for people. He wanted to be the Papa Hemingway of the art world," he says. "Being in Mary's gallery was like playing for the L.A. Dodgers. Paula Cooper's gallery was like a family. Mary Boone's gallery was a team. That's why it all happened."

A brash new art was about to engulf America, but not America only.

In the novel *A Voyage to Pagany* the poet William Carlos Williams observes, "Europe's enemy is the past. America's enemy is Europe." The American Impressionist Childe Hassam was rather a precious painter, but a feisty talker. In 1932 he told a reporter, "Our own art is as good as any other in the world today and it should certainly be the

most important to us, in spite of all the little snobs who come out of college and litter the land with encomiums on every dab of paint that comes out of dressmaking Paris." This, mind you, when Paris was the abode of giants. After the war, with the triumph of American painting, to borrow Irving Sandler's book title, the mood had darkened on both sides of the ocean. There had been exceptions, like the Fluxus movement, which practiced the same benign internationalism as the later hippies. By and large, though, the radical art worlds of Europe and America—effectively, New York—looked on each other with suspicion, when at all.

American writers—like Tom Hess with his essay "The Death of Paris"—hammered the École de Paris. Paris was lambasted both for the inferior talent of its younger artists and because various of the maîtres, like Cocteau, with such Aryan movies as *Le Retour Eternel*, had to some degree truckled to the Third Reich. Politicized Europeans struck back. Serge Guilbaut claimed in *How New York Stole the Idea of Modern Art* that the CIA, rather hipper then to the uses of the avant-garde than since, had subtly orchestrated the takeover by the New York School as a weapon in the battle for Cold War hearts and minds.

Artists could be as chauvinistic as anybody. The summer course that Oskar Kokoschka ran in Salzburg between 1953 and 1963 was in some part a crusade against the hegemony of American art. The German painter Georg Baselitz said he had not been interested in New York artists like Pollock when he was young, and had far preferred the Art Informel of the Paris-based artists Fautrier and Wols. Patrick Heron, a British painter and writer, a former supporter of the Ab Exes, published a lengthy attack on "U.S. cultural colonisation" in 1974. This was illustrated with reproductions of work by de Kooning, Richard Diebenkorn, and Helen Frankenthaler, along with works by three British artists, William Scott, Peter Lanyon, and himself, suggesting that the Americans were little more than painterly pickpockets.

Pop had precedents too. Eduardo Paolozzi, a Briton, made an art piece based on a cover of *Time* magazine in 1949. Lucio Fontana

used neon in 1961. The French artist César began making sculptures
with an industrial compressor in 1960, before this became the signa-
ture manner of John Chamberlain. Certainly, Americans were not shy
of enjoying revenge for their long period as third-class citizens of the
global art world. Mark Rothko famously turned his back upon being
introduced to Yves Klein. For his part, Yves Klein snubbed Rauschen-
berg. Christo and his wife, Jeanne-Claude, dined with a famous Pop
artist in the 1960s. The Pop artist grew surly after too much wine and
recommended they return to Paris. "There are too many of you over
here already," he complained. As late as 1978, César grumbled that
he would like to show in the United States, "but unfortunately the
American market is virtually closed for us French artists."

The art world tends to regard these concerns as unsophisticated.
The standard response is that it doesn't matter who did it first; it's who
did it best. This is usually correct (Césars look nothing like Chamber-
lains), but not always. Time and place can be important, too.

Arte Povera, "Poor Art," which had reigned in Italy rather as Mini-
malism did in New York, was so called by Germano Celant, an Italian
curator/critic. Celant, a soft-voiced tough guy after the Jesuit fashion,
used the term to solder together a group of artists—Kounellis and
Mario Merz, for instance—who worked with rough, raw industrial ma-
terials. It was a Sicilian critic, Achille Bonito Oliva, who named *Arte
Povera*'s successor. Bonito Oliva noted that a bunch of younger artists
who had begun in acceptable forms—Conceptualism, Performance,
etc.—had moved on to something more questionable: painting. Bonito
Oliva's nominees included Mimmo Paladino, Francesco Clemente,
Sandro Chia, Nino Longobardi, and Enzo Cucchi. He came up with
the name Transavanguardia, meaning that the abandonment of for-
ward progress in the arts did not necessarily mean a collapse into
reaction. Crablike forms of motion, he felt, were the most appropriate
for the time. I visited the critic, a short man with crafty eyes and pitted

skin, in his Rome apartment at the end of the 1980s. *"La Trans-avanguardia sono io!"* he told me, with sly pride. The Trans-avant-garde is me!

Bonito Oliva, who speaks no English, attacked his detractors with vehemence, then asked a question I didn't quite get. What did I think of critics as anarchists? I repeated.

"Not anarchists. *Narcissists.*"

He presented me with two books as I left. One, a brief biography of the critic, lauds him as "Showman, Latin lover, VIP, dancing star, matador." The other contained photographs of Bonito Oliva with an eclectic mix of individuals, from Bianca Jagger to Umberto Eco; poems dedicated to him; and no fewer than forty portraits of him made by loyal Transavanguardisti, including James Lee Byars, who made a cast of Achilles' heel.

Not all felt warmly about the critic or his artists. "For us it was spaghetti painting. Easy! And they were quoting from the art of the thirties. That was dangerous," Germano Celant told me. As the Americans admired Picabia, some Italians professed regard for the later works of Giorgio De Chirico, those stallions prancing beside a calendar sea and self-portraits in period costume, all executed in paintwork with the hard repellent sheen of a glazed biscuit. Celant particularly cited Sandro Chia's borrowings from Mario Sironi, a painter whose broody perspectival canvases are paeans to the fascist aesthetic, and a reminder that Sironi supported Il Duce until 1943. "Kounellis and the others in Arte Povera were men of 1968," Celant added, weightily. The Year of Revolutions! Not all were so stern, though. Gian Enzo Sperone, a dealer with galleries in Rome and Turin, and a shared space in Manhattan with the dealer Angela Westwater, showed Arte Povera. He looked over the Transavanguardia, and took on Enzo Cucchi, Francesco Clemente, and the Italian artist provoking the most buzz at the time, Sandro Chia.

Chia, who was born in 1946, is a big man, with short curly hair and a hefty, rather sculptural presence. He had begun making Conceptualist work, but by the time he moved to Rome in 1976, he was

making figurative paintings. They were fluently drawn figures in a childhood-mythic vein and seductively colored, a kind of painterly *bel canto*. In 1979 Sperone, taking note of the success of a Manhattan artist of similar expressive brio, Jedd Garet, proposed that he and Westwater give Chia a Manhattan show.

It was a no-lose situation, really. "Gian Enzo at that time was always complaining that his New York gallery cost a lot of money. So he said, 'Okay, we're not going to sell any paintings for sure. There's no danger of that,'" Chia remembers. "'But a show will be very good for your curriculum.'"

Chia's love affair with Manhattan began at JFK Airport. "The customs agent asked why I was in the United States. Always I am scared of the customs. But I said I was going to have a show at a gallery," Chia says. "And the agent was so happy. He starts smiling. He gives me three more stamps on my passport."

Manhattan was fizzing. The dealer Annina Nosei, a compatriot, introduced Chia to Schnabel on the street. "She already had some of the plate paintings," he says. The New was everywhere. Chia's show opened on January 12, 1980. It sold out completely. "Which at that time was still very rare," he says. He decided to stay on in New York. "I wanted to see how long this game could last," he says.

Did he *believe* in his success? I ask.

"Success is like wine. You don't believe in wine. You drink wine," Sandro Chia says.

It is easy to forget the sheer *speed* with which Manhattan had been transformed. In 1977, for instance, Donald Baechler, a young artist from a Quaker family in Connecticut, became friendly with Jiri Georg Dokoupil, a Czech-born artist, at New York's Cooper Union, where the éminence grise was the anti-painter Hans Haacke. Both Baechler and Dokoupil decided to take up the reviled craft. "I started to paint because in the late seventies for a serious artist it was the *worst thing* to do," Dokoupil explains.

In 1978 Baechler went to stay with Dokoupil in Cologne. "I left New York because it was pretty dull," Baechler says. "But nothing was happening in Germany, either. The museums were full of American art. The Ludwig Museum was full of Lichtensteins.

"I remember seeing a couple of Polkes in a small room. People like Polke had reputations. But it was all considered second-rate compared to American Pop art. Even in Germany, Polke and Richter were considered kind of marginal," Baechler says. Salle uses the word *marginal* too.

Baechler returned to New York the following year. "I worked for eight months at Dia as archivist for the Blinky Palermo estate. I was fired," he says. "Meanwhile, back in Germany, the Berlin scene was erupting." What was erupting in Berlin was a group of clunky Expressionists called the Wild Bunch. According to Dokoupil, what was under way, as in New York and Italy, was a revolt against the whole Modernist power structure. "Something had to happen, because in this time, which was '78, '79, there was an incredible boredom in the galleries," Dokoupil says.

"You could see another stupid installation of Carl Andre. Or another Dan Flavin thing. Everybody was bored. *Completely.* And the artists were not holding to what they had promised. All the idea of escaping from the market had become completely absurd. Because the photograph of an installation had value. It was sold in a gallery. There is no escape. You have to accept the wall and the gallery. So why not paint?"

Berlin's Wild Bunch, though, were soon written off as housecats. "We were laughing about it," says Dokoupil, who was with a group of Cologne artists. "They were stupid. The decision to become a dumb painter has to be your decision. If you don't decide, you just *are* a dumb painter." The dumbness, Dokoupil says, lay in the Berliners' reverence for such early German Expressionists as Kirchner. "For me, German art of the twenties and thirties was not interesting," Dokoupil says. What he did find interesting was the work his Italian contemporaries in the Transavanguardia were doing. Nor was it just interesting to the young German artists. A few of the nimbler dealers outside

Italy—like Paul Maenz in Cologne, Art & Projekt in Amsterdam, and Bruno Bischofberger in Zurich—were picking up on it too. Dokoupil says, "There is something mystical about Bruno. If something is happening somewhere he is *the first*," Dokoupil says. "I don't know how he gets the information."

Europe 79, an exhibition in Stuttgart, featured paintings by Clemente; a flamboyant (real) tigerskin, nailed to a wall and the floor, by Nino Longobardi; and paintings-cum-objects by Sandro Chia, who was still not out of his Conceptualist phase. In 1980, Paul Maenz, who had shown the Italian work, showed a group of young German painters, including Dokoupil, Albert Oehlen, and Georg Herold. One of the exbibitors, a former Conceptualist, Peter Adamski, remarked of the show with the nonchalant ruthlessness that would characterize the coming decade: "If we hadn't been successful with these pictures, then most of us would have given up painting."

It was a time when things were changing dramatically within months or weeks. The Europeans first became aware of what their American coevals were up to via the art press. "To be honest, the only American artists that did things interesting for young Germans in '79 were Jonathan Borofsky, Jedd Garet, and Julian Schnabel," Dokoupil says. "We saw very clearly that these were outstanding. Schnabel's first solo show was with Bischofberger in Zurich in 1980. That same year he showed pieces in Milan and with Daniel Templon in Paris. Europeans were indifferent to David Salle. He's too clever. He doesn't make mistakes in his art. He never approaches anything unknown."

By the time the Venice Biennale of 1980 opened, Clemente had shown at Sperone Westwater in New York, and was soon to be followed by Enzo Cucchi. Along with Chia, they were known as "the Three C's." The other Transavanguardisti, like Mimmo Paladino, would have to wait their turn. For the Americans, the shock in Venice was the upsurge among the Germans.

"Three artists were invited to be in the German pavilion," says Michael Werner, who had a gallery in Cologne but was born in Ber-

lin and has a pawky Berliner sense of humor. The three included none of the sardonic Cologne crew but were deeply serious, being Georg Baselitz, Markus Lupertz, and Anselm Kiefer. "I was there with Lupertz and Baselitz when they looked at the pavilion, which they had never seen. Kiefer didn't come. He was the younger, so he had to wait till the older artists had said their piece."

Georg Baselitz painted rawly Expressionist canvases. His first subjects had been "heroes," young males, who seemed bereft in manly fashion in a wasteland of anomie. In 1969 he had begun showing the canvases with the figures upside down, like the hung fowl of Chaim Soutine, except that the point, as Baselitz himself would frequently make, was that the viewer should be looking at the canvas, not the subject matter. The ordinary viewer, of course, will ignore the artist's stated intentions and try to make sense of the image anyway, but Baselitz had painted like that more or less ever since anyway. He now said, or demanded: 'I want to have the middle space.'

"It was embarrassing. Because there's only the major middle space and two little rooms. Markus said, 'I don't know. We have to discuss it . . .' Then, after a very short time, fifteen minutes of discussion, Markus, who is one of the most generous artists in existence, said, 'I'll wait until I get the whole space myself—another time.'

"So Baselitz got the space for his sculpture and Kiefer did the other two spaces."

Baselitz showed heads and figures, hacked and gouged out of living wood with an ax. Kiefer showed huge oblong images, straw-strewn, puddled with lead, covered with scrawled Teutonic signs, and opening into unfashionable perspectival views, like a cathedral or a battlefield. "The New Yorkers kind of gulped," a dealer says. "We had taken the Italians on board. But these Germans were so . . . *German*."

Michael Werner says, "It was a strange thing. Ileana was totally freaked out. She loved it. Peter Ludwig bought work. It was as if the discussion was over. This was the new direction, and everybody followed it. But they were very insecure. Nobody knew if Kiefer was bad and Baselitz good, or if it was the other way."

Marian Goodman, who had recently opened a gallery space on Fifty-seventh Street, had no doubts. "I asked Kiefer to be in the gallery. And he accepted. At that time there weren't that many people running after him," she told me, adding with an acid laugh, "A little bit later half of New York began to run after him."

The dealers swiftly bored into the mother lode. Leo Castelli and Barbara Jakobson arrived at Michael Werner's gallery in time for a show of the work of Jorg Immendorff, whose *Meisterwerke* was a dark Brechtian story painting, *Café Deutschland*. "He said, 'This artist is a genius!'" Werner remembers. Germanophilia went into a more manic phase. "They all tried to show everything! Marian Goodman showed Lupertz and Kiefer . . . Ileana showed Baselitz and Immendorff and Penck . . . and Fourcade also showed Baselitz. So that was divided already. There was a big fight."

How did the artists react to their new desirability? Werner grimaces and says, "Their reaction was: *This took long enough!*"

It sometimes happens, but rarely, that an art school becomes a crucible. In the early 1970s it was CalArts, the California School of Art, which had been funded by Disney, partly in the misguided hope that it might become a spawning ground for animators. "Burbank paid a surprise visit," says Eric Fischl. "The trustees came through at seven in the morning and found half the student body naked in the swimming pool. The faculty, too. They flipped, and tried to close the school."

Students of Fischl's generation included Ross Bleckner, Matt Mullican, and David Salle, with whom Fischl shared a room. John Baldessari was a teacher. So sweepingly successful did that generation become when they moved to New York that there would be resentful art-world rumors that the school had taught a "strategies" course. Not so, but it surely had been professional.

"Everybody at CalArts knew painting was dead," Fischl says. "That was something I never bought. But we were taught no technical skills, no craft. Most of us had to go and learn it by ourselves later." He was hugely impressed by subversive Abstract painters, like Elizabeth Murray, who made a painting of a circle in a square. "That was one of the primary abstract structures. The idea of perfect harmony. Only, her circle didn't fit. It bulged. I just thought, Well, that's it. It's over now! We can go and do whatever we want."

After graduating from CalArts, Fischl resisted the idea that all serious artists had to go to New York, and moved to Nova Scotia. In 1976 he made a figurative painting of a boy and a boat. "It was in Nova Scotia that I made the transition to figuration," he says. The canvases he learned to make tell troubling stories and are painted with a hand that sometimes seems disturbingly close to losing control. This is no accident. He talks of a canvas by Bonnard. "The longer you looked at it, the more you realized how clunky it was," he says. "It had a kind of transcendent beauty and a kind of awkwardness that was just *shocking*." Fischl did move to New York at last in 1978. In due course he joined Mary Boone, by no means to the delight of Julian Schnabel, who was said to have invited him to his studio to teach him how to paint.

For Julian Schnabel, 1981 was a very good year. He told Boone that her space was too small for both the work he was making and the work he was planning. He approached Joe Helman of Blum-Helman at a party. "Did you see the show?" Schnabel asked. Helman hadn't. "It doesn't matter. I'm ready for the big time!" Schnabel said. Helman, who had already been scouted on Schnabel's behalf by an artist with heft, hadn't been interested. SoHo had begun seething with rumors that Schnabel was Castelli-bound even before he had met the dealer.

Actually, Boone and Castelli agreed to represent the artist to-
gether, fifty-fifty. "This was the first new artist I had taken on since
1971," Castelli says. For Julian Schnabel, it was a juicy situation. He
could hang with his team and he could hang with history. For Mary
Boone, too, it was opportune. And no accident. Pre-Schnabel, she had
suggested to Castelli that they jointly show the Bykert Minimalist Ralph
Humphrey. Castelli had turned her down and Humphrey had gone
on to another gallery. That was then. This was now. "Leo has a big
backlog. He has people he owes favors to and people who owe him
favors," another dealer says. "If he wants to sell something, he can select
five or six key collectors from the ten or twenty in the world."

And Leo Castelli's interest? Simple. A covey of middle-aged deal-
ers had been eyeing his artists for years and waiting for him to do a
slow dissolve. He had leapfrogged them with a bound. The two-gallery
show with Julian Schnabel opened on April 4. The thirteen pieces
hung included plate paintings and a piece to which antlers had been
affixed, as though ready to gore Rauschenberg's goat. There were a
few pure abstractions that put tawdry materials like pink and black
velvets to superb use—Hilton Kramer described one of these as "un-
forgettable" in the New York Times—but most of the paintings used
images that ranged from the religiose to classical motifs, which looked
like dry husks, drained of meaning.

Prices ran from $9,000 to $40,000. This was a tenfold jump in
three years, and Schnabel said he had pushed for it. "Mary started out
very conservatively," he told ARTnews. "But I needed more money to
live, and prices had to go up. I didn't make that many paintings. And
I was tired of cooking." His sense of what the market would bear was
on the button. Almost every piece had been pre-sold, and the wall
labels carried not only the title of the artwork but the name of its
new owner. This was Boone's idea, and it caused comment, because
the trafficking side of things was still rather hush-hush. Castelli would
later admit he might have been wrong to have gone along with it.
But since the names included such collectors as the Swede Fredrik
Roos; Philip Niarchos; and Peter Ludwig, the Cologne candy manu-

facturer, the tactic made the few works still up for grabs twinkle with desirability.

Schnabel was also one of the thirty-eight artists included in a landmark show, "A New Spirit in Painting," that opened at London's Royal Academy on January 15, 1981. The intent was to show both the surge of energy that had returned to the canvas and the tradition to which this could be related. Thus the show included seniors like Picasso (the splooshy late paintings). Julian Schnabel was the youngest artist in the show, but for once he was peripheral to the rumpus that followed. "The show nearly didn't open. They thought it was a European plot," says Norman Rosenthal, the institution's secretary of exhibitions, who was one of the show's three curators. The problem was that the Big Room, a sacral space, had been given over to foreigners. David Hockney and R. B. Kitaj showed up on the premises the evening before the opening. "They were going to remove the work *physically*," Rosenthal says. They were talked out of this, and the show opened as planned, if not to wild applause. "Even Charles Saatchi didn't like it," Rosenthal says, with the feline smile of somebody whose judgment came to be shared by anybody who counted, but later.

Mary Boone was also on the move. Her landlord, Walter Germans, said he couldn't find her more room in 420, but offered her a space just across the road, at 417 West Broadway. According to Gary Stephan, "It was a garage where all those mafia-type garbage trucks were parked." By the time Boone was done with it, the place had become a paradigm of Brutalist elegance, with snow-white walls and floors of pearly poured concrete. She had chosen a stark, unfussy typeface for her correspondence, and invitations to her openings were printed on the sort of creamy cards that uptowners called "stiffies." A reporter for the newsletter *Art Economist*, who was at the opening of the new premises, headlined his account "The House That Schnabel Built."

It was remarkable. Not since Andy Warhol had a figure popped up in the art world who excited greater passions—pro, con, or betwixt and between—than Julian Schnabel. In, among others, Warhol himself. "They're so ugly. He can't draw," said Warhol with a rare inten-

sity in the fall of 1981. *"He can't draw!"* By the following year, though, Warhol had become a convert, and made a big to-do of introducing Schnabel to the curator Henry Geldzahler. "He was throwing at me that this is the new artist. This is the new artist!" Geldzahler says.

Schnabel's friendship with David Salle peaked when the two agreed to swap paintings, a convention among pros, a sign of respect. Salle came through first, delivering a diptych, *Daemonization*. Schnabel's sign of respect was unusual. He separated the panels, reversed the order, and drew a line portrait of Salle on what was now the left-hand panel, directly from a tube of orange paint. "I used the painting. It's an act that had to do with his work and our relationship," Schnabel told *ARTnews*. Just what it had to do with them, he didn't say. Both artists, now co-owners, showed the work, now called *Jump*, at Mary Boone.

The juggernaut continued. The writer Schnabel had approached in the restaurant—but who had not come through—found the artist bearing down on him at a party with his usual alternating current of bonhomie and prickliness. "Well, you missed the boat," Schnabel told him. Leo Castelli called Grace Glueck at the *New York Times*. "Leo said, 'Grace, we must have lunch. I want to clue you in on a few things'" she recalls. He showed her the Schnabels. They affected her powerfully. "I thought, Yuck! I'm not going to mention this artist. I should have known that if I had that adverse a reaction it would soon be the hottest thing on the block," she says. Her lead story in the "Arts & Leisure" section on October 18, 1981, was headlined "Fresh Talent and New Buyers Brighten the Art World" and was accompanied by photographs of Stephen Hahn with a Matisse, Leo Castelli with a Lichtenstein, and Mary Boone with a Julian Schnabel.

It is the way of things that when new stars shine with exceeding brightness, others wane, this being especially so in the celebrity culture of the United States. Quickly affected by the rise of what were being called the Neo-Expressionists were others who had for a while been seen as possible Next Big Things—for instance, those artists who

had been included in the "New Image" exhibition at the Whitney. Certain dealers, also. The sudden change in the climate grates on Holly Solomon to this day.

It had been she, Solomon insists, who introduced Schnabel to Charles Saatchi. It had been Boone, though, who sold Saatchi five Schnabels by the fall of 1981, and it was Schnabel himself, with his overbearing charm, his persuasive sense of entitlement, who managed to put himself on a personal footing with a collector fastidiously shy of hobnobbing with actual artists. It had also been Solomon who had introduced Schnabel to a crucial dealer.

Bruno Bischofberger had been interested in the work of one of Solomon's stable, Joe Zucker, who had come up with a way of energizing a picture surface by an accumulation of paint-soaked cotton balls, a technique he had begun working on in 1969. Solomon says she heard Schnabel "bad-mouthing" the work to Bischofberger at an opening of Zucker's. "I went over and said, 'Keep your fucking mouth shut,'" she says. It was art politics, she feels: "bully power." Bischofberger never did follow through on Zucker, anyway. He was, though, interested in another New York artist who was enjoying a meteoric career, Rodney Ripps.

Brooke Alexander, a print dealer who had decided to show young artists, first saw the work of Rodney Ripps at a gallery, and paid a studio visit. "This guy was *on fire*," Alexander says. "He had been up the Amazon and had become obsessed with leaves. He was painting on these artificial leaves, and painted some magnificent pictures." Rodney Ripps became Brooke Alexander's first painter. "We got a lot of attention for his work, and he was quite active in promoting his work himself," Alexander says. Ripps himself hooked up with three powerful European dealers, Hans Meier in Cologne, Daniel Templon in Paris, and Bruno Bischofberger in Zurich. "Bruno came into the gallery and bought three works," Alexander says. "Whap! This was '79, '80."

The largest piece Ripps had ever made was in the Whitney Biennial of 1979 and at the Venice Biennale of 1980 and made the cover of *Flash Art*. "I thought we were doing an okay job, and I was fond of Rodney personally," Brooke says. "After the Venice Biennale, Rodney spent part of the summer with Bruno Bischofberger," Brooke says. "He came back and said he was going to dump the relationship.

"I said, 'Rodney! Come on. What's behind this?' He said, 'Well, Bruno told me you weren't a good gallery. I have to be with my peers!' And so forth. He had decided to get fancy. He wanted everything in five years. He kept saying, 'I've got to get it now. I've got to get it now. You're *too slow!*'"

Ripps agrees that he left Brooke Alexander at Bischofberger's urging. He went with Holly Solomon. Bischofberger called him when he was passing through New York about a year later. "I will never forget. He was supposed to come over to see some more work," Ripps says. "He said, 'I can't . . .'" Ripps's stint with the Zurich dealer had lasted two years.

Neo-Expressionism had arrived. "Painting on leaves! Like painting on plates," Ripps says. "The force of the work, and the intent, was similar." But they were Abstract, and not faring well with Holly Solomon as the Neo-Expressionist waves thundered up the art-world beaches. Ripps called Brooke Alexander. "We had a meeting," Brooke says. "He said, 'We should really get together again and finish what we started . . .'

"I said, 'Times have changed, Rodney.'"

Donald Baechler remembers drinking with Ripps one evening. "He spent all night doing little drawings of Mary Boone hanging and Julian Schnabel with a knife in his back. I've never met anyone so bitter," Baechler says.

Ripps has rented out his SoHo studio and lives in "a great carriage barn" in the Berkshires. He sounds more resigned than bitter. "I have a family and everything. I'm making a living. I'm doing really super work. But it's not the same," he says. "It's a great thing to do shows all over the world and be a well-known artist. There's nothing like it.

"It's not the greatest reward of your work. Your greatest reward *is* your work. But there's another level to being an artist, and I enjoyed that. It's great. But let me tell you this. This is a postscript. Once you're out, you're out. It's a really sad thing. It's like in Hollywood. When people are not interested, they're not interested. The work is great. But so what? Either you're hot or you're not.

"But the record should be straightened out. Before Julian Schnabel, Rodney Ripps was doing paintings that forged the way. Art is so much about who was the innovator, who opened the way. And I know what I did. I was really young and naive. The problem was that now every-one is switching galleries and I was one of the first to do this. So I built up resentments. As they say in fashion, you're better off being second than first. It's true. It's so true."

There was a *faux* Schnabel as a stage set when the curtain went up on the new musical *Cats*. In the first week of February 1982 even the financial biweekly *Forbes* got into the act. Its story, "Portrait of the Artist as Money Man" was accompanied by photographs of the art-ist Harry Jackson with "marketing brain, Tim Yarnell"; Christo with his "wife/business manager Jeanne-Claude"; and "Gallery owner Mary Boone and protégé Julian Schnabel." Boone could not be blamed for the phrasing of a caption writer, but the body of the text showed her at her most driven and controlling. It read: *"Boone takes credit for getting the artist into the right museums and shows."* She was quoted: "Julian could get much more for his paintings, but it would not be good for him long term. Many artists have had their reputations blighted by raising prices too fast."

She was as good as her word. The collector George Waterman had been trying to buy a Schnabel back when another collector, Patrick Lannan, had secured one for $10,000. Boone had quizzed Waterman about the art he already owned. "It was as if I was trying to adopt a baby," he says.

Schnabel was not perhaps as appreciative as Boone must have hoped. The "protégé" caption in *Forbes* had maddened him. He told one reporter: "I expected to have on a little blue cap and shorts." To me he snapped, "Mary Boone is famous because *I'm* famous." His heavier mood did not escape notice. "Julian was very ebullient," Paula Cooper says. "He never smiles anymore. He's so serious. I'm so sad for him."

Boone and Castelli had given David Salle the two-gallery treatment in the spring of 1982. They let it be known, though, that there wouldn't be another double whammy for Julian Schnabel. Castelli told me, "We don't want to do these so-called blockbuster exhibitions anymore." It was perhaps too late for a retraction of horns, because the hoopla was taking on a life of its own, as it does in the celebrity culture, but seldom in the art world.

The "retrospective" of four years of Schnabel's work that opened at the Stedelijk Museum in Amsterdam in the spring of 1982 was applauded by some but attacked by others for hubris. Shortly thereafter, Schnabel became the first young American artist to have a solo exhibition at London's Tate Gallery. There was a fancy opening, an attempt to kick-start "Patrons of the New Art," which was the museum's (laudable) attempt to whip up some local enthusiasm for the cutting edge and was very much at the initiative of Charles and Doris Saatchi.

The bombardment began on cue. John McEwen wrote in the *Spectator* that "Out of schlock comes Schnabel, king of it all. . . . On present evidence Schnabel has one ounce of talent, two of wit and a ton of ambition." William Feaver noted in the *Observer* that "nine out of the 12 paintings in the Schnabel promotion, sorry, exhibition . . . come from the collection of Doris and Charles Saatchi." Regarding their formal qualities, Feaver wrote, "Schnabel paints big because that's as good a way as any of suppressing doubts."

Which was nothing compared to the paean in *Art Monthly*. "He has not yet realised that working on a surface the size of a boxing ring will tend to expose, rather than conceal, his inability to draw," the writer noted. "Nor, of course, will heaping broken crockery into a bed

of body-filler mounted on canvas disguise the fact that Schnabel has rather less touch than an incompetent washer-upper . . ."

It was the Carl Andre bricks all over again, if a bit higher up the intellectual food chain.

In Europe the backlash was expressed with less gusto but a deeper disquiet. It was complained that the new German and Italian painters had authentic roots, whereas the Americans had come out of nowhere. Now New York was yet again trying to Steal Modern Art. Dr. Willi Bongard told me that Rudi Fuchs, who was curating Dokumenta that year, would be including neither Schnabel nor Salle. "I asked him, 'Why not Schnabel?'" Bongard says. "He said, 'Because he is not a very good painter . . .'"

Backstage pressures were brought to bear. Fuchs flew to New York and picked a David Salle. On Schnabel he remained immovable. He wrote a rather tangled rationale in *Flash Art* before the opening of Dokumenta, complaining that nowadays people "can only think about artists in terms of the Olympic Games: Who is the best? Everybody asks us why not Julian Schnabel? The absence of this particular artist is in a way conspicuous, considering the maintenance of the present-day market system and current taste. . . . It is completely impossible to talk about actual works." This didn't cut much ice with the Americans. In a later issue of the same magazine, the excellent art writer Carter Ratcliff wrote, "New Yorkers very quickly get past their annoyance at the petty, anti-American tactics of Dokumenta's hanging committee," and described Fuchs as "an authoritarian crypto-fascist monster." It is just as well that the lapidary poet-writer had gotten past his annoyance.

Julian Schnabel himself adopted the excellent strategy of taking all this as a tribute. "I think I was punished for being too successful," he told me in his studio just before Dokumenta opened. He gave a sad, incredulous smile. "It's like having a meeting of the United Nations and not inviting Russia. If they asked me now, I'd say no." His attention switched to the plate painting upon which he was at work. "I don't think anyone made a painting before that looked like that,"

he said. "I make them for myself. I don't make them so people can buy them. I'll give you a quote: A *painting is a bouquet of mistakes!*"

Dokumenta weighed on his mind, though. He said, broodily, "I know there's animosity out there. You have to act as though it doesn't exist. You want to know about success? All that shit?" He riffled through a sheaf of papers on the table and extracted a sheet. It was the translation of a 1937 poem by Viejo, a Spanish poet. The first stanza began: "Starved with pain."

The poem ended:

> he was daring
> fatidic scarlet
> irresistible

Irresistible was the word. Neo-Expressionism was roaring through the art world. In London, Georg Baselitz had a two-gallery show, with a difference—competing exhibitions mounted by Lesley Waddington and Anthony d'Offay. Gian Enzo Sperone closed his Turin gallery and focused on selling paintings in Rome. "He saw the way the wind was changing," says Giovanni Anselmo, an Arte Povera sculptor, fluttering his fingers. "Bye-bye!" But it was "Zeitgeist," a Berlin show in the winter of 1982, that convinced even the stragglers that things had changed, and Schnabel was one of the hits. A writer in Britain's *Guardian*, which had been as sniffy about the Tate show as anybody, allowed that "he could well be the new Jackson Pollock."

The review was headlined "The Shock of the Shameless," which seemed much to the point. Shamelessness would be one of the distinguishing characteristics of the decade, and the Neo-Exes were at the forefront. "At some point Julian did away with self-criticism as a conscious act," says Donald Newman. This was a compliment.

The hubbub over Schnabel caused Charles Saatchi to distance himself from the Tate—an ugly sort of victory for the enemies of the New Art, and an ineffective one. Schnabel, David Salle, and their peers would be continuously lampooned, but this would only show up the

impotence of writers—whether the scholar-poets of the art press, the heavy guns of the "quality" press, or the jokers in the tabloids—in the face of the art establishment and the marketplace. The power that had been wielded with a heavy hand by critics and curators in the 1960s and 1970s was now in the hands of a handful of collectors and dealers, and especially of mega-dealers, who liked to be seen as pure collectors. The traditional triage among the contenders was now up to them.

Four / The Heat
& The Cool

Futura 2000 was in Tony Shafrazi's gallery on Mercer Street.
He was wearing a white Adidas running jacket and tuxedo trousers,
with a satin stripe, which were of clownish bagginess and tucked into
laceless white sneakers. Futura was a Graffiti artist. The look was *impor-
tant*. "Want to see a painting?" he asked Shafrazi. "I just brought it
back from Paris." He unfurled the canvas. It bore an image. "That's a
spray can," he said.

Keith Haring came in, wearing viridian shorts.

"Did you see your photo in the *East Village Eye*?" Shafrazi asked
Futura. "Yeah. Didn't like it too much," the young artist said.

"It's like a Clash picture," Shafrazi said, soothingly.

"Did you see *People*?" Haring asked Futura. "You're in it. You're
good. They've got a piece by Kenny but not his name." Kenny was
Kenny Scharf, and Haring recited a chunk of the magazine text from
memory. "Fifty million people! That's *People* and *Time*," he said.
"*Time* really got me, though. They said I stole my thing from a Ger-
man artist, A. R. Penck. I had never *seen* Penck."

He had come to pick up one of his painted pots and a roll of
drawings, and to ventilate a couple of grievances. A woman in Los
Angeles, who had bought one of his drawings, had turned it into a
commercial motif. Now he had learned that some of his designs had
been put to unauthorized use as fabric designs in Japan.

"No more commercialism," Shafrazi promised. He added that
he had some people who wanted to look at the new work.

"Yeah. But here. Not in my studio," Haring said. "I learned the hard way . . ." The chorus of publicity, and the sour note, were appropriate.

The reemergence of Tony Shafrazi, the Sprayer of *Guernica*, as the Graffiti dealer of choice was further proof that reality can be more high-colored than any novelist, but it was no more extraordinary than the trajectory of the Graffiti movement itself. The movement had a specific origin, namely the legendary Taki 183. Taki, a Greek whose real name was Demetrios, borrowed the number from his street address and scrawled his name, or tag, around New York at the end of the '60s. Tagging became a craze, and a group of "writers" from the South Bronx developed it into "bombing," which was more ornate, and borrowed from the counterculture comic artists of the sixties, especially Vaughn Bode's Cheech Wizard in the *National Lampoon*.

In 1972 a group of graffiti writers founded the United Graffiti Artists. The following year they showed graffiti-sprayed canvases, priced between $200 and $3,000, at New York's Razor Gallery. During *Deuce Coupe*, Twyla Tharp's ballet for the Joffrey, there were Graffitisti onstage, spray-painting to the sound of the Beach Boys. Norman Mailer published *The Faith of Graffiti* in 1974. Graffiti were reminescent of the San Francisco comics and poster movement of the sixties, and not just stylistically. Both movements were anarchic, the Graffiti movement more physically so.

"We came from the only underground culture this planet has ever had," Rammellzee, a leading member of the group, told me. "We were *in the underground*. Actually in the subway. And that means something. When you can actually turn a letter into ornamentation and then into an armored tank in the dark. Where there is virtually no light. That is true technical talent.

"There might be a small lightbulb every twenty-five yards in the tunnel. In the yards aboveground you would have the moonlight, but

you got to have a talent and a technique to do a *rare thing* on a train—from the fear . . . the cats . . . the dogs . . . the bats . . . and the cops . . . and the third rail that might electrocute you to death."

He laid down some of the Elements of Style. "There is the Burner, the Griller, Panzerism, the Wild Style. The Burner is when you're getting ready to go in a technique of discipline. You're about to burn another artist. You know? Competition. Burn the boy! *Destroy the boy!* By doing it much better! And then as you get better, you get into this style called the Griller.

"Instead of burning it, now you're grilling it. Like a hamburger on a grill. Panzerism is where you have so much detail that an arrow turns into a missile. Wild Style is a style of candy-cane frenzied letters. Wild Style is illumination. We used an Arabic style of writing, which is very connected. It's a very militant technique. There were only seven people who could actually do it all correctly out of all the ten thousand who rode on the trains."

The fact was, though, that despite the hoopla, the art world did not immediately warm to Graffiti, and the United Graffiti Artists soon faded. But the success of the Neo-Expressionists created an appetite for work that issued from the hand without marinating too long in the cerebrum. Europeans, furthermore, had a famously soft spot for what they considered the "real" America—Brecht's City of Mahagonny; Josephine Baker's Harlem—and the Graffiti writers, who were mostly young Latino and black men, Lady Pink being practically the only woman, might have been picked by some art-world casting office for this market. If, that is, they could be lured out of the tunnels and alleys and into studios, where they could do their stuff on salable canvas and paper.

The venerable Sidney Janis Gallery, spying an opportunity to leapfrog over Leo Castelli, soon followed Shafrazi into Graffiti. How many of the original seven showed? I asked Rammellzee. His tone grew melancholy. "I'm the only one," he said. "Sniper and 131 and Jester and the rest were too old. They were either in jail or dead." What happened to the famous Taki? "He's gone. Who knows," Rammellzee said.

The art world Graffitisti were a younger generation. They were known by their tags—Crash, Daze, Toxic, Phase II, Fab Five Freddy, and Lee—and they soon picked up some art-world savvy. In 1980, Fab Five Freddy decorated the side of a subway car with a row of Warholesque Campbell's soup cans and Crash borrowed liberally from Roy Lichtenstein.

The urge to take art public was widespread aboveground, too. Anonymous posters, printed with texts like MORALS ARE FOR LITTLE PEOPLE and MURDER HAS A SEXUAL SIDE, were appearing around town and were the more disturbing because it was hard to figure out what the artist—actually, Jenny Holzer—really meant. Kenny Scharf, a young artist who had come from Santa Barbara to study at the School of Visual Arts and who was successful enough to have his solo show "Fiorucci Celebrates the New Wave" at that terminally hip store in May 1979, went out on forays making wall drawings with Jean-Michel Basquiat. "I would do Jetson and Flintstone heads and have them speaking some foreign tongue," Scharf says. Beriah Wall struck clay coins, printed with designs and epigrams, like A SHARP SPEAR NEEDS NO POLISH, a thought from the imperialist novelist H. Rider Haggard, and left 100,000 of them around the city. Kenny Scharf and Jenny Holzer are now part of the record, but Wall has shared the fate of most populist artists: obscurity.

The "Times Square Show" of 1980 was the cyclotron where a lot of these energies collided and struck sparks. It was organized by Colab—Collaborative Projects Inc.—which was founded in 1977 by a group of artists including Robin Winters, who had been one of the first to join the Mary Boone Gallery, as he was one of the first to leave, and James Nares, a recent arrival from London. It was a sprawling show, with 150 artists, other political cooperative ventures—like Fashion Moda and Group Material—and a full-time disk jockey, Anita Sarko, put up in a condemned former massage parlor near Seventh Avenue and Forty-second Street. It was at the "Times Square Show" that Scharf and Keith Haring, who were sharing an apartment, met

the "real" Graffitisti Fab Five Freddy and Lee. "Keith immediately latched on to them. So through Keith I met all of these guys," Scharf says. "Right after that, Keith began to do the subway drawings."

Keith Haring had come from Kutztown, in Pennsylvania Dutch country, in 1978. He didn't paint on the trains in the subways but on the sheets of black paper with which the Transit Authority covers expired ads. He was soon turning out quantities of rapidly executed chalk drawings, deploying a vocabulary of yapping dogs, radiant babies, running gingerbread men, UFOs, and airborne pyramids, energized by darting lines, all calculated to amuse or provoke a public that wouldn't get the point of much art in SoHo.

Haring joined the Shafrazi Gallery in 1980, but made a point of letting people know that the stuff he was doing for free was every bit as good as the stuff being sold by the gallery. Richard Hambleton, another young artist, took him at his word. According to the dealer Andrew Terner, Hambleton would find out when Haring intended to hit a station and paste up sheets of black archival — nondegradable — paper. "He slapped up Stonehenge paper . . . waited . . . ripped them down, and fixed them," Terner says. So much for yet another attempt to subvert the mechanisms of the market.

Richard Hambleton was also working aboveground. Between 1976 and 1978 he made a series called *Image Mass Murder*, drawing chalk outlines of "homicide victims" on streets where no murder had actually been committed. He then started making *Shadowman*, spikily elegant black spray paintings, on New York walls.

In the fall of 1980 the curator Diego Cortez, who had become interested in the Graffiti artists, was putting together a show of American art, supposedly for Italy. It made it as far as P.S. 1, an alternative exhibition space in Long Island City, where it opened in February 1981, being billed as "New York/New Wave." It included murals by a dozen Graffiti writers; photographs by Robert Mapplethorpe and rockers like David Byrne and Brian Eno; and graphics from *Screw* magazine.

* * *

A resentful feeling that the grandiose golden boys—and they *were* all boys—had made SoHo too tough a nut to crack was everywhere. "SoHo had become pompous and snobbish. It was no fun anymore," says Patti Astor. Patti Astor, who was born Patricia Langton Tichener and came from Cinncinnati, lived in the East Village, a run-down proletarian neighborhood occupied mostly by Italians and Hispanics. "People from outside would be scared to death to even come visit you," she says. The East Village had been a bohemian enclave since the 1960s. New Wave music broke in the mid-1970s. "It seemed that everyone played guitar," says James Nares. He got into the spirit of things quickly, dying his hair red one week and shaving it off the next. "We consciously stood against what was happening in SoHo," Nares says. Then came the underground movies.

The films were low-budget two-reelers and they were shown at a midget movie house on St. Marks Place, the New Cinema. "The figure was coming back into painting," Nares says. "My solution to the problem was to put narrative into film." He made *Rome 78*, starring the painter David McDermott as a Nero-Caligula composite. Patti Astor appeared alongside such future art-world figures as the painter Jedd Garet and the writer René Ricard in the magnum opus of the movement, Eric Mitchell's 1979 *Underground U.S.A.* How long did that movie-music thing last? "It was voooom! A good year or two. And then a lot of burnouts and casualties. Drugs and overload. A lot of things," Nares says.

Astor was answering the phone for a real estate agency run by a would-be art dealer, Bill Stelling, who had a little storefront on Eleventh Street between Second and Third Avenues. The rent was $150 a month. "It was literally eight feet wide and twenty feet long," Stelling says. He told Astor he would like to do something with the space. Patti Astor was working on Charlie Ahearn's *Wild Style*, the first movie about Graffiti, rap, and break-dancing, so she had got to know such co-stars as Fab Five Freddy, Lee Quinones, and Lady Pink. "She said, 'Oh, I know all these *artists*. We can show them there,'" says Stelling.

The Fun Gallery was Kenny Scharf's suggested name. "We thought it sounded so stupid that we let it stick," Astor says. They opened in June 1980. Their first show was of an artist called Steve Kramer. "Everybody came . . . the homeboys from the neighborhood, ladies in mink coats, just mingling . . . we sold everything in the show . . ."

The second show was Kenny Scharf. "Patti was sitting in the gallery and Bruno Bischofberger walks in. It was like, *How did you get here?*" Stelling remembers. "He was our first limo," Patti Astor says. "Where Euro-trash goes, yuppies are sure to follow." Their third show was Futura 2000. "Don and Miera Rubell bought something from the show," Stella says. That September they opened in a larger space on Tenth Street. Another gallery was started by a young dealer called Patrick Fox. Then came Civilian Warfare, 51X, Gracie Mansion, and a deluge.

There was a specific look to the art, too. It was the look of the neighborhood. Graffiti was part of it; so were kitsch, facile Surrealism, comics, and punk. Dealer Jay Gorney called the manner ACI — Apocalyptic Cartoon Imagery — and the late critic Craig Owens lambasted it in *Art in America* as an "enfant-garde." Artists with SoHo careers were attracted by the energy and showed in the East Village too, though: Vito Acconci and Ross Bleckner, for instance, and a rising star, Jean-Michel Basquiat.

Jean-Michel Basquiat was born in "an integrated middle-class section of Brooklyn" — his phrase — to a Puerto Rican mother and a father from the Haitian middle class. He had begun drawing very young on paper his father brought him and had gone to the Museum of Modern Art as a child, looking again and again at Monet's *Waterlilies* and, especially, at *Guernica*, and he himself pointed out the irony that it was through Picasso that he became aware of the aesthetic of African art. Basquiat's family split apart. He ran away from home at fifteen and wound up in Washington Square. Nights he spent in the

Mudd Club. "I slept on friends' floors for years," he told me a year before his death.

He was already making art, of a sort, and selling painted T-shirts to tourists. "I was very flowery and LSD-influenced. Actually, my basic influence was probably Peter Max," he said. Seeing "some things by Andy Warhol and Cy Twombly" saved him from psychedelia. Graffiti had caught his eye. Basquiat had already come up with the notion for a phony religion while at school. He called it SAMO. "Samo was sophomoric. Same old shit!" he explained. "It was supposed to be a logo, like Pepsi." He and a high school friend, Al Diaz, began writing cryptic sentences in a methodical, unflowery script on the walls of lower Manhattan in 1978. They ran from the simplistic — SAMO FOR THE ART PIMPS — to the poetically ominous. The curiosity they aroused was intense. Basquiat told a *Village Voice* writer that he could do thirty on a productive day. But Basquiat and Diaz had a falling out. Basquiat said, "So I wrote SAMO IS DEAD all over the place. And I started painting."

He had a transitional piece in the "Times Square Show." Jeffrey Deitch, art consultant to Citibank, reviewed the show for *Art in America*, and focused on "a patch of wall painted by SAMO, the omnipresent graffiti sloganeer, [which] was a knockout combination of de Kooning and subway paint scribbles." Basquiat's first full-fledged paintings were at Diego Cortez's "New York/New Wave" at P.S. 1. He had fifteen — the only painted canvases in the show. Sandro Chia offered $1,000 for one of them. Cortez held out for more. Christophe de Menil bought it for $2,500. Alana Heiss of P.S. 1 says, "By the end of the show, people were trying to find Jean-Michel to buy pictures. Things had gone a bit bananas already." It was here too that his work came to the attention of dealer Annina Nosei.

"She gave me a studio," Basquiat said. "Right in the gallery. Downstairs. She used to bring collectors there, so it wasn't very private. I didn't mind. It was a place to work, which I had never had before. I took it, not seeing the drawbacks until later." The chief drawback being symbolic. Fab Five Freddy, whose actual name was Fred Brath-

waite, admonished Basquiat. "I said, 'A black kid painting in the base-
ment. It's not good, man. But Jean knew he was playing with this
wildman thing. Annina would let these collectors in, and he would
turn, with the brush in the hand, all wet, and walk towards them . . .
real *quick*."

Patti Astor is sardonic about the Nosei opening. "The fashion that
year was for these hideous green-dyed mink coats," she says. "Jean-
Michel was hiding in the back. I couldn't go and say hi because I
couldn't face that *horrible phalanx*. I felt that Jean-Michel needed a
place to show where he could really have some input."

He showed at Fun shortly after. That show was a huge success,
except, as he would often complain, financially. Basquiat made his
first real money in Europe later that year, selling ten pieces at Emilio
Mazzoli's gallery in Modena. "Suddenly from nothing he has thirty
thousand dollars in his pocket," Astor says. He also had such a cocaine
problem that he had perforated his septum, and a growing appetite
for heroin. Martin Aubert, a friend, had seen him sitting on the steps
of a club as early as 1980. "He was covered with paint and shivering.
He said, 'I'm on heroin. I guess you don't approve of that, but I have
decided the true path to creativity is to burn out.' He mentioned Janis
Joplin, Hendrix, Billie Holiday, Charlie Parker. I said, 'All those people
are dead, Jean.' He said, 'If that's what it takes . . .'"

The "Post-Graffiti" show, which opened at the Sidney Janis Gal-
lery on Fifty-seventh Street on December 1, 1983, was an attempt to
sell a lot of art, but it was also an attempt to bring Graffiti into the art
world, and it had some historical resonance. It was almost exactly
twenty years since Janis had mounted the show that helped legitimize
Pop (which so irked his Abstract Expressionists that several subse-
quently left the gallery). There were nineteen artists in the show,
including Basquiat, Haring, Scharf, and the Graffiti writers Crash,
Daze, Futura 2000, Lady Pink, Rammellzee, A-One, and Toxic.

The Graffiti writers present, especially the younger ones, were elated at the attention they were getting, scrutinizing the invitation cards they were being given to yet other Upper East Side openings and throwing themselves into break-dance poses for the photographers. A director of documentaries was subdued, though. "Our guy just got beat up by the vandal squad," he said. He had arranged to have some writer or other decorate one of the city's new Japanese supertrains. "What do you think?" a woman in furs asked. "I'm really excited, really excited," said a man in a hectoring voice. "I've got about twenty works."

The excitement was not general. "They look better on the subways" the painter Marcia Grostein muttered. Arnold Herstand, another Fifty-seventh Street dealer, told me, "I think it's tragic. They don't have the training, the background. If you believe in Malraux, art feeds on art. I feel very strongly negative about the whole thing. It's like taking the basketball players off the playgrounds, exploiting them, and then throwing them back."

A few days later I happened to run into Julian Schnabel on Fifty-seventh Street. Had he been to the Graffiti show? "No. There's some work I just don't want to look at," he said glumly. David Salle hissed at me on some occasion or other, "I don't think Keith Haring is an artist *at all*." Robert Hughes said of the Graffiti movement, like one barely daring to hope, "I think that will be the first big crack in the art market." A rare moment of agreement.

At the end of 1983 Basquiat went out to Los Angeles to stay with Larry Gagosian. "I had a big house on the beach in Venice, and I gave him an enormous room for a studio," Gagosian says. Basquiat stayed for six months, forcing himself, in both life and work, to the limit. His girlfriend was the then unknown Madonna. The dealer Fred Hoffman took them to lunch in the Twentieth Century-Fox commissary and remembers them both looking around and throwing off vibes of ambition, like heat from a stove.

In the art world, at least, Basquiat was now a star, which both excited and disturbed him. Keith Haring told me after Basquiat's death, "From being so critical of the art scene, Jean-Michel was all of a sudden becoming the thing he criticized." Basquiat coped by profligacy, tossing $100 in one-dollar bills from limo windows to the panhandlers on Bowery and Houston and painting in his designer suits. He also left Annina Nosei for Bruno Bischofberger in Zurich and for Mary Boone in New York. In February 1985 a shoeless Basquiat adorned the cover of the *New York Times Magazine*. Elated, he signed copies. But he quickly decided to be offended by the title of the piece, which was "New Art, New Money: The Marketing of an American Artist." "As though I didn't do it myself," he complained to friends.

Operation Pressure Point, a publicized campaign to clear the East Village of crime and crack, began in 1984. It was just a cosmetic success, but cosmetics count. The East Village did clean up, just in time to show a cooler sort of art. It didn't come out of nowhere. Indeed, at the end of the 1970s, cool art had looked ready to be the next big thing. Cindy Sherman and Robert Longo, for instance, had arrived from Buffalo in the summer of 1977, Sherman very much at the insistence of Longo, her beau. "I didn't want to give in to the idea that a budding artist type should have to go to the city. I wanted to think that somebody could be creative in the boondocks," she says.

Nor was Manhattan that great when they *did* move. "The art world was dying. I ended up seeing Godard every night at the Carnegie. Or Fassbinder," Longo says. That fall, funds dwindling, Sherman got a job on the desk at the influential nonprofit art center Artists Space, where she amused herself by dressing the part in a rapidly changing sequence of Ruby-the-Receptionist type outfits. That winter she had herself photographed in black and white, framed against her own shadowy loft door. This was the first of the seventy-five or so *Untitled Film Stills* that she would shoot between then and 1980. Always there is a

"story," but the story is achingly difficult to comprehend—a movie fragment, with the soundtrack missing. Longo was working in a similar idiom, borrowing a film still from a Fassbinder movie, *The American Soldier*. A character has his back elegantly arched, as if executing a dance step. He has been shot. This was the basis for a series of drawings, *Men in the Cities*.

Longo and Sherman soon had a gallery. It was started by Helene Winer of Artists Space and Janelle Reiring, a five-year veteran with Castelli. They chose a fine tacky name, Metro Pictures, and both felt that they and their group of artists, who included Richard Prince, had their fingers on the pulse. "We thought that our group—the evolution of that kind of work and those ideas—were *it*," Winer says. It wasn't a simple program, more a matter of a group of artists with overlapping obsessions. The borrowing—*appropriation* was the word—of images from a media-saturated environment was one. It was a retread art. Much would have the bright, noxious light of a trash fire. It seemed to be the art of the immediate future.

It wasn't. Something happened. "Nobody suspected this other thing was beginning. We called it the Schnabelization of the art world," Winer says. But waves follow waves, and the Metro artists duly followed Neo-Expressionism into the spotlight (Sherman made the cover of *ARTnews* in November 1983). Now the appropriationist aesthetic was also cropping up in the East Village, as were other cooled-down forms of art. In the fall of 1984 I walked into a gallery at 94 Avenue B. It was about the size of a walk-in closet in Beverly Hills, furnished with a Formica table from Dunkin' Donuts, and hung with blurry blue drawings of hurrying figures, beach balls, and the like, done with a sort of brisk sophistication by an artist new to me, Donald Baechler. The prices ran from $500 to $1,000 apiece, which seemed ambitious for the neighborhood. The young woman tending the place had a pale, haughty face and penciled lines both above and below the eye, Catwoman style. Her name was Pat Hearn. She was a former video artist and jazz chanteuse with a band called Wild and Wonderful.

George Condo, who made Picassoid pastiches with enormous brio, made his bow at Pat Hearn, as did two painters, Peter Schuyff and Philip Taaffe. These were mature un–East Village artists. So was Peter Halley, whose work I saw at International with Monument, another new gallery, run by Elizabeth Koury and Meyer Vaisman, a couple of graduates from Parsons, at 111 East Seventh Street. Halley painted geometric shapes, straight-edged forms in Day-Glo colors, executed with the passionless regularity of a cafeteria wall. Seeing them in the context of the East Village was like running into a bevy of computer nerds among the wild men at one of the local clubs, say Save the Robots. The canvases were priced between $1,500 and $2,500. The assistant said it was a sellout. Amazing.

Halley turned out to be a slight man, bespectacled, with dark untidy hair and a dry sense of humor. The son of a lawyer on the Kefauver Commission, he actually grew up in Manhattan, as rare a phenomenon in the New York art world as native Parisians had been in the upper echelons of the École de Paris. He had studied art at Andover and Yale, but traditional techniques were not his cup of tea. "Learning to draw a coffee cup in perspective is simply a technique. The craft tradition has never been interesting to me," Halley says. "Oil paint, brushes, brushwork . . ."

Halley set to making a name as a writer and a curator. "Science Fiction," the show he curated at the John Weber Gallery in the fall of 1983, proposed that the new science fiction delivered "a vision of technology and capitalism developing out of control . . . a mesmerizing nightmare, not a comforting dream" and that a new generation of artists were reflecting this. His writing, for magazines like *Bomb*, was precise and resonant. His references ranged from the *Mad Max* movies to Parisian savants, especially Jean Baudrillard, whose most famous essay, "The Precession of Simulacra," took off from the Situationists to propose that the culture had been so devoured by spurious imagery that real things had been replaced by "simulations."

Halley's paintings were diagrams. "This imagery—the idea of cells, prisons, conduits—started appearing in my work in about 1981,"

he says. How can you paint a simulation without making a dead painting? Halley says, "The meaning has to be embedded in the image visually. Very few people feel that these are just lovely abstract paintings. They experience a sense of stress, a sense of discomfort."

Halley had shown up at International with Monument shortly after the gallery opened and had shown Vaisman his work on slides. This was just the sort of professional touch that the Old East Village abhorred. He had first show soon after, and became the focus of talk, which was just what Halley wanted. "I grew up with a generation of teachers and artists that believed in the primacy of visual experience. But I completely enjoy the interrelationship between visual images and what can be said or written about them," he says. "That's the basis of art for me, rather than a mute pleasure in the visual. Painting that didn't give people something to talk about is not the kind of painting that I would enjoy." Another artist was going to pick up this ball and run with it, an artist whom Halley had included in his "Science Fiction" show and who was now a stablemate at International — Jeff Koons.

Koons remembers the first artwork he exhibited. It was an oil "in the manner of Watteau" and it hung in the window of Henry J. Koons, Interior Decorators, his father's store in York, Pennsylvania. "One room in the store would be an artificial living room. You'd go down the hall and into an artificial kitchen . . . a sitting room . . . a den," he says. In their home Koons' parents hung the kind of art "that comes from a store, not a gallery," but in his shop Henry Koons hung his son's work. "My father started selling my work for hundreds of dollars when I was nine years old. These horrendous paintings. This gave me a tremendous amount of confidence," Koons says. "I received a lot of love when I was a child."

Koons studied at the Art Institute of Chicago. Listening to Patti Smith on late-night radio convinced him to move to New York (Halley had been convinced to move back from New Orleans after hearing

Blondie's "Heart of Glass"). Koons moved on New Year's Day 1977. His first apartment was on the ground floor on East Fourth Street, just behind the restaurant Phebe's. Koons set aside his pencils and brush just as Kosuth had a decade before. "I decided to Enter the Objective Realm," he says, in airy capitals. He bought some inflatable flowers, blew them up, and settled them on twelve-inch mirrors. The art writer Alan Jones, who arrived in Manhattan the same month as Koons, says the apartment looked "like a huge installation. There were inflatables everywhere, floor to ceiling, including a rabbit. He had clear shopping bags filled with inflatables. All the colors were oranges and greens."

Nothing sold, of course. Koons supported himself working at the Museum of Modern Art. "He was using the museum as a laboratory," Jones says. "He wore a floppy tie made from a bathroom sponge. Groups of little old ladies would come up looking for directions and they would go home with memberships. It was this seduction." Koons says, "I really enjoy sales. Sales is a form of conscious control. Sales and directing are very important to my art." His contribution to an art-world magazine, *Just Another Asshole*, included a letter of May 1979 from a supervisor at MoMA praising his skills.

That year he moved to a West Sixteenth Street high-rise. His place was all white, with a dark-blue wall-to-wall, a frigid showroom look appropriate to his new work. He had begun to work with household appliances of a commonplace sort, gluing or bolting them to backgrounds. The first, a toaster, is owned by Ileana Sonnabend. Julian Schnabel dropped by because he was buying a green Mercedes that Koons owned. "I thought the work had something," Schnabel says. He suggested David Salle visit. In due course, Mary Boone also made a studio visit. She offered Koons a show and hung a piece in her office: a rug shampooer.

Koons was going to share a show with another of Boone's non-painters, Matt Mullican. He decided to show a brand-new Mercedes-Benz on a turntable. But in the wake of the rearrangement of the art-world scenery that the show of Schnabel's plate paintings occa-

sioned, Boone postponed the show and Koons left the gallery. They differ over the circumstances, but not greatly. "He came and said he was leaving the gallery because he wasn't famous yet," Boone said a few years later. "These young artists are like *yuppies*." Jeff Koons says, "It was generally that Neo-Expressionism was grabbing hold and I could see my work was going to be totally in the background. Mary just wasn't going to be supporting it."

Koons was supporting himself by selling mutual funds, and put all his money into new pieces. They were vacuum cleaners. He bought them and encased them, unaltered, in Plexiglas, which he rigged up so that they were bathed in fluorescent light. They were Duchampian ready-mades, but with some American twists, like the Pop fascination with low-tech consumerism, the addictions to novelty, and shopping, and something more baroque. "They are very virginal and very frightening. They are dealing with the immortal," Koons says. "They are anthropomorphic breathing machines. But I was using them for their newness. If one of them is turned on, it is destroyed." Alan Jones remembers Koons exulting, "I'm draining the sexuality out of my work! I'm draining the sexuality out of my work!"

Most didn't get it. The reaction to some pieces in the window of the New Museum was pretty typical. "People kept coming in off the street and wanting to buy a new vacuum cleaner. The guards got very upset," Koons says.

Koons showed a double-decker—two Shelton Wet/Drys, one atop the other—with Annina Nosei. Franco Pellizzi, the collector, then married to Philippa de Menil, bought it for $4,500. Koons asked the dealer to underwrite some larger pieces. Nosei, who is as famous for her frugality as for the sharpness of her eye, did not come across with the dough. "I didn't leave Annina. She told me to get lost. *'Pick up your slides! It's over!'*" Koons says. "She realized the work was going to be difficult to sell."

Koons was twenty-five. He had had a shot with a couple of major galleries and was all washed up. He had several unsold pieces and no money. He had to give up both his apartment and his studio. "Your

relationships in the art world are often based on a level of success. One level is maintaining your loft. So I lost a lot of my early friends. They thought I was a has-been," he says. "They wouldn't have a beer with me." He went to stay with his parents in Sarasota. "I made money getting signatures for a senator's campaign," he says. "Finally I was able to get back after about six months. And slowly all my friends returned."

Koons was determined to function independently of the art market, though, and returned to selling. His five-year career in commerce has become part of the fell lore of the eighties art world. He flung himself into selling as he had done at MoMA, and used some MoMA contacts. He sold "mint edition" Dali prints, mutual funds, and commodities. He sold by telephone for companies infamous for churning, and worked his way up. Andy Moses, an artist who had gone into selling cotton, says, "He was top salesman where we were working two months running. He lived cotton. He would tell his clients, 'Cotton is light . . . it's fluffy . . . you can't get hurt by cotton!'" Koons would seduce himself, too, and plunk his winnings into cotton, always getting wiped out. "He would go into deep depressions," Moses says, "such bad depressions that I wouldn't expect to see him the next day. But by the next morning he would always have turned it around. Jeff knows how to accentuate the positive."

Koons was offered a job by Merrill Lynch but went to Smith Barney instead, where he was soon promoted twice. Years later, assailed by an interviewer at the Chicago art fair for making so much money from his art, Koons disagreed. Going into the art world had been a sacrifice. If he had stayed in business, he would have been running a huge enterprise. As usual, he wasn't joking.

Koons would sometimes see David Salle and Salle's then girl-friend, Karole Armitage, a dancer, during this period. "He really needed friends," Armitage says. "He had gone into hibernation—like a mad scientist." One day Lizz Lambert, a design student Koons was dating, found him bent over an empty fishtank. "He was drawing a circle on the paper they put on the back of the tank," she says. This

was the genesis of "Equilibrium." Like G. F. Watts, a Victorian who
made paintings with titles like *Physical Energy* and *Hope*, and like the
Futurists he admired, Koons likes giving a physical body to some lofty
abstraction, and his notion here was to get a (real) basketball to float
in a water-filled glass tank—if not forever, then for the museum
equivalent.

Koons left Wall Street to bring this idea to life. He worked with
a number of physicists, including Dr. Richard Feynman, the Nobel
Prize–winner and author of pawky best-sellers, whom he had contacted
after reading that Feynman was interested in art. They would try solu-
tion after liquid solution. Sooner or later, the basketball would always
end up on the floor of the tank. "I could have worked with oils. But I
wanted the womblike situation of water. We realized in the end that
it was unachievable. But I went for it. I pushed it to the limit," Koons
says.

Koons's "Equilibrium" show opened at International with Monu-
ment in 1985. It was in three parts. There were the tanks; some post-
ers for Nike shoes featuring basketball stars, which Koons had framed,
unaltered; and such supposed lifesavers as an inflatable raft, cast in
bottom-of-the-ocean-ready bronze. The show was a "success"—at a
price. Collectors Eugene and Barbara Schwartz paid $3,000 for the
life jacket, which it had cost the artist $8,000 to make. He sold the life
raft, which had cost him $20,000, for $8,000. He made a small profit
on the tanks. Collector George Waterman bought one for $3,000,
acquiring also the artist's commitment to refloat the ball three times
when it sank. Koons was pilloried for charging $1,000 apiece for the
Nike posters, but he had made two round trips to Nike's Oregon
headquarters with a specially built portfolio, so he had lost money on
those, too. "Equilibrium" simultaneously made Koons seem money-
obsessed while costing him a five-figure sum, his entire Wall Street
earnings. Tactically, the show was a disaster. Strategically, it was bang
on target.

Money was also crucial for his next move. Funding came from
International and from a Los Angeles dealer, Daniel Weinberg. Koons

chose a variety of objects, including a seven-piece model train, in which each piece held a fifth of Jim Beam bourbon, and cast them in stainless steel, which he calls "the precious metal of the proletariat," to repellently seductive effect. Koons called the show "Luxury and Degradation." A common denominator of the pieces was alcohol. Koons has been known to have a drink or two but is unwilling to accept any autobiographical element to the work, just as he gets skittish when asked if "Equilibrium" had been occasioned by the turbulent period he was surviving. "My work exists in the Objective Realm," he says, as always in those airy capitals.

There was a show at the Cable Gallery on Broadway in 1985. The artist was Ashley Bickerton, a Briton, wearing a seaman's cap and the air of aggressive bonhomie that often goes with this headgear. Bickerton was in his early twenties, the son of a linguist and had grown up in Hawaii. A CalArts graduate, he had been an assistant to the painter Jack Goldstein—a group of younger artists were collectively known as the Assistants.

Among the most striking pieces in the show were some boxes on the wall, decorated with symbols used in urban planning and with guttural exclamations, like UGH, which, Bickerton noted in an artist's statement, are associated with the bathroom and the bed. He also wrote: "Through the last few decades it [the art object] has been ripped off the wall and twisted through every conceivable permutation, yet back to the wall it insists on going."

There was a mighty buzz about the show, and nobody was more aware of this than Bickerton himself. "I realized things were beginning to move fast where I was concerned. Things were spinning," he says. To seize the moment, he needed to be with a gallery perceived as generating heat, and moved to International with Monument. It was patrolled by art "consultants," a newly powerful breed, who would shepherd a flock of devotees around to show them the work of bud-

ding Art Stars, meanwhile collecting 10 percent commissions from the galleries on all sales. One of the more formidable was Estelle Schwartz, a blonde with a voice that could peel the chrome off a hubcap, which she used in support of International's roster. "She could sell thirty pieces. Just imagine!" says the dealer Jay Gorney. That very eighties phenomenon—the show that sells out before its opening— had become as much a phenomenon of the East Village as of SoHo.

On May 28, 1984, *New York* magazine ran a cover story on the way the coming of the galleries had led to the upscaling of the neighborhood. That June the Larry Gagosian Gallery, at 510 North Robertson Boulevard, Los Angeles, showed "New Painting and Sculpture from the Lower East Side." A reviewer remarked tartly that "the Big Apple needs something new and exciting (read, 'marketable') to ward off the encroachment of Düsseldorf and, heaven forbid, Los Angeles . . ." It was a fine conceit: the local Wild Ones as protection against the Wild Ones from elsewhere.

The hype made real estate values rocket. A single-story cinderblock shack on Avenue D could cost half a million dollars. Rentals on the storefronts could go to twenty dollars a square foot—SoHo prices. In the summer of 1985 Patti Astor threw a "Sink or Swim" party, a jaunty *cri de coeur* to collectors, asking them to help her cope with rising rents. Nobody bought a thing. On July 15 she sent me a postcard. "Newsflash! I'm closing the Fun to resume my film career." She closed in September. The boarded-up front bore the logo NO MO FUN. She said caustically, "If I was going to open up the Fun today, I would call it the Money Gallery." Astor moved to Malibu and landed a lead role in *Assault of the Killer Bimbos*.

In 1984, its first year of trading, International with Monument spent $17,000 on rent and publicity and sold $100,000 of art. In 1986, it made just under three quarters of a million. The closing of the gal-

lery was a tolling of the knell for the whole area. The galleries left, Gracie Mansion being one of the last. The East Village became the Lower East Side again.

The "Arts & Leisure" section of the *Times* carried a feature by Michael Brenson on January 5, 1986, with a headline asking "Is Neo-Expressionism an Idea Whose Time Has Passed?" Brenson noted, "The past months have been quieter than at any point since Neo-Expressionism arrived. There is little sense of waiting for the next hot artist or trend." Ashley Bickerton would not agree. "Everybody was wearing white shirts and black suits and everybody was very, very tense," he says. "Everybody was smiling and polite to everybody else but was holding a knife behind their back. We were out to get the Neo-Expressionist/Graffiti crowd. Julian Schnabel was the big bugaboo."

Meyer Vaisman saw the time was ripe to make a move. News of the impending dissolution of International with Monument traveled fast. "Everybody wanted to give Meyer's artists a show," Jay Gorney says. Or some of Meyer's artists. "Marlborough wanted to. So did Mary Boone. But she approached Jeff Koons and Peter Halley separately. And she didn't want Meyer." Estelle Schwartz, who did not hit it off with Boone—a woman who does not take kindly to free-lance Queen Bees—was urging her protégés in the direction of Leo Castelli and Ileana Sonnabend. Peter Halley signed with Boone nonetheless. Word went around that Schwartz's enthusiasm for Halley's work had rather cooled. The art world is not always governed by pure aesthetics.

Vaisman had thought things through. He knew the group should remain together. Castelli, he decided, was too associated with Schnabelismo, the object of attack. Vaisman focused on Ileana Sonnabend, a matronly soft-spoken woman with a laser eye, who visited International and looked over Vaisman's work at Jay Gorney's gallery. She was unbothered at being part of a game plan. "The artists are children

of their time, and manipulation is not excluded," she says. She signed up Vaisman, Bickerton, and Koons. Peter Halley left Boone to join them after just two weeks *in situ.*

The opening of the Sonnabend show in October 1986 was big and brash, and it was heralded by a six-page article in *New York* magazine by Paul Taylor with the unequivocal title "The Hot Four: Get Ready for the Next Art Stars." The following week, the magazine's art critic, Kay Larson, tried to redress the balance with a review, clearly written in near despair, headed "Masters of Hype." Larson ended: "Cynical, consumerist art becomes the perfect mirror of its coked-up, sensation-seeking society. And the society that adores trash snaps it all up."

Koons told me he liked the Taylor piece. And Larson's assault? "It's wonderful" he said. She groaned when I mentioned this and said dismally, "Oh God! I knew it. I'm playing right into his hands." Connoisseurs of previous *succès de scandales* were in no doubt that they could hear the successors to Schnabel, Salle, Haring, Scharf, and Basquiat pulling up in the station.

Arguments over Bob and Ethel Scull's divorce settlement had been bitter and had lasted years. In the end Ethel had secured 35 percent of Bob's assets, primarily the art collection. In the summer of 1986 David Nash, a director of Sotheby's, and his wife, Lucy Mitchell-Innes, the head of Contemporary art there, were on vacation in India. "That was when the telex came," says Lucy Mitchell-Innes. "This crummy piece of paper came under the door, saying BOB SCULL HAS DIED. PLEASE COME HOME."

The sensible—and easy—thing, of course, would have been to sell the art and divide the money. Sense was in short supply between the two sides. "There was so much antagonism that they couldn't agree to do that," Mitchell-Innes says. "They both insisted on a division of

the property. So it was an enormous gamble whether Ethel would successfully choose art worth 35 percent, and I was picked to be her chooser. The lawyer for Bob's estate thought that he would outwit Ethel. And he picked Peter Brant as *his* expert chooser."

Peter Brant is a publisher and a collector who knows his way around. "We all met in the Eagle warehouse on West Twenty-first Street. I will never ever forget it," Mitchell-Innes says. "They were going to choose the paintings alternately. We agreed to toss a coin. Everybody knew that whoever won the toss would pick the most important painting, which was *Out the Window*."

This is a Jasper Johns. "I declined to toss the coin," Mitchell-Innes says. "Peter tossed the coin. And he lost the toss."

Ethel got the Johns. So the picking began.

"Then Bob's executor said, 'I want *absolutely nothing* to do with the sale of Ethel's paintings. And I certainly won't sell them in the same auction house,'" Mitchell-Innes says. "The challenge for me was to persuade him that if they went to the competition, it would draw attention to the animosity of the whole process. And one way and another we persuaded them to do it."

Some expressed misgivings before the auction, which was held on Monday, November 10, 1986. Things had been pretty slow. It was noted that another Johns had failed to reach its $2 million reserve at Christie's in May. Moreover, there had been art-world events of unusual darkness, like the "Mask Murder," involving the dealer Andrew Crispo, and the death fall of Carl Andre's artist wife, Ana Mendieta.

Actually, things went swimmingly. *Out the Window* fetched $3.6 million, a world record for a contemporary artwork. *F-1ll*, a tremendous canvas by James Rosenquist, which was so dauntingly big that Mitchell-Innes had given an estimate of $600,000–800,000, fetched $2 million, a record for the artist. Rosenquist, who was actually in the auction house and had his usual preternatural healthy glow, like a hand-colored photograph, told me afterward, "For a moment there, I felt I was rich. I felt like going out into the street and buying some-

thing. But then I realized I wasn't rich. Ethel Scull was rich!" Lucy Mitchell-Innes says, "I think Ethel Scull got exactly, down to the last dollar, 35 percent of the sum total."

Not all the action involved big-ticket items by art superstars. Lot thirty-four was a piece by Bruce Nauman: a beeswax-coated plaster cast of the artist's own folded arms. The catalog noted that it had been made in 1967. The estimate was $25,000–35,000. This was considered appropriate. Bruce Nauman, who had always kept his distance from New York, had been intensely admired by many artists since his videos of the late sixties, but his work was cool, uningratiating, uncomfortable. Moreover, unlike the Minimalists, of whom this could also be said, Nauman seemed to have gone out of his way to avoid that necessary selling aid, a Signature Style. Nauman, in short, was a paradigmatic Artists' Artist, and collectors had never come courting him in the auction house.

Consequently, there was a stir of interest when bidding quickly reached $100,000. It is rare that opponents are plainly in view of each other and everybody else, but this was now the case. On the left aisle sat Thomas Ammann, a Zurich dealer and a major collector. Ammann, a polished, courteous man in early middle age, would be on anybody's list of the twenty top collectors of Contemporary art. Ammann's competitor was sitting on the right aisle. He was a slender man, also in early middle age, with modishly short haircut and the sort of baggily avant-garde clothes more often seen in fashion magazines than in real life, and he was so wired that he was practically bouncing off his seat. It was only when I saw the woman at his side, a blonde with pale, intense eyes like in an overexposed photograph that I realized who they were—a couple more written about than seen: Charles and Doris Saatchi.

The bidding vaulted. Ammann got the piece. He paid $220,000.

We had watched the artist break his auction record, but we had watched more than that. Ammann and Saatchi had not been speculating in the vulgar sense. They had been getting in on the ground

floor of one of those structural lurches that occur in art history. Bruce Nauman had joined the pantheon.

Of course, it didn't hurt the value of the eight Naumans that Saatchi had bought recently, either.

A friend who dined with the Saatchis that night said "Charles was cross he hadn't taken Thomas Ammann higher."

The critic Donald Kuspit champions the view that the eighties were a triumph for German rather than American art. He told me that "the 'Hot Four' show was seen by some as a counterblast to Germany." The art world is seldom quite that triumphantly Machiavellian. There was a time of floundering while people looked for a name for the new wave. Paul Taylor had written in New York magazine that the hot foursome was "neo-Pop, neo-Minimalist and neo-conceptualist." Others toyed with Smart Art. Soon Neo-Geo, meaning Neo-Geometric, had caught on, though strictly speaking it was only applicable to Halley. "The art world has become a major industry. It needs a new product every eighteen months, just to goose the system up," Les Levine told me at the time. "The Mary Boones and Julian Schnabels don't know their mistake yet. Their mistake was to make things go faster."

Boone, in point of fact, seemed well aware of that. We dined at da Silvano on Sixth Avenue and Houston Street soon after the "Hot Four" show, and her conversation, as usual, would veer from catalog-ready judgments on various artists to mordant revelations about the art world. "Everything is going too fast," she said over gnocchi. "My overnight successes took ten years. Now they want to be David Salles overnight." She was particularly galled by Halley's departure. "We shook hands. In the old days that would have been enough. But somebody poisoned him against me," she said.

"I said, 'Listen, Peter! Is this fair?' He said, 'Mary. This is business. In business you make deals. And you break deals.'" She added,

"Does Peter think he'll never see me again? These artists are like people who go to IBM and expect to be executives right away. They'll never effect a radical shift in sensibility."

She had just parted with another gallery artist, but here she felt more comfortable. The artist was Basquiat. Boone said his problem was his lack of formal training. "He isn't putting together his vocabulary of forms. He can't grow. He's trying. He simply isn't a good enough artist," she said. She repeated, "Everything is going *too fast.*"

In May 1985 Jean-Michel Basquiat, Keith Haring, and Kenny Scharf refused to appear in a group photograph of East Village artists for *Arts* magazine. They suggested they be shot together instead. Reactions were fierce. "The East Village artists excommunicated us," Haring told the writer Steven Hager. "We are SoHo artists to them. I accept the tag. I don't mind being a SoHo artist." Not long after, three attackers tried to tar and feather him outside the Shafrazi Gallery on Mercer Street.

But Street art was becoming roadkill. Art history is chockablock with crashed reputations—consider Fragonard, broken by the French Revolution, dying in poverty—but the art world has become such a massive institution these days that artists who have been through the school machine can usually hang on, often by teaching. The Graffitisti, street kids with no formal training, had no such safety nets.

Basquiat was particularly irritated by what had happened to Futura 2000. "Futura was at the Fun Gallery. Then Tony [Shafrazi] made him cut all his links to other galleries. Then, after a year, he dropped him," Basquiat told me in his studio. "Futura burned all his bridges behind him and then he was abandoned. Now he's a bicycle messenger. I find that pretty sad. No? He just took the test to become a cop.

"There are other kids who were prodded into being artists by dealers and collectors. These kids are only twenty years old and they're already washed up."

Basquiat, Scharf, and Haring were finding their luster dimming too. "People have a very short attention span," Basquiat complained. "They're looking for another artist every six months or year. And it's really impossible. There's only twenty good artists in a century."

If Keith Haring was in the worst shape, it was because his period as poster boy of the New York art world had been the most hectic, so the backlash was the more powerful. "Nowhere to Go but Down" was the headline of a typical critique I read before talking with him in the summer of 1987. He was in the Shafrazi Gallery, which was jungly with cables, because he had just been interviewed for German TV. Haring clearly wasn't about to change his modus operandi. Usually filled with ingenuous energy, Haring was fingering a thin beard in a dispirited fashion. "I believe the artists are the worst. I don't even like to go to openings anymore," he said. "It's not a problem, really. You can say that you wished that they liked you. But there's so much support coming to me from places that are more real. I don't depend on the art world. I get respect from real people, from people outside of the art world." Bleakly, he added, "What remains to be seen is if that's going to mean jackshit."

Haring's productivity had been well intentioned. "It was a sort of eagerness. I liked making things," he said. "The audience was the street." He hadn't wanted to let the taking off of his art career alter his life. "When the work got accepted, it seemed like it was our responsibility to continue that same attitude. Instead of saying I'm a *gallery* artist. I just want to sell paintings for a lot of money. Then I woke up to the reality. All those investors and collectors were getting onto it while it was . . . whatever."

It was as if the word *fashionable* would have burned his tongue. "You have to deal with the fact that these things are going to be resold and come back in on the secondary market. And compete at auction with the things you are making now. Also there's a sort of ongoing crazy hype. People are expecting to see something new all the time."

The artist was sinking more deeply into melancholy by the moment. "I was making things for the public. But I suppose you have to

have an eye and an ear for the art world," he said glumly. "I mean, somehow the amount of time that clarifies when something is part of the so-called history of art is getting shorter and shorter. Neo-Geo is having to prove itself. They want to get in their Ism before they even know what it *is* yet.

"You have this big thing of history hanging over you. Right? Whether you are in or out. All the people that want to minimize me love to talk about that. I'm not sure how powerful the politics within the art world are—that they can actually *write you out of history*. I mean it has been done to other people that were important in their time. People can trash me as much as they want. If I keep handling it the way I'm handling it, it could be an example to a lot of people."

Shafrazi's upstairs office was cheerier. A dealer was leaving for Paris, some arrangements in Brazil had been taken care of, and Shafrazi was on the telephone to Düsseldorf, concerning the fabrication of some Haring sculptures. "Germany is the steel capital of the world. Richard Serra makes all his pieces there," he announced upon hanging up. The dealer was wearing an Art Suit from Comme des Garçons, navy blue and modishly baggy. He chatted briefly with Haring about a couple of benefits to which he would be contributing work—one for AIDS relief, one for the homeless—then the artist left, en route to dinner with Jean-Michel Basquiat and Andy Warhol.

Alongside a bottle of Moët & Chandon in the corner of the office were two small canvases with a very different look from the work for which the gallery was known. In each, the picture space was dominated by an oblong in a single rich hue. "He's been doing these things for a while," Shafrazi said. "It's Neo-Geo in a way."

There was grim comedy in the dismay with which Keith Haring was contemplating the consequences of the speeding up of the art world machinery. He had, after all, called his store Pop; he had ap-

pealed to the MTV generation, which believes not in the ages but in the charts, and he might have been expected to know that the average career length of a pop star with a hit record was eighteen months. Shafrazi once asked what I thought of the paintings of one of his artists. I said I thought they were fine but a bit too like early David Hockney. Shafrazi said, "There's no guilt. He has never *seen* early Hockney." Dealer Max Protetch was at the Whitney's Rosenquist retrospective and was amazed to hear people marveling at the resemblance of the work to that of David Salle. "It's terribly American. They don't believe in history," he said. This sort of creative ignorance seemed more and more a condition of the time. If you don't know the past, it's cool to repeat it.

I once asked Jeff Koons if he had ever seen the chromed figurines of kitsch icons like the Incredible Hulk that the British artist Eduardo Paolozzi had made in 1970. Paolozzi was no sideshow. The critic Lawrence Alloway had invented the tag Pop art to attach to the work that he and Richard Hamilton had done in the fifties. Koons hadn't known Paolozzi's name. This seemed in keeping with the artist's ingenuous quality. In New York, Jeff Koons was rapidly becoming to the second half of the decade what Julian Schnabel had been to the first: the locus of hope in some; in others, of baffled rage.

In 1987 Jeff Koons was invited to show in the German town Münster. He decided to stick with his strategy of replicating something that existed already in shiny steel. The object he planned temporarily to replace was a folksy bronze statue of a farmer in a nearby square. "The piece was to be about Self-Sufficiency," Koons told me. "But it was a total disaster. An industrial foundry made it in Germany, and when they pulled the stainless steel out of the oven to knock the ceramic shell off it, they banged it up against the wall while it was still molten. Every aspect was deformed. It was like Humpty-Dumpty." Rather than pull out of an important show, he brought in a "phenomenal man with steel" to do surgery. Koons still wasn't happy about the piece, but he had learned two things. One was that he could operate beyond pure appropriation. He could make things

or change them. The second was that he could delegate important work to specialists.

Both insights were essential as Koons set about fabricating pieces for a three-gallery show due to open in November 1988. Upping the ante on David Salle's three-gallery show in Manhattan, Koons was to have simultaneous shows with Ileana Sonnabend in New York, Donald Young in Chicago, and Max Hetzler in Cologne. The shows were to be identical. The hefty fabrication costs were borne by the galleries as Koons turned out pieces in editions of three, with a fourth AP—artist's proof—for himself.

There were art-world fidgets as the show approached. Koons was "the latest, and perhaps last, of the 'hot young artists' of the '80s" Peter Schjeldahl confided to the readers of *Seven Days* before the opening. He added, "The prestige of a generation, not to mention the equity in a lot of big collections, rides on Jeff Koons' new work." He ended: "At Sonnabend, good won't be good enough."

Good was not the word.

Koons called the show "Banality." The image on the invitation showed a cherubic child pushing a comical grotesque pig. Koons explained that the pig was Banality. He added, "The child is me." Much of his iconography was borrowed from the garish cards and statu-ettes found on tourist kiosks worldwide, but he had reconfigured the imagery, blown it up in size, and had the pieces fabricated in ceram-ics or color-coated woods. One huge piece showed Michael Jackson in whiteface with his pet chimp, Bubbles. In another, a sad-eyed Pink Panther drapes himself around a centerfold cutie pie. Another piece, *Fait d'Hiver*, showed a Stunning Blonde who has fallen on her butt in the snow. A pig and a penguin are hurrying to her assistance. The first evening of the Sonnabend show was like no art viewing I had ever seen. People were floating around in stunned shoals.

Peter Schjeldahl rejoiced in "Koons' accurate blend of aesthetic perfect pitch and blazing sociological significance." The collectors treated the show like a feast. The artist and his troika of dealers netted

$3 million apiece. Koons was quick to incorporate this into his opaque rhetoric, and his use of such verbiage as "increasing his market share" began to cause great irritation. His five years' experience on Wall Street fueled the resentment. The expression "Commodity art," which had mostly meant art that borrowed images from the consumer culture, acquired a more baleful meaning.

The counterattack slammed into gear right away. Hilton Kramer leveled his attack not on the marketing but on the work itself. He wrote in *New Criterion* of "objects that carry the love of kitsch to a new level of atrocious taste." Kitsch was a given. An article by Robert Pincus-Witten, an admirer, was headlined "Kitschy, Kitschy Koons." The older generation of Pop artists had used kitsch, but with a cool take. "I use this material because I hate it," Rosenquist once told me. Lichtenstein said his material represented aspects of the culture that were "threatening."

Koons didn't see it this way. "I try not to use the material in any cynical manner," he told me earnestly. "I use it to penetrate mass consciousness. This is the only vocabulary I know how to manipulate. If I could manipulate another vocabulary to communicate more clearly, I would. But this is the one I believe in." The money? This was an abstraction, too. "It's not about greed," Koons said. "It's about demanding to be taken seriously on a political stage. What I'm saying is that the seriousness with which a work of art is taken is interrelated to the value that it has. The market is the greatest critic."

The money was far from an abstraction for the owners of some of the original images that Koons used for his pieces in "Banality." First to sue was Art Rogers, a California photographer. Rogers, his voice aggrieved, told me that he felt "violated . . . ripped off" by Koons's use of a picture of a couple grinning over eight puppies. He sued for $350,000, a nice piece of change for a photograph whose only distinction was that Koons had found it to be so seminally banal that he was able to turn it into a piece that could both exhilarate you and make your hair prickle.

Others who sued were the syndicate that handles the comic strip *Garfield*, for unauthorized use of the dog Odie, and MGM-Pathé, for the purloining of the Pink Panther. These were modern problems. Disque Bleu hadn't sued Stuart Davis, nor had Roy Lichtenstein been sued by a comic book. Probably, art had seemed too remote then, not subject to rules of commerce. Warhol had begun to have copyright problems as he became famous, including a lawsuit from the John Wayne estate. But no laws were on the books, because no artist had ever fought a case that far.

Jeff Koons decided to fight. *Garfield*'s attorney was nonplussed. "We didn't want his profits," the attorney said. "We just wanted him to agree not to use our characters again. He wouldn't sign. He said it would infringe on his creative freedom." Keith Haring wanted the street. Koons wanted the world. One source of his imagery was unoffended anyway.

Ilona Staller was a young woman of German stock born in Budapest. She had been tutored in piano and violin, ballet and modern dance. By her mid-teens the slender blonde with deep blue eyes was a photographic model. At the age of seventeen she arrived alone in Rome. There she soon found her training less helpful than she had hoped. "I found that people did not want to see me in concerts playing the violin or the pianoforte. They wanted to see me nude," she said. She gave a silvery laugh, and added: "I like the nude. For me, it was easier to speak with my body than with words. A nude language." She entered porno.

Soon Staller acquired both citizenship and a working name, La Cicciolina. In a city where nordic blondes are objects of reverence, her snow-maiden combination of audacity and a curious stainlessness made her a star in a coarse trade. The leader of the Radical party, a lively left-wing alternative to the stodgy Liberals and Communists, asked her to stand as a candidate. Staller campaigned dressed in a boa constrictor, and was arrested for being topless at Rome's Leonardo da Vinci airport. She won election handily in July 1987 and her parlia-

Leo Castelli and Mary Boone greet each other at a party after Julian Schnabel's two-gallery show in 1981. *Photograph: Alan Kleinberg*

Julian Schnabel and Francesco Clemente. *Photograph: Alan Kleinberg*

Sandro Chia, with the gun, and Allen Ginsberg. The portrait on the wall is of Arthur Rimbaud. Chia pasted it on the photograph to replace his portrait by Julian Schnabel, a "plate" painting, made when the artists were on better terms.

April Gornik, Ross Bleckner, and Eric Fischl. *Photograph: Rose Hartman*

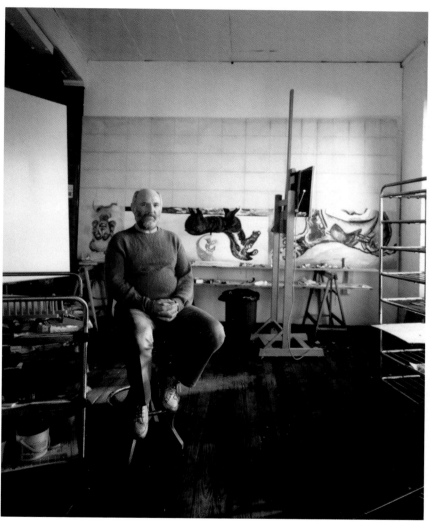

Malcolm Morley in his Bowery studio. *Photograph: Neil Selkirk*

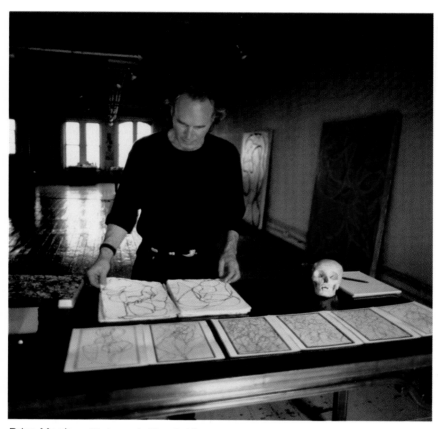

Brice Marden. *Photograph: Nan Goldin*

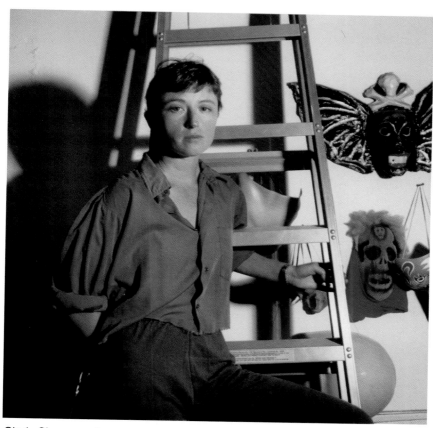

Cindy Sherman. *Photograph: Michael O'Neill*

David Salle. *Photograph: Todd Eberle*

Julian Schnabel at Andy Warhol's memorial. *Photograph: Todd Eberle*

An auction of Contemporary Art at Sotheby's. Taking telephone bids in front of a Philip Guston are David Nash, Mallory Hathaway, Lucy Mitchell-Innes, and Diana Brooks. Nash, who was Director of Fine Arts in New York, and Mitchell-Innes, who headed the Contemporary Department, have since left the corporation to open a gallery. Brooks is now president and chief executive of Sotheby's worldwide. *Courtesy of Sotheby's*

Christie's. Christopher Burge taking bids on Warhol's *Nine Multicolored Marilyns (Reversal Series). Courtesy of Christie's New York*

mentary immunity got her off the bust. She became aware of Jeff Koons when the magazine *Panorama* ran a spread of Koons images, including *Fait d'Hiver*. A journalist identified her as the model. She looked and decided this was not the case.

One symptom of the art world's rising temperature was the reemergence of Andy Warhol in a godfather role. Warhol had never been considered quite the equal of Lichtenstein or Rosenquist in the palmy days of Pop, and he had faded since. There had been impatience with his disco cavortings and his MTV show, inevitably called *Andy Warhol's Fifteen Minutes*. The canvases he had collaborated on with Basquiat had been laughed off, and such recent silk-screen prints as *Reigning Queens* had been correctly seen as a shameless assault on the rich kitsch market.

The revival in Warhol's fortunes was brought about by the most effective engine in the art world: the continuing interest of younger artists. Charles Saatchi bought a *Triple Elvis* for $125,000 at Sotheby's in 1984. "That sale got a lot of attention," Larry Gagosian says. A couple of seasons later Gagosian himself showed the *Oxidation Paintings* of 1978. These were the notorious "piss paintings," cloudy greenish-gold abstractions made by urinating onto canvases covered with ferrous oxide. They had always seemed a hard sell, but Thomas Ammann and Asher Edelman each bought pieces for $75,000 and Saatchi bought a diptych for $175,000.

That winter Howard Read, curator of photography at the Robert Miller Gallery, was called by his spy—Read's word—in Warhol's Factory. The tip: Warhol was stitching photographs together to make new works. Read struck at once. The show was in January. "Andy came for the installation. We had so many up it was like wallpaper," Read says. The show earned Warhol his best *Times* review in years. "It was brilliant. We were on the cusp of something. The show made a million dollars. Andy was overwhelmed," Read says.

"My wife and I had dinner with him on Valentine's Day. He was flying so high. Andy was being *resurrected.*" Eight days later he was dead.

Jean-Michel Basquiat, who had rather pettishly been seeing little of Warhol recently, was wracked by grief and guilt. Indeed he would claim, not correctly, that he had only started to shoot heroin after Warhol's death. Since, though, he had supposedly quit cold turkey. Various of his collectors told me he was making a comeback. I went around early in 1988, planning to write something for *Vanity Fair.* There were canvases on the floor, freshly worked upon, but Basquiat seemed frail, his skin blotchy, and he spoke of the art world with furious resentment. "All my friends sold the paintings I gave them. Pretty much all of them," he said. "Now I lead a pretty solitary life, you know." A few days after this meeting I began to get urgent calls, not from Basquiat himself, but from his support system. Ethel Scull, who had been a proponent of his comeback, was outspoken. "Jean-Michel is very fragile," she said. I killed the story.

At about one in the morning on Friday, August 12, 1988, I was surprised to see him in the club MK. A front tooth was missing, with disconcerting effect. His eyes were remote; his smile, wan. We spoke, inconsequently. He was dead of a heroin overdose twenty-four hours later.

Keith Haring, who was in a similar career slump, died of AIDS in February 1990. "The three of us came at the same time, and we always had this competition. It was exciting. It's very strange to be as young as I am, feeling like I'm the only survivor. Because I do feel like that," Kenny Scharf says.

In April 1989 Cindy Sherman showed nine color photographs at Metro. She scarcely appeared in her horrid landscapes—gruesome close-ups, some with dolls or doll parts, or panties, or destroyed toys in pools of glimmering muck—and I found them extraordinarily pow-

erful. Much more so, in fact, than her next show, which was of herself posed in various period fashions; but that was the show that got the reviews, and sales.

"It's weird the attention and success and compliments that people have about this show now," Sherman said, frankly. "Because I feel this was just one little sideline, and some people are talking as though I have finally figured out what I've been trying to do all along. And that's not it at all. I'm not going to continue making work like that." Sherman also said that she believed people were waiting for her to trip up but that this wasn't personal, just a part of the fame trajectory in America.

In fact Cindy Sherman did make more of the very successful series of old-fashioned-portraits-plus-prosthetic devices, many more. But when she got back to the tough stuff, it was tougher than ever. It was as though she needed an emetic.

Jeff Koons had first seen the photograph in the German magazine *Stern* in January 1988. "I thought this is a beautiful woman. I didn't know who it was. She had on this knitted dress which was transparent and which you could see right through," Koons told me. In due course, he collaged it into the image that would become *Fait d'Hiver*, using only the bosom and the dress. Six months later he stopped for coffee on the Milan-Rome autostrada, checked out the magazine stand, and saw the same woman on the cover of a porno magazine. "When I looked inside, I realized that this was one of the greatest artists alive," he said. "She was able to present herself with absolutely no guilt and no shame. This put her in the Realm of the Eternal."

Koons took to alluding to La Cicciolina as a cultural force, coupling her influence with that of Michael Jackson. In January 1989 he faxed Staller in Rome, suggesting they work together. They got together that Easter weekend, before she went onstage in Milan. "I was taken backstage to meet her. She had her top on, but she had no pants on," Koons says. "I enjoyed very much that she was standing there without

any pants on. And I was attracted very much to her beauty in real life. The tone of her voice. The totality of her beauty."

Koons told La Cicciolina his plan, which was for a photo session. The pictures would be like the four lush advertisements for himself that Koons had placed in art magazines before the "Banality" show, except that the couple would be in flagrante. This relatively unambitious first plan was swiftly superseded. Koons decided to make his erotic union with La Cicciolina the subject of his whole next show. In October 1989, I went to his Manhattan studio. Young female interns scurried around grappling with telephones while Koons showed me color prints of him and La Cicciolina in assorted nude embraces. "This is the shot I've chosen. It's advertising for a porno film I'm going to make with Cicciolina, *Made in Heaven*," Koons said. The movie was to be a full-length feature. "This I like a lot, because it reminds me of Michelangelo." He explained that he and Ilona were "the New Adam and Eve." Koons didn't have an erection. "This is Soft Porn. This isn't Hard," he said. The film would be Hard. Would penetration occur? "Of course. Everything."

Koons and Staller became engaged shortly thereafter. The photo-based sculpture of the naked artist embracing his more modestly clad fiancée was one of the talking points of the Venice Biennale. They married in Budapest in April 1990. A handful of American friends were at the ceremony, but the other members of the Hot Four were not among them.

The show, which was also called "Made in Heaven," was to open that November, so Koons went back into production. Late that summer I went to visit Koons and Ilona in Camaiore di Mare, a resort on the Italian Riviera, close to the workshop where his marble pieces were being carved. Glass pieces were being blown under his supervision in Murano, in the Venetian lagoon. What he called paintings — images computer-transferred from photographic transparencies onto canvas — were being made in Paris. Polychrome sculptures were being carved out of a woodlike synthetic by craftsmen in Oberammergau, Germany. Some of the craftsmen, incidentally, were proving a bit resistant to

the beauty of the penile, anal, and buttocky scenarios, especially in Oberammergau, where their main livelihood was working for churches. "I have had to take some of them off the big pieces. I've set them to carving puppies," Koons said.

Franco Cervietti's marble workshops are famous. The bulk of the production there is humdrum—a head of Saddam Hussein was looming like an ocean boulder over lesser dignitaries, naked women, etc.—but many of Henry Moore's marble pieces were carved there, and the Koonses had run into Fernando Botero, checking on one of his glandular odalisques, the day before I arrived. We walked out to look at a completed sculpture in the sun-flecked yard.

"It's my self-portrait," Koons said. The carving was being done by a craftsman, which was only unusual in that the artisans carving a Rodin or a Henry Moore, say, would be carving from clay or plaster models, whereas the Koons self-portrait was being copied from a photograph taken by Ilona's photographer. "This is the way I wanted to be presented," Koons said. He had been fastidious in his choice of materials. "I don't like the local marble. It's chalky. It's not uplifting," he said. Instead, he had chosen a very white Turkish marble with a rosy tinge that can take a high waxy polish. The base had been carved into New Age-style crystals, and the head had been so idealized that it seemed to belong in a nineteenth-century Poets' Corner—the Young Chatterton?—apart from sly touches of detail, like a fold of flesh at the nape of the neck and a wave to the hair that seemed to belong less to Parnassus than to MTV. "The King," Koons said. "Elvis."

I contemplated the bust of Koons. Eyelids with carved lashes were closed into an expression of enough sweetness to poison a double batch of laboratory mice. "What were you thinking of when the photograph was taken?" I wondered.

"Having anal sex with Ilona," Koons said. As when making all his Bad Boy pronouncements, he spoke with neither a nudge nor a wink but with a breathy solemnity. "It's lost its desire for power," he said of the portrait. "But it still wants to lead. For me, this is the real perversion. It's about as perverse as things get. To know one's

limitations and still want to lead people. But it's always your own ego."

The abstractions hovered around the marble head. "A lot of people are going to think this is the way you really feel," I observed.

"I do feel this," Koons said. He joined in my startled laughter.

Later he told me, "I'm very disillusioned with the art world. I really am. Art lacks charisma. I try to create charisma, and I try to manipulate an audience, and I try to control this environment. But I'm very disillusioned."

Koons's wish was to break free of the moribund art world. One way out would be the filming of *Made in Heaven*, he thought. Ileana Sonnabend was balking at funding it, though, so its making would depend on the success of his forthcoming show, on fighting off claimants in his court cases, and, of course, on the continuing high-flying market for art.

Jeff Koons was hardly the only person to feel depressed about art as the eighties waned. A fatigue was settling in, and not just in art. In 1987 Chrissie Hynde, lead singer of the Pretenders, told the *New York Times* that rock might have exhausted its possibilities. A piece on street culture in the *Village Voice* was entitled "The Shock of the Same." It was noted in the catalog for an exhibition of decor at London's Victoria & Albert Museum that "Modernism is just another style, like Chinoiserie."

Some at least were entertaining the notion that Neo-Expressionism, Neo-Geo, the Appropriationists, and the rest of the *galère* might be killing off traditional art forms much more effectively than had the Minimalists and the generation of 1968. The most ruminative proponent of this new Death of Art theory was Arthur Danto, a professor of philosophy, who wrote a column for the *Nation*. Danto's view was that since about 1905—which was more or less when photography and the movies began taking over so many of the functions of painting and

sculpture—art had been investigating a single question: itself. This had taken artists to various extremes beyond which no further growth was possible. Hence the current scuttling around, the revival of disused forms and unfashionable styles.

This was not in itself novel. That is why the stuff was being called Post-Modernism. Danto's novel spin was that this permanent reforestation simply cannot be done. There comes a time at which forms are used up. How many generations can be startled by new versions of the Duchamp *Urinal*? Can find shocking revelations in nudity? As the young woman says in a William Hamilton cartoon: "Darling! Do you realize this is the second time we've got bored with Art Deco?"

"There's an external market demand that you continue to revolutionize painting. But there's no internal possibility of it at all," Arthur Danto told me in the comfy sprawl of his West Side apartment as the buying frenzy escalated. "The progress of self-discovery and self-definition—that's finished. It'll never happen again. But you've got a runaway market. So you have got all these people doing paintings that had to look important. They had to be big, portentous. And it's all absolutely empty. It's all trash. So what will happen if that market crashes? And it can only crash when people acquire an intuition that this is not the art of the future, that it's manufactured. I don't know. But I wouldn't want to be stuck with a Schnabel.

"I've got this nice idea that once painting comes to an end as a revolutionary activity, it will return in some sense to human needs. It's no longer the world historical force that it was perceived to be till . . . 1965? 1980? But what you can then do is say, 'Sure! But people need their portraits painted . . . people need things decorated . . . books have to be illustrated. There are lots of nice useful things for artists to *do*.'"

Arthur Danto bases his notion that an art—painting, sculpture—will perish when its forms are worn out on the work of the philosopher Hegel, who was thinking the issues through in the early nineteenth century, just about when Saint-Simon was garlanding the avant-garde. The critic Peter Schjeldahl snorted that Danto is "a rube" and decried

talk of the multiple deaths of art as a cliché. "It has been the defini-
tive feeling of every generation since the modern era began that it's
all over. Everything has been done!" Schjeldahl said. "There's a very
understandable tendency to deny the new. It seems to me that when
things are moving at their fastest, a certain melancholy, an ennui, is
at its maximum. But people get over their depression and discover that
the present moment has the unique property of being the *only* present
moment. Things push forward, backward, sideways. They change."

Robert Hughes, who had hitherto dismissed Endism as "cant,"
said: "To tell the truth, I get a little more pessimistic all the time. It
seems to me that the avant-garde game is completely played out and
the myth of progress, upon which modern art was sold to America and
the world at large, no longer operates. There's no progress in the vi-
sual arts. In point of fact, there's a regression, verging on the infantile
idiot savant.

"It's possible that the death of Picasso marked a point, like the
deaths of Sophocles and Euripides. People kept on writing tragedy,
but it wasn't the same. It's possible that the death of Picasso meant
the end of painting as high moral discourse." He added: "There are
still some artists whose work gives me pretty constant pleasure. They
don't all break off like matchsticks."

But who, after all, was paying attention to *writers?*

Five / Boom

It was mid-morning early in 1987. Clement Greenberg was putting away his daily bottle of vodka in his apartment on the Upper West Side. The deceptively soft-voiced old warrior was in a reminiscent mood. The last time the art world had been affected by a collapse in the "real" economy, he said, had been the spring of 1962. "There was a recession," he said. "It was over by the summer. But by then the art season was over. The Cedar Tavern lost its trade. The Artists' Club disintegrated. That fall there was Pop art in all the galleries."

So Greenberg felt the Dow-Jones had helped shuffle the Abstract Expressionists, for whom he had been the most vocal mouthpiece, into the wings. The economy, he asserted, had never had a comparable impact on the art world since.

In April 1987, shortly after this conversation, the children of David Brooke, the earl of Warwick, put a van Gogh up for auction at Christie's, London. It was a version of *Sunflowers* and had been left to them by their American grandmother. Robert Hughes was quoted calling it as "a crusted brown wreck of a picture."

Warwick was lunching at Mortimer's, a Manhattan restaurant, with art dealer Harry Bailey and the Picasso biographer John Richardson the day after the auction but before he had learned what the painting had gone for. "They both told me off," Warwick remembered. "They said my children were very ill advised to sell it off at that mo-

ment." He left the table halfway through lunch to call Christie's and came back with a number. "They said I was wrong. They said that must be the figure for the whole sale," Warwick said. He placed another call. It had been Bailey and Richardson who were wrong. The canvas had fetched $39.9 million. "They both went very quiet" Warwick told me. "Then Harry Bailey said, 'Well, that *is* a high figure.'"

Yakishiro Monimoto, the new owner, was the head of a marine-and-fire-insurance behemoth, and there was a certain resonance to his purchase in that there had been another version of *Sunflowers* in Japan, which had been burned to a crisp during World War II. Journalists failed to ferret out the name of the underbidder. "Prices will keep going up," the dealer Richard Feigen told a *People* reporter who had asked whether the painting could lose value. "Remember, there's a printing press in Washington to make more money, but van Gogh's printing press is closed."

Then came October 17, 1987. The market lost 508.2 points in five hours. Most assumed the art market would follow the Wall Street commodities into the abyss. Some took a grim pleasure in biting the bullet. "When Black Monday hit I said, 'Great!'" says the collector Elaine Dannheisser. "'We'll get back to where we should be.'" Lucy Mitchell-Innes of Sotheby's believes that everybody in the house expected at least a slowing down. "But two or three weeks later we had a very successful jewelry sale. And the painting sales went on just as big as usual. It was really as if . . ." Ms. Mitchell-Innes pauses, then says *"nothing had happened!"* In fact, the market quickly revived. By early spring 1988 Dannheisser saw she had been pessimistic. "The art world hadn't missed a beat," she marvels.

Certainly, there wasn't much worry about Black Monday at the opening of Julian Schnabel's retrospective at the Whitney on November 6. The artist had prevailed on the museum to rip up the flooring for the event, exposing raw concrete, and had installed bronze furniture of his own design. The size of the artworks were a headache when some were stranded in London. Pace called Charles Saatchi, asking

for the loan of a private jet. "The paintings were too large for anything but a private plane," says Lisa Phillips, the curator. "In the end we had to borrow work from local collectors. Luckily Julian's very prolific, so we had enough work. We just hung it very minimally." Schnabel—who clearly thought that as far as he was concerned, the Boom was never going to end—was soon looking into investing in bloodstock along with Peter Brant. Brant, who had already named one horse after Leo Castelli, named another for one of Schnabel's daughters, Stella Marie.

John Whitney Payson, the owner of a van Gogh, *Irises*, had been intending to leave the picture to a small college in Maine. A dumb bit of Reagan administration lawmaking, however, had sheared the benefits from such giving. That, together with Boom-propelled insurance costs, persuaded Payson to put the picture up at Sotheby's on November 11. A crowd of 2,200 watched as the bidding, which began at a remarkable $15 million, proceeded by million-dollar jumps to $53 million. Instead of the usual polite hand clapping that acknowledges the breaking of a record, there was the sort of visceral reaction you get when the home team has scored a game winner at Madison Square Garden.

A couple of days later the gossip columnist Suzy, aka Aileen Mehle, quoted an "unimpeachable spy" to the effect that *Irises* had been bought by an Australian, Alan Bond, and that he had also been the underbidder on *Sunflowers*. Bondy, as he was known among his compatriots, was a beer baron (appropriately keg-shaped) best known for financing the sailboat that had won the 1981 America's Cup. Nobody imagined the brash tycoon was a secret aesthete. This was the point. The price tag proved that the siren voices of the dealers were correct and that it was safe to disregard those ugly-spirited characters who had been glooming that art was being trafficked in like pork bellies and soybean futures and would suffer the same ups and downs. Art was transcendent, immune from the yo-yoing of more mundane articles of commerce. This, of course, made it a wonderful hedge for

speculators, and so it happened that it wasn't until after Black Monday that the art boom truly began.

Tracking the Boom, though, was like listening to the cracking of twigs in woodland to estimate which way a herd is moving. Manhattan's Art Expo in the Jacob K. Javits Convention Center was designed to cater to the huge market for kitsch, including crossover work like late Chagall and some of the more dismal Warhols. In March 1988, though, you could find among the throng such gallerists as Gracie Mansion and Holly Solomon making passes at the LeRoy Neiman heartland of the culture. That April saw the Warhol sales at Sotheby's and the disposition of his collection of cookie jars for $110 million, proof the market was so avid that it was being expanded to take in some récherché categories. Indeed, soon enough records were being busted for fairground carousels and decoy ducks.

There were reservations here and there. Van Gogh, after all, was a talismanic figure, and so, in a different way, was Andy Warhol. But then at the May 10 and 11 evening sales at Christie's and Sotheby's in Manhattan, thirty artworks fetched more than $1 million apiece. Jasper Johns's *Diver* reached $4.18 million, making it the highest price paid for work by a living artist. Their joint take was $150 million. Stuart Greenspan wrote in the *New York Observer* that Sotheby's had pulled in "easily three times what a similarly composed sale would have made two years ago." Greenspan went on to borrow a trope from Robert Hughes and compare what was going on to the seventeenth-century Dutch flower-bulb speculation folly Tulipmania.

It wasn't just purists filled with nostalgia for the garret who were being left in the dust, though. Public institutions were being throttled. The new legislation meant that the flow of donations had become piddling, and the prices were shutting the museums out of buying, too. Even the Getty, with its annual purse of $50 million, was puffing in the wake of the tycoonery. "I feel like a fossil awakened in another era," the Metropolitan Museum's Philippe de Montebello told a reporter after the sale of *Sunflowers*. "The commission alone paid to Christie's exceeds the Metropolitan's total art purchase funds for a year.

Therefore I feel so removed from this phenomenon that I can only watch in amazement."

New York was very much the epicenter. Worried panel discussions cropped up all over town, like "The Price Explosion and the Future of the Art Market," which was put on by the Art Dealers Association at the Guggenheim, and "Effects of the Art Market on Institutions," which was convened by the President's Committee on the Arts and Humanities and took place at the Metropolitan. Both panels were replete with famous art persons, none of whom found anything very effectual to say, except perhaps for Hilton Kramer, who exulted at the Met that the poverty of the museums might stop them from buying the bad new art.

Most ignored the misery-mongers. Elizabeth Taylor had chosen Sotheby's to launch Passion, her brand of scent, in 1987. Donald Trump talked about the "numbers" that art was getting to justify his valuation on the Plaza Hotel. In 1989, when the Metropolitan — stung by a *New York* magazine headline branding it "Club Met" — announced that it would no longer be renting out the place for private shindigs, the feeling was that the venue wouldn't be much missed. It was the fashionable nocturnal sales that had taken on a festive air, being culturally a cut above charity balls but much less demanding than the theater, and they had become a stakeout for paparazzi, eager for a shot of the likes of Cheryl Tiegs and Bianca Jagger.

The auctions were also an effective way to establish reputations of younger artists. *One Wish*, a canvas Ross Bleckner had painted in 1986, in which a shimmery Aladdin's lamp bobs on a blue-green ground, had been sold by Mary Boone for $30,000. On May 3, 1988, the canvas fetched $187,000 at auction. It was widely assumed that this was an attempt to jimmy up Bleckner's prices. They rose anyway. "In today's contemporary market, the canvases just can't dry fast enough," wrote Deborah Gimelson in the November 1988 *Art & Auction*. That same month, the cover of *ARTnews* showed a palette, brushes, and paint tubes wrapped in banknotes, with ripped-up banknotes as pigment. "With estimates of the total annual art market rang-

ing from $10 billion to $40 billion," ran the text, "one thing is certain. Despite last year's Black Monday on Wall Street, the art market didn't even wince. The boom continues . . ."

In the late spring of 1988 a Geneva auction house, Habsburg Feldman, opened up in an East Seventy-fifth Street town house, the former quarters of the Xavier Fourcade Gallery. It was headed by Archduke Geza von Habsburg, who had run the jewelry division at Christie's for seventeen years, and David Feldman, who had launched what became the world's biggest stamp auctioneers. Another associate specialized in watches and scientific bric-a-brac. So much for their expertise. Habsburg Feldman let it be known that it meant to go for a slice of the Big Two's art pie, too. It was left unspoken that the occasional presence of the Habsburg archduke at Manhattan tables should work its magic among the more impressionable new tycoons. But the auction houses weren't hogging all the attention. Some was focused on the dealers, and one dealer in particular—Larry Gagosian.

Larry Gagosian was born in downtown Los Angeles. His father was a stockbroker. Gagosian studied English literature at UCLA and toyed with being a writer. He was a trainee in the William Morris office, a flirtation with showbiz upon which art worlders would later enjoy dwelling, but in 1969 he opened a poster shop in Westwood Village, one of those rare parts of L.A. where people get around, biped fashion, on foot. His taste swiftly progressed, and in 1979 he opened up a gallery in Manhattan together with Annina Nosei. It was on a first floor on West Broadway—"We could look into Leo's windows," Gagosian says—and it was there they gave David Salle his first show. Gagosian's cash business, though, continued to be the selling of New York artists in Los Angeles—"Californians are bored with their surfboard-maker-slash-artists"—and the artists he was mostly showing were represented by Castelli or Mary Boone.

He found it an exasperating situation. "You can only go so far in L.A. I felt completely boxed in," Gagosian told me in 1986 over coffee in Three Guys on Madison Avenue. He was in a fashionably baggy European suit and had short, thick hair, which, like the pelt of the Arctic seal, seemed to change seasonably from iron-gray to dull silver. He has a clipped deadpan humor that gives away little he doesn't intend to, which usually isn't much. "I was completely beholden to the New York dealers. I got tired of begging. Being the Good Boy." Gagosian's rewards had been small percentages, but no pictures to sell on his own. He decided there was nothing to lose in giving New York a Bad Boy shot. "It's the Dillinger quote," he said.

He meant Willie Sutton, who had been asked why he robbed banks: "That's where the money is," he had said.

Gagosian opened up in 1985 in the street-level loading dock he had spotted in Sandro Chia's building on West Twenty-third Street. This location was off the art world's normal trade routes, but Gagosian quickly commanded attention with his first show, a tranche of the famous collection of Burton and Emily Tremaine. He had gotten hold of this through good ears and a lot of gall. "The Tremaines didn't like Leo," Jeffrey Deitch says. "Everybody likes Leo. But the Tremaines didn't." Castelli had simply not made the Tremaines feel sufficiently important. Gagosian said, "I got their number from Connecticut information. I offered a lot of money for a Brice Marden painting. Mrs. Tremaine liked me on the phone. She thought I was funny. Or maybe she liked the money I offered for the painting."

Most dealers try to be guarded about the sources of their financing, but even people who have worked closely with Gagosian for many years find his financing peculiarly impenetrable. He sold a few small pieces for the Tremaines, but then he sold *Victory Boogie-Woogie* to S. I. Newhouse. This is an essential Mondrian, and the publishing magnate paid $10 million. Gagosian would never feel boxed in again. He had found the niche from which he was peculiarly fitted to operate. It is called the secondary market or, more pithily, resale.

Resale requires no studio visits or baby-sitting of fretful artists. It is the business of buying, selling, and trading among collectors, dealers, and institutions—the art equivalent of arbitrage, which was hot stuff in the financial markets in the mid-1980s. Most dealers, even those who show the most fiercely of-the-moment artists, do some resale in their back offices, and many survive thereby. Nonetheless it had been thought of as an unsexy business until the advent of Gagosian, a man who plays high-stakes poker once a week and who seemed forever ready to push in a fresh stack of chips to pry a painting he wanted off its owner's wall or to sweat out a competitor.

The more Gagosian's star rose, the thicker the rumormongering swirled in his wake. Anecdotes began making the rounds and bobbing up in magazine features, mostly concerning his swashbuckling practices—like offering collectors work that was still the property of some other collector, or making transparencies from art in magazines and offering those. Other darker stories—and I, along with other writers, got plenty of unsolicited mail and telephone calls on the subject—were suggestive of compulsive behavioral tics. But Gagosian would look you straight in the eye, daring you to take such stuff seriously. Did Andy Warhol gossip in his diaries about the dealer's bizarre telephone calls? "He called *me* weird," Gagosian said. "Warhol!"

None of this seemed to affect Gagosian's business. Fred Hoffman, a Los Angeles dealer who often worked with him, says, "Larry totally transformed the resale market. He added digits to it." Nor apparently did it bother Gagosian's primary collectors. They seemed to take a covert pleasure in his Bad Boy aura. At one stage or another, he would function as the dealer of choice for Charles Saatchi, S. I. Newhouse, David Geffen, Keith Barish, and Peter and Sandy Brant, the owners of *Art in America*. It was from the Brants that he learned that the top floor of the old Parke-Bernet building on Madison and Seventy-sixth Street was on the market. He took it over. Work on Gagosian's new space was under way when he attended the auctions of November 1988.

* * *

Some feared a still skittish economy might be a dampener. Many more felt a ceiling was about to shatter. The year before, Picasso's *Memory of Le Havre* had fetched $7.6 million in London. It seemed time that an artwork fetch $10 million. Perhaps something by a living artist. If so, almost certainly one of the Johnses. The preview party at Sotheby's was jaunty. Tom Armstrong of the Whitney was peering at Rauschenberg's *Rebus.* "We can't actually bid on anything," he said cheerily. "No money. No *money!* I'm going to get a drink to cry in." Vortices of gossip sprang up around the thronged rooms on such topics as the frail health of the emperor of Japan. "If he dies, all the Japanese are gone," a dealer said. The London dealer Nigel Greenwood said, "It's all leverage. You get the prices here. You know a picture somewhere. That's how we all survive. It's musical chairs. One day the music will stop and we'll all be left, holding bits of pigment . . . pieces of string . . ."

But a few had private reasons for confidence. Leo Castelli, for one, had recently been at a black-tie dinner in Stockholm for a Rosenquist retrospective. "I met Leo in the restroom. I said, 'Do you have five minutes? I want to buy *White Flag,*'" says Hans Thulin, a real estate speculator. "Leo said, 'Do you have five million dollars?' I said, 'Yes.' Leo said, 'If you have five million dollars, I have five minutes.'"

Hans Thulin, whose family had been in the hotel trade, was now head of a company imposingly called the Consolidator-Granaten Group. His first move in collecting had been the building up of a peerless collection of vintage cars. He now wished to do the same in contemporary art. As soon as Leo Castelli heard that Thulin had forked over $10 million for a Bugatti Coupe Royale, he decided Thulin had possibilities. They sat down. Castelli drew up a shortlist of museum-quality pieces that would shortly be on the market. There were just four: *False Start* and *White Flag* by Johns; *Rebus*, and another Rauschenberg, *Winter Pool.*

Back in Manhattan, Castelli was lunching at Ballato's on East Houston Street, a favorite art-world hangout, on Sunday, November

6. S. I. Newhouse was at a nearby table. "Do I need *False Start?*" he asked.

Castelli simply said, "Yes."

Christie's Contemporary Art auction, which took place the following Wednesday, consisted of the collection of Burton and Emily Tremaine, both of whom were by then dead. The room was full, and glam. The art press were either standing around the walls or huddled onto a sort of dais. Christopher Burge, Christie's president overseas and main Manhattan auctioneer, was at the rostrum. Lined up beside him was the customer service posse, mostly comely women with bright, efficient eyes, spotting bids or taking them on the telephone, and generating as much erotic energy as a row of slot machines. To Burge's left was a revolving turntable that swept the portable sales items into view, and above was a scoreboard that would flutter, like eyelashes or settling butterflies, as it converted dollar bids into pounds sterling, French francs, Swiss francs, deutsche marks, yen, and lire.

Frieze, a late Jackson Pollock, was the first auction star. "A new face . . . it's in the room . . . against the telephone," Burge intoned as the painting ping-ponged up the lower millions. (Burge, a Briton who takes a shot of Scotch before doing his stuff, has the smooth, unflappable working manner of a croupier in a good Mayfair gaming house — Aspinall's perhaps — whereas John Marion, his Sotheby's counterpart, now retired, favored the staccato rat-tat-tat of a tobacco auctioneer. Both are dab hands at joking about money, but the differently nuanced cultures of the two houses emerged when an artwork failed to meet its reserve and had to be withdrawn. Whereas Burge would say "Pass," quietly but distinctly, Marion would bang down with his gavel, doing his best to obliterate the ugly word, squashing it like a bug.) "Fair warning . . . five-million-two," Burge said, and hammered down the Pollock. In no time the turntable swung us *White Flag*.

Burge opened the bidding at $3 million. It rose to $6.4 — $7 million, with commissions factored in — but stuck there, as if in mud. The clapping was muted. An Arshile Gorky soared to $3.2 million, a

salesroom record for this artist. The seller had set an even higher estimate, though, and there was an odd whooshing sound, an exhalation of surprise, when the work was withdrawn. A Lichtenstein went for $1.9 million, $700,000 above its high estimate, and a Rauschenberg went for a fat sum, but elicited only a single clap. "Thank you," Burge told the zealot. A Tom Wesselmann reached $420,000, a record for that second-string Pop artist, but the crowd was quiet as they left the auction house, and the air of disappointment was strong enough to be bottled. "It did not seem to be a very lively sale," Castelli observed on his way out of the auction house. The prices had been high, but the expectations had been higher. The $10 million contemporary-art painting still shimmered unreachable overhead, like a grail or a chimera. At the after-sale press conference, the new owner of *White Flag* was revealed to be Hans Thulin, who observed, through a Christie's spokesman, that "you can never pay too much for outstanding quality."

Sotheby's Contemporary Sale was the following evening. Where Christie's main gallery is smallish, pocket-theater-size, Sotheby's main space is colossal, a humongous *Führerbunker*. It is overlooked by windowed private boxes, which are sometimes deliberately left dark, so all those below can see are blurs of faces and, from time to time, mouths folding and unfolding around white telephones. The Sotheby's press area is better than that at Christie's, being to the side and big, albeit cordoned off by velvet ropes. Alert reporters can see much more of the goings-on than can the actual players, who are seated in the main part of the auditorium. Scanning the room, I spotted Gagosian's pelt bobbing and was mildly surprised to see S. I. Newhouse, a rare visitant to the auction room, at his side.

The sale began with the offering of twelve canvases from the collection of Sally and Victor Ganz, six Picassos and a brace by, respectively, Johns, Rauschenberg, and Frank Stella, put on the block by Mrs. Ganz after her husband's death. A total of $30 million was expected. There was relieved applause when a Picasso of 1923, a Cubist still life, went for $15.4 million. The eight-digit ceiling for the work

of a twentieth-century artist was well and truly shattered. There was further clapping when a telephone bidder paid $6.3 million for *Rebus*. S. I. Newhouse paid $3.74 million for the other Rauschenberg, *Winter Pool*. The Ganz pictures had fetched $66.7 million, more than twice the estimate.

It was *False Start*'s turn. Castelli had sold this painting in 1960 to Robert Scull for $3,150, not a bad price in those days, with Johns, of course, getting half. Scull had sold the painting for a six-figure sum to François de Menil, a Manhattan-based scion of the art-supporting Houston clan, and de Menil had popped it into the sale along with a Warhol, *Marilyn Monroe (Twenty Times)*. De Menil, an architect, was seated not far from Ethel Scull.

John Marion kicked the bidding off at $3 million. It rippled quickly up to $9 million, and bogged down in silence. "Don't stop now," Marion said, pleadingly. There was laughter. The bidding picked up again, and there was a surflike murmur as the eight-digit ceiling broke again, with Larry Gagosian as the only active player—at least as far as the most knowing press eye could detect—in the auditorium. "Jasper will be so happy," a female collector seated on the other side of the velvet cord was heard to say. "I guess the Swede picked up his on el cheapo," said her companion.

"Thirteen million," John Marion barked. François de Menil, a cool customer, was maintaining his composure, but Ethel Scull was flinching at each consecutive rise as though a boxer were throwing invisible punches. "Thirteen million two hundred and fifty thousand . . . thirteen million five hundred thousand . . . I have thirteen million seven hundred and fifty thousand . . . *fourteen* million . . ."

It was down to a trio, a Bermuda triangle of art and money: Larry Gagosian versus two white telephones. One of these instruments was being wielded by Lucy Mitchell-Innes, Sotheby's head of Contemporary sales and the coolly beautiful wife of David Nash, Sotheby's top Brit. Gagosian plugged ahead. S. I. Newhouse bobbed his head slightly or made a small gesture with his left hand at each quarter-of-a-million

leap. "Fifteen," John Marion announced. "Say sixteen." Yearningly. Another small gesture from Newhouse. Another half-million jump. "Fair warning!" Marion intoned. And that was that. Factoring in the commissions, *False Start* had fetched $17 million.

So an oblong of canvas to which pigment had been applied by Jasper Johns—who was still applying pigment to canvases in his late middle age—had achieved the cash value of . . . what? A battleship? A small shopping mall! A small town in the Midwest? Among the blizzard of commentary that followed, my own favorite observations came from Tom Wesselmann and Jasper Johns himself. Asked by the *New York Times* about his own $462,000 price, Wesselmann said, "Very nice and long overdue." Concerning *False Start*, though, he added: "Although I like Johns's work, I can't help feeling that there's something surreal about the $17 million price. It reminds me of the great Dutch tulip bubble in the seventeenth century." That again. As for Johns, he had been telephoned by Leo Castelli soon after the hammer fell. His soft-spoken response: "Good grief."

Some were quick to say that S. I. Newhouse had simply been shrewd. As the owner of something like nine canvases by Johns, he hadn't so much spent $17 million as upped the value of his holdings to $100 million. Reality is seldom so well crafted. What actually happened was this.

"**I am the man** who destroyed the art market," Hans Thulin told me over tea in the Essex House on Central Park South, where we were to discuss *False Start*. A fresh-faced, soberly dressed man of forty, he seemed placid, but he could not conceal a certain subversive glee. What did he mean? "When Si [Newhouse] and I took it from seven to seventeen million, that began it," he said.

Thulin had arrived from Stockholm on the day of the Christie's sale and checked into the Helmsley Park Lane. He had secured *White*

Flag, bidding on his bedroom telephone through Lillemor Malmstrom, who ran Christie's Stockholm office and had come to New York specially. The following day Thulin had flown to Miami. That evening, he had bid by telephone from Boca Raton, Florida, this time through Lucy Mitchell-Innes. He had bought *Rebus,* another item on Leo Castelli's little list, and then had gone after *False Start.* Charles Saatchi, the other telephone bidder, had dropped out at about $10 million, a decision he would later claim he regretted, and Thulin followed him, a turbulence of digits later.

Much of the real life of auctions goes on out of the public eye, and usually in the auction's immediate wake. Newhouse shortly paid a visit to Thulin, who was back in his New York hotel. Newhouse owned another Johns, *Jubilee,* which is very like *False Start* in concept but smaller, and in black and white. Thulin bought it for something like $8 million. Publishing magnate Newhouse, a canny trader, had made good what the Swede had cost him.

An interesting thing about the Thulin intervention was this. He had no real money, had never had real money, even when he was assembling the car collection. "He wasn't even backed by a bank," a specialist says. "He had convinced a finance company called Nikeln. He said, 'I am going to corner the market. And then I'm going to start selling them.' And they bought it! So when he bought a car for ten million, they would just send the ten million."

The selling part of the car scheme had not been gone into when Thulin moved into art. It was addictive. Shortly after buying *Jubilee,* he walked into the Scott Hanson Gallery on West Broadway, a space specializing in mass-market stuff, like Warhol silk screens, and gotten into a conversation with a young woman behind the desk, Helen Horowitz. Which were the best galleries for the latest, hottest stuff, he asked? She made out a little list of her own. It included Barbara Gladstone, Paula Cooper, Lisa Spellman's 303 Gallery, and Colin Delland's American Fine Arts. Thulin telephoned later, complimenting her on her eye, and soon enough Horowitz found herself on his payroll as the market reached for the sky.

* * *

Just how far would S.I. Newhouse have gone to secure *False Start*? Gagosian said he had no idea. "The andrenaline kicks in, the competitiveness," he said. At an early point Newhouse had been so caught up that he had bid against his wife, who was on a telephone. Gagosian was still exultant at the results of the sale. "It was a victory for American art. It really is," he said. "Earlier that evening a Picasso went for $15 million. For a week, that Johns painting was the highest price ever paid for a twentieth-century work of art. Then another Picasso went for $24.8 million. But the Johns was there for a week."

This was January 20, 1989. We were talking in Gagosian's new gallery, which had opened the week before—as if perforce—with Johns. He said he couldn't imagine any decline in the market. There was, for one thing, the increase in public attention. "More and more commercials are incorporating art," he said. "Those guys know the demographics. They are giving away certificates to buy Miró prints on *Wheel of Fortune*." Would he return to representing artists? "Yes. That's one of the reasons I made the gallery. But I want to go on giving historical shows." What artists was he after? Mary Boone had just put her stable under contract, a defensive measure that was a novelty in the art world. "I question the legality of it," Gagosian said. "I think it's restraint of trade."

Gagosian's competitors had recently been unpleasantly surprised by the news that he and Leo Castelli were going into business together. They had opened a gallery space at 65 Thompson Street, and this was being interpreted as Leo's way of anointing Gagosian as his titular heir, a position that had once seemed Mary Boone's alone. "Leo likes me," Gagosian said. "It's not like I'm someone lurking in the bushes trying to take his artists. Joe"—Helman—"went for the throat. What he did was *profoundly misguided*."

Did he see a dark side to the Boom? He did. It was unexpected: the effect on the artists. "It creates a lot of expectations. Some artists are really fucked up by it. They are arrogant with their dealers. I'm speaking objectively—I don't have any artists right now. It pumps up

the lifestyle. They start getting interested in antique furniture and wine and adding another wing to the house in the Hamptons. They go and live in exotic places. Basquiat was a flagrant example, but there are plenty of others.

"There's nothing wrong with making money. An art dealer shouldn't be moralistic," he said, but cautioned that the worst of it was the effect on an artist's work. "You've got to keep the dealer happy. You've got to keep the pipeline loaded. And the marketplace doesn't tolerate a lot of experimentation. And there's a relentless reevaluation because of the state of the market. Artists' careers are reevaluated on a daily basis. But they don't change that fast."

The telephone rang. Gagosian picked it up. He had been looking rather cheered up by his jeremiad, but his look soured. "Tell him I'll call him after lunch," he instructed. To me, he said, "What a putz! He wants a week. Then he asks $25,000 more on a million-dollar painting. Some people are cheap."

What about rumors that Charles Saatchi had begun selling big time? Gagosian confirmed that he was handling the sales. "In some cases he has duplicates," he said. "He is honing the collection." *Honing,* which, of course, means sharpening, as of a knife, is a euphemism often used when a collector sells. An art reporter once told me, "Whenever I hear it, a little red flag goes up . . ."

Leo Castelli's staff, incidentally, was a lot less sanguine about the Gagosian connection than was the boss. "Leo has a history of dealing with people who are universally disliked," his gallery manager, Susan Brundage, told a reporter. "Before Larry, it was Doug Christmas and Daniel Templon." But these dealers have superior eyes. Brundage conceded: "As for Larry, he keeps the other vultures off."

The Picasso that had knocked Johns off his perch was one of the master's more Hallmark Card–ready works, a Blue Period canvas called *Maternité.* It had been bought at Sotheby's on November 14 for $24.8

million by an Argentine socialite, Anna-Maria Fortabat. A far finer Picasso, *Woman at the Mandolin*, an oval Cubist composition, went up at Christie's the following evening at an estimate, available "on request," of $7–$10 million. These figures are not guesses. Christie's Martha Baer had been given to understand that the underbidder on the Picasso Blue would be in on the action. It didn't happen. The painting went up to $6.8 million, stuck there, and was removed from the fray.

"The boys did a number on it," Christopher Burge told me immediately afterward, sounding resigned rather than angered. He didn't say who "the boys" were, and didn't have to, since what he meant was a brief opportunistic alliance among dealers, collectors, and gossips at the rival house, who had insinuated that the canvas had been overrestored and that, at any rate, it had been hawked around too much already. The grape had lost its bloom; the girl, her virginity. "It was *brulé*. There was a distinct smell of burning in the air," Burge said. None of which reasoning prevented Souren Melikian, the canny art writer for the *International Herald Tribune*, from heading his account of the sales "Wind of Change in Art Market."

In December Alan Bond issued a press release, confirming Suzy's scoop that he had bought *Irises*. It was known that his ramshackle empire was in trouble. Shortly afterward, Bond took the occasion of a black-tie affair at Australia's National Gallery of Art in Canberra, at which *Irises* and five other of his purchases were shown, to call upon the artists in whom he had invested as mute character witnesses, saying, "They believed in what they were doing and they were vindicated." He didn't say what his plans for the van Gogh were. "This is a classic sign that he is about to sell it," an old Sotheby's hand told the *New York Post*.

It was January 1989. Mary Boone was in the office in her gallery and in just the posture in which a portraitist might have put her:

on the telephone to a collector. "I've got good news," she purred. "It's yours! Didn't I say I would try to get it for you?" She was in a flowery Chanel skirt that glowed like a chapel window, and fondling an ivory figurine, which I inquired after. "David gave it to me. It's my *mascot*," she said fondly. David Salle, a man with an eye for telling detail, had chosen a figurine of Napoleon.

How were Boone's artists being affected by the Boom? She was nonchalant. "Artists do what they do," she said. The really weird behavioral zigs and zags were coming from the collectors. There was, for instance, the guy who had bought an Eric Fischl from her in 1986 for $70,000. This had (she said) been a fairly low price even then. She had agreed to it only because the man knew Fischl personally and he had promised—in writing—to leave the piece to the National Gallery of Ontario. Now she had learned the painting was being offered to another collector for $1.4 million. She had forced the deal to a screeching halt. "But each time it leaves a scar. Artists will withhold their work. If they just need to sell two or three a year to live, that's what they will do," she said.

Beginning on January 1, she had resale contracts. She was, in effect, trying to bring the resale market under her control. Barbara Kruger came in, acrid as tumbleweed, complaining about a critical review in the *Times*. Boone soothed her, reciting a litany of names— Eli Broad; the Fishers—who were buying from her show.

At this time I had occasion to pay several visits to the studio of one of Boone's artists, Ross Bleckner—I was working on a magazine piece about the artist—and found the *mise en scène* different every time. On one occasion there would be incomplete pieces, raw canvases with their surfaces built up with modeling paste or acned with burn holes by a propane torch. Another time there was an entire suite of all-but-complete canvases laid out or propped against the walls. "I like to have a lot of paintings around me so that I can rotate the energy," Bleckner said. "It was such a struggle to make these paintings. I wanted them to have this dull, throbbing light."

The whole show had been pre-sold, at roughly $75,000 per piece. That fine critic Thomas Hess once wrote that in the studios of the Abstract Expressionists in the forties and fifties, one avoided the subject of money as one abstained from talking about rope in the presence of a condemned man. Such niceties now seemed unnecessary. "Some artists, myself included, have, I think, demystified the whole cliché about what an artist is," Bleckner said. "An artist is not a street-corner lout who wears funny hats and who you can easily dismiss.

"Because of the nature of the art world now, where you have artists making as much money as the heads of major American corporations, you can be accepted in terms of your imagery without alienating the audience, and I think that's much more effective. Anyway, why shouldn't the ideas of artists be as privileged as the deals of these collectors? What these guys are doing basically is fucking artists. They don't do productive labor. All they do is tie up large sums of capital."

In April 1989 Irving Blum was visited by a Japanese man who announced he was representing a major collector. The collector was interested in some work that Blum had owned for twenty-eight years, Andy Warhol's iconic *Soup Cans*. Blum had originally shown them at the Ferus, his gallery in Los Angeles, in 1961. "There were thirty-two paintings. They were a hundred dollars apiece. I sold six of them," Blum told me over lunch. "And two weeks into the show I had the idea of keeping them intact. I called Andy. He said, 'They were conceived as a group. I would just love it if you could keep them together.'"

Blum called the six purchasers, who included the actor Dennis Hopper, explained that the artist wanted to keep the group together, and asked to buy them back. "Everybody said, 'Fine!'" Blum said. "They were a hundred dollars apiece. There was nothing at stake. I got them back easily, promising them whatever, down the road. I called Andy and said, 'What do you want for the group?'

"Andy said, 'A thousand dollars.' I said, 'How long will you give me to pay you, Andy?' He said, 'How long do you want?'" They settled on a year. "So I sent him a hundred bucks a month for ten months, and bought them."

By 1985 the work had grown so valuable that insurance had become amazingly expensive, and Blum loaned them to Washington's National Gallery, stipulating that they be permanently on view. When the Japanese agent asked if the work was available to be bought, Blum didn't hestitate. "I said, 'Absolutely!'" he said. "The agent said, 'How much do you want for them?'

"This was just at *the high*. I said, 'Eighteen million dollars.' He said, 'Can you give me a week?' I said, 'Take as much time as you like.' He came back in a week and said, 'My guy is prepared to offer you sixteen.' I thought, 'If he's offering me sixteen, he'll go to sixteen-five or seventeen. I said, 'Eighteen is really what I want. Get back to him. And get back to me.'" Blum laughed uproariously, and said: "He never came back. I've never seen that guy again.

"And not long after, the *Soup Cans* were worth virtually what I paid for them."

Money glimmered all around. Artists were in the glossy magazines. Parties were given for them in Palladium. There were fits and starts of righteousness. An essay in the Whitney Biennial catalog, co-signed by the three curators, Richard Armstrong, Richard Marshall, and Lisa Phillips, took the high road, observing: "We have moved into a situation where wealth is the only agreed upon arbiter of value. Capitalism has overtaken contemporary art, quantifying it and reducing it to the status of a commodity. Ours is a system adrift in mortgaged goods and obsessed with accumulation, where the spectacle of art consumption has been played out in a public forum geared to journalistic hyperbole."

The essay also warned against "the spurious authority of a collectors' consensus."

An artist told me that reading it gave her the chills. "It's like listening to a deathbed conversion," she said.

It was possible to be overly moralistic about this. The critic John Berger, writing in 1965, had disapproved greatly of the fact that Picasso had stayed at London's grand Savoy Hotel in 1918. "Having 'shocked' the distinguished and wealthy, he joined them," Berger wrote. Berger also wrote, acutely, that "the greater extremism of contemporary artists is the result of their having no fixed social role; to some degree they can create their own."

One thing is plain. The attention of the American public had been caught for the first time by a handful of rich and famous artists. The arts, and any government agencies that supported them, would become a target of opportunity for the right.

The May auctions were studied as Roman augurs would study steaming entrails. At Sotheby's, the cubicles above the main salesroom looked like overstocked aquariums. A. Alfred Taubman was with a group in a lit booth. In a darkened one alongside, a young blond woman in a scarlet dress, wineglass in hand, could be seen floating close to the glass, while a Japanese man just to her rear seemed to have his head grafted to a glimmering white telephone.

The Auction Star was a Pollock that fetched $11.55 million. Jeffrey Deitch, who bought it for a client, showed off a scrap of paper he had been slipped, rock groupie–wise, reading DEAR J — YOU ARE A GENIUS. Only seven pieces in the sale failed to find buyers. When is it going to stop? I asked Lucy Mitchell-Innes. "When is it going to stop?" she repeated reprovingly. "It *isn't* going to stop."

The soufflé distended the following night at Christie's. Fifteen artists' records were set. More remarkably, two of these had been set just the night before. A box by Joseph Cornell went for $418,000. The Cornell box at Sotheby's had gone for $220,000. An Ellsworth Kelly at Sotheby's had gone for the artist's personal best at $577,500. At

Christie's, a Kelly reached $715,000. These coups were attended by murmurous applause, which reached sonic peaks with those two perennial bellwethers, Andy Warhol and Jasper Johns.

The Warhol was *Shot Red Marilyn*, so called because it had been among the works bullet-holed by the artist's murderous wannabe, Valerie Solanas. It doubled its estimate and went for $4.07 million. The Johns was a 1959 painting, *Alphabet*. It is very small, eight by fourteen inches, and it had been put into the sale by Barbara Jakobson, who was sitting, lemur-eyed, her glasses atop her shiny dark hair, alongside Leo Castelli. This was no accident. Leo Castelli had sold Jakobson the painting in 1961 for $450, allowing her to pay in three installments. At Christie's it reached $3.52 million. According to the instant calculations of my neighbors, it was now, inch for inch, the most expensive painting in the world. A man said, "I'm very rich. I can't even afford to underbid anymore."

Later, I dined at Odeon with a group that included Castelli, Larry Gagosian, and a couple of artists, Brice Marden, and a younger artist, a Conceptualist straight from the "unofficial" art world of what was still called Leningrad, who worked under the name Afrika. Even the dealers seemed shell-shocked. "It's hard to like a painting that's not expensive nowadays," Gagosian said. "It's like a beautiful woman in a cheap dress. You have to look very closely."

It was mentioned that Jasper Johns had just bought *Bathers*, an iconic Cézanne. "Only Jasper can afford a Cézanne," Gagosian said. Castelli said, "Only Jasper and *you*, Larry." They talked of the red Warhol. "I had to dust that when Rauschenberg owned it," said Marden, looking back to his days as a studio assistant. Larry Gagosian and Leo Castelli began speculating about the future, which they did with delighted bafflement. Neither mentioned any likely end to the boom. "Even the Getty is out of it now," Gagosian said.

I wondered what the artists were feeling. Marden was listening but saying nothing. I turned to the young Russian. How did he feel about an art world where all that anybody talked about was money? He gave a gleaming smile. "It's great," he said.

On June 6, I dined with Mary Boone in Sette Mezzo on Lexington Avenue. She was in a silvery-green Norma Kamali, and gleeful. One of the things buoying her was the fact that she was suing Jeff Koons for calling her "a compulsive liar." Might it not be a problem that Koons and David Salle were close? "He isn't close to David Salle. Not as close as I am," she said. Just a few days before, another dealer had told me that Salle had gone to Larry Gagosian. This turned out to be true.

On one subject Boone was irritable. "I'm sick of people copying me," she said. What she felt was being copied was the perfectionism of her catalogs, and certainly the catalogs were remarkable—and cost her between $2 million and $3 million a year. She had paid Gore Vidal and Jean Baudrillard, respectively, $25,000 and $35,000 to furnish text for catalogs, and when it came to the Roy Lichtenstein *Mirror Paintings* catalog she had paid $100,000 just for the silver endpapers.

The Koons case was, sensibly, dropped.

At the beginning of the decade, Kentucky magnate Wendell Cherry had set a record for a twentieth-century artwork by paying $5.3 million for the early portrait canvas *Yo Picasso*. Cherry had said he would be giving it to a museum one day, but hadn't said when. Instead, it went to Sotheby's and it reached $47.9 million at the May sale. At the end of July the auction house announced that its sales had topped $1 billion in the second quarter alone and that it was looking toward an "extremely active" fall. Among the collections it would be dispersing was that of John T. Dorrance, Jr.

Sotheby's did *not* announce that it had gotten the Dorrance pictures by offering a guarantee. Christopher Burge was dead set against guarantees to sellers or loans to buyers, so Christie's hadn't had a ghost of a chance of a shot at the haul. William Acquavella, a private Manhattan dealer with a gallery on East Seventy-ninth Street and very deep pockets, offered the Dorrance estate a guarantee of $100 million.

Sotheby's upped this to $110 million. Rather unusually, this wasn't an aggregate of guarantees on individual pieces but on the whole she-bang. They got the sale.

Some at Christie's, worrying at the prospect of other estates going the way of the Dorrance, began suggesting to Burge that he adopt something on the lines of the Sotheby's system of loans and guaran-tees. This machinery had theoretically been in place since the early 1970s but had only achieved its current efficiently humming splen-dor beneath the suzerainty of A. Alfred Taubman. It was pretty simple. The house would agree to a guarantee to a seller. This committed the house to forking over that sum even if the goods never reached that hammer price, in which dismal case the house would swallow its losses or hang on to the work to sell it later. A loan would be made to a buyer. This would normally be 50 percent of the hammer price of what was being bought, and would be at an interest rate that could be as lofty as 4 percent over prime. If the borrower stiffed Sotheby's, the house got to write off its loan against taxes and could sell the artwork on its own, hoping for its new, quasi-fictional value.

This system, which put Sotheby's in cahoots with both sellers and buyers, was in effect a cash-flow machine, and one of dazzling effi-ciency in an inflationary time. It was also questionable. The censori-ous, including several dealers, pointed out that anybody who might try it in a regulated commodities market could have been looking at hard time. "We don't hear that from dealers to whom we lend money," David Nash of Sotheby's told me, a bit irritably. The system was a machine that could go wrong if things started deflating, but there seemed no fear of that.

Certain collectors seized the time, just as Sotheby's had. Among the most audacious was Asher Edelman, a paradigmatic fig-ure of the times. He was a financial raider, who would build up hold-ings in a rich, stagnant company, then move in to take control, his

most conspicuous success being with Canal Randolph, a corporation that owned the biggest cattle stockyards in the United States. As such, Edelman was routinely mentioned alongside the likes of Carl Icahn, Ivan Boesky, and Sir James Goldsmith, but he was also a consummate lone wolf, with an oddly righteous streak. In 1979, Edelman took up another iconic business of the period, risk arbitrage. He built a mighty personal fortune and began accumulating Contemporary art as obsessively as he had built up power and money.

A man with round, brilliant eyes and an alert unflappable manner, Asher Edelman was not bashful about his role in the art world. "Museum patronage and critics' opinions have never had much to do with art actually happening," he told me. "Art actually happening has to do with the marketplace. Go back to the Medicis if you like, or any period of history. So although it's kind of a hog pit out there, it's also wonderful."

How many collectors wield that sort of actual power over the art? "There are a lot of people who collect paintings who have no significance in being on the leading edge or making something happen in the world of art," Edelman said. "Of those that are profound and sensitive thinkers, there's Peter Ludwig . . . Charles and Doris Saatchi . . . I would *like* to include myself in that. I would say fewer than ten in the world."

Edelman now made two business moves to prove his point. The 1988 annual report of Canal Capital, his holding company, predicted that "ancient art collecting will attract the next wave of international investors." Through a new subsidiary, Canal Arts, Edelman made $10 million available to Edward Merrin, a Manhattan antiquities dealer, and invested $2 million in a brand-new antiquities gallery, Daedalus, to be run by a young dealer, Tom Swope, who had run the antiquities side of the Robert Miller Gallery. In December 1988, Merrin, beating off another famous dealer, Robin Symes, who was bidding for the Getty, paid $2.09 million for a nine-inch Cycladic head carved in white marble in about 3000 B.C. that Sotheby's had estimated would go for between $400,000 and $600,000.

Merrin said that the "steep ascent" in the prices of antiquities had begun just after and directly because of October 19, 1987 — "Black Monday" — and investors' consequent loss of confidence in the stock market. He also said Edelman's $10 million was for the first year of operations and that Edelman had promised that $50 million would be available. Predictably, not everybody was over the moon at the entrance of private enterprise into such a scholarly field. "It's just the worst possible development," Clemency Coggins, a specialist at Harvard's Peabody Museum of Archaeology and Ethnology, told the *New York Times.*

Asher Edelman's other stroke was bolder. Jules Olitski, a New York artist, had had a thoroughly frustrating career. Originally a Color Field artist of the same generation as Morris Louis and Helen Frankenthaler, he was acclaimed early but had been sidelined by the Minimalists and Pop. Recently, Olitski had taken to working thick, ripe pigment into roiling swirls, loops, and eddies. Clement Greenberg had told me that Olitski was "America's greatest living painter." The respect he enjoyed, though, was the sort given a worthy, unread poet.

In the fall of 1989 Edelman signed Olitski to a five-year exclusive deal. The work was to be marketed by Salander-O'Reilly, a gallery on East Seventy-ninth Street that had been carefully making a corner in this school of abstraction. There was a four-page agreement between Salander-O'Reilly and Canal Capital, which was co-signed on November 30 and which included an "Annual Olitski Guarantee" of $300,000. Appended to this were five pages listing some fifty paintings, with the cost of the work to Canal, the former retail value, and the new retail value, which was in most cases about double the old.

The intention of the operation — which Larry Salander of the gallery cheerfully called "the Olitski Project " — was clear-cut. The Boom had driven the prices of the new classics — Johns, Lichtenstein, et al. — out of the reach of a well-heeled segment of the market. Asher Edelman had singled out an undervalued artist, just as he had used to research undervalued stocks and neglected companies. Some saw the operation as that only. "It seems to be more in the nature of a finan-

cial operation than a labor of love," Leo Castelli told *Art & Auction*. Asher Edelman demurred. "I have owned Olitskis since 1970," he said. Indeed, he hung a huge one, like crusted magma, on a wall alongside an ethereal late de Kooning.

Jules Olitski at least makes paintings. Avid collectors were casting their nets around and pulling out every sort of underknown and difficult art. Sometimes the market-driven reappraisals were overdue. The reputation of Eva Hesse had long been mantled in shadows, because she was a woman and had also died young. Now Hesses were showing up in international shows and getting good prices at auction. Works deliberately made to confound the market were proving to be thoroughly collectible, too. A Sol LeWitt wall drawing fetched $28,000 at Christie's. Gagosian was offered $20,000 for the padlock to Chris Burden's locker in Irvine (he turned the offer down). The dealer Paul Kasmin offered Guy Debord's *Memoirs*, a book published with sandpaper covers so that it would destroy any book beside it, for $1,000. In 1990 a can of Piero Manzoni's *Merda d'Artista* fetched £38,000 — $67,980 — at Christie's, London.

It was Robert Hughes's *Time* magazine cover story "Art and Money," published on November 27, 1989, that alerted me to the return of Bo Alveryd. Hughes, who gloomily prophesied that the gallery system might become dominated by six or seven Brobdingnagian dealerships, noted that Alveryd had just spent $70 million on art in London in one weekend, merely en route to the mother lode in Manhattan. Alveryd was holed up in Morgan's hotel on Fortieth Street and Madison Avenue.

Bo Alveryd claimed not to have read *Time*, so I showed him the sentence about his activities. He read it. "The figures are wrong," he said. So he hadn't spent $70 million? "It was much more. Double of that," he said.

He was not, he took pains to point out, buying on his own ac-

count but in the interests of an organization he called the Roc Group. How had this startling change in his fortunes come about? The big man eyed me in silence for a while, then said there was no mystery. He had simply grown bored with low-level picture pushing. "I didn't feel comfortable with these dealings," he said. "You buy a painting and you sell it. Sometimes I didn't even look at the painting."

He had moved to Switzerland, and pondered. "I think art is the only value you have. Diamonds and so on, it's rather boring, isn't it?" he said. A friend had introduced him to somebody with access to one of the biggest industrial fortunes in Europe. The man had been dazzled. The funds twinkled into existence.

Was Alveryd going to found a museum? "It will be some kind of museum," he promised. "But museum for me is such a dead word. It's dead, isn't it? Here in the States you can sell from a museum, but that's not possible in Europe. When a painting comes to a museum, it's *there*. You can't sell it."

So the difference between the dead and the living is that the living is the stuff you can sell. How much dough was there behind the Roc Group? "A couple of billion," Bo Alveryd said.

In January 1990, Stuart Greenspan, an art writer for the *New York Observer*, looked back at the 1989 season and noted it was "time either for the $100 million painting to come along—I'm surprised it hasn't happened yet—or the market to retreat a bit and get real." Actually, the notion of the $100 million painting was floating tantalizingly around, rather the way the notion of the $10 million painting had floated around, astonishingly enough, just a year before. In March, Christopher Davidge, a poobah at Christie's, announced that the house had made a guarantee to the heirs of financier Robert Lehman on the sale of five paintings in May. Diana D. Brooks of Sotheby's promptly denounced Christie's as "hypocritical." "It is very clear that Christie's has caved in to the demands of the marketplace. They have thrown

their ideals to the winds," David Tunick, a Manhattan dealer, told Rita Reif of the *Times*. He added, "I don't blame them."

The malling of SoHo proceeded apace. The artist Ed Ruscha ran into Leo Castelli outside 420 West Broadway and asked what some busy construction under way next door could be. "A boutique, probably," Castelli said equably. He was right. Galleries were proliferating like fish in a plankton-rich sea. Michael Werner, now separated from Mary Boone, opened wood-paneled premises on the Upper East Side. Arne Glimcher, doing his bit to prove Robert Hughes right about the rise of the mega-dealers, opened at 142 Greene Street on June 28, 1990, with a show of sculptures by Julian Schnabel. As bashful as ever, Schnabel looked over his sculptures, compared himself to David Smith, and said thoughtfully: "I can't think of any other sculptor who holds the ground that well."

The most remarkable collection of new galleries was in a four-story building that had once held a bakery, at 130 Prince Street. These included small spaces run by conceptually minded gallerists—a word recently borrowed from Europe as more lofty than dealers—like Andrea Rosen and Christine Burgin. Perry Rubenstein opened with a group show of paintings. "The St. Valentine's Day Massacre!" he crowed. "That's the day to get out there and kill them!" Other spaces were occupied by Luhring Augustine, who had moved from Fifty-seventh Street, and the Louver, a new Manhattan outpost of the Los Angeles gallery; but unquestionably, the most talked of space was that occupied by the unsinkable Tony Shafrazi.

Shafrazi had the whole top floor. It was filled with a creamy light, its walls were white as milk, and there were fifteen thousand square feet of poured concrete that glimmered like gray pearl, so it had the Rich Bohemian look, like a four-star monastery. The rent was $36,000 a month, but what few could figure out was just what Shafrazi was planning to put there, since he now represented relatively few artists. "For Tony it's like the ballplayers in *Field of Dreams*" his downstairs neighbor Perry Rubenstein said. "They will come!"

* * *

John Baldessari was a beneficiary of the Boom, partly because the success of such CalArts artists as Salle, Bleckner, and Eric Fischl had focused attention on the work of their teacher. He had taken a loft on Jane Street. "Lately I've been selling things. That's why I'm not teaching this year," he told me in the spring of 1990. He was alert to the downside of the Boom. The rocketing of SoHo property values was making it increasingly difficult for artists to survive there while they waited for their break. The Boom was also rough on scholarship. "More and more museum people are getting unhappy with their low salaries," Baldessari said. He reeled off a list of curators who were reportedly to be wobbling, nationwide. "They see a lot of money out there," he said. "They're all playing footsie. But so far no wedding bells."

He had just been discussing a rather startling scenario with Nicholas Logsdail of London's Lisson Gallery. "The auction houses might try to bypass the galleries," he suggested. "They would approach certain blue-chip artists and offer to pick up their whole output and sell it off at auction." Why give a dealer 50 percent when Sotheby's or Christie's would be content with just 15 percent? "I know somebody's going to crack the ice," Baldessari said. "All the apparatus is in place. As the prices go up, there's a lot more scum around. Because of the smell of money." Thoughtfully, a bit wistfully, he added, "I have this other theory, which has not materialized. It seems like there should be the rising up of a lot of Hair Shirt artists. Wouldn't you think? Prophets in the Wilderness, warning about the excesses."

Actually, the excesses seemed ever better organized. *Globalization* had become the voodoo word, a charm to ensure against any plunge, and high-tech systems with names like Centrox and Thesaurus were being made available to guarantee it. Centrox was offering a World Auction Monitor—code name WAM—that could fax subscribers images and details from 170-plus international auction houses. Another Centrox service was advertised thus: "What have Warhol paintings sold for recently? Do you want to know how much your art is worth? Are any Matisse oils coming up for sale? Centrox State-of-the-Art: Search through millions of art records—in seconds."

This was one way of taking the drudgery out of looking, but more traditional kinds of entrepreneurs were springing up to service all the brand-new art lovers. Godfrey Barker, the salesroom correspondent of London's *Daily Telegraph* was sent a letter in February that read: "Urgent. I have located the following paintings. They are available for private sale (very private sale)."

The writer, a woman called Jai Andrewartha, gave addresses in New York and Hawthorn, Australia, and identified herself as representing the "Pirada Art Fund." She listed two Gauguins, several Monets, a Picasso, and five van Goghs, and she gave a collective valuation of $435 million. Interested parties were asked to send a "refundable deposit" of $5,000. Interestingly, van Gogh's *Irises*, which Alan Bond, whose empire was tottering, was known to be trying to unload, was listed among the van Goghs. Doubtless, Ms. Andrewartha was pure as spring water, but the Pirada deal was typical of what was going on in an increasingly active netherworld of art entrepreneurs.

This was to some extent a payback for the the Art Stars' lavish media coverage, which got art the attention not only of the religious right but also of criminals. Art theft, like vandalism, has always been with us, of course, like fire, war, and flood, perhaps as human nature's way of preventing us from being smothered with past art. Sometimes art crimes have mirrored the specific preoccupations of the culture at a particular time. In 1974 the theft of a Vermeer in London was followed by a demand for half a million pounds sterling worth of food, which was to be distributed on a Caribbean island, this being a copy of demands made after the kidnapping of Patty Hearst. Such woozy idealism played no part in the late 1980s crime boom, though. In May 1988, IFAR, the Manhattan-based International Foundation for Art Research, which keeps files on art theft worldwide, reported that there had been "twice as many gallery break-ins in Manhattan as the year before." That same month, a van Gogh and a Cézanne were among work stolen from the Stedelijk, Amsterdam, and in December three more van Goghs were taken from the Kroller-Müller Museum, also in Holland. Call it the *Sunflower* syndrome. Works by the artist who famously had sold only one canvas in his life had become treasure.

By 1990, again according to IFAR, the art-theft business was tak-
ing work valued at between one and two billion dollars a year out of
the system, which were also the given rough parameters for the legiti-
mate art traffic. That April there was a massive heist from Boston's
Gardner Museum, after which Sotheby's and Christie's jointly ponied
up $1 million as a reward for the works' recovery. Robert Hughes wrote
in *Time* that theft was "the blue-collar side" of a system that had turned
artworks into "crass totems of excess capital." He described the reward
offer as "a touching p.r. gesture, like a cigarette company giving money
to a cancer ward." One clumsy thief had actually sat on a Vermeer in
the back of a getaway car in the course of a different felony. Hughes
told me: "He crushed it like an eggshell."

One more statistic is provoking. The recovery rate for stolen art
is held to be a stable 10 percent. Some of the remainder winds up in
countries where the statute of limitations is short, like Japan, where
the work's new owner enjoys full legal rights to it after five years. But
the bulk of stolen work just disappears. That fall, somebody walked
out of a Berlin museum with an early Lucian Freud, a pellucid por-
trait of Francis Bacon executed on copper. It is a famous image and
impossible to sell legitimately. "Lucian called me in a state of some
botheration," Robert Hughes told me. "At the end I said, 'Lucian, you
can at least take it as a compliment that somebody out there really
loves your work.'

"Lucian said, 'Do you really think so? I don't think so. I think
somebody out there really loves *Francis*.'" Hughes chuckled, but
added, more somberly, "They'll probably never get it back."

Irving Blum was nervous. We lunched in the spring of 1990 a
few days after I spoke with Baldessari, and Blum was still goggling over
the fact that a painted pot by Keith Haring had been sold at Sotheby's
for $220,000. "It's lunacy. It's lunacy," Blum said, repeating himself
in his trademark fashion. "It's like a gold rush. Everybody is saying,

'My God! A Brice Marden drawing went for half a million dollars. Let's go out and buy drawings!'

"A Kounellis just went for half a million dollars. It's unheard of. Unheard of! Kounellis had never gone for over two hundred thousand. Two million dollars for a Ryman painting! It's unheard of. Everybody knows that there's something very peculiar going on."

One of the things going on was that the auction houses were carrying out Peter Wilson's threat of years before and clobbering the dealers. What advantage would there be in taking a painting to Blum-Helman rather than popping it into an auction? "None," Blum said. "Unless I had a particular client for it who was willing to pay top price. Even so, if you're a bit of a gambler, you'd go to an auction house. I still represent a stable of artists, but my background business has almost dried up. And that was the lion's share of my business.

"We are in there, pitching. But it's extremely competitive, very difficult. In order to buy a black Stella, which we would ordinarily do, and have done in the past, it's now five million dollars. It stops you dead in your tracks. A Lichtenstein, a cartoon painting, is five million dollars. All of these guys."

So it's like poker? You have to have enough on the table to take ten big losses? Blum agreed vigorously. "Exactly! Fifty million dollars' capitalization is what you need."

How were Gagosian and Boone keeping their respective acts together?

Irving Blum's Cary Grant eyebrows worked, and he chuckled ripely. "Ah, Gogo! He's in everyone's heart and mind," he said. "He's putting it together by doing it far more dangerously than anybody else—offering *enormous* sums of money. In an up market he's successful. But everybody is waiting for him to have a misstep.

"Mary is very strong. But even Mary is having a hard time getting product. When things sell, artists are kind of reluctant to give you work. They don't need the money that badly—they would rather hang on to the paintings."

One of the more striking victor/victims of the art boom was one
of Mary Boone's strongest artists, Brice Marden.

At first, this seemed odd. Few had benefited more from the
giddy market, both materially and in the close attention paid to his
work. When Schnabelismo had blown along, Brice Marden—like the
Minimalists—had rather lost his purchase on art-world attention. Inter-
est in his work had blossomed again in the mid-1980s—partly because
of the coming of Neo-Geo—ironically, because he wanted to move
on. "I got to the point where I could go on making 'Brice Marden
paintings' and suffer the silent creative death," he told the magazine
Flash Art, adding, "You get stuck in an economic bind. You think
you're being very independent and that you're not locked into some
market. Then, twenty years later, you find that you can't change the
way you paint."

Something else needed changing—his life, which also had been
on a trajectory not uncharacteristic of the times. He drank and used
drugs. The effects on his work were various. "I don't think drinking
had much of an effect on what I was painting," he said. "What I *thought*
had an effect on what I was painting was drugs. I used grass *a lot*. You
would work, and then you'd take a smoke and look at the paintings.
And you'd be getting your insights that way.

"But then I started using cocaine. I would just end up walking up
and down the studio all the time. Cocaine's a really shitty drug, you
know." He knew he had to cut it out. Sadly, this meant cutting out
the other stuff too. "The most difficult thing to give up was grass. But
for me it was, well, what do you want to do? Do you want to do drugs, or
do you want to be a painter? I thought it would be much more interest-
ing to go on and be a painter. It was like a professional choice."

His main problem was getting accustomed to the notion that he
could work without smoking grass. "I had a six-month block," he said.
It was a fruitful block, though. When he did get back to work, he began

moving into a new landscape of forms. After twenty years, he aban-
doned the double Monochromes and began covering his canvases with
wavy traceries of strong or blurry lines. They derived their power both
from forms found in nature—like the twigs and shells displayed in
Marden's studio—and from Chinese methods of manipulating line,
which he had seen in works to which his wife, Helen, had drawn his
attention. Marden, in short, had made what history loves and the
market loathes: radical change of style.

Certainly Mary Boone had not been overjoyed. She had, after
all, advanced a million dollars to a painter who had promptly stopped
making his signature work. She had shown seven of the new Mardens
in 1987. None was priced at more than $100,000, while the Mono-
chromes were several times that. "I probably offered them to thirty
collectors before they were sold," she told Paul Taylor. She also told
the writer of her strategies with slow-moving artists: "Get them into
debt. What you always want to do as an art dealer is to get the artist to
have expensive tastes. Get them to buy lots of houses, get them to have
expensive habits and girlfriends, and expensive wives. That's what I
love. I really encourage it. That's what really drives them to produce."

Within two years, the Marden canvases were $125,000 and sell-
ing so briskly that he had earned out his advance from Boone. Larry
Gagosian approached him in the fall of 1989 and said he wanted
Marden to be his new gallery's first artist. Marden, who had often been
irritated with Boone, talked the offer over with a lawyer and told Boone
about it directly. She was incandescent. Items about the tug-of-war
between the most gossiped about dealer of the first half of the decade
and the most gossiped about dealer of the second were soon pepper-
ing the gossip columns.

For Brice Marden, though, the experience was no less painful
for being at such an elevated financial level. "I don't make paintings
to make speculative objects," he said. "I make paintings to make con-
templative objects. I've spent years keeping *out* of some collections.
You're trying to make art. But it always seems to me that there are these
forces trying to stop you. There's always something.

"At the beginning they try to make it too expensive so that you can't do it. Then you get to some level that you never dreamed possible. Not only am I making my living by making art, but I'm making a lot of money at it. You don't go into it thinking that's what you're going to do. But still.

"But you only have so much time. Ideally, I should be able to put forty to fifty hours a week in the studio. I don't do forty or fifty hours a week in the studio . . . I do this, that . . . this, that . . ."

This and that what?

"Business!" Marden said, with a kind of a strangulated laugh.

Because of the money you're making?

"Yes! Taxes . . . this, that . . . you can be involved or you can be *not* involved. But if you're not involved, you tend to get ripped off." Again he said, "There's always something."

Marden said, "Everybody worries about Larry Gagosian. But nobody *writes* about why everybody worries about Larry Gagosian. Also, nobody mentions that Larry Gagosian is the only art dealer in New York that's *doing* anything—exercising some creativity in what he's doing. It's always blah blah blah. They're just jealous that he's putting on great shows."

Marden took soundings from a few friends. Restaurateur Brian McNally strongly recommended Gagosian (and was promptly accused by Boone of being offered a slice of the deal). John Yao, a poet and critic, said he felt ill equipped to offer advice. "I make thirty thousand dollars a year from my writing. What can I tell Brice?" he said.

Finally Marden decided to stick with Boone. The reason, as expressed to writer Deborah Gimelson, was none of the above, but rather because on a visit to Gagosian's premises, Marden saw a giant canvas by the nineteenth-century French academician—and foe to the Impressionists—Bouguereau. It was "a painting that I feel goes against everything a modern artist is about," Marden said. "He had it there to stay in good with Sly [Stallone] and didn't understand why I took umbrage at its presence.

"This doesn't mean we've stopped talking, though. I didn't say a definitive no. I said no for now." Indeed, Marden helped Gagosian put together a show of work from the 1970s, the *Grove* paintings.

David Salle *did* go to Gagosian in October 1990. Mary Boone publicly ascribed the move to the artist's "midlife crisis," and it was noted that he had also had plastic surgery. I once asked him why he had bothered. "It's a private decision" he muttered. Boone sold off some gifts Salle had made her of his work.

What distinguished the later 1980s were Rumor Offensives that seemed strategic rather than opportunistic mushroomings, and Mary Boone became a hard target. Stories that her gallery was in financial distress, which had started being repeated in the fall of 1989, became epidemic in 1990. Several people, I being one, were sent a mailing, a single sheet of paper of (authentic) Boone stationery upon which was written in the same distinctive typography:

BASEMENT SALE TO 70% OFF

Boone publicly accused Gagosian of hiring Linda Robinson, a publicist who normally worked Wall Street terrain. He denied this vehemently. "A lot of people are reveling in Mary's discomfiture," Perry Rubenstein told me. "It's a media tease that is poorly researched."

Tales of artists quitting their galleries ran wild. Many of these tales were spawned by malice of fantasy, and some were based on discussions that went nowhere, but several were cold fact. Georg Baselitz left the post–Michael Werner Boone gallery for Arne Glimcher's ever-growing Pace Gallery, and Donald Judd left Paula Cooper for the same destination. "Artists today are like baseball stars," Cooper told Grace Glueck of the *New York Times*, adding that "conditions are now so uncertain in the art world that big galleries willing to give artists large stipends win out." A Boone lunch with Chuck Close, who was also with Pace, in Glueck's words, "busied phones and fax machines from here to Tokyo," and Richard Artschwager went to Boone from Leo Castelli.

"Leo was devastated. Devastated!" a woman friend of Castelli's told me. "He only has two artists to himself now, Roy and Jasper. He has been going around saying, 'Well, at least he went to a friend.'"

I visited Mary Boone in her apartment on the Upper East Side soon after Leo Castelli's eighty-fourth birthday party, to which she had not been invited. "Do people think I am biting the hand that fed me?" she asked with her usual laser intensity. The child she adored was somewhere out of sight. Everything in the apartment looked under control: climate control; visual control; dust control. Three spotless silver litter bins were lined up on the black-and-white-checkered kitchen floor, as though set there by Haim Steinbach. Boone admitted that she had been spooked by Larry Gagosian, her mongoose to his cobra. Trying Gagosian tactics, she had paid through the nose for a de Kooning in which she knew Gagosian was interested. Ill suited to that game, she had taken a hefty loss.

Boone was avid for the latest rumors, but said, "None of my artists left me because of money. Julian wanted to get away from me. And away from David." She was not even close to going bankrupt, she said. She had $5 million in inventory and $2 million in the bank. She called the rumor campaign "the Watergate of the Art World." No wonder there was little slow or quiet about a journey through the art landscape in those days, few zones of contemplation or renewal. It had taken on a heated, garish quality, like the set for a game show.

There has always been bad blood between Sotheby's and Christie's. Now it was bubbling like boiling tar. A panjandrum at one house had to threaten legal action against the other for circulating gossip that he had secured an estate by sleeping with a distinguished legatee. The Japanese were using the auction system for money-laundering operations of glassy transparency. Paul Quattrocchi, an art dealer, observes that the buyer would report that such-and-such a sum had been spent. The corporation would dutifully send it over. What-

ever was necessary would go to pay off the auction house; the rest would be posted to the buyer's personal account. "And this was at public auctions, not private deals. It was amazing. There was consternation in Japan when newspapers started publishing the real sales figures," Quattrocchi says. But the financial signals coming from Japan were a dissonant jangle. Shigeki Kameyama, "Mr. Mountain Tortoise," had failed to unload the Picasso and the de Kooning that he had bought at Sotheby's in November for $45 million-plus. He tried to get Sotheby's to take them back. No deal. David Nash paid him a covert visit and negotiated to take on consignment ten other canvases, each worth over $1 million, to help pay off the debt.

There was worse news about *Irises*. It had been the $53 million sale of this painting to Alan Bond that had done more than anything to calm Black Monday jitters. It was now revealed that Sotheby's had advanced Alan Bond half of the dough and that he had been unable to make good on the loan. In January 1990 Sotheby's announced that it would no longer allow a buyer to use an actual artwork as collateral for a loan toward its own purchase. The house also sold a Bond-owned Manet, *La Promenade*, but was still well out-of-pocket. A poor sport, Bondy denounced Sotheby's, claiming that there had been no real underbidder and that the auctioneer had been, as they say in the trade, "selling to Mr. Chandelier." It was a fine grace note to the art world of the 1980s to learn that Bond had been claiming annual depreciation on his art. He listed it in the same category as office furniture.

In the event, the Getty bought *Irises* for an undisclosed sum, sparing Sotheby's further embarrassment over the affair. In January 1990 the auction house announced that it would no longer sell "on margin," which is to say lend money when the art was collateral for the loan. It had also become known that Sotheby's had taken a beating on two sales, the Dorrance being one, on which it had given inflated guarantees. A few days before the May sales, its fledgling Manhattan rival, Habsburg Feldman, had a memorable fiasco, a sale of art in which estimates had been between $35 and $47 million and the take had been $1.8 million.

But there were always excuses. Excellent art, it was felt, would always prevail, and many of the signals were not bad at all. In early May, the disposition of the Pierre Matisse inventory was announced. Pierre Matisse, the owner of a Manhattan gallery that bore his name and the painter's son, had died the preceding August, leaving an estate—which included 2,300 paintings by the great Modernists—highly vulnerable to the tax man. The Manhattan dealer William Acquavella told a reporter, "I realized that if I bought the shares of the corporation and took over the tax obligation, the estate would save a considerable sum of money."

Both Christie's and PaineWebber, the brokerage house, which was run by a collector, Donald Marron, had been pondering along similar lines, but Acquavella moved first and acquired the Matisse inventory for $143 million, in partnership with Sotheby's. This was another peak, the biggest art deal ever, and it was attacked in some quarters for giving the auctioneers further entrée into buying and selling. Acquavella said simply: "The deal demanded a new formula. The market has changed. It has just gotten too big for a lot of people to do it alone. I think more deals like this will come along."

The results at the London sales, which precede the Manhattan May sales, were dismal. By then, though, both houses had printed their New York catalogs, rosy estimates and all. "I guess nobody told them the music stopped," Larry Gagosian said to Perry Rubenstein. Actually, both houses were busy telephoning clients, urging them to lower their reserves. Works up for sale included two canvases of which any museum would be proud—van Gogh's melancholy *Portrait of Dr. Gachet* and a resplendent Renoir nocturne, *Au Moulin de la Galette*, each of which had spent years in private American collections—and each carried an awesome estimate of between $40 and $50 million.

Just before the sales, Robert Hughes was pensive, uncharacteristically ambivalent. "A sixty million dollar sale on the Renoir would certainly boost confidence. But it wouldn't boost it right across the board. Do you think it will make sixty?" he asked. He wondered

whether the Getty might not be the safety net, then said, "But everything feels kind of weird . . . tremulous . . . *iffy* . . ."

Dr. Gachet went up at Christie's on May 15. Burge opened the bidding at $20 million. Three bidders, one of whom was Thomas Ammann, propelled it upward at a million bucks a shot. A Tokyo dealer, Hideto Kobayashi, jumped in at $39 million. Curiously, there was only tentative applause when the bidding reached $50 million, erasing the ill-fated record set by *Irises*. There were just two bidders left—Kobayashi, and somebody on a telephone. When the bidding reached $75 million, Burge dawdled seductively a full minute before bringing a reluctant hammer down.

Au Moulin de la Galette was gaveled down at Sotheby's by John Marion two nights later. The tag: $71 million. Both had been bought by Ryoei Saito, a magnate with a paper factory close to Mount Fuji. Percentages added, he had paid $160.6 million for the two canvases, and said, "I feel like riding to heaven." He added that he had been ready to go to $100 million apiece. So the $100 million painting had come . . . *that close*.

The Art Treasures were just that—treasure. A fine Manet had failed to reach its reserve, though, and work by de Kooning, Basquiat, and Eric Fischl had been trounced. Robert Hughes had been on the button. The mood as we left both auction houses was weird . . . tremulous . . . iffy.

Later, the individual events would seem like the loud reports that herald the breakup of an ice pack. They had seemed part of the normal to-and-fro of any market at the time. Alan Bond's problem had appeared to be just that—*his* problem. When Centrust, a Florida savings and loan, sold its corporate collection in November for a whopping loss, it raised few eyebrows because it was a rotten collection.

The May sales in New York made just half of the expected $100 million. Saddam Hussein's army invaded Kuwait in August. Oil went to forty-two dollars a barrel. Tokyo's Nikkei Index slumped. Ripples hit Europe. In November, Souren Melikian predicted in the London periodical the *Art Newspaper* that there would be "a slide of 30 to 50% in everyday stock." But before the November sales in New York, Tomonori Tsurumaki, who had paid $51.4 million for Picasso's *Les Noces de Pierrette* the year before, predicted that there would be more, not less, Japanese buying.

Lot seventy-three at Sotheby's on November 6 was *Anh in a Spanish Landscape*, a plate painting by Julian Schnabel. This had been bought as recently as 1988 by a young couple, Patrick Painter, a Canadian, and his girlfriend, Winnie Fung, the daughter of a Hong Kong billionaire. "We had never really bought art before. But there was all the brouhaha, so we decided to start," Painter told me later. They called one of London's most prominent dealers, Lesley Waddington, and said they wanted to buy three of the plate paintings. "He said, 'Fine. If we sell them to you, you have to have the money here in twenty-four hours.'"

The couple came up with the dough and bought the three Schnabels—portraits, of Ross Bleckner for $95,000; of Joe Glasco for $125,000; and of the artist's then girlfriend, Anh, for $225,000. Painter and Fung split up, though, and agreed to dispose of some work. Painter decided to sell *Anh*, called Sotheby's, and spoke with one of the specialists on Contemporary art, Anthony Grant. "He said they would profile it and it should do very well," Painter says. He also called Julian Schnabel, whose acquaintance he had made at the Bel Air Hotel in Los Angeles, and asked if he could put it up. Schnabel wasn't over the moon about it, but acquiesced in the sale.

It had an estimate of $350,000 to $450,000. "It was a disaster," Painter says. "I was shocked." There was a hush at first when the painting didn't sell, then a burst of harsh laughter, then applause. It seemed appropriate in a melancholy way that Julian Schnabel should have become the scapegoat for the market he had done so much to create.

When the smoke drifted off the battlefield, 55 percent of the Impressionist, Modern, and Contemporary artworks up at Christie's and Sotheby's had failed to find buyers.

Those in the trade spoke soothingly of "corrections." "What we've gone from is a very, very inflated market to more sensible levels," Christopher Burge said, manfully, to a reporter. Some of the artists were less gung-ho. Ashley Bickerton, for instance, had always been interested in the marketing aspect of art. Indeed, he had embedded digital counters in a couple of pieces included in his first solo show, at Sonnabend in 1987. The counters were set at the prices at which the pieces were sold, and were programmed to advance a cent in value every thirty seconds. "It corresponded roughly to how much pieces were going up at that point, which was ten thou," he told me later. "God! It seems so funny now . . ."

In 1990 he bought a town house. The seller was a broker who had gone bust on Wall Street while the art boom had roared on.

"I remember the day the Boom ended," Bickerton says. "It ended the day we bombed Baghdad. Everybody was watching television. They weren't interested in buying art. When the smoke cleared, all that was left was an empty shell and some tinsel."

That was January 1991. "There had been cracks in the market, but people were buying paintings. Then the war started," Lucy Mitchell-Innes says. "It switched off like a light."

The dry years had begun.

Six / The Dark Side

Many artists, including some of the best, like to be seen as solid citizens and are no more fascinated by the louche side of life than any other professionals. The art world, though, is also by tradition a preserve for bohemian temperaments and for those drawn to raffish extremes, creatures with a fondness for the demimonde, even the underworld. The Scottish artist Gerald Laing once ran into a former habitué of the Warhol Factory in Los Angeles. "He kept on saying, 'Come on, Gerald! Do crime! Do crime!' It was like, 'Do lunch!'" Laing remembers. "He was into the rhapsody of crime." A friend, then with the Marlborough Gallery in London, was a background figure during an unsettling scene when Francis Bacon, a compulsive gambler, received an unscheduled visit from a couple of hefty representatives of London's feral gang lords the Kray twins. "Well, Franny! You owe us fifty thou. You won't paint too good *without hands*," one of them reasoned, convincingly. The dealer said, brightly: "At least it got Francis back into the studio."

That said, the making of art is usually an inward affair, and often fairly solitary, pitting the artist against himself. The history of the arts is low in crimes of violence. Masaccio was rumored to have been poisoned at twenty-seven by a rival in fifteenth-century Florence, and Caravaggio killed a man in Rome, but that was over a bet on a game of tennis. Christopher Marlowe's death—he was stabbed in the eye in a Deptford tavern—was seemingly part of the scabrous Jacobean

netherworld of espionage. In our time, the attempt on Andy Warhol was the doing of a maddened wannabe. The death fall from a window of Ana Mendieta, the artist wife of Carl Andre, came after a domestic drinking bout. These events, however bleak, have antique lineaments.

Clearly, though, the mighty influx of money brought the art world sharply up-to-date as a crime scene. Artworks have proved convenient both as instruments for money laundering and as a covert international currency, in which area, if not as universally acceptable as armaments or narcotics, they are at least less likely to land you in the slammer or the earth. As early as 1982 the FBI discovered paintings had been used as collateral in Texas in a mafia case. The art world also has always been a happy home for the newest in big money, and not much money is newer or bigger than crime money. Or money from economies fattened by crime. The Colombian artist Fernando Botero has never had much support from the avant-garde establishment but commands prices in the six- and seven-figure range. It seems his vision of a gorged, infantile, roly-poly world drums up strong collector support on his home turf, Medellín.

As the amour of love and money ripened, exotic stories multiplied in and around the art world. A long-lived rumor that three leading New York dealers had been named in a sealed indictment somewhere in Europe was much investigated. To no avail. But few stories are darker than that of the artist often referred to — at least, in Holland and Germany — as the Dutch Andy Warhol: Rob Scholte.

The news that Rob Scholte and his wife, Micky, had been victims of an explosive device rigged to the artist's BMW outside his Amsterdam studio on November 23, 1994, was only cursorily reported in the American press. A policeman was quoted saying the bomb had been intended for somebody else. I learned from a mutual friend that the artist had lost both legs just below the knee, that his young wife

had lost a baby, and that the artist himself by no means felt that he was an accidental victim. I called Scholte. The explosive device had been a grenade, he said, and he was sure it had been meant for him. He added that the police now shared this view. "It's about the corruption of the art world," he told me. I flew out to Amsterdam at the beginning of February.

Rob and Micky Scholte were living under protection in a suite into which they had moved since Scholte had left the hospital a couple of weeks before. It was in the Hôtel de l'Europe, a grand hotel of the old-fashioned sort. (Modern artists, like modern architects, tend to shun *modernismo* when their own comfort is concerned.) Scholte, a handsome man with an athletic build, was practicing moving around on a skateboard. "It's strange living without legs. You get used to it," he told me. "I've done some very sad drawings."

Actually, he looked and sounded ebullient as he wheeled himself around, hoisted himself onto a sofa, and swiftly shuffled through his latest press clippings for my benefit. The prospect of meeting Scholte had, frankly, been a bit unnerving. It wasn't like dealing with somebody who has cancer or AIDS. There, language can cope. What had happened to Rob Scholte, though, had been so extreme, so gothic, that it risked forcing an inappropriate Charles Addams–cartoon response. But Scholte seemed an amiably aggressive extrovert of a sort common among actors or politicians but rare in the moody art world, and the aplomb with which he was carrying off his double amputation made my jaw drop.

"Finally, from yesterday, they aren't asking any longer, 'Rob, are you sure you didn't make a drug deal?'" Scholte said breezily, but he was serious, because a popular rumor blamed the bombing on a deal gone sour. It was, though, just one of many, many rumors. The first had been launched by a neighbor of Scholte's, a lawyer, who had been due to take the stand in a money-laundering case. He claimed that he had, in fact, been the target. This notion had now been dismissed as self-serving. Also abandoned was the theory that the bomb had been intended for other neighbors of Scholte's, parents of those involved in

the famous kidnapping of the Dutch magnate Freddy Heineken. It was now accepted that Rob Scholte had been the target. But the who and the why were other matters entirely.

"The Wild Stories About Rob Scholte," an article in an Amsterdam magazine shortly after the bombing, caught the hectic mood. "His success, both artistically and commercially, combined with his arrogant attitude: Maybe he got what he deserved" is the way the duo who wrote the piece summarized the local response. A dozen "wild stories" were cited. In one, the Japanese mob, the Yakuza, was indicating disapproval of a multimillion-dollar art project the artist was partway through near Nagasaki. Another theory, proposing that Scholte was an "out-and-out party animal and Casanova," suggested that a "jealous ex-lover, or an ex-lover of his present wife" might have done the deed.

But most of the stories blamed art-world corruption. One ascribed the hit to a gallery owner who also dealt drugs. Another pointed a finger at "a collector based on the Cayman Islands, who, 'of course,' is a coke dealer and supposedly pays for his art with complex coke deals." A nonnarcotic scenario laid the botched murder at the door of "international art speculation. Some company supposedly has been buying up all of Rob Scholte's work available on the market to inflate prices. Apparently the strategy isn't working. Rumor is company thought: A dead artist sells better."

Some of these sounded plausible. They were hokum. The Caymans, three coral sand islands between Cuba and Jamaica, are a famous tax shelter, not a haunt of collectors. Dead artists *don't* necessarily sell better. An inquiry into the car bombing of Rob Scholte requires a journey through the contemporary art world—a frustrating journey, too, with bizarre, contradictory maps.

Rob Scholte was born in Amsterdam in 1958. His father was a liberal and a successful businessman, reponsible, as an executive with

Ahold, the country's fifth largest company, for bringing McDonald's to Holland. In Scholte's art student days the youth culture was dominated by a fairly aggressive squatters' movement and by punk. Scholte wore military camouflage as lead singer with a New Wave band, the Young Lions. In 1980 he went to Berlin, the stomping ground of a crew of young Neo-Expressionists who were being touted as the coming Euro-thing, the Neue Wilde, sometimes Americanized as the Wild Bunch.

In 1982 Scholte was still at school when he first showed work publicly. It was work he made with his girlfriend, Sandra Dercks, and it was part of a sprawling show in a squat with some thirty artists. Scholte's stuff stood out. "The work got a lot of attention," he says. The next year he launched an avant-garde magazine, *Angst*, or "Fear," with a group of writers. I leafed through a copy in Scholte's studio and my attention was caught by a cartoony graphic. It showed a pair of chicken legs. They just stood there. A curling twist of smoke above each suggested the explosion that had ripped away the absent body. It was the work of Sandra Dercks, Scholte says, explaining: "She was very much in love with me. And I was in love with somebody else." Koos Dalstra, a writer who was part of Scholte's entourage, told me that Dercks had not invented the image of severed legs. It was part of the Graffiti vocabulary of the time.

In May 1984 Scholte was one of eight Dutch artists included in a show in Cologne. Neo-Expressionism was then ripe, verging on rottenness. "The time was the celebration of running paint. To me it was a farce," says the Czech-born artist Jiri Georg Dokoupil, who was then living in Cologne. Milan Kunc, another Czech painter, says dryly, "Germans, they like expressive style. You know, one-hour paintings! You paint with big brush. Very quick results. Like Penck or Baselitz. They get on my nerves."

Dokoupil represented something new. In 1980 Paul Maenz, one of Cologne's best dealers, had put him into a group show called "Mulheimer Freiheit," meaning "The Freedom of Mulheim," a jokey title for a nonchalantly shocking show of paintings, many of which

dealt graphically with bodily functions. The show was a smash. It established a persona for the Cologne School, which was post-hippieish, with plenty of Dada gestures and Bad Boy behavior, to say nothing of a determination to be unimpressed by New York.

Dokoupil took in the Dutch show and was impressed by the Scholtes. The work was slickly painted, and involved a jiggling around of pre-existent imagery. To a certain extent Scholte was channeling the same energies that were coursing through New York, the feeling that the world did not require "original" images, being chock-a-block with stuff clamoring to be used; but where Jeff Koons, Richard Prince, Sherrie Levine, and the other New York Appropriationists were deadpan and direct, presenting "reality" in single chunks, Scholte was very much the smart-alecky European with a cool eye. "I immediately responded to his work very strongly," Dokoupil says. "I bought five paintings. I brought other people to the show." Dokoupil, although just four years older than Scholte, was an Art Star. "I talked a lot about Rob's work," he says. In November 1984 Scholte had his first solo show at an Amsterdam gallery, the Living Room. The following year he had work in art fairs in Toronto and São Paulo, Brazil, and in 1986 he was accorded a solo show by Paul Maenz. Rob Scholte was en route, with high velocity, to 1980s success.

But where New York, Cologne, and London make room for the latest hotshot on the block, smaller art worlds are more fragile. Peter Schjeldahl compares Scholte's position in Holland to that of Per Kirkeby in Denmark. Kirkeby is that rarity, a Danish artist with a world reputation. "The Danes have got a dry sense of humor about it. But he's an affront," Schjeldahl says. "They wish he was dead. So that they could celebrate him." Dutch artists, what's more, were used to a peculiarly cosseted life. If somebody was accepted as an "official" artist, it meant that the state was committed to buying a certain amount of his or her work every year. This well-meaning notion created a complacent avant-garde bourgeosie, to say nothing of a swollen archive of mediocrity. It was nicknamed the Art Mountain, and it was as ugly a

feature of the Eurocratic landscape as its Butter Mountains and Wine Lakes. Fred Wagemans, an Amsterdam curator and critic, points out that Amsterdam is much closer to Cologne than are other German cities, like Munich, but that Dutch artists shrink from foreign exposure. "They are too well protected," he says. "They do not stick their fingers in the wheeling and dealing." This was the system Rob Scholte was bucking.

Successfully, too. "It's as if somebody looked at all the Dutch artists of the early eighties and said, 'Well, that's over!'" says Peter Schuyff. "All that's left is Rob Scholte." Schuyff, who was very much part of the New York art world, is Dutch-born and looked at the Scholte phenomenon with an alert eye. "You knew when Rob was in a room. You could feel the energy," he says. "Rob was very physical. He took big steps. But he had a success that people resented. In Amsterdam he's the biggest. But it's a small place. It's like *In the Belly of the Beast*: No injury is forgotten."

Scholte was impervious. His girlfriends were the most stunning. His use of cocaine progressed swiftly from the dabbling stage. "Between the middle of 1986 and the middle of 1987 I was an addict, really," he says. "But my cocaine use was always related to work—like the cabdriver who wants to work at night. I was not using it in bars and discos. I was using it to paint longer, to have more energy. I made some good paintings in that period. There was even a magazine, *Mediamatic*, that called them 'Coke Paintings.' I didn't mind. You can't see in the paintings if they were made clean or under the influence."

In 1987 Scholte showed at Dokumenta. "Rob was kind of arrogant but very nice," says Leonard Bullock, an American Abstractionist who shared a hotel suite with him outside Kassel. "I wasn't having this huge success he was having, but he would always see I was invited to the soirées." At Dokumenta Scholte was jostling for attention, though, with a bevy of his equally demanding international peers. This was not the case in Amsterdam. There he appeared in a group show at the Stedelijk Museum and put together a brothel installation, "La Vie en

Rose," a collaboration with Dokoupil, in the red light district. "My star was rising. I got so much attention I needed an answering machine," Scholte says. "I was not prepared for all the hype."

In 1988 Scholte had a show of "portrait" paintings at Paul Maenz. It included two pieces that became iconic. One, *Self-Portrait,* is a large painting of the copyright symbol with a tiny painting of the artist in the corner where the symbol is customarily found. The other is called *Derision by Two Lesbians (Linda Lovelace).* It is a collage in which one woman's head is so positioned over the pubes of the other that she appears to be wearing a beard. An accompanying essay explains that Lovelace is a pun and that Linda Lovelace was a formerly famous porno star. It concludes: "Needless to say, the objects juxtaposed are, in English slang: cunt (the female sexual organ) and the chin area in the face, where, by the way, men grow beards. When we take a closer look at the picture we discover the features of a male lead singer of a pop group (Iron Butterfly) in one of the faces. More than perhaps any other painting the story behind the image of this painting illustrates the complex interplay of meanings that Scholte uses."

That same year Scholte had his first museum show in Holland. Its insolent title was "How to Star" (in English) and the endpapers to the catalog were reprints of the current Hot Hundred Artist listings in Dr. Willi Bongard's *Art-Kapital.* There were fifty paintings in Scholte's show, not that *painting* is quite the word, because he had slammed the door on that old-fangled craft as definitively as his New York and London contemporaries, except with a can't-be-bothered attitude that was all his own. "Scholte's paintings have the impact of a poster or a magazine cover," said the catalog's introduction. "His inspiration is directed more toward the message, the content, of a work than to painterly issues. New meanings, pictorial inventions, are formed from montage of existing visual material. . . . These have to do with the flood of information with which modern society is inundated, particularly by the mass media."

In terms of art-world politics, it was to the point that the show was not at Amsterdam's Stedelijk, which had rather faded, but at the

Patti Astor with the Fun Gallery refrigerator, which has been signed by Fab 5 Freddy, Keith Haring, Kenny Scharf, Jean-Michel Basquiat (as SAMO), Zephyr, Dondi, and others, 1982. *Courtesy of Pink Poodle Productions*

Futura 2000, 1981. Futura, whose given name is Leonard McGurr, was down and out after the Graffiti movement's early death. He now sells in Europe and Japan and is fashioning work on the Internet.

Keith Haring, who had abandoned the East Village for SoHo, was splattered outside the Shafrazi Gallery by unknown assailants in 1985. Just then Leo Castelli sauntered by. A cusp moment. Especially since it was caught by Nan Goldin, whose informal, snapshotty work would make her the focus of intense art-world interest in the 90s.

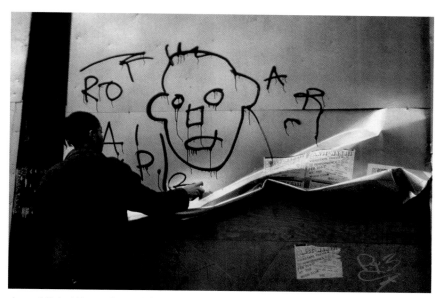

Jean-Michel Basquiat making Graffiti. A still from *New York Beat*, a movie starring Basquiat, which was lost in the coils of the Italian legal system when a producer was indicted. It should reemerge. *Image: Edo*

Peter Halley and Mayer Vaisman in the East Village Gallery, International with Monument, 1984.

Dealers Mary Boone and Pat Hearn with painter Philip Taaffe. Taaffe is now with Larry Gagosian. *Photograph: Todd Eberle*

Dealer Tony Shafrazi with painter Kenny Scharf. *Photograph: Rose Hartman*

Dealer Paula Cooper. *Photograph: Rose Hartman*

Art Chic. Invitation for an *après*-show party for Andy Warhol and Jean-Michel Basquiat at the Palladium. *Photograph: Michael Halsband*

Ashley Bickerton. *Courtesy of Sonnabend Gallery*

Jeff Koons with marble self-potrait, 1991. *Photograph: Helmut Newton*

Keith Haring. *Photograph: Tseng Kwong Chi, courtesy of Keith Haring Foundation*

Dealer Irving Blum with his Warhol *Irving Blums*. *Photograph: Marcia Resnick*

Museum Boymans-van Beuningen in Rotterdam. The thing is that
Scholte, like the New York Appropriationists and the rumpus-makers
of the Cologne School, rather got up the noses of orthodox Modern-
ists. At the 1988 ARCO, the Madrid art fair, Rudi Fuchs—who be-
came the Stedelijk's director in 1993—yoked Scholte and Jeff Koons
in the daily *El Pais*. He called them *putas*, "whores." Scholte's fairly
public private life was also savaged. "There was a book published in
1989 called *Gimmick*," Scholte says. This novel portrayed the Dutch
art world as the playpen of venal types, churning out "art" for cash.
"The book was a best-seller. The only recognizable figure was me. It
wrote about me as a cynical coke addict. So all the blame came on
my shoulders," Scholte says.

There was more. "I was in other trouble. I did a series of porno-
graphic photographs with my girlfriend," Scholte says. This was Diana
Stigter, the daughter of a leading Dutch novelist and art critic, who
had introduced Scholte to Duchamp's work when he was fourteen.
The photographs showed the artist with an erection. Finicky as any
avant-gardist when it comes to establishing who did what first, he adds,
"It was only after this that Jeff Koons made his work with Cicciolina.
I thought they would be published just in a photocopied magazine,
but it turned out to be an edition of ten thousand. And they were re-
printed in newspapers. Even my *grandmother* saw them! So I became
a symbol of the Post-Modernist. Everything goes! No values, no moral-
ity. It made me look like a real bad guy.

"And I had a bad feeling about my friends, and about Amsterdam
and about what Amsterdam did to me. It was a little bit too much. I
needed some fresh air. To get away from all the gossip." In 1988
Scholte and Stigter moved to relative anonymity in Brussels.

In 1990 Scholte was chosen as a Dutch entrant for the Venice
Biennale. The Biennale is, of course, a terrific place to break out of
the pack. Scholte published his own promo material there, an inter-
view conducted with a writer friend. In this, he was bumptious in
the Cologne fashion, saying: "The Futurists, they hated Venice.
Marinetti wanted to throw a bomb on it. . . . You can sympath-

ize with him." He also shrewdly counterprogrammed against suggestions that he was a follower of Warhol, saying that he disliked the Warhol oeuvre—"I thought he was a very bad artist, though. Dull. Totally boring"—but admired his administrative practices. "I want to be big business. That's necessary. That's important to me. And then I'm just the manager," Scholte explained. "One thing is for sure: When somebody makes a painting in my workshop—totally for 100 percent, without me lifting a finger—then it's Rob Scholte for 100 percent."

Scholte did not, in fact, break big in Venice, which was dominated by the New Yorkers again, especially Koons and Cady Noland. He got the attention of Amsterdam, though, when he likened his method of work to that of Rembrandt. Rembrandt is God in Holland. Were people affronted by this? I asked one of the people who had translated the interview into English. "I was affronted," the translator told me, still bristling. Joost van Oss, a Dutch Abstractionist of Scholte's age, says, "For him, it was a step in his career. But for a lot of people in Holland, he was acting like a spoiled brat."

The artist was now no longer Rob Scholte but Rob Scholte BV, which means Rob Scholte, Inc., or, as he sometimes put it, Scholte & Partners. This SoHo move might very easily have left Scholte looking fairly silly, because soon after the Biennale came the Gulf War and the art slump. His luck held, though, because the slump had not yet hit Japan, which had an ancient trading relationship with Holland. A Japanese entrepreneur, Nihon Sekkei, was making this the motor of a giant tourist resort he was building near Nagasaki, a sort of ecological Disneyland, called Holland Village. Scholte secured a $3 million commission to execute some colossal paintings for the principal building. Again, he was sitting pretty.

Scholte's other art was as much in people's face as ever. In 1990 he executed a series, *Yours Sincerely*, which consisted of the blown-up signatures of such famous persons as Jasper Johns, Barnett Newman, and Fred Astaire, and he followed this up with reproductions of Mo-

nopoly money with manipulated values. He was as insouciant in his private life. He had broken up (badly) with Stigter and was living with Micky Hoogendijk, a twenty-year-old model he had met on a visit to Amsterdam. "I was working in a restaurant. He was upset that I didn't know who he was," she says. They spent a year in Japan, but she became homesick. "I went back to Amsterdam because I love Micky," Scholte says.

They returned in February 1994 and Scholte bought the building that had housed his former gallery, the Living Room. He still seems not to understand the extent to which this rankled his peers whose careers had flagged or failed, but was aware that Amsterdam is no safer nowadays than anywhere else in the New Europe. "He put in a complete new security system," says Colin Huizing, an assistant. "Rob is very alert."

Rob Scholte and Micky Hoogendijk were married in May 1994. It was a lavish affair, with four hundred guests and heaps of publicity. Aldert Mantje, a sardonic artist friend of Scholte, observes, "People went to the party . . . they ate . . . they drank . . . then . . ." He mimes quacking tongues. "People are resentful," he finishes.

Scholte found himself increasingly uncomfortable, but felt he was only in Amsterdam for the short haul. That winter he was to relocate to Tenerife, the capital of the Canary Islands, a former Spanish colony off the coast of northwest Africa. The Canaries, a four-hour flight from Cologne, had dependable weather, a friendly tax situation, a relaxed attitude to narcotics, and had become something of an art colony. Such New Yorkers as Peter Schuyff, George Condo, and Donald Baechler had worked on Tenerife, and Jiri Georg Dokoupil, who is by no means the only contemporary artist to dabble in real estate, had bought a couple of houses there. Otto Muehl of Vienna Aktionismus had been refused permission to locate his Art Cult there. (Unhappily for Muehl. He was convicted of having sex with a minor shortly after being turfed out of Tenerife and sentenced to seven years.)

Scholte worked at his computer through October on a set of silkscreens, *Golden Horizon*, reworkings of images from a children's encyclopedia that were to be shown simultaneously at his Amsterdam gallery, the Leyendecker in Tenerife, and the Kent Gallery in Manhattan. This last was perhaps the most important. Rob Scholte had yet to get on the map in New York. Indeed, there was some question as to how well his flippantly clever work would go down in a culture with little liking for the sleek intricacies of contemporary Rococo. (Artists who do baroque work do fine in the U.S., which has been habituated to the baroque by Hollywood.)

Scholte was booked to fly to Japan on a Monday, November 21, 1994, but his computer memory failed—he was using a Macintosh—so he rebooked for Friday, November 25. On Wednesday evening he went alone to a function honoring Sigmar Polke. He was wearing his work clothes, a white T-shirt and white jeans, and was a bit abashed to find some of the Dutch royals were in attendance. He chatted briefly with Polke, then left for a Turkish restaurant, where he ate dinner with Micky and a couple of his assistants. As usual, he put in a little more studio time before going to bed. Scholte's studio and his Amsterdam pied-à-terre are a few doors apart on Laurierstraat, a quiet street of two-story houses, mostly lived in by young families. The neighborhood is called Jordaan, which means "garden." Scholte's dealer, Rob Malasch, who lives around the corner, calls it "a fairy-tale world."

The Scholtes got up early the next morning. Micky wanted to go to their doctor to confirm a home pregnancy test. "It was very important to us because Micky lost her first baby in her ninth month of pregnancy. It was a beautiful boy," Scholte says. "She said she would take a cab. I told her I would drive her. I wanted him to look at an infection I had between my toes, a fungus."

Scholte's dark blue BMW was parked alongside a row of the metal posts that the Dutch use to discourage indiscriminate parking. The couple climbed in at about half past eight. After a few seconds of driving they heard a ticking. "It was not a sound that belonged with the

car," Scholte says. "We looked at each other. But I didn't stop. Six or seven seconds later we were bombed."

Scholte finds luck here. "If I had gotten out and looked, it would have been more terrible," he says. "My head would have been blown off for sure." It was also lucky that their short drive had taken them into a small crossroads, so that the shockwave, which would otherwise have been thrown back at the BMW, had four exit routes. "My first thought was that something had gone wrong with the car," Scholte says. Micky was able to unclip her seat belt and scramble out. "Then I tried. But I fell, because I had no legs anymore," Scholte says. "Then the flames started to come up. There was more blood than I have seen in my life."

Scholte tried to scuttle, crablike, away from the dangerously smoldering metal hulk, but found that the fingers of his painting hand seemed only attached by straps of skin. "I thought I had lost my legs and hands. I was a corpse," he says. Micky, shocked as she was, reached her husband, grabbed him, and hauled him away from the car, screaming. Rob, for his part, was quiet. "The blast took away my voice. The only thing I said to her was this: 'They finally got me,'" Scholte remembers. He had, he says, no specific enemy in mind.

It was remarkable, given the time of day, that the blast, which broke hundreds of windows, caught no children bound for school. Things seemed to the Scholtes to be moving with abnormal sluggishness, and there were objective reasons for this, because reports had reached the civilian ambulance service that the BMW had been the target of a criminal action. The civilian ambulance service wasn't allowed to get involved. There were television crews among the milling crowd by the time the police ambulance arrived forty-five minutes later.

Rob Scholte was in the hospital when it was confirmed that the weapon had been a grenade. No surprise. Grenades, which have a street price of about fifty dollars, and the transient thugs to use them, have been part of the Western European landscape since the fall of

the USSR. The grenade had been attached to the underside of the car. It was surmised that its pin had been ripped out by a cord attached to a rear tire: schoolchild-simple, but effective. Micky lost her baby, but was neither maimed nor scarred. The grenade had been on the driver's side, and Rob Scholte had borne the brunt. When his world firmed up he was heavily bandaged. He had lost both legs just below the knee. His torso was torn. His genitals were intact. Micky had her work cut out convincing him that the surgeon had saved his hands, but so it was. He was a working artist still.

It was characteristic that Rob Scholte should have put his splayed BMW on show in Arti et Amicitiae, the Amsterdam Artists Club. Arti et Amicitiae occupies a slush-colored Neo-Classical building on one of the city's principal canals, Rokin. I climbed the stairs with the artist Aldert Mantje to look at the car. There was a wall-text by Lawrence Weiner, reading: SHOT TO HELL WHILE WISHING UPON A STAR—AND A REAL STAR. The innards of the BMW had hemorrhaged, with springs and wiring spilling out like pasta from where the dashboard used to be. A crotch-protecting metal saddle, like a tractor's, was all that was left of the driver's seat. Around it was empty space, ringed by fanged metal. There was a background susurrus in the room, a muttering audiotape. Mantje said the voices were those of a man and a woman, churning over theories as to who had planted the bomb.

 Hand grenades leave no fingerprints. "I don't see how you survived," I told Scholte upon my return. "There was an angel watching over us," he said, without irony. It was with similar intensity that he and Micky had set their minds to figuring out who was responsible for this thing, and why, just as soon as his head had cleared. But it would become a complicated art-world whodunit, a sort of Agatha Christie amongst the Isms, long before they were done.

 An early scenario had been the brainchild of an American artist, Peter Fend. It happened that I had spoken with Fend in New York a

couple of days after the bombing, indeed before I had gotten in touch with Scholte himself, and Fend had come around to my apartment hefting paperwork. A pale, balding forty-year-old with intense black eyes that flicker hither and thither as he talks, Fend had begun as a fan of those artists of the sixties and early seventies who had conceived of big, ambitious projects like Earthworks, artists like Robert Smithson, Christo, and Dennis Oppenheim. But Fend came to the decision that these projects, however large-scale, were still only pieces of "art," with little influence on real life. In 1980 he started an art corporation, Ocean Earth. Its function was "to extend ideas from art out into the world."

Since then Fend, whose preferred tools are the planetary surveillance satellite and the fax machine, and whose distrust for "originals" is such that even the hand-scrawled notes he gives me are Xerox copies, has been making art that deals with the Big Issues, like global survival. In 1988 he initiated a satellite monitoring program of the Rhine-Meuse river systems and the North Sea, together with a Japanese artist, Taro Suzuki, and a few interested scientists. One dominant theme was the replacement of fossil fuels as an energy source by giant algae systems—Fend calls this part of the program GAS. Documentation relating to the monitoring program was published in a German art magazine in 1990 and exhibited at Floriade, Holland, two years later. It was there that Rob Scholte saw it.

Peter Fend's art, like the art of many political artists—Hans Haacke comes to mind—offers more food for the mind than for the eye. Rob Scholte, who has an image maker's respect for the brainy, was deeply impressed. He and Fend got together and talked. In 1990 Fend had organized a Cologne art-gallery show of photographs of a German secret policeman's bombed motorcar. Fend thought that the bombing, which had been blamed on the RAF (Red Army Fraction, a radical group) was a fraud. He called the show "Kleine Fragen," or "Small Questions." The cop's car was a BMW. Fend showed Scholte a thick file about car bombings that he thought had been perpetrated by the West German secret police. Fend is himself of German stock,

by the way. "Aryan," he says. "Nazis on both sides. That's why I feel the way I feel."

Scholte let his name be listed as a participant in a Green-type political movement of Fend's, Beach Party—Fend has a manifesto writer's knack for a catchy title—and he agreed to finance a co-venture with Fend based in Amsterdam. Scholte, who was then a professor at Kassel, the influential German art college and home to Dokumenta, arranged for Fend to expound his ideas there on October 18, 1994. One of Fend's most fiercely held ideas is that Germany, using both guile and economic muscle, is trying to take over the international art world. A number of people concur with this view, by the way, but few would go along with Fend's suggested solution: dismembering the German state.

It might be added that Peter Fend doesn't nourish just big plans but big fears. Like Thomas Pynchon—or, come to that, Robert Ludlum—he has turned his paranoias to creative use, but Fend is convinced also that the security services of various nations have him in their crosshairs. "I think what happened to Rob was a warning to me," Fend told me just after the bombing.

Scholte and Micky gave Fend's scenario serious thought, and there was much phoning and faxing between them. On February 20, 1995, Fend wrote in a fax sent by way of his New York gallery, American Fine Art: "The public posture will be that the bomb has nothing to do with Fend, GAS, Ocean Earth or anything else involving our joint work." By this time, though, the Scholtes found the aforementioned public posture was okay by them. "Why would they bomb me?" Scholte asks. "Why not bomb Peter Fend?"

Quite so.

Given the horrifying injuries he had sustained, Rob Scholte can hardly be blamed for casting his net rather wide in looking for suspects—and hauling in some innocent parties—and during his stay in the hospital a second scenario suggested itself. Scholte learned that an artist he knew, Erik Hobijn, had been projecting the camera footage shot while he was bleeding onto the cobbles of the Laurierstraat,

onto the walls of a chic Amsterdam boîte, the Supper Club. "Like decoration," Scholte says.

"While people were having dinner," says Micky.

"You become entertainment. Something that people enjoy looking at," says Scholte.

"He said that this was the ultimate way of showing that Rob is art. Because Rob is so close to reality. And blah blah blah," says Micky, a bit desolately.

It suggested a fresh line of thought. Might somebody have planned the blowing up of Scholte's BMW as, in itself, a nihilistic artwork? The BMW is a powerful piece of German engineering. Might the perpetrator have just intended a scary prank? There is a history here.

Since Gilgamesh and Homer, both high and popular art have celebrated the human appetite for death and destruction, but it is an area in which the popular arts have a definite edge. How can an individual artist compete with the whiz-bang budget of a Stallone or Schwarzenegger movie, with the special effects of outfits like Industrial Light & Magic, or with the technical resources available to the producers of video kill-games, say, or Japanese anime, like "Akira" and "The Legend of the Overfiend"? What's left to hand-wrought art is the dangerous object and the unnerving event. André Breton said that firing a revolver into a crowd would be a piece of pure art. The philosopher Ananda Coomaraswamy theorized that a bomb could be a work of art, but only if it killed and destroyed according to its function. That kind of stuff, like Futurist rhetoric, can be dismissed as intellectual noodling, but the real-world potential of this aesthetic was expressed with some clarity by Count Baudissin, who was put in charge of the Folkwang Museum by the SS. Baudissin exulted that "the most perfect shape, the sublimest image that has been recently created in Germany, has not come out of any artist's studio. It is the steel helmet."

A slew of Post-Modernists have circled this dangerous terrain and planted their flags there. Some have used images, like Gerhard Richter, who made news photo–based images of the Baader-Meinhof group. Richter was attacked for sanctifying the terrorist cell, but he was using traditional means, like David painting the *Death of Marat*, or a rebel Roman legion stamping its general's head onto a coin. Others have made actions, like Chris Burden, shooting himself in the arm, and yet others have made objects. Ron Jones has made sculptures in which he puts together shards from real events — relics, for instance, from the bombing of Pan Am 103 over Lockerbie. TODT, a four-person group based in Minneapolis, puts together lethal-looking *Blade Runner–*ready-looking gizmos.

Gregory Green, an American artist in his mid-thirties, dismisses the work of TODT as "a bit like Rube Goldberg." Green, whose influences include Chris Burden and the Found Object tradition, has exhibited actual workable book-bombs, a homemade missile capable (he claims) of knocking down an airliner, and a small nuclear bomb. Green, who is a pacifist from a military background — his father was an air traffic controller with the American Army when de Gaulle kicked them out of France — says all his pieces are in full working order. "They aren't armed," he says. "But they're all mechanically complete and functional."

The program notes for a project that Green was preparing in the summer of 1995 read: "*Take a ball of Plutonium 239 about the size of a baseball. Wrap a layer of paraffin wax around it (to retain the neutrons). . . . Start packing a layer of plastique (homemade or commercially produced Composition C-4) around the bowls; this will create what is called critical mass. . . . Upon initiation, the plastique will implode the baseball into a golf ball and fission will result instantaneously; in a microsecond temperatures within a 20 foot area will rise to 300,000 degrees centigrade, and 30 seconds later there would be total destruction within 1200 feet, heavy damage to 5,000 feet and light damage to 4 miles. Expected yield: 10 Kilotons. To date there has been no recorded instance of an atomic weapon failing to explode in some fashion. It is*

estimated that two tons of plutonium are unaccounted for in the USA today."

If this work doesn't represent a sort of contemporary Realism just what does?

The thing that focused Rob Scholte's attention on Erik Hobijn, the artist who had played the video on the walls of the Supper Club, was this. Hobijn, he remembered, had worked on a project with the Survival Research Laboratories. The SRL, founded in 1978, has been, in America at least, the godfather of life-threatening artworks. A San Francisco–based group of radical inclinations, the SRL is headed by a charismatic tough, Mark Pauline. The group's specialty has been putting together robotic tableaux that tear themselves apart explosively. These actions are recorded on videos, which are merely relics of the actions, like Chris Burden's *Relics*. Pauline's gleefully apocalyptic politics are underlined by the resonantly Brechtian titles given to the SRL performances, like *Bitter Tears of Hopeless Grief*; *Illusions of Shameless Abundance*; and *Extremely Cruel Practices: A Series of Events Designed to Instruct Those Interested in Policies That Correct or Punish.*

I visited the SRL workspace some years ago. Typically, it is located in one of the few ugly neighborhoods in that operetta of a city. What I admired about Pauline's project was the way he gave up on any notion of being in the avant-garde of multibillion-dollar techno-businesses. Instead, he runs a kind of derrière-garde, scavenging Silicon Valley for giveaways and throwaways to make his totemistic art for a New Dark Age. The SRL is to art what Cyberpunk is to fiction.

The explosions, at any rate, are core. They are the SRL equivalents of brush strokes. Nor is conflict alien to Pauline's temperament. He once challenged Dennis Oppenheim to a duel; the weapons were to be their machines (Oppenheim did not take him up on this offer).

At our meeting in the hangar, Pauline was airily waving around a hand, minus several fingers lost making a piece, it turned out.

All in all, it occurred to Scholte as perhaps not irrelevant that Erik Hobijn, his unwanted memorialist at the Supper Club, had worked with the SRL. "I said to the police, 'Please check him out,'" Scholte says. The police told Scholte that the lead had led nowhere. He reluctantly accepted this verdict.

Another unmerited target of Scholte's suspicions was an assistant, John Studulski, who was himself an artist. Many New York artists, even most New York artists, have been assistants—some, like Frank Stella, have platoons—and how easy it is on the ego depends on the artist-employer. In Studulski's case it did not, perhaps, help that he was a few years older than Scholte, whom he had accompanied to the 1990 Venice Biennale. Studulski had plowed ahead with his own work since, but still had been called in by Scholte from time to time. They had had a flaming row a week before the bombing. "You're not fit to live. I'll fire-bomb you at home!" Studulski had shouted.

At Scholte's urging, Studulski had been questioned by the police. Studulski is philosphical about the process. "With Rob it's a little bit strange," he says. "His best friends are always those he's working directly with. He's had no time for friendship because of a kind of workaholic situation. Everything is mixed up with Rob. His public life . . . private life . . . artistic life. He's constantly working on his thing— being an artist."

Studulski had been cleared too. So, in whodunit terms, the butler hadn't done it after all.

There was still a shallow crater in the road where the BMW was blown up. It was the first time that Scholte had returned to the scene of the crime, and he looked around almost with wonder, like a tourist, wheeling himself over to look at some creeper on the wall that still had scorch marks from the blast. Faces peered down at us, float-

ing behind smeary panes of freshly installed glass. "Some of the children still have trauma. They are peeing at night," Scholte told me as he trundled down a red brick road toward a coffeehouse for lunch. "This freaks me out. It's the first time I got dog shit on my hands," Scholte said as he wheeled over a small bridge. The energy in the coffeehouse pumped up as he came in. Bowls of pea soup were brought. "This soup saved my life. They brought it to the hospital. It was the only thing I could eat," Scholte said, plunging a spoon into a soup thick enough to trot a mouse.

Back at the studio, he plunged into last reworkings on the *Golden Horizon* silk screens, which have the same slightly repellent surface computer-generated prints tend to have, like shiny biscuits. Scholte was peering over the shoulder of a fair-haired man who was tinkering on-screen with an image from a *Tintin* comic book. "He's painting," Scholte explained. What about Jeff Koons's problems over reproduction rights? "That's a very good question," Scholte said, adding that he felt "official artists" should be allowed to use popular imagery, just as the radio does. But radio doesn't alter what it plays. "That is true," Scholte said abstractly as he checked for jarring hues of yellow on a print.

These were Scholte's last days in Amsterdam, and his formidable energies were assigned to completing the prints, packing up for Tenerife, and bringing to book whoever had crippled him. His suspicion, and that of the police, had now settled on two figures: Max Hasfeld, a man of shadowy reputation who had emerged during the eighties as a major Dutch collector of contemporary art, and one of that country's most remarkable photographers, Paul Blanca. These suspicions had been expressed in an article in Amsterdam's main daily, *Het Parool*, written by reporter Bart Middleburg.

Lanky, shaggy-haired, and sardonic, Middleburg has the air of a rock reporter but is actually the crime whiz on a paper that didn't used to need a crime whiz. "Until 1988 there was no organized crime here. Only tulips, windmills, and wooden shoes," Middleburg told me over coffee. Early in 1994, though, his series about a narcotics network he

called "the Octopus" and a police drug connection brought about the resignation of both the minister of justice and the minister of foreign affairs. His Scholte article alluded to links between Hasfeld and Blanca, and both of them with Rob Scholte, but came up with no scenario and not much by way of motive. Hasfeld and Blanca were only identified by the initials A and Z, but each man accepted, indeed angrily insisted, that he was the man portrayed. Equally insistently, each denied any connection to the deed.

Het Parool depicted Max Hasfeld as a man who had made his pile in real estate, and had been the target of various police investigations along the way. Hasfeld had also become an enthusiastic collector of Contemporary art, and would make studio space available to artists in exchange for work. It was noted that he had been accused of attempting to extort about $1 million from "an internationally known art dealer." It was claimed that Hasfeld "had set some Yugoslavian thugs on him to exert pressure." The article did not identify the dealer, though, whose name is Michel van Rijn and who had been the subject of a profile in an American magazine, in which he boasted of passing himself off on some potential Japanese clients as a descendant of Rembrandt. The article was titled "The Lying Dutchman." These are opaque waters.

In 1987, before *Gimmick* was published, Scholte discussed such a deal with Hasfeld twice. The first time, no studio was available. By the time a studio *was* available, Scholte had second thoughts. He says he decided that dealing with Hasfeld would be "too heavy." No deal gelled. Scholte now speculates that Hasfeld might have been angered by this, and *Het Parool* pursued this. I asked Hasfeld about this. "There have been hundreds of articles about Rob Scholte," Hasfeld grumbled. "But no journalist, nobody on television, has followed this story."

I asked other questions, mostly concerning Hasfeld's beginnings as a collector, which he answered by fax. His parents, he wrote, had been intellectual Jews who survived the war by going into hiding. His own interest in art had been kindled while he was studying econom-

ics at the University of Amsterdam. Hasfeld had begun as a fashion designer, had opened boutiques and "collected huge amounts of clothing by up and coming designers, Katherine Hamnett, for example." He wrote me that he had since gone into property, and "often rented to artists at a very reasonable price which is also occasionally, if there are problems, supplemented with works of art." Renters have included artists from Holland, Latin America, Canada, and Russia. He added, "As for the slump of 1990, it did not affect me as regards my art collection. Although art is a priority, it has nothing to do with my business." Rob Scholte was not mentioned. Certainly, Hasfeld could have written more, and more juicily, about his other business—and a mention of Hasfeld in Amsterdam will elicit a frisson that you won't get from dropping Charles Saatchi's name, say, on Cork Street or Eli Broad's in Malibu—but connecting him to the Scholte affair has more and more seemed a stretch.

Paul Blanca, the other figure referred to by *Het Parool*, is a photographer. A man of Scholte's age, he is a volatile figure, seething with energy but with an oddly vulnerable sensibility. In 1985, he met Koos Dalstra in Manhattan at an International with Monument opening on the Lower East Side. Dalstra has had a curious career. A former professor of criminology at Holland's Free University, he gave up crime for poetry. He had been an editor of *Angst* with Scholte. Blanca and Dalstra agreed to collaborate on a book about Amsterdam's Upper Bohemia.

Blanca first met Rob Scholte prior to photographing him in 1985. Each man has vivid memories of the shoot. Because many of Scholte's paintings of the period used twinned images as a motif, Blanca decided to capture the effect by posing the artist with a white dove on each shoulder. "We ate herring together and bought the pigeons," Scholte remembers. But when the birds were released, they flew straight for a closed window. "These beautiful white pigeons! They broke their bills. There was blood everywhere," Scholte says. Blanca denies this, heatedly. "I caught the birds. I put them in a basket. They were fine," he says.

A Scholte photograph was included in the book, which was called *Timing*. It was published in 1986. It was a success. "Paul's a great portraitist," says Bill Katz, a New York designer and collector of photography, who works for Dutch dance and theater companies and met Blanca in Amsterdam. Katz was struck by Blanca's work and showed it to Robert Mapplethorpe, who also admired it. "I saw the greatest single picture Paul has ever taken. He's embracing his mother. Both are entirely naked. It shows a great deal about him. His mother has this bemused, tender understanding."

Katz said he wanted to buy a print, but recognized a degree of turbulence in Blanca and wasn't surprised that it turned out not to be a straightforward transaction. "He sent me a copy. But in typical Paul style, he just put a piece of cardboard with it and it got here completely mangled. I called him and said, 'Paul, I would really like one that's flat.' So he said, 'I'll bring it to you . . .'"

Blanca did have a New York project, another book of artist photographs. Katz loaned him his place in SoHo and came up with the artists' numbers and addresses. "He took lots of pictures," says Katz. "One of the most special was of Francesco Clemente. It went on one of the gallery invitations. I have one of the few prints because somehow or other with Paul the negative always seems to disappear.

"I put de Kooning's name on the list, but I told Paul he wouldn't be able to see him. Well, he just drove right out with a girlfriend and managed to make his way into the studio. De Kooning said, 'Did you ever try and paint? It's a better game.' And he gave him the brush and took a picture of him touching the painting with his brush. Paul took the last picture of de Kooning that I know of. It's an incredible picture."

There were other pictures, too. As a young man Paul Blanca had been a championship-level kick boxer, and his mastery of that most violent of contact sports fitted in with something darker in his imagination. One of Blanca's better-known pictures shows his back with the figure of Mickey Mouse cut into it, dripping blood. "There's another where he has a nail through the palm. Like he has crucified himself onto a piece of wood," Bill Katz says. "Paul has done these self-

explorations. And he reaches a kind of poetry that very few photographers have."

In 1992 Paul Blanca was staying with friends of mine in SoHo. I got to know him somewhat. He had a shaven head and the compact muscularity of a whippet and was charming, but threw off waves of unstable energy, which was not hard to account for, because he flaunted the fact that he had taken to using both heroin and crack cocaine. Quite what effect this was having on his work it was hard to say. At a photo shoot he asked an artist friend to carve tic-tac-toe into his—Blanca's—forearm so that he might take a picture. The friend quailed, and refused.

Blanca and I got on fine for a few months, a minor altercation at a party aside—he lifted me as though I were a pillow—but I have never known anybody about whom so many anecdotes fluttered. The lore of which he became the center had mostly to do with drugs, violence (of which he was sometimes the victim), and the notion of a raw talent boiling to waste. He left Manhattan for Egypt, where he had a photographic project involving the Coptic Christians. He fell afoul of the police, who brutalized him, and returned to New York. Then Amsterdam. He had become a paradigmatic figure, the Photographer as the *poète maudit* of our times.

It is natural, really, that the photographer should have become the legitimate heir to all those artists and writers laboring under their dark stars, back to François Villon and further. It hasn't just been "art" photographers, like Diane Arbus and Robert Mapplethorpe either. Many of the more talented fashion photographers of the 1970s had destructive career arcs—of drinking, drugging, becoming eccentric to the point of being barely employable, and, in some cases, like Bill King, dying young (their coarser successors, the eighties generations, weren't good enough to go to the bad). It is a tough medium, photography. Artists and writers are their own taskmasters and, if they are smart, permit themselves cave time, periods to replenish, and it happens they are working in forms where a few ideas can go a very long way. Not so photographers. Photographers must produce, constantly, and not sit-

ting at a keyboard or looking at a blank sheet, but confronting their
raw material, with just a lens between.

Photographers are wired directly into some of the more perilous
energy sources of our time: voyeurism, narcissism, action-junkiedom.
Don McCullin, the documentary photographer of the Vietnam
period, would quite literally go in ahead of the marines. In the 1970s,
Guy Bourdin used his personal pathology to create commercial
images that went way beyond the commercial for Charles Jourdan
shoes and Paris *Vogue* month after month. He then entered a mel-
ancholy period of self-parody. No wonder Alexey Brodovitch, the art
director and mentor to the great post-war generation of New York
picture-takers, warned that "the creative life of a photographer is
seven years."

Paul Blanca, it seemed, could always come up with fresh images
of outrage. It was, nonetheless, unnerving to find Scholte so convinced
that Paul Blanca had played a part in his bombing. Their relationship,
it turned out, had been fraught ever since the picture with the doves.
Scholte believes that Blanca envied his international success and that
he had made a point of bedding two of Scholte's former girlfriends,
Sandra Dercks and Diana Stigter. Blanca, for his part, claimed that
Scholte had slept with a girlfriend of his. Petty stuff, but antipathies
are built of petty stuff. Paul Blanca was not invited to Rob and Micky's
wedding. "I told him we would have a dinner just ourselves — after the
wedding," Scholte says. Blanca watched, sitting alone across the street.

In the winter of 1994, Holland, like much of Europe, was heavily
flooded. Paul Blanca was working on a photographic project, captur-
ing the water world, and he had begun writing for an Amsterdam
weekly, *Nieuwe Revu*. His writing, at once obsessive and detached,
dwelled on his double life as an artist who was also functioning in the
underworld. One feature dealt with his life as a junkie. A second,
entitled, with jaunty grimness, "Lying & Stealing," told such tales of
the dark side as the time he held up a drug dealer with a Colt .38.

Blanca's third assignment was an investigation into the ease with
which weaponry could be picked up in the dislocated New Europe.

His haul on the streets of Holland and Germany included a Browning, a false Colt, and a hand grenade. It was being readied for publication when Rob Scholte's car blew up. Blanca was interrogated by the police for several hours.

In January 1995 I spent a night on the town in Amsterdam with Paul Blanca. He hurried me through narrow, crowded streets, moving familiarly among characters with the body language of those who have several skins too many or one too few. Hard drugs were involved, and a woman, and Blanca would move with breakneck speed from warmth to ferocious passion, and was spilling over with violent anecdotes, describing in some detail how he might or might not have killed on various occasions. About one thing he was insistent, though. It had not been he who had placed the hand grenade beneath Rob Scholte's car. "If I want to kill somebody, I will kill them face to face," he said. We agreed to meet again the next night. He borrowed a little money, returned to borrow some more, then telephoned in the early hours to cancel, saying he was again talking to the police.

Neither I nor anybody who knows Blanca, though, thought him capable of the bombing. The volatile quality that made Paul Blanca a suspect also ruled him out. But Rob Scholte needed a villain, and the pool of art-world suspects was thinning out.

The following day Rob Scholte was to address a press conference at the airport. He and Micky were flying to Tenerife by way of Madrid. "I will sit and smile. Like Buddha," Scholte promised. Some five dozen media types were gathered, and most affected the usual blasé machismo as Scholte wheeled himself onto a dais, followed by Micky, but there was a hush when he hoisted himself onto a table to their front, displaying his truncated torso to the cameras as deliberately as he had shown his BMW.

It was an astonishing performance. He read a piece of hate mail promising that he would be "eliminated" if he gave this self-same con-

ference. He then addressed himself to the meat of the conference, which was the lending of his support to a movement that would address the moral rot in Holland and in Europe generally. As an issue, moral rot—which, Scholte thinks, cost him his legs—has been more or less appropriated by the authoritarian right, so Scholte skillfully invoked the precedents of the anti-fascist movement before the war. The conference concluded with Rob and Micky singing a folkish nursery rhyme. Even the media were moved. He and Micky then left for Madrid. A few days later he was at work in Tenerife on his Kent Gallery show.

There had been one piece of mail too ugly to read aloud. Written in crude capitals with numerous exclamation points, it begins:

YO ROBBIE! COKE BOY! YOU'VE LOST YOUR FEET, ASSHOLE!! I'M FUCKING MICKY NOW!! I, AT LEAST, HAVE MY BALLS AND FEET! FAKE ARTIST! LOSER!! THE REST OF YOUR LIFE IN A WHEELCHAIR! HAVE FUN! I WILL BE FUCKING MICKY NOW!!!

This was "signed" by an Amsterdam artist well known to Scholte and written in a good copy of that artist's handwriting. It was accompanied by a drawing, executed with effective rawness, of two standing human feet with legs to half-calf length, each topped with a wisp of cartoon smoke. Just like those chicken legs that Sandra Dercks had drawn for *Angst*. "It's clear to me that this letter comes from somebody in my circle," Scholte told me, almost dispassionately.

But a violent crime unsolved is like a sore that won't clear up, a bruise that doesn't heal, but throbs and spreads. The case wouldn't go away. In the summer of 1995 somebody hurled a Molotov cocktail through a window on the Scholtes' house in Tenerife. That fall, Rob Scholte finished his project in Japan. The poet Koos Dalstra gave a reading. Scholte and Dalstra had been working together for eighteen months on a report that Dalstra describes as being about "jealousy and power . . . a sketch of subculture. The art scene." Scholte describes Dalstra's reading at the ceremony as full of hatred.

He now had a new suspect. Dalstra, he says, had a fanatical admiration for the Dutch artist Bas Jan Ader, a doomed purist. "He

thinks I'm a blind man. That I don't see the truths of the world," Scholte says.

Koos Dalstra just says of the bombing, "Probably he did it himself. In a certain way."

But the bomb was actual, not an emblem. So, too, was the horrid image of severed two legs, the wisp of smoke.

Suzanne Janssen, one of the translators of Scholte's screed at the Venice Biennale, said, "This is a small country. We live close together. We compromise. If a blade of grass gets too tall, it gets cut off." She added a saying I must have heard a dozen times, "Be normal. That's strange enough already."

Aldert Mantje discounted the notion that Scholte had been the victim of a professional hit. Organized criminals are efficient, taking out their targets on highways or in parking lots. He is sure it originated in the tight, rigid art world. "We're Calvinist assholes!" he said, with sudden ferocity. John Studulski, the cleared assistant, says, "There can be jealousy. There were people that wanted some of Rob's success. They wanted some of his money." Fred Wagemans, the critic and curator, says, "Rob's enemies are the people who knew him in the early eighties. When he was trading his paintings for fast food and singing in a Punk band."

Peter Schuyff, sardonic in the Chelsea Hotel, says "It's late at night. . . . I can see somebody . . . drunk . . . angry . . . crawling under Rob Scholte's car."

This would make the bombing of Rob Scholte the action of some barely noticed art world failure—an unsuccessful painter, a bitter writer, a "loser," as the hate mail put it—done with his or her own hands, or by flinging a few dollars in the direction of one of those vagrant men of violence awash in the New Europe: an act of revenge upon one of the European art world's more notable successes. Which would also mean that what happened to Rob Scholte was a bit like what happened to Andy Warhol, after all.

Seven / More

"I should put the flag up—it's been a month,"
Jeff Kopie said fretfully. "There's no need to be maudlin." The flag-
pole stood in the yard of La Mansana de Chinati, normally known as
the Block. The flag was at half-mast for its late owner, the great, often
cantankerous, artist Donald Judd, who had died of cancer in February
1994 at the age of sixty-five. Kopie, a pale, distrait man, who had been
one of Judd's principal administrative assistants, knew that maudlin
sentiments were among the things—the many, many, many things—
that Donald Judd had abhorred.

There were tall plum trees in the pebbly yard and an uninviting
swimming pool, surrounded by concrete blocks and pieces of wood
furniture—all of Judd's own design. "Don pretty much regarded all
of this as a work of art," Kopie said. Judd's adobe walls were high, but
not quite high enough to wall off West Texas in the form of the sil-
very cylinders of the Godbold Feed Mill. A couple of black-and-white
German shepherds loped up and began to gambol around as Kopie
unlocked the door and let us into the nub of what was one of the most
ambitious art fiefdoms anywhere. Ever.

This was April and my first visit to Marfa, a cow town, from which
life had been leaking since the Levi Strauss factory and the Coca-Cola
bottling plant had been shuttered soon after World War II. The small,
conservative-minded town was now best known for two phenomena,
the Marfa Lights and Donald Judd. The Marfa Lights are a nocturnal

show of moving flickering lights over the local scrubland for which no objective evidence exists, aside from some blurry UFOesque photographs, but which a great many claim that they have seen. Perhaps a leap of faith is required—rather the same sort of faith that is often required by art. Some art, anyway. Like Donald Judd's. Typically, Judd himself declared that the Marfa Lights were "a hoax."

By the time of his death, Donald Judd had bought up enough of the local buildings to have become Marfa's largest property owner. These included some of the swellest buildings in town, including the Marfa Hotel, many private houses, the First Marfa National Bank, where he maintained a drawing office, the Wool & Mohair Building, which he filled with the baroque artworks made by John Chamberlain from the carapaces of Detroit automobiles, to the more-or-less polite befuddlement of most Marfans, and the unswell but imposing Block, through which I was being conducted by Jeff Kopie.

The fundamentals of the Block are a couple of airplane hangars, originally on a local base but moved into Marfa's little business district after the end of the war. They had seen service as an automobile repair shop for a while, but Donald Judd had bought them in 1973 and raised his family there. The spaces—*rooms* is not the word—were filled with Judd's work of all periods, furniture of his own design, and other goods in which he saw merit, like Mission furniture, Biedermeier, horse saddles, Navajo blankets, and arrowheads—all in quantity. There was a bar, richly stocked with tequilas and Scotches, especially the single malts of which Judd was fond, and a scholar's library. The roofs are hangar roofs—metal, with struts.

"It gets cold here," Kopie conceded. "The room with the Navajo blankets has another bed. You can put another heater in. It didn't affect him much. And it can get to be 110 degrees. He hated air conditioning. The heat didn't seem to bother him."

We walked out into Marfa. Sunny, with unpeopled streets, it had the feel of one of those brightly eerie American townscapes in a movie by a European director. Many of the Judd-owned houses, it turned

out, were as empty as when the artist had bought them, but one building was hung with the earliest of his artworks that he cared to show, thickly textured and rather labored abstractions, made before he had repudiated painting as "finished." His businesslike later sketches on yellow paper lay on desks in the bank building, but the casualness was misleading. "Don kept every drawing," Kopie said.

One room contained a palette bed close to the ground. Judd, who was meticulous in allotting different spaces to different work uses, had such simple beds, ready to drop into, in most of his houses. I peered from an upstairs window. CLARENCE JUDD was lettered on a road-level pane across the street. This was the building within which Judd worked on architectural projects, using his grandfather's name, but not for sentimental reasons. "He didn't want to be sued by the Association of American Architects," Kopie explained. "He wasn't licensed."

There was another oddity about that window. It was brown-papered from within. That, it came to me, was a reason the streets had struck me as eerie. Most of the Judd windows were similarly papered up. A security measure, I supposed, occasioned by the artist's death. Wrong. "Don was having a fight with the town," Kopie explained. It had been just before his death, and he had been threatening to move out of Marfa, his buildings included. It had been the last in a life of fights.

We drove to the most ambitious project of all, the Chinati Foundation, which is on the outskirts of town and occupies the 440 acres of Fort D. A. Russell, a former army camp. On one side of the entrance lay the big, bland headquarters of the region's largest employer, the Border Patrol; on the other were some shanties and satellite dishes. At the entrance itself stood a metal historical marker, noting that during World War II the fort had been "home to a chemical warfare battalion, as well as German prisoners of war."

The core of Chinati are thirty-two former army huts. They are the color of creamy peanut butter and the shape of much-elongated Monopoly houses, except for eight, which are in a squared-off U shape,

and they still look much as they must have when the soldiers pulled out in 1946. But the stuff in and around the huts includes a gargantuan red horseshoe by Claes Oldenburg, a ring of stones by Richard Long, an installation by Ilya Kabakov, and plentiful Judds—enough, in short, for Donald Judd to have described Chinati as "one of the largest visible installations of contemporary art in the world." Kopie explained: "He felt otherwise it wasn't going to last."

Most immediately visible of Judd's own pieces are a row of concrete blocks lined up on the ragged land immediately inside the camp's gate. They are examples of Judd's never ingratiating art at its least seducing, and "Buck" Newsome, author of *Shod with Iron: Life on the Mexican Border with the United States Border Patrol*, certainly represented a segment of local opinion when he railed to me over a cup of coffee about "those cement things—so-called art." But the pieces have an obduracy other than they might have against the usual white walls, standing among rough grasses against the sky, and it suggests Judd's singleness of vision that sitting not far from his pieces there are some plain circles of slightly yellower concrete, getting crumbly. Drinking troughs from army days. It simply never occurred to the artist that they would tug away attention.

I threaded my way through the antelope droppings and prickly-pear cactus toward the twin gun sheds, which are the biggest buildings at Chinati. Their original flat tops had been replaced by hemispherical roofs of Judd's own design and the walls that ran lengthwise were mostly glass. There were still German-language orders painted on the brick interior walls, and the poured concrete floors had a greasy glimmer. Aluminum boxes lay on the floors of both gun sheds in three lines, sporadically broken by columns. Each box was as high, wide, and deep as the others. Every edge was screwed or joined, not cast—Judd could be raw but was no brutalist—and no two boxes were precisely alike, because the interior of one box had a single horizontal shelf; another, two. A third had a shelf set at such-and-such a slant, and so on, so that the light pouring in through the great windows affected each box differently, causing one to stand out in hard detail, making another trans-

parent as glass, while a third was substanceless, as though carved in smoke. I looked into one box and it was dark—it was like peering into a well, but its neighbor was filled with furious light—which was like looking into a furnace. Then the sun dropped behind a cloud bank, and everything changed.

I wondered just what Donald Judd would have been thinking when he looked the way I was looking. Walt Whitman has some lines where he described God as a sort of living square. Walking through the gun sheds wasn't a bit like walking through a museum (and, God, Donald Judd abhorred museums) because there was a sense of scale and time, so it was more like walking the aisles of a cathedral or among standing stones on a Bronze Age site. This, though, was a monument to the Age of Reason, and as such, it looked both fiercely rational and quaintly vulnerable in a way that old-fashioned work is not. The moldy wreckage of the Parthenon still looks pretty good, considering, and many experts suggested that the murky ceilings of the Sistine Chapel be left that way. But wear and tear is ruinous to much Modernism. A smear will ruin a purist painting—an Ad Reinhardt black painting, say—and when the work is not just purist but high-tech, the problems become overwhelming.

Now that their peppery creator and guardian is gone, increasing numbers of visitors will come to the gun sheds.

Kopie cautioned me against touching any of the seductive surfaces. "Your handprint would come up a couple of days later. It doesn't come off," he said. For those who positively have to cop a feel, there is a metal slab leaning beside the entrance to each building. A visitor in a wheelchair has already gouged one of the boxes. The Chinati Foundation can replace a panel, perhaps even an entire box, but at what point does it stop being a Donald Judd? No wonder the artist once told a friend, Peter Arason, that he had contemplated making his masterwork in Iceland. He didn't, though. It is in the Judd fiefdom in the ratty Chihuahua Desert. It is there that Donald Judd rules—a crackpot visionary in a peculiarly American vein.

＊　＊　＊

I first met Donald Judd in the mid-1980s at a show of his in the Blum-Helman Gallery on East Fifty-seventh Street, and followed this up with a visit to Spring Street. He had reddish hair, an angular face, the pink skin of the quick-to-anger, and vivid blue eyes that disappeared in crinkles when he smiled, which was more often than his reputation for savagery might have suggested. He was also so soft-spoken as to suggest diffidence until you caught the drift of what he was saying, which did not incline to diffidence at all.

Judd was born on his grandfather's farm in Excelsior Springs, Missouri. Both sides of the family had been long settled in America. In later years he would develop a fondness for bagpipe music and would wear a green plaid, but no particularly strong Scottish strain is known of in his family. His children, Rainer and Flavin, are only aware of mixed British and German blood. Judd's father was an executive with Western Union, and in later years Judd would attribute his shyness to the number of times the family moved. Judd remained a Missourian, though. "Don Judd had a very midwestern sensibility" says Joe Helman, a partner in the gallery, who himself comes from Missouri. "Missouri is the 'Show me!' state."

Judd did military service, and was a sergeant in Seoul during the Korean War. He then went to Columbia, where he gained a B.A., and studied painting at the Art Students League. At the beginning of the 1950s he was painting moodily figurative interiors rather in the vein of Hopper, or perhaps Vuillard, and he never exactly disavowed these any more than Roy Lichtenstein disavowed his time as an Abstract Expressionist—Lichenstein indeed once told me wistfully he was sorry so little of his early work has survived. Some of Judd's early woodcuts have been published by Schellmann Éditions, but he never welcomed them into his record, either. Judd returned to Columbia to work for an M.A. in art history. One classmate was the future critic/curator Barbara Rose. "He was clearly brilliant," Rose says. "He was very exigent and difficult. He did the tough Germanic art history courses." The friendship continued after Rose married the painter Frank Stella.

"Don was our preferred baby-sitter. He was incredibly kind, and generous. And brilliant. And polemical."

The polemical side found an outlet in *Arts*, a magazine, whose editor, Hilton Kramer, began assigning Judd reviews. His writing was pithy, free of affectation, and could be not so much witty as grimly funny. It was also executed with a distinctive rhythm, like somebody banging in nails. As for his own art, he had been making paintings, but in 1961 Judd gave up the canvas forever and began working in three dimensions. He rejected the word *sculpture*, with its connotation of old-fashioned techniques like carving and modeling, so he came up with a coinage of his own: Specific Objects.

Judd would describe this evolution in his last piece of extended writing: "Some aspects of color in general and red and black in particular." He wrote it just before his death and was to have read it, had weakness not intervened, upon being given an award in Amsterdam. In this he claims the credit for two breakthroughs of great importance, writing: "It is impossible for people to understand that placement on the floor and the absence of a pedestal were inventions. I invented them.

"Also: the use of the whole room, which is now called an installation, which basically I began."

The thing is that the second claim is preposterous; the first, disingenuous. Room installations dated at least as far back as Kurt Schwitters. The British sculptor Anthony Caro had shown works that snaked on the floor free of their pedestal in 1960, a fact of which Judd was certainly aware, since Clement Greenberg had famously proclaimed the Briton as an heir to David Smith. If Judd chose to ignore this, it was because to him Anthony Caro simply didn't matter. What Caro was making was still composed, "sculpture," on a pedestal or off it—and sculpture, like painting, was dead and done with. De Kooning, Pollock, and a few others, including Agnes Martin—Judd was rare in his group in his support of women—were the "Last Painters," Frank Stella being the last of all. Donald Judd and a few peers were creating the New Art.

In 1962 Judd approached Richard Bellamy, director of the Green Gallery. His reputation was already such that Bellamy suggested he go directly to Leo Castelli, but Judd said his work was still in the process of formation, and he liked the notion of a similarly raw gallery. He was making boxy wooden shapes, often incorporating chunks of ironmongery, picked up on a walk or bought cheaply on Canal Street. "When I first went out with him, he was making a piece with a pipe in it," says Julie Finch, a fine-boned woman, speaking of the time when she was in her early twenties and working in an art gallery. "He was working on the surface of the pipe with acid. It was a long, long struggle." Judd showed with Bellamy in 1963 and married Finch the following year. She was awed by his fierce purity. "I can still hear him say, 'That's corny. That's a cliché,'" she says, and describes a dinner with Barnett Newman and his wife, Annalee, in the Newmans' apartment on the Upper West Side.

Newman had toiled unrewarded for years and was still just making ends meet. "Annalee had taught stenography to support him," Finch says. (Things improved when Annalee got a job with the New York public school system.) "Barney showed us a box of records in the closet. They couldn't afford a record player, so they had bought the records one by one, waiting till they could hear them. It didn't matter to Barney that he was unfashionable. He kept going. Barney's work meant a lot to Don. It was the purest, plainest work he had ever seen."

Judd joined Castelli's gallery in 1966. He hated the term "Minimalism," which was applied to his work, as to the work of Dan Flavin, Carl Andre, Richard Nonas and a few others, but actually it is a more serviceable tag than most. His pieces were made — by other hands, but according to Judd's fastidious quality controls — in materials that varied from the industrial luxury of colored Plexiglas and anodized aluminum to the penny plainness of plywood and galvanized iron. Judd made single units and also grouped units in series, called *Stacks* or *Progressions*, that seemed organized according to some formal logic but nothing as old-fashioned as "composition." (This, in point of

fact, was not the case. Judd's organization was more intuitive than it appeared.)

Donald Judd was pushing the art world's face in its own oil paints, and Judds were understandably rather a very hard sell. Castelli managed to sell a metal piece to Robert Scull for $700. Scull left the work outside his beach house, and bored a hole in the bottom to let the rainwater out. The young artist's reputation grew swiftly, and Scull asked him to remake the piece. Judd — typically — complained that his own profit had only been a hundred dollars, flatly refused, and held the whole thing against Castelli forever.

At any rate, Judd was doing well enough to stop writing reviews, and in 1968 he gave an early demonstration of his appetite for control by putting together $65,000 for a five-story building on Mercer and Spring. It was then that the city planner Robert Moses announced plans to raze the whole cast-iron district to make room for an expressway. Judd, who had an inborn distrust of all governing institutions and would describe himself as an "anarchist," joined forces with the publishers of a radical pamphlet, *The Public Life.* "We tried to get people interested in organizing," he told me many years later. "We wanted to start a Lower Manhattan Township and secede from New York." He added: "We couldn't have seceded, of course. But we could have been a political force."

No support materialized. "The artists were afraid that if they stuck their heads up, they would be thrown out of their lofts," Judd told me. "Even I was illegal. And I owned the building." It was economics, not Donald Judd, that laid low the gruesome Moses plan. By then he had decided to get out of what he had come to detest as SoHo anyway.

The art world was pretty much by then in the hands of the Pop artists and the Minimalists. In contrast to the sociable and urbane Pop artists, there was about the Minimalists the dourness of an exclusionary sect. For instance, most would describe the work of Tony Smith and Anne Truitt as Minimalist. Judd slammed the door on them. He

accepted few artists as his peers, most notably Carl Andre and Dan Flavin.

Judd certainly felt secure enough to put some distance between himself and the art-world machinery. He had a sister in Arizona, and he and Julie visited that state five summers in a row. "He would bring back cactus. He loved the beautiful symmetrical shapes," Finch says. "And being in the desert, how you can always see the shape against the horizon. It was the perfect studio." They went camping in Newfoundland while she was pregnant with the boy they would call Flavin, after Dan Flavin. They were also camping, this time in Baja, California, when Julie was pregnant again, with a girl. Finch had wanted to call her Indigo, a word plucked from a Wallace Stevens poem, but Judd would have none of it. "He was so stubborn. She was just Baby Judd for three months," Finch says. They settled on Rainer, after another friend, the dancer Yvonne Rainer.

Judd went to reconnoiter Texas alone, though. "He said the heat was so harsh," Finch says. "He had a map. And the emptiest county was Presidio." The Spanish had called this region Despoblado, the "Empty Quarter." Judd had already seen the land when he passed through it during his army service, and he had liked it then. He knew he had reached his journey's end when he looked around the county seat of Presidio, a town called Marfa.

The area in which Presidio County is located is called Big Bend, for an undulation of the Rio Grande, and Marfa had been founded in 1883 as a stop of the Southern Pacific Railroad. It was named—a notion of the chief engineer's wife—after a character in Dostoyevsky's *The Brothers Karamazov*, which had been published in the U.S. that same year. "It was such a beautiful town," Julie Finch says. "Very wealthy ranchers lived there and had a tight control over zoning." Not that there was much pressure, because the population had drifted down since the end of World War II by half. The Judds rented a first summer house there in 1972 from a Mexican family in a poor part of town nicknamed Sal si puedes, meaning "Get out if you can." He bought

the hangars that would become the Block the following year, and became a Texas resident in 1975. The following year Donald and Julie separated, a rupture so bitter on his side that he never spoke to her again.

From then on, Judd would usually spend no longer than six months a year in Marfa. The rest of the time he would be on the art exhibition circuit, grumblingly in SoHo or, later, at his house in Switzerland. Marfa, though, was his domain. It was there that he planned to install works by the handful of his fellow artists he admired. But although he prospered through the later 1970s, plans remained embryonic. Then one of the art world's more peculiar entities hove into what I will ineptly call the picture: Dia.

Heiner Friedrich, the progenitor of the Dia Foundation, has pale blue eyes, a manner at once bluff and fervid, and a somewhat half-hearted beard. He was born in Berlin just after the war and saw plenty of *après*-Götterdämmerung. He grew up with a passion for whatever was most advanced and sublime in art, and since his father had prospered in industry, he was able, in due course, to open galleries in Munich and Cologne, where he showed Donald Judd and various of the Earth artists and Conceptualists who were crowding on the Minimalists' heels. Indeed, it was clear to Friedrich that much of what was most advanced and sublime was being dreamed up by American artists. He became determined to help turn these visionary schemes into solid reality, and in 1973 he moved his operations to Mercer Street, in SoHo.

Friedrich met Philippa Pellizzi while he was visiting the Rothko Chapel in Houston. The Rothko Chapel is owned by the de Menil family, part heirs to the Schlumberger oil fortune and famous patrons of the contemporary arts, and Philippa was herself a de Menil, married to an anthropologist. She was dazzled by Heiner Friedrich's

ambitions and agreed to finance them. The Dia Foundation came into
being in 1974.

Dia's first venue was Heiner Friedrich's gallery on Mercer
Street. Its name—*dia* means "bridge" in classical Greek—was an
emblem of its airy intentions, a self-distancing from the clunking self-
importance of most arts patronage. Dia took out no advertisements
and mailed no announcements, and for years its only logo was its
name as tapped out on an IBM Selectric. In 1977, typically, its space
was sacrificed to house its first major art project when Walter de
Maria, one of the artists on the payroll, caused the room to be filled
with coffee-colored dirt to a level of twenty-two inches. *Earth Room*
is still watered and kept free of mushrooms and remains open to the
public to this day. Dia moved to new quarters on Franklin Street,
where its style remained unchanged—Richard Tobias, an artist who
worked there, speaks of staff lunches of beet juice and broiled Swiss
chard—as did the scope of its ambitions. *Earth Room*, frankly, is a
piece that requires a public well schooled in the rigors of art theory,
but this cannot be said of Dia's next projects, which were spectacu-
lars, if of a rarefied sort.

Walter de Maria's 1977 piece for Dia, *Lightning Field*, required
the purchase of a tract of land in New Mexico. This was then impaled
with four hundred stainless steel rods, which catch and play with natu-
ral electricity in the way that gives the work its name. *Lightning Field*,
which it costs Dia $250,000 a year to maintain, exemplifies the fact
that pieces of Conceptual art or Earth art, or indeed Minimal art, are
not necessarily nuts-and-bolts fabrication of cerebral notions but can
draw on deeper sources, including the prehistoric and the alchemi-
cal. This is, of course, equally true of another piece that Dia funded
the same year, when it advanced the Los Angeles artist James Turrell
$64,000 so that he could buy the Roden Crater, an extinct volcano,
near Flagstaff, Arizona.

Heiner Friedrich's first visit to Donald Judd in Marfa was in 1979.
He came back soon, accompanied by Philippa Pellizzi. The timing
was neat. Neo-Expressionism was exploding worldwide. Dia would

seem to be a natural ally of Judd and the Minimalists in a battle with such retrograde forces as painting. There were also more specific congruences between Judd and the patrons. Two of the artists that Judd had felt worthy of installation in Marfa—Dan Flavin and John Chamberlain—were on the Dia roster already. Actually, Donald Judd's Marfa project was just the kind of thing that Dia had conjured itself up to support. They huddled, and began to hammer out the details.

The basic notion was this: The Dia Foundation would provide funding but would then, as with other Dia projects, fade, Cheshire Cat–like, as soon as the artist had organized things so that it could be a self-supporting foundation. They moved briskly. Donald Judd would have preferred new buildings, but even Dia's pockets weren't that deep so Fort D. A. Russell, which a local real estate firm had tried to market as low-cost housing, was bought for Judd, and the handful of people who had taken up residence there were bought out. A folksy name was found for the Judd/Dia enterprise: the Art Museum of the Pecos. Just one factor had been neglected—Marfa.

As the *Dallas Times-Herald* would put it: "The foundation's propensity for paying more than the top dollar touched off a small land speculation boom, as residents bought up long-ignored tracts with the idea of selling them at inflated prices to the artsy crowd from Manhattan." That was the most mundane reaction. The *Big Bend Sentinel*, the Marfa daily, quoted Philippa Friedrich—she and Heiner had since been wed in a Sufi ceremony—as saying, "I assure you that this is not a Mafia operation in any way."

May Quick, a local woman, who sold Dia one of the first properties they bought, the Wool & Mohair Building, and who would become one of the rare Marfans on good terms with Donald Judd, says, "There were rumors that there were wild parties and devil worship. There was talk about Whirling Dervishes and drugs." Orgies were likewise whispered about, and it was said that Judd harbored a witches' coven and had a room painted black. Indeed, such rumors were never totally to die. Jeff Kopie reports that upon his first arrival in town, he heard that nobody could actually have a legitimate reason for want-

ing a Judd box and that the boxes were actually containers for drugs being shipped across the Mexican border.

The reality was almost as curious. Soon after Dia became involved, Heiner Freidrich was quoted in a paper exulting that Dia had found the area "most suited to Don Judd's work." Judd responded crustily, telling a reporter: "I'm a little touchy about that. They came here because I was here, not the other way around. The arrangement is that they can't do anything in Marfa unless I let them, to put it bluntly." He hadn't worked his will on lower Manhattan, but this was his own turf.

In 1981 a deal was finalized. Judd's contract, which ran through to 1984, guaranteed him $17,500 a month as a salary-cum-installation-fee, and also that the project would be maintained in perpetuity. The more he got, though, the more cross-grained he became. On April 18, 1983, Friedrich wrote:

> Dear Don,
>
> I am happy to send you the enclosed information representing our first studies towards the creation of "The Marfa Museum of Contemporary Art" (or whatever name you choose) which will preserve and present the works of Donald Judd, Dan Flavin and John Chamberlain. . . . The Marfa project must continue to grow under your care and, for the moment, under ours as well. I am willing to do my part to foster positive, mutual understanding. . . . There is no furtherance of our common, proven interest by threatened law suits, angry and accusatory [sic] language and an atmosphere of distrust. By letting negative energies rule we can only destroy; by combining our positive energies we are sure to succeed.

Distrust or no, Judd set to work. He worked on the concrete pieces, which were made locally, and the aluminum boxes, which were fabricated by Lippincott in New Haven, Connecticut. Dia installed the Chamberlains in the Wool & Mohair Building in town. Dan

Flavin visited, looked over the six U-shaped huts he had been assigned, gave instructions for the installation, and waited. And waited. "That was another point of tension between Don and us," Heiner Friedrich says. "He felt that six buildings was too much. And we, having commissioned Dan already to do the works, were very strongly supportive of the idea. But it was not Don's priority, let us say."

Dia had problems rather worse than an artist's ego, though. The oil glut that had begun in 1981 was knocking hell out of the value of Schlumberger stocks and brought the Friedrichs fluttering to earth. Dia pared its staff. Not long after Friedrich's wounded letter, Judd was told that Marfa was being put on a back burner. Judd thundered about a breach-of-contract suit, but that summer oil prices went from a decline into a slump and Dia had to take out a multimillion-dollar loan, pledging Philippa's stock. At that juncture, Philippa's mother moved in.

Dominique de Menil was herself one of America's most significant supporters of Contemporary art, but a hardheaded woman withal. "The foundation was re-formed. I was surprised at the outcome," Heiner Friedrich told me in a TriBeCa coffee shop across the street from a Sufi bookshop, which he owned, and which is one block from a mosque. "I had been in fullest control of the foundation, and I did not remain in control. That was the surprise."

At the time, Friedrich, talking to the writer Phoebe Hoban, blamed his comeuppance on Judd's "malfunctioning mind." The years have brought serenity. "Don is a very saintly person in many ways," Friedrich told me in the spring of 1995, still using the present tense. Dia's new board, upon which Philippa was the only holdover, staved off the Judd suit by promising a further three years of funding for Marfa. On June 20, 1985, for instance, Dia was billed for "the cost of polishing and lacquering" half a dozen pieces. It came to $8,900. By this stage, too, the project had acquired a name satisfactory to Judd, borrowed from a humpbacked nearby mountain: the Chinati Foundation. Records indicate that Dia was continuing to dip into its pockets until 1992. By which time it had spent how much? "It's substantial,"

Friedrich said, flapping the air as though the numbers were a bothersome cloud of midges. "Eight million . . . nine million . . . This was unheard of, this commitment to one artist."

Donald Judd's dark rage against the Dia Foundation, though, held until the end of his life. It baffled John Chamberlain. "It was their money. That's what I said to him," the affable sculptor says. Lucas Samaras, another of the few artists Judd esteemed, feels the anger was in Judd always. "You can see it in his writing," he says.

I discussed the rage of Donald Judd with one of his closer artist friends, sculptor Claes Oldenburg, who had known Judd since the sixties. Oldenburg observed: "Don said Dia had meddled with his creativity. He became very, very paranoid. One of the reasons he bought up so many buildings in Marfa was that he was afraid that still the Dia Foundation would get to him. This was going very deep."

Barbara Rose suggests another source for Judd's growing rage. "Judd got angry and paranoid as the world turned to kitsch," she says. "This man had a very concrete aesthetic. And his aesthetic was his ethic. He felt betrayed. He was furious." Not only had such obsolete methods as pigment and canvas made a comeback, but figuration, metaphor, "story," had come pouring back into the art world, like goblins streaming from Pandora's box. Or a Judd box. The German Anselm Kiefer was specific. He built a cube, painted a woman on the interior, and entitled the piece *Donald Judd Hides Brunhilde*. The New Art had come. And, it seemed, gone.

Claes Oldenburg and his wife, Coosje van Bruggen, became fairly frequent visitors to Marfa in the 1980s. In a conversation in early 1995, Coosje described watching him at work upon ten small concrete boxes that had just been delivered by the fabricator. "At first sight you would think they had been very well executed," she said. "Don looked at them for about twenty minutes. And then he tore them apart! He was very specific. He pointed out exactly why this color wasn't what

it should be or why this texture was too much in the way of the form. You began to see exactly the way he saw. There stayed maybe three boxes."

She had an answer to my question, What did Judd see when he looked at his hundred aluminum boxes? "I have the answer for you," she said. "He was thinking, This one is scratched . . . this is not done right . . . this one is this . . ."

I mentioned how unalike Oldenburg and Judd's work was, considering their great mutual respect. There was no humor in Judd's work, for instance.

"Yeah! That's the difference," Coosje agreed.

"My viewpoint is that I seldom find anything humorous in my work," said the maker of the Soft Sculptures, solemnly.

Coosje and I looked at each other. We both laughed.

"All right," Claes Oldenburg said, permitting himself a chuckle. "But I'm thinking about it as form."

Note: Artists are frequently the least reliable persons to ask about the springs of their own work.

Judd had two passionate interests, related to but other than the strict making of art objects: furniture and architecture. Judd designed tables, desks, beds, and, perhaps most distinctively, straight-backed chairs, and had made a small and modestly profitable business out of it, headquartered in one of the Marfa buildings. When I visited, the building was full of Judd pieces, and it was interesting that the chair behind the desk at which the clerical work was conducted was a Thonet bentwood. Jeff Kopie observed that it suited him a bit better if he had to sit there for extended periods. The fact is that although you often see Judd chairs in the offices of such of his aficionados as Rudi Fuchs of Amsterdam's Stedjelik Museum, most people find them fairly uncomfortable to sit in, a fact the artist acknowledged in wonderfully cranky style, advising complainers to go and lie down on a bed.

Judd was no less high-minded about architecture. Lauretta Vinciarelli, an Italian architect who teaches at Columbia and who was

close to Judd, says he told her he had thought of actually becoming an architect but had balked at the notion of dealing with clients. But he took his work at Marfa with the utmost seriousness, noting that he had taken the gun sheds and "turned them into architecture." So he was not backward when Oldenburg got him invited to participate in the development of a sizable corporate center in Cleveland, Ohio.

It was a lakeside site and the developer, insurance magnate Peter Lewis, had brought in two architects, Peter Eisenman and Frank Gehry. Four artists were then brought in: Richard Serra, Carl Andre, Oldenburg, and Judd. The notion was that everybody should work on different aspects. The dapper Eisenman, for instance, suggested a parking garage that would follow the shoreline. "It was all gobbledy-gook to us," says Frank Gehry, one of the few architects on close terms with the art world. "The artists said it, and I said it."

The group shrank. Serra had never become wholly involved, and Carl Andre recused himself because of his upcoming trial in the death fall of his wife, Ana Mendieta. "He didn't want to burden us with the public stuff that was coming down on him," Gehry says. The survivors went to work on their schemes.

They convened at a meeting in Cleveland attended by the developer. Gehry showed his models. "Then Don spread out his plans and said, 'I'm against what Frank Gehry is doing,'" Gehry says. Judd showed them his scheme, and said, "Don't take Frank Gehry. Take me." Frank Gehry has understandably vivid memories of this get-together. "Eisenman couldn't deal with it," he says. "Judd's proposal invalidated his proposal. If they did Judd's proposal, all of us would be gone. I wouldn't be there! Oldenburg wouldn't be there!"

Laughing uproariously, Gehry says, "He had eight office buildings. They were three stories high. He had separated all the parts of the company. It was a Judd piece. It was a beautiful Judd piece. If they had built it, it would have been one of the most beautiful sculptures in existence, and I said that. But it was untenable as a project. It was not real about the project. And not real about the collaboration. He just pushed us away." Coosje van Bruggen says, "Frank was generous

enough not to see it as backstabbing but as an interesting idea. Frank said, 'Yeah! From Judd I can take it.'"

"I loved his work. I loved being with him," Gehry says. "He wrote terrible things about me. Oh, he said terrible things! But I only lost contact with him artistically when he became religious. He lost me on that."

Gehry means the Religion of Art.

"He always grabbed a high moral plane," he adds. "He was always purer than anyone in the room. By one notch. He would always wait for everyone to speak, then take the one-notch-higher jump on you . . ." The Cleveland project was not built. "Probably, I was not very surprised," Lauretta Vinciarelli says.

The paradoxes are slick as punch lines. The heating up of the 1980s art market was created by just the sort of artists Judd thought he had consigned to the trash can of history, but if it was the likes of Schnabel who were getting the attention, the older artists were getting rewards as rich — or richer. Prominently, Donald Judd. As the prices for works by Pollock, de Kooning, and Jasper Johns had gone over the moon, collectors developed a hunger for new Masters. Judd's work was "difficult" but had engendered an impressive critical discourse, and he was a hero on the museum circuit. Also, and this is subtler, there was to his very rigor something that collectors could respond to, as a corrective in fat times, a cleansing of the palate. By 1989 Donald Judd was taking in $4 million a year, most of which he plunged back into the work, and into Chinati.

To Judd, though, the Boom only made the art world more unsavory. In the spring of 1990, Count Panza di Biumo, one of Europe's most assiduous collectors, sold a slice of his holdings in Minimal and Conceptual art to the Guggenheim Museum for $32 million. Count Panza is not admired by all of his fellow citizens. "Panza never bought Italian art. He always bought because of the dollar value," says critic/

curator Germano Celant. The Panza deal became the *scandale de jour* in the American art press when it was learned that the museum had sold off several Kandinskys to raise money for the deal and that many of the Panza pieces only existed as plans, on paper.

Among the nonexistent pieces were several by Donald Judd, who promptly came out swinging. The text he wrote, "Una stanza per Panza" ("A Song for Panza"), is ten thousand words long, sometimes cogent, sometimes bizarre, but always corrosive. Judd declared that Panza had merely purchased the right to have Judd supervise the making of a piece. Without his supervision, the pieces would be fakes. "The Guggenheim has bought dubious pieces of paper, some completely unfounded claims, not on paper, and some forgeries, as well as a few pieces made under my supervision. Needless to say I have no intention of helping the Guggenheim," Judd wrote exultantly. "The Guggenheim has bought a pig in a poke, *comprar a ciegas, hacer un mal negozio, puerco a panza.*"

As for Panza himself, whom Judd refers to as "Count (1940) Giuseppe Panza di Biumo," indicating a Mussolini title, he calls him "a dumb, arrogant man intent on making money in a dumb, soft spot in society." To wit: the Art World.

For a time during the heady Boom Judd had a workforce of fifty-four and a payroll of half a million dollars a year. His assistants seldom came through customary art channels. Rob Weiner, for instance, a would-be stage director, met Judd in 1989 while taking on the paid chore of painting his elevator shaft in SoHo. He stayed with Judd and in due course introduced his boss to Jeff Kopie, who was just out of college and had done some accountancy for a Madison Avenue boutique. They became Judd's chief administrative assistants. Their responsibilities went way beyond oiling the wheels of the exhibition circuit.

Judd had become a rancher. He had bought three separate spreads, some forty thousand acres in all, on the Mexican border, and he had stitched them together, calling the place the Ayala de Chinati. He built more art there and kept Longhorn cattle and some horses,

but few, because the land was overgrazed and he wanted it to regenerate. He owned some twenty buildings in Marfa, most of which were still empty, and another some twenty miles away in Fort Davis. Judd, who like many idealists was awkward around individuals but felt warmly about human beings generally, planned to turn this into a co-op where local artisans—saddle-makers, blacksmiths, etc.—might practice their craft and farmers might sell their produce. He contemplated bottling spring water from his ranch, and made prototypes of cunningly interlocking glass bottles to this end. He also thought of becoming a New York distributor of *sotol*, a fermented agave liquor, and he provided Dean & DeLuca, the SoHo provision merchants, with a sample of the hard white local cheese, *asadero*. "My cheese guy was pretty excited," says Giorgio DeLuca. "But logistically it was too daunting."

Not all Judd's plans were so functional. "There's a big mountain of rock on the way to the ranch," says Douglas Baxter, who had worked with Judd for years at the Paula Cooper Gallery and had also gone to Pace. "This mountain became available for sale. Don bought it for $185,000. *There's nothing you could do with this real estate.*

"But he had a very pure idea of nature. It was about protecting it from development. But it was also like buying an object. This big rock mountain!"

The artist John Baldessari, whose father is in real estate, found this land hunger amazing. He was shown a map of Judd holdings. "I don't know if they were kidding or not," he says. "But there was this one parcel that had a swastika on it. I said, 'What's that?'

"It was a holdout, somebody who wouldn't sell to Don."

Judd was also as choleric as ever about the Authorities, and not without reason. A couple of locally based FBI agents raided the Chinati Foundation, for reasons that remain unclear. The G-men removed a couple of blow-ups that Judd had caused to be made of Le Corbusier's identity card of the 1920s. When they were returned a while later, one was tagged EVIDENCE FEDERAL BUREAU OF INVESTIGATION. "Don loved that," Rob Weiner says. "He had me write to the FBI, asking for a bit

of tape for the other one, so that they could both have this provenance. The FBI wrote back, saying they appreciated our interest in their procedures, and blah blah blah."

Judd's brushes with officialdom didn't always end so cheerfully. He joined in a lawsuit to prevent a nuclear waste dump from being sited 160 miles from Chinati. Another party to the suit, the city of El Paso, had more muscle. The dump was relocated. "It's sixty miles closer to us now," Weiner says. Annoyed by sonic booms over the ranch, he traced the nuisance to a base in Albuquerque and looked into suing the air force. "A lawyer warned him that if he did, they would subpoena his entire life," Weiner says. "Don wasn't persuaded. He wanted to fight it." Of course.

As far as the Chinati Foundation went, though, things seemed set fair. In 1989 Claes Oldenburg and Coosje van Bruggen erected their piece, a monument to Fort D. A. Russell's last horse, Louie. Awaiting installation was a very early rubber piece by Richard Serra, glass works by Larry Bell, and much else. Already *in situ* were a couple of astoundingly patinated bronze cones by Roni Horn, a woman artist working in Manhattan, who happened to have been the only artist whose name occurred to Judd when I asked him at our last meeting which younger artists he admired. And outside the Arena, one of the largest buildings in Chinati, once the army gymnasium and used by Judd for rare formal dinners, there is a ring of black volcanic rocks gathered by the British artist Richard Long in Iceland. It seems appropriate to note that Donald Judd was himself enthralled by Iceland's severe beauties, that Roni Horn has worked there, as has Richard Serra, and that they are in this the heirs to that not un–Judd-like figure, the patriarch of the arts-and-crafts movement of the late nineteenth century, and exceedingly rich Socialist, William Morris.

The collapse in art prices hit Donald Judd peculiarly hard, lopping his income by an estimated 80 percent. "I had to write, cutting off his stipend," says Lesley Waddington, London's largest dealer in Contemporary art, who was also hard hit. "He said I was leaving him

to starve in the desert. But he had champagne and pâté waiting for me when I visited him in SoHo. I liked him immensely. You know, I knew Sam Beckett well. He and Sam were always very close in my mind."

Judd did not let the harder times cramp his style in Chinati, either. In 1991 he was introduced to the Russian artist Ilya Kabakov, by Marianne Stockebrand, a Cologne art historian, who had entered his life when she curated a show of his work in Münster. Kabakov and his wife were invited by Judd to Marfa and were much taken by West Texas. "Enormous spaces where nobody lives. It's very similar to Russia," Kabakov says. It was agreed that he should make an installation there.

One of the formal occasions for which Judd put the Arena to use was the October get-together, which would be attended by many in Marfa, who would be wined and dined and entertained by a Judd crony, Pipe Major Joe Brady, playing the pipes. Ilya Kabakov attended the October Fest the year of his installation, taking his New York dealer, Ronald Feldman. A balding, sharp-featured man, Feldman was far from being a Judd partisan. "I never felt that close to Judd's work," he told me. "There were these shiny objects that materialized here and there. It left me cold."

I mentioned to Feldman that Judd's work had focused my attention on the way that certain artists require faith, belief. You don't have to believe in a Picasso or a Paul Klee. It is all there—take it or leave it. Other artists, like Joseph Beuys, have shrewdly played the shaman role. Judd had no shamanistic pretensions as a man, but the work required faith, in part because it excluded so much. Feldman had found the same in the gun sheds. "What's expected of you is that you become a believer," he said. "It's definitely to obliterate all other artists. There's no question.

"I sat down in one of the buildings. First, I had to dissociate myself from the megalomania that caused all this to exist. But I realized that without that, the work couldn't have come into existence. It took too much energy. Too much vision. Then I realized that you could spend

a lifetime in there. It was a world of the mind. But if you totally re-
leased yourself into the work, there was the cult thing again. That was
the problem."

Judd could be a generous cultist, though, welcoming to work as
unlike his as that of Kabakov, who has evoked an abandoned Russian
schoolhouse in one of the U-shaped huts. The hut has been painted
barn-red. There are pieces of furniture, dusty vitrines filled with school
stuff and a melancholy litter of papers. It is haunting.

"It's the same as you find in an Egyptian pyramid some small
dolls. And the little girl who was playing, her skeleton left," Kabakov
told me, his wife translating.

"And next door there is a work by Don, which treats the time and
the space completely differently."

The gun sheds. I said: "You provided the children's chamber and
Donald Judd built the pyramid?"

"Absolutely," Kabakov said, in English now. "He did something
which works against time. These pieces are indestructible. They are
forever."

There is a white building with a white fence outside across the
road from the Block in Marfa. It houses the West Texas Ice Company
and its owner, Tom Horn, is a reclusive fellow, who shares living quar-
ters with his mother and was forever hosing down his yard and polishing
up his door handles. In the spring of 1993 Judd returned from Europe
to find that Horn had bought a new piece of equipment: an eighteen-
wheel tractor-trailer — white, of course — that came equipped with a
Thermo-King refrigeration unit. He kept this thrumming noisily away
on an on-off cycle twenty-four hours a day. "Don came to me and said,
'I've never had a problem with this guy. See what you can do about
quieting the truck. See if he'll turn it off between nine at night and six
in the morning so we can get some sleep,'" Jeff Kopie says.

Horn wouldn't respond to Kopie's calls, though. "I finally ran into him in town," Kopie says. "He said, 'It's going to be a long, hot summer. There's nothing I can do about it.' He was very disagreeable."

Donald Judd might have been bested over the nuclear dump and the intrusive jets, but he wasn't going to tolerate a thunderous ice machine. Horn's very finickiness suggested a weapon. Judd had Weiner park their junkiest cars alongside the iceworks. "It drove Horn crazy," Kopie says. In the morning they would find that lights and license plates had been torn off the vehicles, and both Rob Weiner and Ramon Nunez, a Judd foreman, filed charges that Horn had threatened their lives. But the machine still wasn't quieted.

Weiner and Kopie were seeing Judd on a daily basis, and neither noticed a change in his demeanor. That summer, though, Joost van Oss, a Dutch Abstractionist, who arrived in Marfa with a letter of introduction from the Stedelijk Museum director, Rudi Fuchs, was struck by how unwell the artist seemed. "He had a potbelly. He was puffy," says van Oss. Judd asked him to dine in the Arena at six. "I arrived at about three minutes past six," van Oss says. He mimed a back of martinet stiffness. "Rainer told me that when he said six, he meant six *sharp*."

Marfa elected a new mayor in May 1993, Jake Briskin. "I used to tell people that I was the only person who had known Don for fifteen years and never had a conflict with him," Briskin says. "I had a deep appreciation of what he had done for this country and this town. Don added a dimension of light seldom found in rural towns."

Judd tried to enlist Briskin's support regarding the ice machine several times. The last was at a meeting in Briskin's office that lasted an hour and a half. "Don looked terrible that day," Briskin says. "He had a bloated paunch, and he was sweating real bad. His eyes were running. It looked like this ice machine thing was really taking its toll.

"Don wanted me to use public funds to purchase some equipment to lower the noise level of the machine. First of all, it's illegal for me to enter a private dispute with public money. Second, Don had

put himself in a very tenuous position, because he had built his living and thinking space about 150 feet from the biggest feed mill in West Texas that sometimes runs twenty-four hours a day, two hundred feet from Highway 90 and right beside an ice plant. And he didn't want any noise!"

Judd persisted, pointing out how much he had done for Marfa and how much money he had plowed into it. A tricky line of argument, this, anywhere for an avowed anarchist and believer in individual rights, but most especially in Texas, where such rights are practically the state creed. "I said to Don, 'Are you telling me that you're more important than him and I should shut him down?'" Briskin remembers. "'What am I going to do if a more important artist than you comes to town and doesn't like your art? Am I going to shut you down too?'

"And that made him angry. All of a sudden I, who had been a friend, was the other guy. He looked at me in the eye and said, 'Jake, this is just another incident in twenty years of incidents.' With Don, you were either a friend or you were gone. All of a sudden that day in my office I went from being a friend. I disappeared."

Judd's next moves were not namby-pamby. A number of Marfans, among them May Quick, former owner of the Wool & Mohair Building, were living in Judd-owned houses rent-free. He sent letters telling them to vacate in sixty days. He stopped the Judd enterprises from shopping in Marfa and took their business to the neighboring towns Alpine and Fort Davis instead. He had been paying property taxes on a number of buildings, but instructed Rob Weiner to research methods of taking them into a nonprofit foundation. He pruned the October get-together at which 750 had been expected. "We only had about fifty," Rob Weiner says. He cut back on the times that Chinati was open to the public, although he couldn't keep the public out totally, because Chinati — and, indeed, Donald Judd's whole life — was run as a tax-free foundation and access was a requirement. Perhaps most striking, he brown-papered the street-level windows of his Marfa houses and threatened to move them out of town. "He was so pissed off," Kopie

says. "He was talking about taking them apart piece by piece and re-building them in Germany."

Judd never did follow through on his eviction notices, and what he would have done with his houses cannot be said. Mayor Briskin thinks it was "a bluff." By the summer's end Weiner and Kopie could see all was not well with the artist. "He was obviously having trouble breathing," Kopie says. "He thought it was the flu. We had a doctor come, and he prescribed some antibiotics. Those symptoms dissipated, but Don said when he went to Europe he would have a full examination."

Judd wanted to visit his mother before leaving, though. His father had recently died, and his sister also, of pancreatic cancer, just a year before. "He booked a flight but had to reschedule because he felt too ill to travel," says Kopie. "But I didn't think much about it. I thought he would be around another twenty years. I really did. I thought I would be long gone from here."

Judd had a full calendar in Europe. He met Marianne Stocke-brand in Cologne and went with her to the Kunstverein, the museum where they had first met and where there was a show of drawings by Roni Horn. Douglas Baxter of the Pace Gallery couldn't find them there but was guided to them by Judd's booming laugh. The following day he had his medical examination. The doctor diagnosed lymphoma and told Judd he didn't have long to live. Stockebrand simply describes Judd as "shocked."

They flew to Amsterdam, where Judd had been given a distin-guished if rarefied award, the Sikkens Prize, for his use of color. He was too ill to deliver the talk he had written. Nor was he able to visit a retrospective of his sculpture in the Stedelijk Museum. Judd stayed a few days in the hospital there, flew back to the United States, and checked into New York Hospital. He did a good deal of reading, mostly philosophy—Dewey, Locke, Hume—and art history, bought by Rob Weiner at Ursus on Madison Avenue, and he was strong enough to spend Christmas in his house on Spring Street with Marianne Stocke-brand and his children.

Early in the new year he returned to the hospital, and weakened quickly. "The room was chilly, and I was putting a blanket on him," says Roni Horn, who visited him. "He said, 'It's chilly at the top.' And we both smiled. It was an understanding that we had that he was talking about his position in the art world." Donald Judd died at nine in the morning on Saturday, February 12, 1994.

There is a common-sense assumption that when a famous artist dies, the value of his (now finite) oeuvre must soar, or at least stabilize. Like most common-sense assumptions about the art world, this is false. Actually, prices generally wobble or drop. Judd might have seemed peculiarly vulnerable because there had been muttering that he was overproducing: "Just phoning the stuff in," as one of his former dealers put it. Doubts can also flourish when an artist's work is physically made by artisans. One art-world jest after Warhol's death had been: Will it slow down his production? Soon this was being dusted off for Donald Judd. Wrongly. The artist's dealer and his executors quickly decided that no new work would be made, even from his completed plans.

The Judd estate, which will evolve into the Judd Foundation, owns all of the property and art that isn't owned by the Chinati Foundation. The executors are his children, Flavin and Rainer, and Marianne Stockebrand, with one vote each. Stockebrand, unlike the children, is also on the board of Chinati. Will Chinati be getting more of Judd's work?

"You mean from the Judd estate?" Flavin Judd asked sharply.

"You mean, did he will anything to Chinati?" asked Rainer.

Precisely.

"No," Flavin said. "Chinati's got what it's got. The estate can't just give things away."

The fact is that Chinati, the apple of the artist's eye and his best hope for the future, was left a bit in the soup. "Don made no distinc-

tion between what he owned and what Chinati owned," Marianne Stockebrand says, delicately. "I don't think he quite understood that other people would have to make these distinctions." "We know it's going to be really hard work," says Jeff Kopie. "There are lots of things this foundation won't be able to afford to do. There'll be fewer trips to New York. But we can get by pretty cheaply." He hazarded a bare-bones estimate of $200,000 a year. "Everybody should make an effort to see that Marfa survives," says Heiner Friedrich. "Including Dia."

On my last day in Marfa, I went back to the gun sheds. "Some-where a portion of contemporary art has to exist as an example of what the art and its context were meant to be," he once wrote with his usual crystalline irritability. "Otherwise art is only show and monkey business."

"He was trying to build something. And each time he had some money, he put it there," Coosje van Bruggen says. "Don had this huge vision. Don fought entropy. That's it. Don fought entropy!" It was the last of his fierce unwinnable wars.

Eight / The Saviors

There was, of course, a naked woman. She was in the Italian pavilion. It was the summer of 1993 and the Forty-fifth Venice Biennale was not yet open to the paying public, but its scattered venues were swarming with art worlders—gossiping, politicking, and hectically completing installations of their art. The naked woman was an element in a piece. She had been required to snip tufts of her hair and arrange them into a Star of David on a mirror, and other elements in the piece had been so disposed that viewers were seldom able to see what are still sometimes quaintly called private parts. This seemed an amazing fit of reticence given the thickets of genitalia on view elsewhere.

The Italian pavilion is in the Giardini, where all the national pavilions are located. Achille Bonito Oliva, though, the Neapolitan critic and creator of the Transavanguardia, who was the head of the Biennale this time around, was vehement that his festival wasn't about national pavilions. A short man with a pitted face, cunning eyes, a black shirt, watches on both wrists, and flat silver hair combed straight forward, Bonito Oliva was generous with Xerox copies of a current feature in a New York art monthly, which included him among the "50 Most Powerful People in the Art World." The accompanying thumbnail sketch alluded to his "Napoleon Complex." So that explained the hair. Bonito Oliva said—in Italian, he speaks no English—that his Biennale was shunning national cultural competitiveness. "There is

no more competition. There are no big pavilions, no little pavilions,"
he explained, magnificently. The pavilions were merely "gazebos."
His concept, he added, was that the breakup of the old world order
required a more fluid approach to art. His phrase was *nomadismo.*

Even as expos of Contemporary art proliferated worldwide
through the eighties, the Venice Biennale, which is the oldest of them
and the most ravishingly situated, has held its own as a place for break-
ing art-world news. Cultural nationalism has been a motor of past
Biennales, often taking the popular form of anti-Americanism. Rob-
ert Rauschenberg's 1964 victory rubbed in New York's victory over the
École de Paris and spawned rumors that Leo Castelli had somehow
put in the fix.

Why should anything be different in 1993? Italy was in the toils
of the *tangentipoli*, the serpentine corruption scandals, and Gianni
de Michelis, the political boss of Venice, was under a cloud. Huge
amounts of money raised for the charity Venice in Peril from well-
wishers abroad had vanished. The cash-strapped Biennale bureaucracy
had tried to scrimp by refusing to shoulder shipping costs for exhibitors.
Suspicious American artists and dealers had instantly seen this as a
way of muscling them into leaving their bigger, more ambitious works
at home and had kicked up such a fuss that Bonito Oliva had flip-
flopped. Actually, though, anti-Americanism was rather a nonstarter
at this particular Biennale because of the canny choice of a national
standard-bearer in Louise Bourgeois. Bourgeois was (a) a woman, (b)
a venerable woman, and (c) a woman who was born in Paris, had stud-
ied with Léger, and still spoke with a Gallic accent. She was indeed
swiftly singled out on the Biennale's Gossip Network—murmurings
that soon hardened to a drumbeat—as an ultimate prizewinner.

Bourgeois had one serious problem: She sculpted. Sculpture and
painting were as wan presences at the Forty-fifth Biennale as they were
in the art world generally. True, the Museo Correr on the Piazza San
Marco was showing a massive retrospective of Francis Bacon and there
was a painters' ghetto in the Giardini's main building, including can-
vases by Per Kirkeby and Sigmar Polke. For all the attention the paint-

ers were getting, though, they might as well have been hanging in one of the package-tour hotels on the Lido. The Antoni Tàpies exhibition in the Spanish pavilion seemed unhappily to the point. Tàpies is a painter, and a past master in the making of raw, lush material surfaces, but standing like an awkward hipster at the entrance to his show was a piece of conceptual thingdom that looked like partially assembled camping equipment.

Marcel Duchamp, the godfather, was a presence in Venice, at an encyclopedic show at the Palazzo Grassi and as a spectral presence just everywhere. An American curator, standing on the steps of the Louise Bourgeois exhibition, pointed out a kind of a greenhouse just to our front. "A pity about that," he said smoothly. "It's supposed to be about ecology. It looks as if it's about plastic." It was the work of Avital Geva, an Israeli environmental artist, and it was completely functional in a making-the-desert-bloom-like-a-rose mode. With its plashing waters and greenery, it had the eerie aesthetic of movies like *Solaris* and *Silent Running* and I liked it. Haim Steinbach said it was one of his favorite pieces in Venice because "it wasn't like an art experience at all."

Achille Bonito Oliva's *nomadismo* turned out to be a slippery concept. Sometimes the Biennale brutally reflected the New World Disorder. A kind of a Judd box had been set up in the onetime Czechoslovakia pavilion, with babushka-doll effect. The Czechs were outside; the Slovaks lurked within. I told each artist separately that it was encouraging that they were sharing the same building. Each gave a thin smile. The Yugoslavia pavilion had been disassembled. The Slovenian collective Irwin was out there someplace, and a Macedonian artist had placed shapes made out of straw in the trees by the main gate. Even before the official opening the Macedonians were enraged to find their exhibit restickered as YUGOSLAVIA — FORMER REPUBLIC OF MACEDONIA by Biennale officialdom, cowed by the huffing of Greece.

Mostly, *nomadismo* seemed just a new way of saying International Style. It was like the nomadism of top soccer players, who go where the plum contracts beckon. As such, it was excellent cover for a con-

tinuance of New York hegemony. Joseph Kosuth was in the Hungarian pavilion. Yoko Ono, with her customary whim of iron, had contributed a "Meditation Room" to the Israeli pavilion. The reunited Germans had given their pavilion over to Nam June Paik, a Korean-American, and to Hans Haacke, a German who had lived in Manhattan for three decades. Paik was in the side building, which he had filled with an ur-hippie agglomeration of video screens, plus a soundtrack. Hans Haacke was in the main building.

Ideas tend to pop into being when times are ripe for them. Hans Haacke and Christian Boltanski both played off the fact that previous Biennales had been held under the aegis of Mussolini. Boltanski based his installation on the 1938 Biennale, and Haacke displayed a photograph of Hitler taken there in 1934. Haacke had also had the pavilion stripped of fittings and the terrazzo flooring ripped up. It lay there in jagged peaks, a bombing-raid aesthetic, but what made the piece was the sound. The clambering of the artists, dealers, art journalists, and camp followers over the broken tiles was generating sharp cracks and hollow booms, as though the intelligentsia had strayed into a real, invisible war. Hans Haacke was standing outside when I emerged. "Did you think it was going to sound like that?" I asked. "I was worried that we were going to be drowned out by the sound from Paik's space. It seems it is the reverse," he said. Such honesty about luck is less the art-world norm than might be supposed.

Much of the action was away from the pavilions. The Slittamenti, the ancient warehouses, featured a tribute to John Cage. It was alongside a show billed as a collaboration between the Spanish director Pedro Almodovar and the Manhattan curator Christian Leigh, although nobody could figure out what the absent Almodovar had contributed, apart from his name. Christian Leigh, the prime mover, is an exemplar of a very contemporary breed, the Creative Curator. This was somebody who had a reputation for delivering whatever was most piping hot in art. He or she — or both in the case of Tricia Collins and Richard Milazzo, who practiced as a creative duo with particular éclat

in the Manhattan of the eighties—would present the art in exhibitions that were so High Concept that they were in themselves at least as significant as any individual artworks lucky enough to make the cut. Christian Leigh's art-jammed show in SoHo's Thread Waxing Space in 1992 had actually been entitled "I Am the Enunciator," for those too slow to understand who was in charge. In the Slittamenti he took things to a giddy limit.

Leigh hired a local team to paint the walls to his specifications, which were zigs and zags in shrieking soft-toy colors with a candy store of Dr. Caligari effect. This hanging was no help in actually looking at the art, but it had everything to do with juicing up the art world. Also, as far as the artists went, it *did* mean being in the Venice Biennale. This turned out to be a doubtful privilege, because Leigh's finances had evaporated before the Biennale even opened. The catalog was never issued, the curator evaded creditors by nifty vaporetto-hopping, and the art was impounded by the Italians. Some works were recovered after expensive legal in-fighting; some seem still to be in the clutches of the Doges' heirs. Christian Leigh became a fugitive, and so he remains at the time of this writing, his rotund form the subject of rumored sightings in nooks and crannies of the world, one of the more oddly endearing villain/victims of the Art Follies of the late eighties.

There were other installations, too, installations being an ideal form for a culture with an attention span dwindling like a puddle in the sun. Robert Wilson, France's favorite American artist, had created an earth floor from which protruded a blindfolded head. A beam hung overhead and there was a soundtrack—"Hurry Up Please It's Time . . . There Is No Revolution." The Palazzo Fortuny had been allotted to the annoying Peter Greenaway, a Briton, who makes films (*The Cook, the Thief, His Wife and Her Lover*) as well as art. Greenaway is annoying because his work is intelligent and good-looking, but response to it is deadened by the maker's suffocating smugness. (Not all character flaws wreck an artist's work, and plenty of good artists are sentimental, snobbish, or cruel, but condescending clever-cleverness is a killer.)

Then, of course, there was the Aperto. The Aperto, which was in the Corderia, the ancient ropeworks, was for artists under forty, which is to say those with careers still vulnerable, volatile, in flux. There was a horde of them, the choices of thirteen equally ambitious curators, and this, as far as the working art world was concerned, was action central at the Biennale. The jazz began right at the entrance, with three walls of photographs by Oliviero Toscani, the maestro of the Benetton ads. They featured the larger-than-life-size genitalia of men, women, and children in all the skin tones of the "Rainbow Coalition."

This was an appropriate curtain-raiser. There was a totemic sculpture within by the Los Angeles artist Paul McCarthy—neither McCarthy nor Toscani would say hello to forty-five again, but rules are for breaking in Venice—with an outsize member. Kiki Smith, a New York–based artist, was showing a couple of roughly modeled wax figures, a woman fondling her nipple and a man fellating himself. Another New York–based artist, Sean Landers, showed a video and had some handwritten sheets pinned to the wall. Kiki Smith is uneven, but her modeled figures can be gruesomely compelling. Here she was strident. Landers shows at the Andrea Rosen Gallery in SoHo. Typically, he would scrawl a cartoon on a sheet of yellow paper and pin it to a wall alongside a sheet of his writing. Landers's writings are poignant, misspelled—he is dyslexic—and often very funny, and he would make his points in single pages or three-page sequences at the most. There were dozens of sheets pinned to the wall of the Aperto, which he edited down to a few after the opening. The video showed him masturbating.

If sex was one leitmotif in Venice, death was another. Adam Gopnik wrote mordantly in the *New Yorker* about the Biennale's "peculiar badness." His proposition was that the ironic modes of the eighties had been displaced by a new International Style: "a High Morbid Manner that is likely to survive as a signature style of our fin de siècle." Gopnik mentioned Francis Bacon and Louise Bourgeois as though they were uncle and aunt figures to the mode, and he observed that the single dominant influence in the emergence of this manner was

the clangorous, delectably repellent work of an artist who was an emphatic absence from Venice, Bruce Nauman.

Dada is routinely invoked when artists who work in this manner are discussed, but as Gopnik pointed out, Surrealism is more relevant. If there has been something almost clandestine about the comeback of Surrealism it is because it has long been in bad odor. This is partly because the Surrealists tell stories—heresy when critics like Clement Greenberg ruled—and partly because their seductive rebelliousness was so enthusiastically embraced by *le bon ton*, what with Surrealist balls and Surrealist place settings at Rothschild dinners, that it became hard not to see them as complicit in the pillaging of their vocabulary by such image vultures as admen, fashion photographers, and, most recently, directors of music videos. Indeed, the Late Victorian authority figures lampooned by Max Ernst and Magritte, and in the Dalí-Buñuel movies, make a last bow on *Monty Python*.

Here in Venice was a group of artists who were producing the Surrealist frisson—"convulsive beauty" was André Breton's term—without such period Surrealist baggage as junky Freudianism and porno-kitsch. Gopnik singled out as peculiarly representative of his High Morbid Manner an artist whose contribution to the Aperto consisted of a cow and a calf, both bisected, the halves afloat in four glass tanks in a mixture of formaldehyde and water. Its immediate neighbors included the Kiki Smith, several squalling videos, and a piece by a Japanese Conceptualist, *World Flag Ant Farm*. He had replicated the world's flags in colored sand in a structure that was home to an ant colony, which scuttled around picturesquely dismantling the flags. The cow piece was called *Mother and Child*. The artist was an Englishman, not yet thirty, called Damien Hirst.

I had met Damien Hirst at an art party in Manhattan about a year before. He was short, sturdy, pale, with a shaven pate and a general air of potential turbulence, like a soccer hooligan. Some days later I had lunched with Hirst and his girlfriend, Maia, and found him on an alternating current, flickering between outrage and reticence. He

was wary of New York, and especially wary of being elected to that dangerous position: the Next Big Thing.

The art world had been aching for the Next Big Thing ever since the fall. But too many artworks had lost their luster, too many artists had been cut from the team, and many too many speculative collectors were still smarting from the morning after. An invigorated art economy would require a fresh start, meaning fresh collectors, who would only start champing at the bit when they scented fresh art.

An early front-runner as the Next Big Thing was Nayland Blake, a New Yorker, born in 1960, who had moved to San Francisco in the mid-1980s. Blake is gay, and the pieces he was making—using materials like black rubber and chrome tubing—had an uncomfortable presence, emanations of the lab or the hospital. A piece was noticed favorably in "Mind over Matter," a show at the Whitney in 1990, and yet more so at the Whitney Biennial the following year. That was enough. Nayland Blake was in play.

Blake was introduced to the culture at large in a piece in the "Arts & Leisure" section of the *New York Times* of March 3, 1991. He was paired with David Hammons, a black artist, whose pieces often make use of stuff he has picked up near his Harlem studio, like inner tubes, scrap paper, empty half-bottles of Thunderbird, a favorite tipple of winos. Kurt Schwitters had transformed bus tickets into delicate art, Joseph Cornell used "real life" bits and pieces to build a magical world, and Rauschenberg made exuberant constructions on the line between art and life. David Hammons's pieces are as filled with life as a trashed apartment, and it is not pretty. The *Times* headlined its piece "Art Gets Serious with a New Set of Stars." It was noted that Hammons was represented by Jack Tilton, whose gallery is respected but small, and that Nayland Blake would be doing a show with Mary Boone.

Blake promptly announced that he would *not* be showing with Mary Boone. There are different versions as to the dynamics of what

Donald Judd in Chinati, Texas. *Photograph: Todd Eberle*

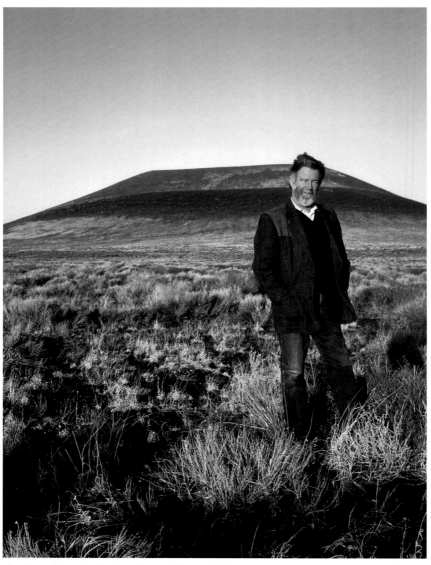

Jim Turrell at the Roden Crater, Flagstaff, Arizona. *Photograph: Todd Eberle*

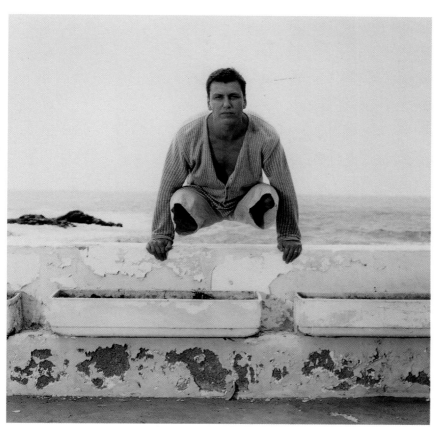

Rob Scholte in Tenerife. *Photograph: Trevor Ray Hart*

Mark Tansey. *Photograph: Todd Eberle*

Larry Gagosian and
Frank Stella. Opening of
the Gagosian Gallery,
Los Angeles, in October
1995. *Photograph: Alan
Berliner*

Arne Glimcher of Pace
Wildenstein. *Photograph:
Timothy Greenfield-Sanders*

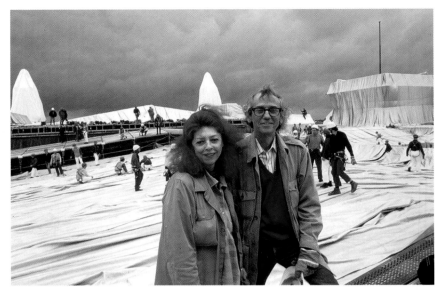

Christo and Jeanne-Claude—who formally announced that they were dual artists in February 1994, thirty years after their arrival in Manhattan—with the wrapped Reichstag, 1995. *Photograph: Wolfgang Volz*

The Survival Research Laboratory; *The Big Arm & The Inchworm. Photograph: Nicole Rosenthal*

Janine Antony, making *Loving Care*. *Courtesy of Prudence Cuming Associates*

Matthew Barney, making *Blind Perineum*. *Courtesy Barbara Gladstone Gallery, New York*

Damien Hirst, with art material. *Photograph: Nitin Vadukul*

happened to Blake next. "They didn't give him a chance," says Karsten Schubert, a German dealer who runs one of London's few core galleries. "Mind you, he played games. I flew out to San Francisco that month, when everybody was talking about Nayland Blake. And it was unreal. He basically played everyone in New York against everybody else. He played Paula against Mary and Marian. And people are not stupid. And people do talk.

"The artist can misjudge that. The problem with being hot is something has to happen pretty much immediately. Because if it doesn't happen, it means only one thing—you're not *that* hot. You have to kind of put up the pressure more and more."

Blake, naturally, has another perspective. "What happened with me is that the art world keeps looking for a savior. Particularly once the market collapsed," he says. "They wanted the person to come along who was going to make it all right again." He sees what he underwent as "kind of a test . . . what happens in that situation is really that you're tempted by the devil. You are shown everything you could have. And all you have to do is part with your soul. I found myself really quite in agony. It was very distressing to me."

Nayland Blake had gone from roasting to room temperature in nothing flat. A couple of years later he would be on the roster of a new young dealer with a canny eye, Matthew Marks. Blake makes strong work and is having an estimable career. But his peculiar moment in the sun was over.

David Hammons remains associated with Jack Tilton. *Associated* is Tilton's own careful term. Black American artists, the dealer points out, tend to be particularly keen on independence.

Already before the Bust there had been fatigue in Manhattan. For a decade, fresh Art Stars were being crowned every few months. After Neo-Geo energies wilted, though, and a handful of dealers began looking elsewhere: Europe. One dealer, Jack Shainman, says, "Until

then most of the interest had been in American art. Marian Goodman and Sonnabend showed a few Europeans, but those were superstars, like Kiefer and Richter." Shainman and his fellows began looking at artists who had made solid reputations overseas but had not yet made much of a dent in the United States. Their thinking came partly from the art world's vaunted "globalization," a tiresome abstraction, but alluding to a real-world infrastructure of art fairs and internationally read magazines. It was more to do with power. In the postcommunist world, the New Europe was assumed to be an emerging superpower. Unlike such other emerging superpowers as the Pacific Rim, it would have more than financial heft. It would produce super artists. It was assumed that these artists would be eager for the World Artist status that only SoHo could provide.

Such, irritatingly, did not always prove to be the case. As a matter of fact, European distaste for the SoHo style was as much a feature of the Boom as of the Bust. Consider Susana Solano, a Catalan sculptor. She makes large cubicles from materials like lead, and it adds somewhat to the poignancy of the work, the sense that they are haunted by an absent body, to learn that she makes every bit of her stuff herself. "It's like making your own car," says Dan Cameron, a New York critic and curator who is active in Spain.

Solano found an articulate and influential supporter in Richard Serra, and there was the gossip buildup that is usually the prelude to major SoHo exposure. But she is a reclusive artist. "The European galleries that showed Susana Solano's work were people that wooed her in the old-fashioned way. They didn't send her faxes or pigeonhole her in art fairs," Cameron says. "They would spend time with her work. They would do it in a way that she would feel wonderful about doing a show for them. But the New York dealers wooed her in a way that was appropriate to that time. 'We want to show you. Here's a hundred thousand bucks!'"

Solano has had work in group shows in New York, but the major solo event has not, at the time of this writing, taken place. Katharina Fritsch, a German artist, has let it be known that SoHo did not much

impress her. Reinhard Mucha, a compatriot of Fritsch, and Juan Munoz, a Spaniard, felt much the same. Dan Cameron says of Munoz: "He just wasn't into America. He had a very clear-cut position about it, which was that the pendulum was swinging toward Europe and that America wasn't quite as urgent as it might have been for a young artist five years before."

Katharina Fritsch finally showed a major piece in 1993, though not at a gallery but at the Dia Foundation. *Rat King* consisted of sixteen rats, nine-footers, cast in coal-black polyester resin. They were set in an ugly ring and you didn't see the most shuddersome thing until you got close, which was that the rats' tails were knotted together in a compact bun, like a ballerina's hair.

An essay handed out at Dia explained that squealing rat-packs, their tails thus knotted, have been found in Germany and other parts of Europe ever since the Middle Ages. Peasants called the phenomenon "the Rat King" and considered it the creature of the Devil, a manifestation of pure evil. Katharina Fritsch, who much admires De Chirico, excavates memories rather as he used to, but fiercer ones. The *Rat King* seems horribly at home in Europe again these days.

Reinhard Mucha picks objects from offices and public spaces and turns them into melancholy Minimalist totems. He did finally get around to having a one-person SoHo show at Luhring Augustine in the fall of 1995. Roberta Smith wrote in the *Times* that "for much of the last decade, the sculptor Reinhard Mucha has been the great German hope, the artist deemed most likely to succeed Joseph Beuys and Anselm Kiefer." She ended, "Strong as it is, this show doesn't feel quite worth the wait. Perhaps it is simply that . . . the moment of its greatest impact has passed." Artists on the cusp are faced with a brutal dilemma. Make their move too quickly, and they can overreach, like Nayland Blake. But coyness can land them in a situation that recalls a bit of business in a Chaplin silent movie.

Chaplin is sitting next to a drunken plutocrat, who gesticulates, offering to buy the Starving Tramp dinner. Chaplin flutters a hand, politely turning him down. Again, the plutocrat insists. Again, the

refusal. A threefold rhythm in the movie has led the viewer and Chaplin to expect the final offer, which will, of course, be accepted. *The offer never comes!* So it can sometimes be with SoHo.

Matthew Barney's first New York show was at the Barbara Gladstone Gallery. The twenty-four-year old artist was on the cover of *Artforum* even before the show opened in November 1991 and the pre-opening buzz became so overheated, as if nostalgic for the glory years of Schnabelismo, that a cool countercurrent sprang up, a suspicion that the viewer was going to be underwhelmed.

The night before the opening, Barney went into Gladstone's space, stripped, and put on a harness. He then embarked on a rigorous three-hour climb, hammering pitons into the walls and ceiling of the gallery, and ended up in a walk-in refrigeration unit, lying alongside a weight lifter's bench that had been thickly smeared with petroleum jelly. The exhibition consisted of a videotape that had been made of the artist's exertions, together with physical relics of the event, like a sled, normally used in football training, and the bench. The show was a wow. "It's like somebody just switched on all the lights again," a dealer said reverently.

Those who were learned in recent art history could see that Barney, like many coming of age in the nineties, had been pondering various artists of the early 1970s; in Barney's case, Chris Burden and Bruce Nauman, from whom he had perhaps learned to use fairly repellent materials—petroleum jelly!—with great sensual effect. But it wasn't *necessary* to know about the seventies stuff, because Barney was more than a nifty revivalist. Consider *OTTOshaft*, the video he made in 1992. One character in this compellingly strange piece plays Jim Otto, a legendary football player. Otto played for the Oakland Raiders, was famously inured to pain, and played toward the end of his career, Robocop fashion, with a false knee. Other characters in the video are played by Barney himself. Sometimes he wears drag; some-

times he assumes the part of another of his icons, Harry Houdini, the escapologist, who was proud of his invulnerable physique but died of peritonitis after taking an unexpected blow to the solar plexus from a fan. The piece also includes three Scottish bagpipers in full regalia, and it fits the weird physicality of Barney's imaginings that he related Jim Otto's sweater, which was lettered with a double O, to a double anus. Nayland Blake, who was still bitter at the time of Barney's sudden success, ascribed it to the fact that Matthew Barney was a straight artist using gay themes.

Matthew Barney handled his success cannily. He stuck with Barbara Gladstone. The shiny-paper magazines, discovering that Barney was not just a successful young artist but a successful young artist who had paid the rent by modeling for J. Press, suggested profiles. Barney turned them down politely, not with punkish belligerence. And he kept striking out in fresh directions. A video showed him transformed into a horned satyr disporting in a limousine. His contribution to the Aperto in the 1993 Biennale was a still from this, framed in a thick white plastic. It should have looked horrible, but looked rather lush. It did not screech, and this already was startling among the yammering attention-grabbers in the Aperto.

Actually, there was another understated piece there, and it was the work of another artist touted as a Next Big Thing, Janine Antoni, who, like Kiki Smith, was a pick of the curator Jeffrey Deitch. Antoni, who studied at the Rhode Island School of Design and lives in New York, was born in 1964 in the Bahamas, the daughter of a plastic surgeon, and she had grown up in the Islands, so—in the spirit of *nomadismo*—she was listed in the Biennale as a Bahamian.

Janine Antoni became one of the young artists who were circling around the notion of using their own bodies to make art. In 1990 she put together an assembly of plaster and Sheetrock that included separate concave impressions of her left breast and nipple, three impressions of latex nipples, and one of the container they had come in. Antoni called the piece *Wean.* "Next I decided to make a sculpture with my mouth," she says. "When I decide to do a piece, my choices

are, first of all, what can I do to give myself an interesting experience. Then I set up the parameters. I make up a set of rules. That's very conceptual. This is how I'm going to make the piece. But when it comes down to the process—the making—I try to be as subjective and intimate with the object as I can. I want to be as obsessive about the process as possible." Meaning she was to be her own lab rat.

It is easy to forget that Conceptual art isn't necessarily as dryly thinky as the name implies, but it can be crazy, with ancestors including the perspectival fanatic Paolo Uccello and deranged systems-builders like William Blake. What Antoni did was to cast a couple of six-hundred-pound cubes—which was a nod to Donald Judd, of course, but an impertinent one, because Antoni's cubes were soft, "female," one being made of chocolate and one of lard. She put them into a show in a SoHo gallery, Sandra Gering, and during the run of the show, which she called "Gnaw," she continually nibbled away at the upper edges of each cube. "The first question was, Do I swallow or do I spit it out?" she told me later as we looked over slides in her studio. The first mouthful had made up her mind. "The minute I decided to spit it out, I decided to turn it into another form." She molded the masticated chocolate into heart-shaped boxes, which she displayed alongside "lipsticks" made from the chewed-up lard and some red pigment. The piece was chosen for the Whitney Biennial, where it got a lot of attention. Being that "Gnaw" was by a woman, and made with her mouth, the politicized read into it a message about victimhood. Antoni held her peace about this—smart artists don't get picky with favorable reviewers—but did tell me, tartly: "The culture tells me it's about eating disorders. Which tells me more about the culture than it does about me."

Janine Antoni is an ardent Conceptualist—"Ugh! He's one of those horrible painters," she once said of an acquaintance, with a real shudder—and in 1993 she pointedly made an "expressionist" painting by daubing several bottles of hair dye onto a gallery floor and using her long dark hair as a brush. She called the piece *Loving Care*, which was the brand of dye, and made it in a couple of galleries, one being

the Anthony d'Offay Gallery in London, where she turned down a commission to make it all over again on a big sheet of paper. "I didn't want it to be hung on a wall, like a painting," she says. She also made some small companion pieces, drawings of calligraphic elegance, which she called *Butterfly Kisses*. She made them with her eyelashes, and they took weeks, sometimes months.

This, too, requires endurance, but it doesn't have much to do with the weepy self-indulgence of the Victim Artists displaying their sores or reciting their woes. True, the mouthfuls of lard nauseated her, the chocolate blistered her lips, the dye damaged her hair, the mascara-clogged eyelashes with which she made the drawings were her own, not falsies, and the crouch she had to adopt to paint the floor was fairly abject, which was a voguish term at the time. All this was a misreading, Antoni insists. "This wasn't anything to do with masochism," she says. "Athletes push themselves to extremes too."

The Aperto piece was called *Lick and Lather*. She had begun by having her head cast in dental alginate, while she breathed through two straws stuck up her nose. "That was an incredibly frightening experience," she says. "I had done a lot of scuba diving, so the feeling wasn't completely foreign. But I could never ask anybody else to do it for me." It had to be her body. She cast molds from the mask, some in white soap, some in dark chocolate. "I was shocked by how lifeless they were. They were like death masks," she says. But she set to licking the chocolate ones, and rubbed the soap heads against her body in the shower. "In the process of washing and licking, they sort of came back to life," she says. "The problem with the licking is that it takes forever. It's hard not to stop and see how it looks. The washing was beautiful, because the process was so natural. I'm in the shower, rubbing. Six hours, that was the longest." Fourteen of them were in the Aperto, seven of each material, set on plinths, in a circle. They were not facing the world but themselves, so they seemed to be free-floating in a dumb otherness, like Damien Hirst's cow and its nonoffspring in *Mother and Child*.

✳︎ ✳︎ ✳︎

Damien Hirst and his fellows are the liveliest generation of Brit artists since the Royal College crew of Pop artists a quarter of a century before. Mention "the Goldsmiths Phenomenon" and you will get a strong—sometimes tetchy—reaction among British artists to this day. There had been other powerful schools in London, but if Goldsmiths had an analog, it was a transatlantic one, CalArts. It was partly a matter of the faculty. At Goldsmiths this included the American Conceptual artist Michael Craig-Martin, who had made a career in London and hastened back to Manhattan when the gusher of Schnabelismo hit: "I went back in 1980 and sublet a loft in TriBeCa. But my New York was the New York of 1966. It had changed. There are only two ways of being happy in New York—being very young and being very rich."

Craig-Martin returned to London and got a gig teaching at Goldsmiths. Art schools in Britain perform a function rare elsewhere—they are receptacles for students who can't get into a "real" college—and art students had enjoyed the reputation of being fairly dim bulbs. "But my students were as bright as anyone at Yale," Craig-Martin says. He was there when Goldsmiths decided to dismantle the venerable system that had required students to pick their courses in advance. "You don't know what you're going to be doing in three years. We don't either," Craig-Martin would tell his students. He told me: "Most people didn't learn how to draw or paint. It takes a lot of nerve for a school to do what we did."

It paid off, because there was a group of students who were smart and knew it. The way people describe it there was the sort of power surge you could have sensed around punk some years before. The Boom was creating a commodity that differentiates art capitals from the provinces: information. In the early 1970s the Swiss-based English-language monthly *Art International* had been the principal source of information about who was doing what. Now there was a slew of glossies with new Coverboys and Covergirls every month, and peppy coverage even in mainstream mags.

There was something else in the air: ambition. The self-deprecating assumption that Britain was a second-rate art power had come to seem antiquated, and just as it is difficult to imagine the eighties art world except in a context of Reaganomics, so there is a sense in which the Goldsmiths crew are Mrs. Thatcher's brattish children. This wasn't a matter of Mrs. T.'s politics or of her art interests—Sir John Pope-Hennessey once described her as the most philistine politician he had ever had to deal with, and as a ranking mandarin, he had dealt with plenty—but of her attitude. For generations Britain has been producing artists who begin strongly but subside into gentility. The distaste for extremes, which is one of the more pleasant parts of the nation's politics, is less helpful in the arts. It was no accident that many of Britain's strongest postwar artists were outsiderish, being homosexual, like Francis Bacon, or the children of Jewish immigrants, like Frank Auerbach and Lucian Freud (Howard Hodgkin, an Old Etonian, being one of the necessary exceptions to all human rules).

But Mrs. Thatcher liked nothing better than affronting squires. She had made it okay to be ambitious, a careerist, a youthful entrepreneur, and it wasn't just to yuppies that this made sense. Writers caught the bug, too, and artists. Tony Cragg, Richard Deacon, Richard Long, and Gilbert & George, all artists in their prime, were ranking heavyweights overseas. Nor was deference required. Julian Opie, one Goldsmiths graduate, had one-man shows in Germany and two significant London venues, the Lisson Gallery and the Institute of Contemporary Art, in 1985, when he was twenty-seven. The ground was well prepared for the next generation. Including Damien Hirst.

Hirst was born in Leeds, an unlovely industrial city in Britain's North Country. Imagine Pittsburgh with less joie de vivre. His family was middle-class—middle-middle; his father was an automobile salesman—but his mother was an amateur artist, and Damien went to an art school in Leeds. He did a good deal of drawing. "I got to the point where I knew that if I carried on I would be a perfect draftsman. Then I stopped," he says. One fruitful source of models had been a local

morgue. Before leaving, Hirst had himself photographed there. The snapshot shows Hirst cheek by jowl, literally for once, with the sev- ered head of a bald old fellow with fleshy exaggerated features and a look of campy gloom, as though offended by the art student's cheery grin. It is not surprising that Hirst should have recuperated it as his first published work. High Morbid Manner indeed.

Hirst was turned down by St. Martins, the first London college to which he had applied, and again by a college in Wales. He was accepted by Goldsmiths. "As soon as I got there, I saw it was the only place I wanted to go," he says. The artists he looked at most closely as a student were an ill-matched duo — the Expressionist Chaim Soutine, whose most enduring images have been of carcases, and the German Dadaist Kurt Schwitters whose collages of garbage were once shock- ing but now seem as delicate as porcelain.

Hirst decided the canvas was not his arena. "I could never paint," he says. "I was always terrified by a white void. I just couldn't choose what to paint there. *Figures?* God! What position should they be in? It never used to work." He took the Schwittersesque route. He says: "With the collages I found I could work with already organized ele- ments. I *arranged* them.

"So you're arranging all these bits of colored wood and tissue paper or whatever on the wall. And you think, Well, that's great! And then you realize that Tony Cragg was doing it ten years ago."

Hirst slogged on. The idea was floating around his generation at Goldsmiths that it was high time they got their work out where the world could see it. "I had friends who tried to organize exhibitions and it never worked out," he says. He was spurred to action by frustration. "I didn't feel like sitting in the studio, waiting for somebody to come in and say, 'Great! Do a show!' I didn't feel it was working without it going through the whole cycle," Hirst says.

He picked a title: "Freeze." He was lucky in his timing. The art boom was even impressing the British (in 1989 Francis Bacon, Lucian Freud, and David Hockney, three living Britons, placed in the top five in contemporary auction-room prices worldwide). The Boom had also

brought in some unlikely entities. The Turner Prize, which was to do for avant-garde art what the Booker was doing for fiction, was funded by the junk-bond maestros Drexel Burnham. In the event, Hirst raised money to mount his show from Olympia & York, an arm of the empire of the Canadian Reichmann brothers, who were building London's most grandiose folly of the later eighties, Canary Wharf.

Hirst included the work of a dozen artists, all current or recent Goldsmiths graduates, and got hold of a cavernous industrial space by the Thames. As a do-it-yourself exhibition, "Freeze" had illustrious predecessors, like the "Bulldozer Show" in Moscow—so called for the means the authorities took to destroy it in 1969—and the 1980 "Times Square Show" in New York, but part of their aesthetic and their politics had been a lack of documentation. Hirst out-SoHoed SoHo, preparing a sleek catalog.

"Michael Craig-Martin told me I should meet this young bloke because he would show me all the artists," says Clarissa Dalrymple, a Briton, who at the time had just closed her Manhattan gallery, Cable. She says, "I met this young hotshot who did not posit himself as an artist. He did, but he wasn't pushing it. He was really very interested in being the exposer of everybody. So he took me to every studio." She invited him to Manhattan before the show even opened. It was the crest of the Boom. Hirst hit the wilder side of downtown life like a heat-seeking missile. "I thought he was an obnoxious kid. A scumbag," says Ashley Bickerton. "He was a holy terror basically." "I thought New York was wonderful," says Hirst, who characterizes his visit as "quiet."

"Freeze" opened midsummer, a sleepy period anywhere, in London in particular, but was soon generating excitement. Even before the opening, the dealer Lesley Waddington had taken on two of the painters—Fiona Rae, who made splattery abstractions that seemed as deliberately inert as Peter Halley's work, and Ian Davenport, who would hold a paint-loaded brush at the top of a canvas, allow the wet pigment to dribble down, and repeat the process till he thought the canvas looked okay. Ray and Davenport were both twenty-one. Karsten Schubert, a young German dealer who ran one of the best of the hand-

ful of London's avant-garde galleries, picked up two of the "Freeze" artists. One of them was Gary Hume, who painted abstractions, a rectangle on another rectangle; but they didn't look sublime—they looked like doors. Hume painted as if he had given up hope of finding any meaning in what he was doing, which was his basic point.

As for Hirst, his pieces were Schwittersesque, made of gummed-together cardboard, bits and pieces of boxes, and they weren't prominently displayed. "He skied them," Michael Craig-Martin says. To most, Hirst just seemed an organizer with immense push, an attitude he himself seemed to share. "He was the catalytic member," says Maureen Paley, an American dealer working in London. "But he was the *curator*. He was quite ambivalent at the time about his own work."

In early 1989 there was a second warehouse show, "Modern Medicine." "That was when the real hoopla began," says Karsten Schubert. He gave Gary Hume a one-man show in June. "I sold every single one," Hume says. For how much? "Eighteen hundred pounds. Each painting."

The return of Charles Saatchi was a sign of the times. In the upper echelons of the art world, Saatchi had a dual reputation. He was, of course, no longer the Museum Builder. Lesley Waddington says, "Charles Saatchi has made a hundred and fifty million dollars. He is the most successful art dealer of our time." The younger British artists could not have cared less. "The most important thing about Charles Saatchi was not to do with the collecting," says Michael Craig-Martin. "It was to do with the fact that young artists grew up with that place on Boundary Road. So their idea of what art could look like—how ambitious it could be and all of that—was established. There are very few good international exhibitions here. Charles showed the best things, and he wouldn't just show a single work—he would show a whole room. And everything was shown to absolute optimum. There were no compromises involved."

There was some surprise when Saatchi began buying the work of the younger artists, though, as before, in bulk. Some speculated that Saatchi, burned in New York, still hungered for the power he had

once exercised, and found that he could wield it in London for a much lesser outlay. Karsten Schubert says, "He buys the work. But I don't know what it means to him any longer. I can't work out how serious his interest in it is. It's the kind of support you don't want to rely on. It might be on the market *next year*. I think the artists are very wary of that."

Gary Hume is more positive. "I think Charles Saatchi is really great," he says. "Without him, the young contemporary art world here wouldn't happen. He takes your work and makes money out of it. But without him, this pisspot country that we live in would be so apparent. His purchases early on enabled me to live for six months. Then he buys from people you think are shit. But he's the saving grace."

In the winter of 1990 Hirst, who was still considered an impresario rather than an artist, curated another group show, "Gambler." It included a piece of his that earned him a different order of attention. It was called *A Thousand Years*. Its housing consisted of two connected cubes, glass-walled and steel-framed, so it was like a Joseph Cornell come to gothic life, or a haunted Donald Judd. A colony of maggots hatched into flies in a skinned cow's head in one segment, then droned into the other, which contained bowls of sugared water for their sustenance and an ultraviolet bug zapper, which sent insect after insect to the Lord of the Flies with a sizzle and a pop. It was a midget universe of life and death, put together with a science-fair clarity. It was also a piece in which time was a crucial element, as in performance art, or video. Hirst made a second Fly piece — his phrase — and called it *A Hundred Years*, a tipoff that his titles might sound more meaningful than they actually were.

"Two weeks before Francis Bacon died, he went to the Saatchi collection and spent an hour standing in front of the Fly piece," Jay Jopling says. It is easy to imagine the older artist being put in mind

of his own compositions in decomposition, and of the cases that quarantine his own shrieking popes.

Jay Jopling is Damien Hirst's dealer. The son of a Conservative politician who was at one point the minister of agriculture and fisheries, Jopling went to Eton and studied art at the University of Edinburgh. In 1986, when Jopling was twenty-one, he and a couple of friends organized a charity art auction, and he went to New York, where he contrived to wheedle pieces from, among others, Haring, Basquiat, Schnabel, and Claes Oldenburg. The sale, which was held in London and beamed to New York live, was a sellout. He fooled around with a couple of movie production projects—indeed, a first meeting with Jopling at the Basel art fair in 1989 left me with the idea that movies were his main project and the art a sideline—but he found it maddeningly difficult to get a project actually done. The art world, he decided, would be more tractable.

The artists who interested Jopling were his own age and had ambitious plans for pieces. Fabrication of the work alone would require deep pockets. Jopling, who had kept his eyes open while crisscrossing the Manhattan art world, set to building up a war chest by dealing in the Minimalists, mostly Judd and Dan Flavin. In 1988 he put on his first show in London's Docklands. It was the work of a young British artist, Marc Quinn. Charles Saatchi bought four.

Jopling and Hirst met in a London pub about the time the Fly pieces went up. Both were a bit sozzled and got to talking in the pub. Tall and polished, Jopling wouldn't have seemed a probable soul mate for the unruly Hirst, but they hit it off. "We both come from Yorkshire. And we were both living in Brixton," Jopling says. And, mostly, there was the art. "The ideas that he had were so exciting that I wanted to finance them and make them happen," Jopling says. Thus began a cooperation like no other in the art world. "I don't know what to call Jay," Hirst says. "Dealer . . . manager . . . nothing sounds right." Probably, one should return to Jopling's original career choice. The one is the director; the other, the producer. It is Hirst's movie, but it wouldn't happen without Jay Jopling.

Hirst's first piece beneath the Jopling aegis was the following summer. *In and Out of Love* was installed in an empty corner, cheekily just around the corner from the gallery of Anthony D'Offay, a grandee of contemporary, where Hirst had worked as a picture hanger during his college days. *In and Out* was a diptych. In the upstairs room, pupae, which had been attached to blank canvases, hatched into Malaysian butterflies. These huge white butterflies — each has an eight-inch wing-span — wafted around in thick, humidified air or sipped from saucers of sugary water. That was *In Love.* Downstairs, dead butterflies were stuck to white paintings and a table was set with ashtrays brimming with butt ends. *Out of Love.* Damien Hirst doesn't mind hammering things home. His pieces, so allegory-rich, so packed with emotion, and so well made, were rather like those huge Victorian story paintings, and were none the worse for that. "Exceptional," wrote the *Arts Review.* "Powerful stuff," noted *Time Out.* Mr. Fix-it had gone to the top of the class.

In the summer of 1992 Hirst was included in "Broken English," a show of the new British art at London's Serpentine Gallery. His piece consisted of a great many dishes of different sorts, floating in formaldehyde-filled glass tanks. It was called *Isolated Elements Swimming in the Same Direction for the Purpose of Understanding.* They were "ready-mades," but with a surreal charge. That summer Hirst, who was then twenty-seven, was interviewed by the writer Stuart Morgan in the pilot issue of *Frieze,* an art magazine that was in itself a vote of confidence in the British art world. Hirst talked up a notion he had: an embalmed shark. "I like the idea of a thing to describe a feeling," Hirst said. "A shark is frightening, bigger than you are, in an environment unknown to you. It looks alive when it's dead and dead when it's alive."

Charles Saatchi duly commissioned Hirst to make the piece. Hirst had planned to use a great white, which is to sharks what the grizzly is to bears, but found that they had just gone on the endangered-species list, so he had ads posted in the fishermen's drinking holes on the coast alongside Australia's Great Barrier Reef and made do with a

fourteen-foot tiger shark instead. The shark was floated, ugly mouth agape, in a tank filled with a mix of formaldehyde and water, as part of a show of younger British artists in the Saatchi collection.

There were other strong pieces in the show. It included, for instance, Marc Quinn's self-portrait. Quinn had made models of his own head, back and front, in dental alginate—just the process Janine Antoni had used for her self-portrait—and had cast his portrait in eight pints of his own blood, which is roughly the amount of blood in an adult body, and which he had extracted from his body over several months. The process had given the head a striking flayed look, like an anatomical etching. A sense of the head's impermanence was underscored by the fact that it glimmered dully as a peeled grape in a refrigerated container, which was connected to a power unit; and if a janitor, say, unplugged it with a careless broom, all that would be left would be a puddle of slasher-movie glop on the gallery floor.

Quinn's piece is actually called *Self-Portrait*. Forget it. It has become the Blood head. Damien Hirst actually called his piece *The Physical Impossibility of Death in the Mind of Someone Living*, but that was futile. It was the Shark. As such, it was the wow of the show. Quinn's Blood head had attracted its share of comment—SAATCHI'S SHOCKING BLOOD HEAD shrieked London's *Evening Standard*—but the shark swam straight out of the puddle of the art world into the mainstream of the culture. The tabloids hadn't had so much fun with an artwork since Carl Andre's brick pile and the Quality Press joined in merrily. The London *Sunday Times* magazine section included a photo of the piece as one of the "Follies of '92." Cartoonists had fun with entanked caricatures of the queen and Prime Minister John Major. An alert letter writer to one of the nationals pointed out that the last time an individual artwork had provided the central image for so many political cartoons was 120 years before, with Whistler's *Arrangement in Grey and Black: Portrait of the Painter's Mother*.

"Wonderful!," said Lesley Waddington of the symbolic alignment of Charles Saatchi and a tiger shark. Saatchi had paid Damien Hirst

just £50,000 for the shark piece, for instance. It was a peculiar moment for Hirst and his fellows. The glittering peaks seemed within reach—they had been gulping down their first lungfuls of the heady oxygen of the Boom—and now came the dead air of the Bust.

But Cork Street (which is the code word for the upper echelon of the British art world) knew, as much as SoHo did, that salvation depended on the coming of fresh talent. Anthony D'Offay decided to show six of the new Brits, but the offer came with strings. "I represented three or four people he wanted," says Karsten Schubert. "He said, 'If this works out, I'd like to represent them with you jointly for six months.'

"I said, 'Well, why should I do that? I've been working with these people for two years. There are only three possible outcomes. After six months you take them away from me, which I shouldn't like. After six months you say you want to carry on representing them jointly with me, which I wouldn't find that interesting. Or after six months you say this isn't quite my cup of tea. So I'm stranded with a bunch of people Anthony D'Offay has rejected.' What was new for them was that Jay [Jopling] and I have the power to say no to those people." The D'Offay show did not take place.

The art world in London, moreover, had such shallow roots that the local attention span was particularly short. "Everybody buys new artists' work. Then they lose interest," Schubert says. "There is no long-term support." He built up the careers of his artists by showing and selling in Europe. After the artists had had two or three years of attention elsewhere, the fickle British art world might decide that the artists were in for the long haul.

Gary Hume remembers telephoning one of London's principal art warehouses in the early 1990s and asking for one of his paintings. "It belonged to me. I wanted to have another look at it," he says. The people at the warehouse misunderstood him. "This huge truck arrived. I opened the back of it, and it was full of my paintings. At that point I had sold everything I had made and I naively thought that they were

bought, because people were really interested, and liked them. And they were all in storage! A truckload of your effing work!"

"Heartbreaking," Anya Gallaccio, another Goldsmiths artist, says. "Karsten told him to keep it quiet. That they were all in storage."

Hume says, "So that was a salutary lesson. Those same people might be wanting something else. Or they never wanted it anyway, did they? So the loss is a loss financially, but it's not a *loss* loss. It's not like somebody has taken your painting, looked it over for a while, and has decided that it's not up to their idea of what a piece of art is and they want to get rid of it."

The glass in the tanks that housed *Mother and Child* was three inches thick. "Like Sea World," Damien Hirst says. The liquid that sustained the carcasses is often called formaldehyde, wrongly, because formaldehyde is a gas. The solution Hirst uses is 12 percent formaldehyde in water. It was too much for the Biennale committee, though. When Jopling submitted the proposal originally, it had been turned down on the grounds that it would be a danger to the public if the glass broke.

"They were all the wrong reasons," Hirst says. "The glass is made to British standards. You can fire a Magnum into it from twelve feet and it won't break. You can let off a small bomb next to the tank and it will break the glass, but it won't actually puncture the tank."

The Biennale at last acceded, and Hirst set to work. There had been nothing haphazard about his choice of a cow. Horses were too noble, too Gericault, and goats had witchy associations, but cows were null and normal. Acquiring a carcass was not a problem. Hirst knew somebody who worked in a knackers' yard, and specified only that it should be black-and-white. Cow number one was a fiasco. "I skinned it," Hirst says. "The problem is the bone. It's very difficult to cut. You've got frozen meat and bone. We got to the head and came up with a

funny angle, so one side was smaller than the other. They just looked stupid."

Cow two was another failure, but by the third he had it down. He sewed the bisected carcasses to silhouettes of ten-millimeter-thick Perspex with heavy-duty needles and fishing twine. They were injected with the solution of formaldehyde and water, a process that took six weeks of immersion. "I did everything. It took me four days to do·each half," Hirst says. "Ugh! Horrible. Then it was vacuum-sealed and sent to Italy."

The furor was not the point. "I think somehow you have to over-ride the hype. Or ride through it. Or something," Hirst says. "I've been through the phase where everybody thinks you're great and wants to promote you. Then suddenly they think, Who the hell does this guy think he is? And they want to put you down. It's difficult, because all you really do is make your work."

The money? That was secondary. "As long as I've got enough for a drink," he says. "I *missed* the eighties."

The qualms of the Biennale commitee were not totally unjusti-fied. The formadehyde did leak some days after the opening. It killed the ants in the *World Flag Ant Farm*, and the Aperto had to be evacu-ated for a while.

A sixteen-year-old Czech girl bit off the noses of three of Janine Antoni's chocolate self-portraits and was just prevented from devour-ing more. "Wasn't that great?" Antoni said.

Achille Bonito Oliva was told he was not to organize the Biennale of 1995. The new committee eliminated the Aperto. It made for one of the flattest Venice Biennales ever.

Nine / Ends

The BBC culture squad was standing on the edge of the Roden Crater, setting up cameras and lights. Below stretched the Painted Desert and the Navajo reservation. The San Francisco mountains reared up on the horizon. The sky was both dark and bright, an evening sky, and it was getting colder by the second. Only James Turrell seemed oblivious. Fine-featured, with a sweet, slightly absent smile, his longish hair gone gray since our first meeting, the artist was standing on the rim of his work in progress, looking at the setting sun, and talking about "the Green Flash."

The Green Flash is just that. The lore is that it occurs, very occasionally, just as the sun plops behind the horizon. I asked if this was a myth. "Oh, no," Turrell said. "I've seen it two or three times. But it's actually not as interesting as some of the other phenomena. The Twilight Arch rises here," — a stab of the fingers — "it's sort of silver-gray, and the top of it is pink. It's actually the shadow of the earth projected in the atmosphere, when the sun goes down here." Another stab of the fingers.

It did not occur to me to question this. Several hundred thousand cubic yards of earth and rock had now been scooped out of Turrell's dead volcano, and he had had the tracks left by motorbikers scaled off the outer cone. Earlier I had lain down in a spot of the artist's choosing within the crater and looked up to where the reworked contour meets the sky. For some moments I was looking up into the

familiar blue vault, then it somersaulted, flipping from concave to con-
vex, pressing me down like a blue crystal thumb. Turrell had done
increasingly giddy things with light—during his Whitney retrospec-
tive in 1980, three people sued for damages sustained while leaning
against nonexistent walls, for instance—but if this was what the crater
could now do, its transforming powers when it was completed would
be something to contemplate.

Turrell plans to bore through the core of the volcano with tun-
nels, which will meet and join with stairways and inner chambers.
"Walking into each aperture will be like walking through a camera,
but without the lens. A large pinhole camera," he explained. It would
be a big camera, with the ability to focus on deep space. Turrell pro-
poses to capture varieties of celestial light and use them with the same
discombombulating effect to which he had always used light, ever
since the cutouts in the walls of the Mendota Hotel. He plans to—
his phrase—"play the music of the spheres with light."

The pure ambitiousness of Turrell's project had captured atten-
tion from its inception. John Russell wrote in the *New York Times* that
the Roden Crater would "mediate on our behalf between geological
time and celestial time." Count Panza had called the crater "the Sistine
Chapel of America." The thing is, though, that I have lifted both those
quotes from an article by Fred Hapgood published in the *Atlantic
Monthly* in August 1987. The BBC team shivering in the blue-black
night was the second BBC team on the story.

There is geological time and there is celestial time and there is
art-world time, which is more querulous. I have heard art worlders
compare the Roden Crater to masterworks that were never completed,
like Gaudi's cathedral in Barcelona, or to projects that never got liftoff
from the drawing board—like the work of such "visionary" eighteenth-
century architects as Boullée and Ledoux, or, indeed, to Werner
Herzog's movie *Aguirre, the Wrath of God.* The most blasé—the ones
who called the Chinati Foundation a tax dodge—said the crater was
a sublime scam.

They are likely to be proven wrong. The proposed completion date on the Roden Crater is the year 2000. Turrell, who has secured fresh funding from both Dia and another foundation, the Lannan, is confident that this is a can-do date. Work has commenced on two chambers since my visit in 1992. Just as Turrell spent eighteen months of 1978 and 1979—the same period when Neo-Expressionism was beginning to pump through the art world—in a cabin with no telephone, perched a few hundred yards along the rim from where we were standing, so he has carved away at his crater through the 1990s, years in which outside interest in art has guttered down to what it had been in the early 1970s. In the early seventies, though, the art had been, if hermetic, furiously exciting. Few, I think, would make this claim of the art of the first half of the nineties.

The wisdom amongst gallerists during the gray years was: Keep alive till '95. It was not always adhered to. There have been art economy–related suicides. Many, many galleries have folded since the Bust in New York, London, Paris, Los Angeles, and every art capital. Among them are both such venerable avant-garde galleries as Paul Maenz in Cologne and a slew of the young risk-takers. Some self-destructed in spectacular fashion, like Vrej Baghoomian, who quietly locked his doors in New York and took off for parts unknown. Few escaped some damage. Mary Boone's revenues slumped by half in 1991. Lesley Waddington in London, who had restocked his gallery immediately after Bo Alveryd's buying binge, reported a loss of £40 million that same year.

Asher Edelman, who had opened a private museum in Pully, near Lausanne, in 1991, becoming a Swiss citizen in the process, closed it in September 1995 without fanfare. He announced he would sell a few paintings to raise seed capital. Perhaps a hundred million dollars' worth. "The museum for all of these years was costing a great deal of

money. And I just decided it might be interesting not to spend that amount of money on the museum anymore," he explains. The "Olitski project" was over. "We're not partners with Salander," Edelman says, adding that he still has "a very interesting inventory" of Olitski's paintings.

Edelman once explained to me the phases of reputation of a collector of new art. "There's a heroic moment," he said. "Getting a collection of young artists—being at the edge. He buys a lot of paintings, so he gets a great discount. He's a great hero! Later, one day he decides he wants to make some money. And he sells a few. And then he sells others. And everybody hates him! He's a heel. He's gone from the heroic to the heelic level." Edelman, who, despite the closure of his museum, still owns "in the vicinity of nine hundred to a thousand pieces of art," is not himself, he insists, entering his Heelic Phase.

Some of the human motors of the Boom were likewise dawdling. Hans Thulin dabbled in the hotel business in the Midwest, then wound up doing prison time in Britain for fraud. Les Levine ran into Bo Alveryd in late 1995. Alveryd seemed a bit down. "What would you buy if you had the money now?" Levine asked him, curious for the former wunderkind's prognosis.

"A Mercedes-Benz," Alveryd told him, sourly.

The art world has always thrived on chatter, and it is often healthy—who's up; what's down—but with the market dead in the water, the tone changed from a culture of gossip, as it were, to a pathology of rumor. David Salle's departure from Mary Boone to Larry Gagosian in October 1990—her first major loss since Schnabel had gone to Pace—set the flywheels spinning. They spun the more rapidly when Donald Judd left Paula Cooper, also for Pace. In hard times, the galleries with the deepest pockets were hard to resist. "Rumors began flying that Mr. Marden and Mr. Fischl were also leaving," reported Grace Glueck in the New York Times on January 14, 1991. "And the fact that Ms. Boone was seen not long ago lunching with the sought-after painter Chuck Close has busied phones and fax machines from here to Tokyo. "Actually, those artists stayed put. Glueck also reported

that Eric Fischl accepted a luncheon invitation from an uptown dealer but said, "I think you should know I don't plan to leave Mary Boone." The dealer said, "In that case, lunch is canceled."

As the dry years continued, the mood grew uglier, the gossip more pathogenic. Rumors of gallery closings were rife, and often accurate. Vrej Baghoomian reappeared and reopened in Shafrazi's former space on Mercer Street. He was soon again closed. Ashley Bickerton wondered whether leaving New York might not be the right strategy. "You're fighting an uphill battle," he said. "You can be doing your best work and you still can't get attention. And if you do less than your best work, it can do you real damage. Perhaps it's best to wait for the climate to change."

Survival strategies among the dealers went beyond the seduction of Art Stars. When the usual markets are stagnant or shaky, smart operators look for new markets to develop. They may nose out a work by a surefire name, they may make a market in work that has been for whatever reason underpriced, or they may look for new buyers. Much attention was paid to the increasing heft of the Pacific Rim, and to Korea and Hong Kong, both of which were seen as home to the Hans Thulins and Charles Saatchis of the 1990s.

The opening up of the Soviet empire had not produced new collectors but new artists. On July 7, 1988, in the very eye of the Boom, Sotheby's had held Moscow's first international auction in Armand Hammer's Sovincentr. Sotheby's chairman, Lord Gowrie, had conducted it with exquisite tact, not in Yankee dollars but in pounds sterling and a solid currency used for such occasions, the "golden ruble." A canvas by Ilya Kabakov reached $41,576, and, more remarkably, a painting by Grisha Bruskin, *Fundamental Lexicon*, had been knocked down to a West German collector for the equivalent of $415,756. The "unofficial" art world in Moscow was now the official art world, and the Sotheby's sale did more to destroy comity in one evening than decades of neglect and KGB harassment had done between them.

Bruskin was snapped up by the Marlborough Gallery. "He loves money. They deserve each other," the dealer Phyllis Kind said at the

time. Kind was showing Soviet artists in New York, as was Edouard Nahamkin, an immigrant who had grown wealthy in "Little Odessa," the Russian community in Brighton Beach. Nahamkin opened galleries in Los Angeles and in Manhattan, one downtown and one uptown, on Madison Avenue and Eightieth Street, selling work both by Soviet-based artists and by ex-pats. The glasnost market withered after the Bust, though, and Nahamkin closed. The effects of the fall of Communism, the End of History, and the New World Order upon the art world have proved to be slightly comic, in a melancholy fashion. There was no surprise when some art on the market was identified as coming from the National Gallery in Havana.

Dealers and artists have made ingenious attempts to ginger up the marketplace. In SoHo, the livelier avant-garde galleries banded together to give block parties. In April 1994 a number of galleries rented rooms in the Gramercy Park Hotel for the first of a sequence of annual shows. A similar event was launched at the Château Marmont in Los Angeles. Inventive invitations have included a cigarette printed ART ALWAYS WINS from Gracie Mansion, a length of rope from Morris Healy, a barf bag from Artrax, a key for a show of Yoko Ono, and, on different occasions, from the same young artist, William Scarborough, a burned coffee spoon and a blue bag lettered UNIDENTIFIED REMAINS containing foul-smelling animal parts.

The prediction by Robert Hughes about the coming of megadealers seemed on the money, too. Arne Glimcher joined forces with Wildenstein, the vastly rich dealers in Old Masters, to form Pace-Wildenstein. As such, he has successfully taken over entire estates, convincing executors it would be more profitable to sell piece by piece, over time, rather than in the crapshoot of an auction. So Sotheby's didn't bury the dealers, after all. Pace and Gagosian also opened up in Los Angeles, on the premise that Californian magnates could finally be persuaded to buy on their home turf. They opened, by no accident, in the same week.

The continued onrush of boutiques to SoHo meant that fewer and fewer of the people who drifted into a gallery on a weekend had

any real interest in the art, let alone any notion of actually plunking down money for a piece. A bunch of the livelier young dealers set up on the outer fringe of the area, at Wooster and Canal. Friedrich Petzel, one of them, dubbed it SoSoHo. After a rancorous dispute with her landlord, Mary Boone moved to 745 Fifth Avenue. But the most popular new district was Chelsea. Matthew Marks, Annina Nosei, and Pat Hearn moved there in 1994, and several new galleries opened up from scratch. Chelsea, which already has a busy commercial life, seemed less susceptible to malling.

In 1996 they were followed by Paula Cooper, who had been first into SoHo. When Cooper moved to a building near Dia on West 21st Street, she sent out a letter. It read in part: "We will be getting out of the personal service business and back into the art business," she wrote. "For the record: The Gap is not taking over our present space at 155 Wooster Street. Robert Gober has not left the gallery. My friend, Elizabeth Murray, has joined the PaceWildenstein Gallery and we wish her many years of continued success." Thus Cooper dealt with the rumormongers in her own forthright way.

Robert Motherwell once observed that art at the end of the twentieth century would be a battle between Picasso and Duchamp. A good call. Since the waning of Neo-Expressionism, there has been no shortage of painters making excellent work, like the underknown Mary Corse in Los Angeles, but as far as attention-getting went, the Duchampians won hands down. The Hair Shirt artists, whose absence had puzzled John Baldessari during the Boom, proliferated after the Bust. The eighties had been poetical bombast, posing, and freeze-dried irony. *Sincerity* had been a joke word. Sincerity now gushed in. Mark Dion's explicit ecological pieces struck me as powerful, but most message art has had a thundering obviousness that puts me in mind of a visit to Moscow's Tretiakov Gallery in the Brezhnev epoch. "See!" an Intourist guide instructed. "The drunken priest is treading on the Easter egg!" Got it.

Confessional and Victim art flourished, but this was a mode in which the avant-garde, far from leading the way, was hastening after Phil Donahue and Oprah Winfrey and writers like William Styron, dwelling on his depression. One characteristic figure was Bob Flanagan, a lifelong sufferer from cystic fibrosis. Flanagan's installation *Visiting Hours*, which opened at the Santa Monica Museum in December 1993 and moved to New York's New Museum of Contemporary Art on Lower Broadway the following fall, consisted of himself lying on a sickbed in an impromptu hospital room. I saw him there, wracked, perforated, and pallid but talking to whoever wished about his sickness and his addiction to the extremes of masochistic sex (he once publicly had a nail driven through the head of his penis).

Flanagan, who starred in a video for the rock group Nine Inch Nails—he was shown being mechanically disemboweled—died on January 4, 1996. That March another artist, Steed Taylor, presented a performance/installation piece at the Franklin Furnace, entitled *The War Room*. In this, the HIV-positive artist solicited advice from all comers. The press release ended: "From this installation, the artist will develop a plan of action to combat the HIV virus in his body. This plan will be presented at the end of the installation."

Other artists focused on more psychological wounds. Tracey Emin, for instance, a young British artist, appeared in a small room in the Château Marmont, Los Angeles, discoursing about the molestation she had been subjected to as a youth, making urgently scratchy little drawings as she spoke. Helen Chadwick, another British artist, made "Piss Flowers," bronze casts of the shapes created by her urine in the snow. In December 1993, China Adams, a Los Angeles artist in her early twenties, focused on cannibalism. She advertised on the UCLA campus for a "flesh donor," severed some meat from the thigh of the (female) volunteer, cooked it with garlic and salt—"It was actually very bland"—and ate it in the presence of Henry Hopkins of the Armand Hammer Museum. The following year she exhibited fourteen X rays on lightboxes in the Ace Gallery, Los Angeles. The gallery's

release explained: THESE X-RAYS ARE OF PORTIONS OF ADAMS' BODY WHICH HOUSE A SPECIFIC BONE AVAILABLE TO THE POTENTIAL COLLECTOR.

So a quarter of a century after Gina Pane and Vienna Aktionismus, it remains possible to create a frisson. By and large, though, it has proved hard to recapture the hard, bright, wired glitter of that earlier moment the second and third time around. One thing about Idea-based art is that different people frequently have much the same idea. In 1993 Donald Newman made a painting inscribed with the name of every woman he had slept with. A couple of years later Tracey Emin listed every man. Jason Rhoades, a young California installation art-ist, based a piece on the build-it-yourself-furniture behemoth IKEA. Several artists, mostly women, made paintings and objects using Bad Words like *fuck* and *cunt*. (Sarah Schwartz, neatly playing with Minimalism, embossed the dirty words on bars of soap.) Thomas Eggerer and Jochen Klein, two German artists, did just the same. The Slovenian group Irwin founded a country. Gregory Green, ditto.

A Russian artist has made Duchampian urinals, but added Constructivist motifs. An American copied the Sotheby's catalog cover showing Malcolm Morley's copy of a Vermeer. It is as if somewhere a computer has been stuttering out every possible combination and recombination of the moves of Duchamp, Joseph Beuys, and Andy Warhol as game plans for young artists. Conceptual art has more and more become an academic art for people who don't know how to make even academic art, and race, gender, and AIDS continue to elicit their quota of high-minded, self-righteous work. What light-years it seems from the huge ambitions — spiritual, formal, or rawly ego-driven — of a Malevitch, a Mondrian, a Pollock, a Serra, even a Julian Schnabel.

On May 15, 1996, a quorum of art worlders, including Lynne Cooke of the Dia Foundation, Peter Plagens of *Newsweek*, and Rob-ert Storr of the Museum of Modern Art, had a panel discussion at the American Art Museum entitled "Invisible Ink: Art Criticism and a Vanishing Public." In a review of the video artist Cheryl Donegan, Holland Cotter of the *New York Times*, making an observation all the

more depressing for its nonchalance, noted that the work was "well-suited to a decade when contemporary art, unwanted by the world at large, is its own most attentive audience." Douglas Blau, an artist/curator, notes: "The degree to which the outside world despises us and hates us is truly amazing." He adds that in popular TV shows like *Friends* and *Murphy Brown*, the "artist" figure was "nerdy . . . geeky . . . pathetic . . . dishonest . . . a fraud."

Now that the Modern movement is history, it has become permissible to wonder whether art might not just be suffering from a short-term continuing exhaustion after the strip-mining of the eighties or whether it might be losing some if its heft permanently, as happened to poetry with the rise of the novel.

"Finally a Proper Show," Damien Hirst said. The emphasis was his. "A Big Show in New York." Does New York still matter? The prickle-haired British artist pondered. "Yeah. But in a different way. It's hard to put a finger on it. New York is New York," he said.

Indeed. Despite the depredations of the Bust, despite the more important fact that inarguably some of the most influential American artists—Bruce Nauman, Charles Ray, Paul McCarthy—were working in California, New York did, in some peculiar sense, still rule. Contemplating the New York art world, it was easy to be reminded of Paris couture in the 1960s. All through that decade, the wisdom had been that Paris fashion was dying. Paris hadn't died, because that was where the indispensable machinery was—from people who knew how to sew buttonholes to an urgent communications system. So it has been with art, and New York.

This was May 1996, and Damien Hirst was installing a show at the Gagosian Gallery on Wooster Street. It had initially been planned for the previous September with a different centerpiece, *Couple Fucking Dead (Twice)*. "There were going to be two steel-and-glass tanks, each with a couple of cows in them," said Jay Jopling. "The cows were going

to be peeled, so it would be just flesh in front of your eyes. And they would be attached to a hydraulic system, with one cow mounted behind another in each tank. They would be moving. One cow would be looking as if it was copulating with another. It was not in formaldehyde. Damien wanted a piece that decayed in front of your eyes."

Hirst managed to concoct a filter system, which would have eliminated the stench of decay. There would have been no repeat of the fiasco of the Aperto. The Gagosian Gallery, though, anxious that the Environmental Protection Agency might pull the plug, canceled the show. Hirst's new centerpiece, *Some Comfort Gained from the Acceptance of the Inherent Lies in Everything*, consisted of two cows, sliced like a loaf of bread, in fourteen glass tanks. This piece, too, had posed a problem. The advent of "Mad Cow" disease had been characteristic of the way that random publicity finds Hirst the way that iron filings skitter toward a magnet. U.S. Customs had to be persuaded that the pieces were art not foodstuffs, and thus not contrary to USDA regulations. The Gagosian Gallery had contacted Senator Frank Lautenberg, himself a collector, and everything had cleared customs without trouble.

Hirst duly arrived with a team of five to install the work. It took a week of twelve-hour workdays. The first pieces up were giant circular paintings, made by an assistant, who had poured paint onto a spinning disk, carnival-attraction style. "It's impossible to make a bad one," Hirst said gleefully. (He had tried, by applying a broom to one as it spun, so that the colors smeared, turning it to a primordial first watercolor gunk. "And I still loved it," Hirst said.) Pink and baby-blue dots were painted on a wall. A bisected sow, called *This Little Piggy Went to Market, This Little Piggy Stayed Home*, was installed—one section moving, the other not. A beach ball was balanced on a jet of hot air. A forty-foot billboard made of three-sided strips rotated its dumb message, the words *The Problem With Relationships*, followed by images of a peach and a hammer, then a cucumber and a jar of Vaseline, executed with painterly anomie. A few butt ends and matchbooks from London's Groucho Club were tossed into the giant white ashtray, turn-

ing it into what Hirst called "a backwards Oldenburg." He and the others finished and knocked off work at half past seven in the morning of the day of the event.

There were black velvet cords attached to brass stanchions outside the Gagosian Gallery that evening. In January, Marie-Claude Beaud, director of the American Center in Paris, had told the *New York Times* forlornly, "The problem here is that the [French] public doesn't support artists as they do, say, in Britain." A truly amazing remark, but several dozen Britons had flown over for the event. Brisk young women, Aubrey Beardsleyesque in black and white, were floating around with wine and mineral water on silver trays. "I've got to find a camera. I'm shattered," said art writer Jerry Saltz, looking around at Roy Lichtenstein, Julian Schnabel, David Salle, Alex Katz, and a bevy of working artists such as had not been seen at a gallery opening in a decade. David Hockney deposited a butt on the growing mound in the ashtray. Richard Serra liked the Pig piece. "What's that—Vesalius or Leonardo?" he asked, and thrust a muscular forearm in the direction of the whirling Spin paintings. "Beat that, Gerhard Richter!"

The crowds were so large the next day that an impromptu public opening was declared for the evening. Thirty-eight hundred people had been clocked in by nightfall. The Hirst show was the first event of its sort since the Schnabel and Koons shows of the eighties, and like those shows it was essentially critic-proof in that anybody who mauled it would be playing a part in the spectacle. The dealer Ronald Augustine said the excitement reminded him of Mary Boone's first show of Jean-Michel Basquiat. Gagosian said it reminded him of when *he* first showed Basquiat, and added, "The whole show has been sold out. I could have sold it twice." Charles Saatchi bought the Cow piece for almost half a million dollars, adding a naught to what he had paid for the Shark. The excitement wasn't just over the show. It meant that the art world finally had a pulse.

Christie's Contemporary Art auction was held the following Tuesday. The work wasn't up to much, but the sale went swingingly. Sotheby's the following night had stronger work, including a de

Kooning, *Woman as a Landscape,* which had been there in 1990 and estimated between $9 million and $12 million. It had gone unsold, and had been bought privately by the actor Steve Martin supposedly for $6 million. Another highlight was *Gray Painting with Ball,* a Jasper Johns, which was being sold by Asher Edelman. He wasn't planning on being there. "I don't think I would come to the salesroom for a sale of my things," he said. "It would hurt my feelings. I would feel funny."

There had been drastic changes in Sotheby's. Lucy Mitchell-Innes had been so thoroughly undercut in Sotheby's internal power struggles that she had departed to become a private dealer. David Nash, her husband, had soon also left the auction house. John Marion had retired. This had left Diana D.—"Dee Dee"—Brooks both in control and at the gavel for the sale of Jacqueline Kennedy Onassis memorabilia—unmemorabilia, actually, in their upper-class blandness—the week before. This had dominated the media, sold tens of thousands of catalogs, and crammed the auction house with buyers, most of whom were unfamiliar with their surroundings and had the glazed thousand-yard stares you more commonly see among the Las Vegas slots. Its success had been overwhelming. Such previous auctions of Celebrity holdings as the Barbra Streisand and Warhol sales were left reeling in the dust.

But the shenanigans had clearly left the auction house reeling, too. Even the bid spotters stood, lined up on Contemporary night, with none of the glimmery spruceness of the Mitchell-Innes years. Brooks was shaky at the rostrum, unable to wheedle those crucial extra bids. There was a gasp when bidding on the de Kooning stopped at $4.9 million. The veteran Los Angeles dealer Paul Kantor didn't even believe that figure. "There wasn't a real bid in the room," he said. Joe Helman did not believe this, but he wondered about the "meltdown" at the auction house. Edelman's Johns didn't sell, either. By and large, though, the flops were discounted. "Prices and Hopes Rise as Spring Art Auctions Reveal a Robust Market," ran the *Times* headline.

Walter Benjamin famously observed that reproduction stripped art of its "aura." This had seemed a bit high-flown, but then came the Boom and the Bust, which between them so stripped art of its enigmatic presence that it seemed allowable to wonder if faith could ever be fully restored. Well, faith could be seen to be budding, like grass in contaminated soil.

Years ago I came upon a painting, *Above the Snows,* in a Moscow museum. It was a landscape, with thin trees growing out of rosy snow, beneath a lowering gray-violet sky. It might have been by a Barbizon School painter from the late 1840s or by an unadventurous Post-Impressionist but for one thing: A plane with a red tail is flying in the upper-left-hand corner. The canvas, which was painted by one G. G. Nissky in 1959, was unremarkable, but it was a war of worlds.

The new technologies have been part of both the subject and practice of art since the beginnings of Modernism, which is one of the things that make Modernism so distasteful to those with a horror of change. In 1966 Maurice Tuchman created a program, Art & Technology, at the Los Angeles County Museum. In 1968, Robert Rauschenberg and Bill Kluver started Experiments in Art and Technology in New York. That same year, Pontus Hulten curated a show at MoMA, "The Machine as Seen at the End of the Mechanical Age," which boasted a catalog with tin covers and which told the tale of how artists had fed off techno (as I shall refer to these exploding technologies) up until that date. It was then, though, that the shadow of Vietnam fell. Various of the corporations sponsoring artist projects, like Martin Marietta, were stigmatized as being involved in the war effort. Techno fell into disrepute, at least in the art world, apart from low-tech stuff like video.

Over the last years, though, techno has again come crashing in upon the art world. As you are sucked into the new domains of information technology—websites, digitalized photography, computer

graphics, interactive CD-ROMs, VR (which is to say virtual reality), cyberspace, and the proliferating rest of it—you can be easily persuaded that what *Wired* magazine called a "Second Renaissance" is just an electronic whisker away. Nor is the art world ignoring areas where technology impinges more and more directly on the material world. "Post Human," an exhibition curated by Jeffrey Deitch, was centered on this. The introduction to the catalog dramatically inquires: "Does the art presented in this book and the exhibition warn of a world from which the humanity has been drained? Or, on the contrary, does it celebrate a world where one will have unprecedented freedom to reinvent oneself?" The thought sags at the end. "It is quite unclear whether the post-human future will be better, or worse, or whether it will even be post human at all."

It is hard to avoid a feeling of déjà vu sometimes, a sense that this future has a bit of a past. The fuss over the Internet brings to mind the 1960s euphoria about offset litho, which was going to democratize publishing, and the later notion that cable television, with its myriad channels, including those for public access, was going to free up the airwaves. Offset litho did indeed open up the publishing process—it made the whole world of "fanzines" possible—but neither public access nor cable have done much to transform the ether.

Current developments represent a considerable upping of the ante, though. We live—in our lands, at least—in a world where the freeze frame, the sound bite, the fast forward shape our perceptions, both in reality and art. We are what we eat. "It has been suggested that he is the first hero of the highlights era," a journalist, Robert Winder, wrote of the British cricketer Ian Botham, "but the more likely story is that is the first cricket star whose game was shaped by watching highlights." It is also a world where pixels and digital alterations play an increasing part, and where those with visual skills might expect to be in demand.

The institutional underpinnings are being put in place. In 1989 the company ArtNet began an auction database. This now documents the action at 2,000 auctions in twenty-eight countries. There are hard

facts about 180,000 artists on file. In 1995 Thomas Krens, the deal-making director of the Guggenheim, signed an agreement with ENEL, the world's second biggest electric power company, to "develop joint projects relating to CD-ROMs and virtual reality." Bill Gates of Micro-soft has bought the Bettmann Archive of seventeen million photo-graphs and the rights to make electronic images of several museum collections, including the Kimbell in Fort Worth, London's National Gallery, and the Hermitage in St. Petersburg. In May 1996 UCLA opened a Center for Digital Arts, with funding and high-tech equip-ment from the Intel Corporation. Robert Winter, the co-director, ex-ulted that "the arts have historically been on the fringe of society, but in the digital world, the arts are in the center. The design has a pro-found effect on the content. It is the center."

Those are the blue skies. As far as the actual making of art goes, smog still prevails. There has been some art activity on the techno frontier. Komar & Melamid curated a show on the World Wide Web. Jenny Holzer posted some Truisms on the Internet, a less dignified home for them than marble slabs, but preferable to T-shirts. In 1971 Christo first conceived of the notion of wrapping the Reichstag in Berlin. In 1995, despite the dogged opposition of German chancellor Helmut Kohl, Christo and Jeanne-Claude—the Christos have billed themselves formally as joint artists since February 1994—got permis-sion and packaged the ominous dump in aluminized fabric. Three Californians were there to record the process. They divided their images into "Regular Old Chemical Photos" and "Daily Digital Pho-tographs." Kay Larson, writing somewhat for the converted in the magazine *Virtual City*, rhapsodized that "antique technologies—120 and 35-millimeter cameras—produced pictures as drab as the evil step-sisters. . . . The digital images picked up the gleam of the fabric and converted it into phosphor monitor glow, a direct transposition that conveys the ghostly thrill of being there: the scale, the drama and the crowds."

The French artist Orlan began her project "The Reincarnation of Sainte Orlan" in 1990. Since then she has had a series of nine radi-

cal cosmetic surgeries, which are turning her into a collage that will incorporate "the nose of a famous, unattributed School of Fontaine-bleau sculpture of Diana, the mouth of Boucher's Europa, the fore-head of Leonardo's Mona Lisa, the chin of Botticelli's Venus and the eyes of Gerome's Psyche." She reluctantly gave up on the notion of having her legs lengthened when she learned she would be in great pain for a year and that it would be another year before she would be walking properly. Orlan's next operation will require the removal of the flesh around her eyes. No surgeon in America will do the eyesight-threatening surgery, so she is planning to have it done in Japan. She sells vials of her fat—it has a viscous amber-greenish hue, as opposed to Damien Hirst's animal innards, which are slug-gray—and video and photographs. The videos are rather aestheticized, after the French fashion, gussied up with clips of Antonin Artaud and suchlike. Post-human would seem the right term.

The Brothers Quay, two Czechs who live in London, use star-tling animation techniques to make movies that are darkly compelling exemplars of Adam Gopnik's High Morbid Manner. Matt Mullican has been creating versions of an eerily unpeopled supercity since 1987. In 1989, a version he had modeled on computer graphics and stored on laser disc was shown on videotape at MoMA, thereby becoming the first example of computer-generated art to be seen at a major mu-seum. The following year, a Virtual Reality version was commissioned by France's Ministry of Culture. Wolfgang Staehle has been on the Net since October 1991 with the Thing, which he describes as a "so-cial sculpture" and a "virtual nightclub" and which is, in intent at least, an alternative art world.

There are knotty problems, the information bottleneck, for one. (In September 1848, when Millais, Rossetti, Holman Hunt, and their fellows founded the Pre-Raphaelite Brotherhood, they had actually only seen one painting from before Raphael's time, a Bellini in London's National Gallery.) Consider video. It is almost thirty years since Bruce Nauman and a handful of others began making video, and what they made is the stuff of legend, literally, because it is sel-

dom seen outside of an occasional museum show. The video artist Bill Viola represented the United States at the 1995 Venice Biennale. But only a determined segment of the art world buys artist videos or shows them. Video remains a specialty form.

Also, the gee-whiz factor is perishable. Morphing became a bore before artists even got around to using it. In 1992 *The Lawnmower Man* dazzled with its simulation of Virtual Reality. In 1996, *Lawnmower Man 2: Beyond Cyberspace* came out. The *Daily News* reviewer wrote: "VR as a plot element is now about as cutting edge as a slide rule." Artists need time (and funding) to assimilate this stuff. They are seldom in the avant-garde of the techno culture; a derrière-garde, rather, like the Survival Research Laboratories, scrounging the leavings of Silicon Valley."

Jeffrey Deitch's "Post Human" was a fine show, with the expected names in it and a snappy title, not wholly earned. Jeanne-Claude Christo emphatically disagrees with Kay Larson about digital sparkle. "There is nothing on the Internet that matches the superb beauty of what the Reichstag was. While some of the photographs can slightly relay that beauty," Jeanne-Claude says, "the Internet cannot. Because it is fuzzy and out of focus." Well, it will doubtless unfuzz. But so far, what techno has mostly done is provide a home for an Arts & Crafts movement for our own fin de siècle.

It was May 1992. Sir Norman Rosenthal, secretary of exhibitions at London's Royal Academy, who was preparing for a show, had just been in Buffalo examining a Jasper Johns *Numbers* painting. "It was flaking away while I looked at it," he said. "The wax encaustic was peeling away from the newsprint." He had mentioned this to the curator. "That's in and out of the hospital *all the time*," the curator had said.

It happens that this subject had once come up in a conversation I had with Johns himself. He was talking about his first American Flag

painting, the one Philip Johnson ultimately gave to the Museum of Modern Art. Johns said he had begun the painting in oils but had found it infuriatingly slow going, so he had switched to the more quickly drying technique of wax encaustic, a method he had never actually tried but had read about while working in a bookstore.

"Isn't that a bit of a conservation problem?" I asked. "Yes," Johns agreed, adding, after a quick, explosive laugh, "But not mine!"

Paintings, drawings, sculpture, buildings all fade, corrode, crumble, but much of the oeuvre of the Post-Modernists is proving particularly ephemeral. Giotto's frescoes, Sung porcelain, and Degas pastels will out-tough huge quantities of the work of our experimental times, not just such intentionally transient stuff as Installations but the work of the Auction Stars. John Chamberlain's earlier work can be preyed on by rust; Anselm Kiefer's straw is shredding, rubber pieces dry and split; and china shards began dropping off the surfaces of Julian Schnabel as soon as they left the studio. Basquiat gave a painting to the writer Glenn O'Brien. "The paint is falling off," he says. A Dan Flavin owned by Donald Judd incorporated a light fixture that had the optical equivalent of a stutter. These parts are no longer made. "It's like watching the piece die," Roberta Smith says. I asked a dealer about the long-term prospects for the felt pieces by Joseph Beuys. The gallerist said, "They will be dust!" as if exultantly.

Some artists don't set out to make work for the long haul but then have second thoughts. In 1923 Man Ray attached an image of an eye to a metronome and called it *Object to Be Destroyed*. In 1957 a group of Anarchists took him at his word and smashed it in a gallery. Man Ray cheerfully authorized an edition of six, which he renamed *Indestructible Objects*. In 1966 Gerhard Richter made a painting, *Fifteen Colors*, offhandedly using house paint. It flaked off, so he repainted it in oils in 1993.

Some of the most vulnerable art is just the art the eye has approved as the most well wrought or "painterly." Francis Bacon, for instance, achieved his witchery with paint on unprimed canvas, which the acid will destroy in time. The Rothko Chapel in Houston has

become, fairly literally, a shadow of itself. The better artifacts, our equivalents for William Morris wallpapers and Charles Rennie Mackintosh chairs, are going even faster. "They'll be extinct before people get the hang of it. Museums are having to play this catch-up," says Jonathan Hallam from the gallery Barry Friedman, which works in this field.

It was Friedman that showed a 1927 chair by Rietveld and a 1930 Mies van de Rohe at the Antiques Fair in the Park Avenue Armory in 1995. It also sold a 1925 watercolor by Theo van Doesburg, a friend of Mondrian, and the founder of De Stijl, there for $26,000. Antiques! If Modern can be seen as so patinated, the notion of Contemporary is getting a bit cobwebby itself. Indeed, with so many of the stars of "Contemporary" auctions dead of old age, Christie's and Sotheby's will doubtless soon be casting around for a new term.

The backlash against the eighties Art Stars has been immediate, brutal, and rather predictable. The *Times* castigated some fine canvases by Robert Yarber as being "apt symbols for the go-go 1980s." The *New York Observer* scolded Barbara Kruger, saying "someone has to tell Ms. Kruger that the eighties are over." Those who had been made icons of the time reacted in various ways. Mary Boone spoke nostalgically of "'seventy-nine . . . 'eighty . . . when I did my great shows." Robert Longo, David Salle, Julian Schnabel, and Cindy Sherman all made movies. This would in other times have seemed a perfectly normal thing to do—what creative person wouldn't want to make a movie, after all?—but, so far as Salle and Schnabel went, many chose to see it as a hunger for the eighties fix of celebrity, if not a vote of declining confidence in picture painting. The columnist Baird Jones reported that Clemente snapped at Salle, "I'm a painter, not a filmmaker." Salle said, equally, "There is still time for you to do it. You can be both." Sandro Chia, perhaps the first of the eighties victims, showed some richly painted canvases at Sidney Janis. His strategy remains one of rejoicing in his scapegoat status. "I think it is a healthy thing," he said. "To have

moments of victimization. I feel that I have nothing to lose and there-
fore I am free." He conceded that this was "an exaggeration."

Ashley Bickerton, the object maker, told Ileana Sonnabend he
was going to start making traditional paintings during his 1993 open-
ing. Ileana Sonnabend, he says, had simply registered disbelief. In
order to make good on his word Bickerton felt he had to put some dis-
tance between himself and the New York art world. Accordingly, he
loaded up with pigments, pads, and canvases at Pearl Paint and went
to Brazil with a group of New York Conceptualists, who were in a group
show in São Paolo, and a solitary writer, myself.

The artists included Rirkrit Tiravanija, an American of Thai
descent, whose work consists in preparing and distributing food in
galleries and museums—a Duchampian practice, freighted with re-
membrances of his own family. In this company Bickerton's impend-
ing shift in his mid-thirties seemed the more startling, and Rirkrit was
asked if he thought traditional art-making techniques—painting, draw-
ing, and sculpture that required modeling or carving—could have a
substantial place in the next millennium. "Oh yes," he said. "There'll
always be room for Slow art."

We returned to New York, apart from Bickerton, who remained
to paint. A few months later, he went on to Bali. Two years later he
came back. The twelve canvases he showed at Sonnabend could
scarcely have differed more from the sleek objects he had shown dur-
ing his Neo-Geo period, and he told me, not theatrically but as a matter
of practical fact, that the show was "a last roll of the dice. If it doesn't
work, I'll be driving a cab."

The crowd at the opening, which was the day after the Damien
Hirst jamboree, was clearly jarred by Bickerton's images. These—a
malign goateed "self-portrait" on a long coiled blue serpentine neck,
a junta colonel entering an impossibly obese woman from the rear—
are like the fantastical daydreams of an obsessed adolescent, and were
indeed often developed from drawings he made in that time, but they
are painted with a clarity and attention to detail—the look of bluish
veins in plump, pale flesh, the coarse texture of thick makeup on a
baby's skin—that makes them seduce as they repel.

The pictures, which had nothing whatsoever to do with art or the art world, were pessimistic, and uningratiating enough to make Damien Hirst's ashtray and sliced cows a couple of blocks away seem positively jolly. The show sold out almost completely within a week, and Bickerton flew back to Bali, and work.

As G. K. Chesterton pointed out in *The Napoleon of Notting Hill*, there are few surer ways of making a fool out of yourself than prophecy. It is, of course, possible to look at what has gone before, even not long before, for clues. The dealer Jeffrey Deitch exulted when he was told that things seemed stale, repetitive, flat. "That's a good sign. That's exactly when things start to take off," he said, pointing out that it had been just so in the late 1970s. Deitch said, "Overnight there's something new that just changes everything." The only way to imagine what such things might be is to go where the artists are actually making their work.

Mark Tansey's studio smelled the way artists' studios used to smell. It smelled of the turpentine he used to thin his pigments. He was applying a slurpy coat of paint to a sheet of paper pinned to his studio wall. Tansey, who works in a studio in downtown Manhattan and does not use assistants, had already applied an undercoat of white gesso to the paper, and the paint was the dark, indeterminate color of the sea at night. There were now just six hours until the pigment dried and became unusable. He began to paint. His method of painting is at once ingenious and infantile. He dabbed Kleenex at the surface, sucking off paint, and foliage sprang out of the dark. He prodded around with a piece of rubber with a ragged edge and a gnarled rockface was built. "When you touch, it pulls the paint off," he said. "Wherever it touches is where the light hits. It's very much like flash photos. It's basically finger painting . . ."

Arthur Danto has written that Tansey's highly illustrational style suggests "a certain *old-fashioned* honesty." The sense of unflashy dexterity is underlined by the fact that he likes to work in a single color,

and usually single colors with nostalgic associations—blues like old movies; browns that are close to the sepia of old prints. His forms are apt to his concerns, which might be called philosophical and which frequently have to do with art. Sometimes they are oblique, sometimes anything but, like *Action Painting II*, in which some ten Sunday-ish painters are painting an actual space launch. Some are more slyly art historical, like *Triumph of the New York School*, wherein the artists are dressed as soldiers on what looks like one of the direr battlefields of the First World War. Jackson Pollock watches as Clement Greenberg accepts the surrender of the School of Paris, including a somber Picasso, wearing a helmet and a fur coat.

It was easy to admire Tansey's work, but within limits. There was the sense that the paintings were too smart for their own good, and that some necessary ambiguity was lacking. Perhaps Tansey felt this too. He began moving into deeper water. He started using blocks of crumpled or corroded text in his artificial landscapes in the 1980s. They look, at first glance, like weathered rock. Other media attracted him. A handful of photographers, like Elliott Erwitt, have managed to get a sense of story into their work, and this has been a strength of Cindy Sherman, but photography has been hostile terrain for metaphor. At least until the coming of digitalization. "Digitalization is doing to photography what photography did to painting" Tansey noted.

Tansey took the small landscape he had prepared and ran it through a hefty Sharp copier, keeping the back open with a wedge of paper—an old repairman's trick—the better to control it. "Now I can do stuff I can't do with a pencil or a brush," he said. "I can make several unfixed toner copies . . . rework those copies . . . experiment with the copies. . . . I can bring in other pieces of images. I can repopulate, add figures, and then rework it, so this becomes a way of getting the hand interacting with other sources. When I come up with an image I like, I could put it on the computer. Or I can flip it back and come up with a collage."

The Death of Painting is not something he sees as much of an issue. "It's not that one medium is going to win completely. You'll get

them interacting, a very significant interaction. Where that happens is, I think, where the new life is. As opposed to somebody who is concerned about painting in the pure sense. If you're worried about *that*, then you've got something to worry about. But not if you're centered on the idea of the picture." He got back to work, smearing toner.

There were some sixty assistants working with Jeff Koons at his floor-through studio in SoHo. Koons was preparing his first show since "Made in Heaven." Much had happened to Koons since, little of it agreeable. He did not make the feature movie. He lost his copyright lawsuits, disastrously, especially the one over *String of Puppies*. It was not a coincidence that Koons had also broken up with Ileana Sonnabend, his dealer. He had also broken up with Ilona Staller. The American courts had given him custody of their infant son, Ludwig, but—and this was by far the worst—Ilona had abducted the child and they were now, immovably, in Rome.

Jeff Koons had never been one of those artists who develop gradually from piece to piece and show to show. Each of his shows, indeed, had rung a change on its predecessors, even when he could have done extremely well commercially without harming his career by sticking with a manner for a while. After many postponements and further rumors, a supposedly firm date for his new show was announced. It was to be at the downtown Guggenheim in New York, and some pieces were to go on permanent exhibition in the Guggenheim's newest imperial redoubt, the Frank Gehry building in Bilbao, Spain.

Koons met me at the door. It was a first surprise to see the legal casualty, *String of Puppies*, in a dominant position in the main room. Koons said this was to show that he had always been interested in color. This proved to be a statement of intent. The chromium-steel sculptures, which will be blue, pink, yellow, and green, were still off being fabricated, mostly at aerospace foundries in California, but there were paintings, mostly using the same forms as the sculptures, and they were of Christmas-wrap vividness. The paintings were renderings of photographs that Koons had taken himself, mostly what he called "real-life abstractions," catching the distortions and reflections of undulant

Mylar. They were being painted by assistants. The computer-made paintings in the "Made in Heaven" show had a dully slick surface, which I found repellent. Not these.

The sculptures will dominate, though, and you could get a sense of these, even as resin molds. The shapes were minimal, indeed Minimal, but Koons had always used minimal shapes, from the basketballs to the Brancusi Bunny, which was somewhat recalled by a piece called *Balloon Dog*. There was a formalized heart-shape that Koons called a "Sacred Heart," and there was a bunch of tulips. "All of the stems come out of the back here. And you'll get a rainbow," Koons said. "White . . . pink . . . yellow . . . red . . . blue. All of these are in chromium steel, and there will be all these reflections and distortions."

There was a giant kitten pulling on a sock. The sock will be in a rubberized material, and the kitten is very much in Koons's earlier Rococo-kitsch style. There was a huge bowl of eggs and, strikingly, a high mound of colored pellets that looks at first like a jumbo bowl of sorbets but is actually a heap of chunks of Play-Doh, kneaded by Koons, thrown together, and blown up to a ten-foot cairn, executed in thermal plastic in the original Play-Doh colors.

The cynicism for which Koons has so consistently been reviled seemed utterly absent. The interconnecting studios had something of a festive air, like a huge, dazzling children's party. Indeed, to the left of the door there was a small enclave of children's toys—a Charly Plane, a police car, a wheelbarrow, a Little Tikes pirate boat—that I assumed were the raw materials for fresh work. There was even a party hat. It was made out of paper, and conical, with a brim, and it was covered with brightly colored circles. Koons had already used it in a painting. "This is a large sculpture, too," he said. "It's twelve feet in length. It just lays on the ground."

Where had he got the original hat? "It's my son's," Koons said. He paused. "Before Ludwig was abducted, his nanny and I gave him a little birthday party," he said.

It sank in. The toys alongside the door were "real" toys. The Little Tikes pirate boat, the police car, the wheelbarrow were in Ludwig's

former play area. The origins of many of the pieces in the Guggenheim show are Ludwig's nursery. The red-and-yellow plates in one of the paintings had been his playroom plates. Artists make their work out of what they have to. Jeff Koons had abandoned his adult notion of a Blue Heaven and entered a children's world.

Artists make the work they have to make. They don't always have a choice, even in an unreceptive culture. And how unreceptive is the culture, in the end? In December 1990, Lucien Goldschmidt, a great dealer in rare books, gave a melancholy interview to the *New York Times.* "When I first came to New York in 1937 you could spend weeks going from one rare book dealer to another," said Goldschmidt, who shuttered his own operation in 1987. Not now. "This is part of the whole downgrading of the role of literature in American society and the increase in the role of the image. Now people are far less tempted to read. They are forever looking at pictures." Some of those images, at least, will be artist-made.

Index

Aalders, Franklin, 43
Abolition of Art, The (Jouffroy), 29
Above the Snows (Nissky), 316
Abstract Expressionism, 3, 8, 11, 17, 24, 40, 99, 129, 163
Acconci, Vito, 38–40, 50, 63, 127
Ace Gallery, 310–11
Ackerman, Martin S., 75
Acquavella, William, 8, 185–86, 202
Action Painting II (Tansey), 325
Adams, China, 310–11
Adamski, Peter, 104
Ader, Bas Jan, 44–45, 49–50, 236–37
Ader, Mary Sue, 44, 45, 50
Afrika (artist), 184
Agnelli, Gianni, 2
Ahearn, Charlie, 126
Alexander, Brooke, 111–12
Alexander, John, 76, 87, 88
Alloway, Lawrence, 149
Almodovar, Pedro, 276
Alphabet (Johns), 184
Alveryd, Bo, 61–62, 72, 189–90, 305, 306
Amarillo Ramp, The (Smithson), 47, 48
American Fine Art, 224
American Interiors (Erro), 29
Ammann, Thomas, 74, 144, 153, 203
Anastasi, William, 96

Andre, Carl, 19, 24, 26, 32, 66, 69, 103, 248, 250, 258
Andrewartha, Jai, 193
Angry Arts Colation, 27
Angst, 213, 231
Anh in a Spanish Landscape (Schnabel), 204
Anselmo, Giovanni, 116
Anthony d'Offay Gallery, 287, 295, 297
Antiquities, 187–88
Antoni, Janine, 285–87, 299
A-One (graffiti artist), 129
Arason, Peter, 245
Arbus, Diane, 233
Armitage, Karole, 137
Armstrong, Richard, 182
Armstrong, Tom, 76–77, 171
"Art after Philosophy," 26
Art Aktuell, 57–58, 75, 86
Art and Its Social Significance (Courbet and Proudhon), 4
Art & Auction, 167, 189
Art consultants, 139–40
Art Dealers Association, 17, 81, 167
Art Economist, 109
Artemis, 75
Arte Povera, 100, 101
Art Expo, Manhattan, 166
Artforum, 2, 32, 284
Arti et Amicitiae, 222

Art in America, 127, 128, 170
Art Institute of Chicago, 134
Art International, 288
Art in the Age of Aquarius, 35
Artists Space, 131, 132
Art-Kapital, 216
Art Monthly, 114–15
ArtNet, 317–18
ARTnews, 67, 108, 110, 132, 167–68
Art Newspaper, 204
Art & Projekt, 104
Artrax, 308
Art-Rite, 69, 88
Arts, 146, 247
Arts as an Industry, The, 12
Artschwager, Richard, 199
Arts Review, 295
Art theft, 193–94
Art Workers Coalition, 32
Associated Press, 48
Astor, Patti, 126–27, 129, 140
Aubert, Martin, 129
Auerbach, Frank, 289
Augustine, Luhring, 191
Augustine, Ronald, 314
Au Moulin de la Galette (Renoir),
 202, 203
Austin, Gabriel, 79
Australian National Gallery, 15
Avalanche, 34, 44–45

Baader-Meinhof group, 29, 226
Bacon, Francis, 17, 209, 274, 278,
 289, 290, 293–94, 321
Baechler, Donald, 102–03, 112, 132,
 219
Baer, Martha, 179
Baghoomian, Vrej, 305, 307
Bailey, Harry, 163–64
Baj, Enrico, 41
Baldessari, John, 13–14, 59, 106, 192,
 261, 309
Ballard, J. G., 33
Barbara Gladstone Gallery, 284, 285

Barish, Keith, 170
Barker, Godfrey, 193
Barney, Matthew, 285–86
Barry, Robert, 26, 63–64, 69
Baselitz, Georg, 99, 105, 106, 116,
 199, 213
Basel Kunstmuseum, 16
Basquiat, Jean-Michel, 124, 127–31,
 130–31, 146–47, 148, 153, 154,
 178, 203, 294, 314, 321
Bates, David, 76
Bathers (Cézanne), 184
Bathurst, David, 78, 80, 81
Baudissin, Count, 225
Baudrillard, Jean, 133, 185
Baxter, Douglas, 261, 267
BBC, 303, 304
Beach Party (political movement), 224
Beaud, Marie-Claude, 314
Bell, Larry, 262
Bellamy, Richard, 248
Benglis, Lynda, 38, 93
Benjamin, Walter, 316
Berger, John, 183
Berri, Claude, 59
Bettmann Archive, 318
Beuys, Joseph, 17, 58, 68, 263, 311, 321
Bickerton, Ashley, 139, 141, 142, 205,
 291, 307, 323–24
Big Bend Sentinel, 253
Bischofberger, Bruno, 74, 104, 111,
 112, 127, 131
Black Monday, 164, 166, 188, 201
Blake, Nayland, 280–81, 285
Blake, Peter, 70
Blake, William, 286
Blanca, Paul, 229, 230, 231–35
Blau, Douglas, 312
Bleckner, Ross, 89, 91, 93, 95, 97, 98,
 106, 127, 167, 180–81, 181, 192,
 204
Block, René, 29
Blue Poles (Pollock), 15
Blum, Irving, 9, 16, 181–82, 194–95

Blum-Helman Gallery, 246
Bode, Vaughn, 122
Body art, 39–41
Boltanski, Christian, 276
Bomb magazine, 133
Bond, Alan, 165, 179, 193, 201, 203
Bongard, Dr. Willi, 57–58, 75, 86–87,
 115, 216
Bonito Oliva, Achille, 273–74, 275,
 299
Bonnard, Pierre, 107
Bontecou, Lee, 10, 58
Bookchin, Murray, 30, 31
Boom in art prices, 163–205, 259,
 260, 290–91
Boone, Mary, 77, 85–86, 131, 141,
 142, 145–46, 168, 177, 179–81,
 195–96, 280, 281, 305, 306–07,
 322
 Bleckner and, 97, 167, 180
 Koons and, 135–36, 185
 Marden and, 196, 197, 198
 moves gallery, 109, 309
 rumors of gallery's financial
 problems, 199, 200
 Salle and, 97, 110, 180, 185, 199,
 200, 306
 Schnabel and, 74, 85–86, 93–97,
 98, 107–08, 110, 111, 112, 113–
 14, 200, 306
Borofsky, Jonathan, 67, 104
Botero, Fernando, 157, 210
Bourdin, Guy, 234
Bourgeois, Louise, 274, 278
Brant, Peter, 9, 143, 165, 170
Brant, Sandy, 170
Brathwaite, Fred, *see* Fab Five Freddy
 (graffiti artist)
Brenner, Marie, 86
Brenson, Michael, 141
Breton, André, 225, 279
Breuer, Marcel, 79
Briskin, Jake, 265–66, 267
Brodovitch, Alexey, 234

Brooke, David, earl of Warwick, 163–
 64
Brooks, Diana D., 190, 315
Brothers Quay, 319
Brundage, Susan, 178
Brus, Gunter, 43
Bruskin, Grisha, 307
Buffet, Bernard, 8
"Bulldozer Show," 291
Bullock, Leonard, 215
Burden, Chris, 45–46, 50, 189, 226, 284
Burge, Christopher, 172–73, 179,
 185, 203, 205
Burgin, Christine, 191
Burne-Jones, Sir Edward, 6
Burri, Alberto, 17
Butterfly Kisses (Antoni), 287
Byars, James Lee, 41, 101
Byers, Jeff, 93–94
Bykert Gallery, 93–94
Byrne, David, 125

Cable Gallery, 139
Cafe Deutschland (Immendorff), 106
Cage, John, 64, 276
California School of Art, 96, 106–07,
 139, 192
Cameron, Dan, 282, 283
Canceled Crop (Oppenheim), 38
Caravaggio, Michelangelo da, 209
Caro, Anthony, 247
Carritt, David, 75
Cassatt, Mary, 79
Castelli, Leo, 18, 56, 75, 77, 94, 96–
 97, 98, 106, 107–08, 110, 114,
 141, 165, 168, 169, 199–200,
 274
 during Boom period, 171–72, 173,
 175, 184, 189, 191
 described, 8
 Gagosian and, 177, 178
 Judd and, 248, 249
Celant, Germano, 100, 101, 259–60
Centrox, 192

Centrust, 203
Cervietti, Franco, 157
César (French artist), 100
Cézanne, Paul, 53, 184, 193
Chadwick, Helen, 310
Chagall, Marc, 166
Chamberlain, John, 100, 242, 253, 254, 256, 321
Charlesworth, Sarah, 67
Chatterton, Thomas, 4–5
Chelsea, 309
Cherry, Wendell, 78, 185
Chia, Sandro, 100, 101–02, 104, 128, 322–23
Chinati Foundation, 243–45, 255–69, 304
Christensen, Dan, 18
Christie's, 17, 64, 77–78, 79, 81, 143, 314
 Boom period, 1987–1991, 163–64, 166, 172–73, 179, 183–84, 185–86, 189, 190–91, 194, 200–05
Christmas, Doug, 178
Christo, 63, 64, 113, 223
 and wife, Jeanne-Claude, 54–55, 61, 100, 113, 318, 320
Chucchi, Enzo, 104
Clark, Brigadier Stanley, 53
Clemente, Francesco, 100, 101, 104, 232
Close, Chuck, 199, 306
Closed Gallery (Barry), 63–64
Cocteau, Jean, 99
Cogan, Marshall, 79, 80–81
Coggins, Clemency, 188
Colin, Ralph, 81
Collaborative Projects Inc., 124
Collins, Tricia, 276–77
Conceptualists, 13–14, 25, 26–27, 61, 63–64, 67, 96, 251, 252, 286, 311
Condo, George, 133, 219
Connaissance des Arts, 53
Contemporary Art Museum, 89
Cooke, Lynne, 311

Cooper, Paula, 32, 55, 67, 89, 114, 176, 199, 281, 306, 309
Cornell, Joseph, 183, 280
Corse, Mary, 309
Cortez, Diego, 125, 128
Cotter, Holland, 311–12
Couple Fucking Dead (Twice) (Hirst), 312–13
Courbet, Gustave, 4
Cragg, Tony, 289, 290
Craig-Martin, Michael, 288, 291, 292
Crash (graffiti artist), 124, 129
Crispo, Andrew, 143
Cucchi, Enzo, 100, 101
Cunningham, Merce, 64
CVJ (Schnabel), 88

Daemonization (Salle), 110
Dallas Times-Herald, 253
Dalstra, Koos, 213, 231, 236, 237
Dannheisser, Elaine, 13, 164
Danto, Arthur, 85, 158–59, 324–25
Davenport, Ian, 291
Davidge, Christopher, 190
Daze (graffiti artist), 124, 129
Deacon, Richard, 289
DeAk, Edit, 69
Death of a Misunderstood Man of Genius (statue), 5
Debord, Guy, 28, 32, 189
De Chirico, Giorgio, 90, 101, 283
Degas, Edgar, 5–6, 64, 79
Deitch, Jeffrey, 128, 169, 183, 285, 317, 320, 324
de Kooning, Willem, 3, 8, 13, 14, 99, 200, 201, 203, 232, 247, 259, 314–15
Delland, Colin, 176
DeLuca, Giorgio, 261
de Maria, Walter, 34, 36, 69, 252
de Menil, Christophe, 128
de Menil, Dominique, 62, 255
de Menil, François, 174
de Menil, John, 62

de Menil, Philippa, *see* Friedrich, Philippa (née de Menil)
de Menil family, 251
Demon of Progress in the Arts, The (Lewis), 24
Derain, André, 90
Dercks, Sandra, 213, 234
Derision by Two Lesbians (Linda Lovelace) (Scholte), 216
Deterioration of artworks, 320–22
de Vigny, Alfred, 5
Dia Foundation, 251–56, 269, 283, 305
Diaz, Al, 128
Diba, Farah (empress of Iran), 64, 65
Diba, Kamran, 64–65, 66
Diebenkorn, Richard, 99
Dion, Mark, 309
Directed Seeding (Oppenheim), 38
di Suvero, Mark, 27, 68
Diver (Johns), 166
d'Offay, Anthony, 116
Dokoupil, Jiri Georg, 102–03, 104, 213–14, 216, 219
Dokumenta, 30, 86, 115, 116, 215, 224
Domus magazine, 66
Donald Judd Hides Brunhilde (Kiefer), 256
Donegan, Cheryl, 311–12
Dorrance, John T., Jr., 185–86, 201
Double Feature (Rauschenberg), 16
Double Negative (Heizer), 35
Double White Maps (Johns), 14–15
Duchamp, Marcel, 10, 28, 30, 90, 275, 309, 311

Earth artists, 251, 252
"Earth Art" show, 35
Earth Room (de Maria), 252
"Earthworks" (Oppenheim show), 36
East Village, 126–27, 131–34, 140–41, 146
Edelman, Asher, 153, 186–89, 305–06, 315
Eggerer, Thomas, 311

Eisenman, Frank, 258
El Pais, 217
Emin, Tracey, 310, 311
Emmerich, André, 8, 17
ENEL, 318
Eno, Brian, 125
Equivalent VIII (Andre), 19
Ernst, Max, 279
Erro, 29
Erwitt, Elliott, 325
Escalade Non Anesthésiée (Pane), 43
Esquire, 96
Estes, Richard, 71
Export, Valie, 43

F-111 (Rosenquist), 143–44
Fab Five Freddy (graffiti artist), 124, 125, 126, 128–29
Factor, Don, 1–2
Fahlstrom, Oyvind, 29
Fait d'Hiver (Koons), 150, 153, 155
Faith of Graffiti (Mailer), 122
False Start (Johns), 171, 172, 174–76, 177
Faulds, Andrew, 58
FBI, 210, 261–62
Feaver, William, 114
Feigen, Richard, 8, 28, 164
Feldman, David, 168
Feldman, Ronald, 263
Fend, Peter, 222–24
Feynman, Dr. Richard, 138
Fifteen Colors (Richter), 321
Filipacchi, Daniel, 71
Finch, Julie, 248, 250–51
Fischer, Karl, 26, 306–07
Fischl, Eric, 106–07, 180, 192, 203
Flanagan, Bob, 310
Flash Art, 112, 115, 196
Flavin, Dan, 24, 62, 103, 248, 250, 253, 254–55, 294, 321
Fluxus movement, 55, 99
Folkwang Museum, 225
Fontana, Lucio, 17, 99–100

Forbes, 113–14
Fortabat, Anna-Maria, 179
Fortune, 53
Fox, Patrick, 127
Fragonard, Jean-Honoré, 146
Frankenthaler, Helen, 99
"Freeze" exhibition, 290–92
Freud, Lucian, 17, 194, 289, 290
Friedman, Barry, 322
Friedrich, Heiner, 251–56, 269
Friedrich, Philippa (née de Menil),
　　136, 251–52, 253, 255
Frieze (magazine), 295
Frieze (Pollock), 172
Frith, William Powell, 6–7
Fritsch, Katharina, 282–83
Fuchs, Rudi, 15, 86, 217, 257, 265
Fundamental Lexicon (Bruskin), 307
Fung, Winnie
Fun Gallery, 126–27, 129, 140, 146
Futura 2000, 121, 127, 146
Futurists, 138

Gagosian, Larry, 50, 97, 130, 153,
　　168–70, 173, 174, 177–78, 184,
　　189, 195, 197, 198–99, 200, 202,
　　306, 308, 314
　　see also Larry Gagosian Gallery
Gallaccio, Anya, 298
Ganz collection, Sally and Victor,
　　173–74
Gardner Museum, 194
Garet, Jedd, 102, 104, 126
Garfield, 152
GAS, 223, 224
Gates, Bill, 318
Gaudi, Antoni, 95
Gautier, Théophile, 5
Geffen, David, 170
Gehry, Frank, 258–59
Geldzahler, Henry, 110
German Expressionists, 78, 103
Getty Museum, J. Paul, 166, 184,
　　187, 201
Geva, Avital, 275

Gibson, John, 35, 56–57
Gilbert & George, 41–42, 289
Gimelson, Deborah, 167, 198
Gimmick, 217, 230
Gladstone, Barbara, 176
Glasco, Joe, 87–88, 204
Glimcher, Arne, 8, 76, 191, 199, 308
Glueck, Grace, 76–77, 110, 199,
　　306–07
Gober, Robert, 13, 309
Golden Horizon (Scholte), 220, 229
Goldschmidt, Lucien, 328
Goldschmidt auction, 17
Goldsmiths (art school), 288–91, 298
Goldstein, Jack, 139
Golub, Leon, 27
Goodman, Marian, 106, 281, 282
Gopnik, Adam, 278–79
Gorewitz, Rubin, 18
Gorky, Arshile, 172–73
Gorney, Jay, 127, 140, 141
Gowrie, Lord, 307
Graffiti artists, 121–25, 127–31, 146
Graham, Robert, 40
Grant, Anthony, 204
Grasshopper, The, 6
Gratz, Roberta, 10
Gray Painting with Ball (Johns), 315
Green, Gregory, 226–27, 311
Greenaway, Peter, 277
Greenberg, Clement, 163, 188, 247,
　　279
Green Gallery, 248
Greenspan, Stuart, 166, 190
Greenwood, Nigel, 41–42, 171
Grostein, Marcia, 130
Guardian, 116
Guernica (Picasso), 48–49, 65, 127
Guggenheim, Barbara, 9
Guggenheim Museum, 12, 19, 259–
　　60, 318, 326, 328
Guilbaut, Serge, 17, 99
Gulf War, 204, 205
Gund, Agnes, 62
Guston, Philip, 67–68

Haacke, Hans, 19, 32, 58, 102, 223, 276
Habsburg, Archduke Geza von, 168
Habsburg Feldman, 168, 201
Hager, Steven, 146
Haggard, H. Rider, 124
Hahn, Stephen, 110
Hallam, Jonathan, 322
Halley, Peter, 133–35, 141, 142, 145–
 46
Hambleton, Richard, 125
Hamilton, Richard, 29, 149
Hamilton, William, 159
Hammons, David, 280, 281
Hamnett, Katherine, 231
Haring, Keith, 121–22, 124–25, 129,
 130, 131, 146, 147–49, 152, 154,
 194, 294
Harithas, James, 89
Harper's, 11
Hasfeld, Max, 229–31
Hassam, Childe, 98–99
Havemeyer, Harry, 80
Havemeyer collection, Doris, 79–81
Hawk (Schnabel), 88
Healy, Morris, 308
Hearn, Pat, 132, 133, 309
Hegel, Georg Wilhelm Friedrich, 159
Heineken, Freddy, 212
Heiss, Alana, 128
Heizer, Michael, 34–35, 36, 69
Heizer, Robert, 34
Heller, Ben, 15
Helman, Joe, 16, 107, 177, 246, 315
Herold, Georg, 104
Heron, Patrick, 17, 99
Herstand, Arnold, 130
Hess, Thomas, 99, 181
Hesse, Eva, 38, 189
Het Parool, 229–30, 231
Hetzler, Max, 150–51
Hildesley, Hugh, 9–10, 80
Hirshhorn, Joseph, 9
Hirst, Damien, 279–80, 287–99, 312–
 14, 323, 324
Hoban, Phoebe, 255

Hobert, Frank, 94
Hobijn, Erik, 224–25, 227, 228
Hockney, David, 109, 149, 290, 314
Hodgkin, Howard, 289
Hoffman, Fred, 130, 170
Hogrefe, Jeffrey, 81
Holzer, Jenny, 124, 318
Homage to Blinky Palermo
 (Schnabel), 92
Hopper, Dennis, 181
Horn, Roni, 262, 267, 268
Horn, Tom, 264–65
Horowitz, Helen, 176
How New York Stole the Idea of
 Modern Art (Guilbaut), 17, 99
Huebler, Doug, 26
Hughes, Robert, 55, 86, 130, 160,
 163, 189, 194, 202–03, 308
Huizing, Colin, 219
Hulten, Pontus, 316
Hume, Gary, 292, 293, 297–98
Humphrey, Ralph, 108
Hundred Years, A (Hirst), 293
Hutchinson, Max, 55–56
Hynde, Chrissie, 158

Image Mass Murder (Hambleton), 125
Immendorff, Jorg, 106
Impressions of the Knees of Five
 Famous Artists (Nauman), 37
In and Out of Love (Hirst), 295
In Search of the Miraculous (Ader),
 49–50
Institute of Contemporary Art, 33, 289
Intel Corporation, 318
International Foundation for Art
 Research (IFAR), 193, 194
International Herald Tribune, 179
International with Monument, 133,
 134, 139–40, 140–41, 231
 "Equilibrium" show, 137–38, 139
Internet, 317–20
Iran, shah of, 64, 65, 66
Irises (van Gogh), 165, 179, 193, 201,
 203

Irwin, Robert, 37
Isolated Elements Swimming in the Same Direction for the Purpose of Understanding (Hirst), 295

Jackson, Harry, 113
Jack the Bellboy (Schnabel), 94–95
Jakobson, Barbara, 65, 106, 184
Janis, Sidney, 8, 15
Janssen, Suzanne, 237
Jenney, Neil, 68–69, 69
Jewish Museum, 67
Johns, Jasper, 1, 17, 18, 50, 58, 90, 97, 184, 200, 218, 259, 320–21
 works of, 3, 14–15, 25, 60, 143, 166, 173, 176, 184, 315
 Ballantine ale cans, 1, 8, 15–16, 18
 False Start, 171, 172, 174–75, 177
 Three Flags, 76–77
 White Flag, 171, 172, 173, 175–76
Johnson, Philip, 9, 321
John Weber Gallery, 133, 134
Jones, Alan, 135, 136
Jones, Allen, 70
Jones, Baird, 322
Jopling, Jay, 293–95, 297, 312–13
Jorniac, Michel, 43
Jouffroy, Alain, 29
Jubilee (Johns), 176
Judd, Donald, 24, 26, 29, 62, 63, 73, 199, 241–69, 286, 294, 306, 321
Jump (Salle and Schnabel), 110
Junker, Howard, 23
Just Another Asshole (magazine), 135

Kabakov, Ilya, 244, 263, 264, 307
Kameyama, Shigeki, 201
Kantor, Paul, 315
Karp, Ivan, 8
Kasmin, Paul, 189
Katz, Alan, 67
Katz, Alex, 314
Katz, Bill, 232–33
Kelly, Ellsworth, 98, 183–84
Kent Gallery, 220, 236

Kertess, Klaus, 94
Kiefer, Anselm, 105, 106, 256, 282, 321
Kind, Phyllis, 307–08
King, Bill, 233
Kirchner, Ernst Ludwig, 103
Kirkeby, Per, 214, 274
Kitaj, R. B., 109
Klee, Paul, 263
Klein, Jochen, 311
Klein, Yves, 41, 64, 100
Kline, Franz, 3, 9, 62
Kluver, Bill, 316
Knoedler Gallery, 8, 98
Kobayashi, Hideto, 203
Kokoschka, Oskar, 99
Komar & Melamid, 318
Koons, Jeff, 134–39, 141, 142, 149–53, 155–58, 185, 214, 217, 218, 326–28
 "Banality" show, 150–52
 copyright lawsuits, 151–52, 229, 326
 "Equilibrium" show, 137–38, 139
 "Luxury and Degradation" show, 139
 "Made in Heaven" show, 156
 self-portrait, 157–58
Kopie, Jeff, 241–45, 253–54, 257, 260, 264, 265, 266–67, 269
Kosuth, Joseph, 23, 25–26, 47, 59, 67, 69, 93, 276
Kounellis, Jannis, 100, 101, 195
Koury, Elizabeth, 133
Kramer, Hilton, 69, 108, 151, 167, 247
Kramer, Steve, 127
Krens, Thomas, 318
Kroller-Müller Museum, 193
Kruger, Barbara, 180, 322
Kunc, Milan, 213
Kushner, Robert, 73–75
Kuspit, Donald, 145

La Cicciolina, *see* Staller, Ilona (La Cicciolina)
Lady Pink, 123, 126, 129
Laing, Gerald, 209
Lambert, Lizz, 137–38

Landers, Sean, 278
Lane, Alvin and Teresa, 62
Lannan, Patrick, 113
Lanyon, Peter, 17, 99
La Promenade (Manet), 201
Larry Gagosian Gallery:
 Los Angeles, 140, 168
 New York, 177, 312–14
 see also Gagosian, Larry
Larson, Kay, 142, 318, 320
Lauder, Leonard, 76
Lebel, Jean-Jacques, 30, 31
Lee (graffiti artist), 124, 125, 126
LeFrak, Francine, 7–8
Lehman, Robert, 190
Leigh, Christian, 276–77
Les Noces de Pierrette (Picasso), 204
Le Va, Barry, 37–38
Levine, Les, 61, 62, 70, 92–93, 145, 306
Levine, Sherrie, 89, 214
Lewis, Peter, 258
Lewis, Wyndham, 24
LeWitt, Sol, 19, 24, 26, 48, 63, 73, 189
Leyendecker gallery, 220
Lichtenstein, Roy, 103, 110, 151, 152,
 173, 185, 195, 200, 246, 314
Lick and Lather (Antoni), 287
Lightning Field (de Maria), 252
Lisson Gallery, 192, 289
Living Room, the, 214, 219
Lloyd, Frank, 9, 16
Logsdail, Nicholas, 192
London *Daily Telegraph*, 193
London *Evening Standard*, 296
London Royal Academy, 109, 320
London *Sunday Times*, 296
Long, Richard, 63, 244, 262, 289
Long Beach Museum, 44
Longo, Robert, 131, 132, 322
Longobardi, Nino, 100, 104
Los Angeles Museum of
 Contemporary Art, 35
Louver gallery, 191
Loving Care (Antoni), 286–87
Lowry, Bates, 32

Ludwig, Peter, 105, 108–09, 187
Ludwig Museum, 103
Lupertz, Markus, 105, 106
Lyrical Abstraction, 18

McCarthy, Paul, 278, 312
McCullin, Don, 234
McDermott, David, 126
McEwen, John, 114
Maciunas, George, 55, 56
McNally, Brian, 198
McShine, Kynaston, 40
Made in Heaven, 156, 158
Mademoiselle de Maupin (Gautier), 5
Maenz, Paul, 104, 213–14, 216, 305
Magritte, René, 12, 90, 279
Mailer, Norman, 122
Malasch, Rob, 220
Malmstrom, Lillemor, 176
Manet, Édouard, 79, 201, 203
Mangold, Robert, 59
Mansion, Gracie, 141, 166, 308
Mantje, Aldert, 219, 222, 237
Manzoni, Piero, 41, 189
Mapplethorpe, Robert, 125, 232, 233
Maps (Johns), 3
Marden, Brice, 59–60, 69, 88, 98,
 169, 184, 306
 art boom and, 195, 196–99
Marfa, Texas, 241–69
Marilyn Monroe (Twenty Times)
 (Warhol), 174
Marion, John, 7, 17, 78, 80, 172,
 174–75, 203, 315
Marks, Matthew, 281, 309
Marlborough Gallery, 2, 9, 16, 67–68,
 141, 307
Marlowe, Christopher, 209
Marron, Donald, 202
Marsh, Stanley, 47, 62
Marshall, Richard, 182
Martin, Agnes, 247
Mary Boone Gallery, 94, 98, 110, 124
 see also Boone, Mary
Masaccio, 209

Maternité (Picasso), 178–79
Matisse, Henri, 12, 23, 73, 110
Matisse, Pierre, 202
Matta-Clark, Gordon, 56, 94
Max, Peter, 128
Mayor, James, 1–2, 16
Mazzoli, Emilio, 129
Medalla, David, 43–44
Mediamatic, 215
Mehle, Aileen, *see* Suzy, aka Aileen
 Mehle
Meier, Hans, 111
Meinhof, Ulrike, 29
Melikian, Souren, 179, 204
Memoirs (Debord), 189
Memory of Le Havre (Picasso), 171
Mendieta, Ana, 143, 210, 258
Mendotta Stoppages (Turrell), 37
Men in the Cities (Longo), 132
Merda d'Artista (Manzoni), 189
Meredith, George, 5
Merrin, Edward, 187–88
Merz, Mario, 100
Metro Pictures, 132
Metropolitan Museum, 2, 12, 73, 79,
 166, 167
MGM-Pathé, 152
Middleburg, Bart, 229–30
Milazzo, Richard, 276–77
Miles, Roy, 58–59
Minimalism, 19, 24, 26, 33, 37, 62,
 73, 90, 248–53, 294
Mirror Paintings (Lichtenstein), 185
Mitchell, Eric, 126
Mitchell-Innes, Lucy, 142–44, 164,
 174, 176, 183, 205, 315
Modarco, 75
"Modern Medicine" show, 292
MoMA, *see* Museum of Modern Art
 (MoMA)
Mondrian, Piet, 24, 169
Monet, Claude, 80, 126
Monimoto, Yakishiro, 164
Montebello, Philippe de, 166–67
Moore, Henry, 157

Morea, Ben (Ben Motherfucker), 30, 31
Morgan, Stuart, 295
Morley, Malcolm, 69–73
Morris, Robert, 37, 62, 69, 96
Morris, William, 262
Moses, Andy, 137
Moses, Robert, 54, 249
Mosset, Olivier, 29, 30, 33
Mother and Child (Hirst), 279, 287,
 298–99
Motherwell, Robert, 309
Mucha, Reinhard, 283
Muehl, Otto, 43, 219
Mullican, Matt, 106, 135, 319
Munoz, Juan, 283
Murray, Elizabeth, 107, 309
Museum Boymans-van Beuningen, 217
Museum of Modern Art (MoMA), 12,
 23, 31–32, 40, 48, 127, 135, 316,
 319

Nahamkin, Edouard, 308
Nares, James, 124, 126
Nash, David, 78–80, 142, 186, 201, 315
Nation, 85, 158
National Gallery, 182
Nauman, Bruce, 37, 68, 69, 144–45,
 279, 284, 312, 319
Neiman, LeRoy, 166
Neo-Expressionism, 110, 112, 116,
 123, 132, 136, 141, 213, 252,
 305, 309
Neo-Geo, 145, 148, 196, 281
New Art: It's Way, Way Out, The, 23
New Criterion, 151
Newhouse, S. I., 169, 170, 172, 173,
 174–75, 176, 177
Newman, Barnett, 3, 9, 11, 16, 218, 248
Newman, Donald, 96, 98, 116, 311
New Museum, 136
Newsome, "Buck," 244
Newsweek, 23
New York, 85, 87, 140, 142, 145, 167
New York *Daily News*, 320

New Yorker, 68, 278
New York Herald Tribune, 10
New York Observer, 166, 190, 322
New York Post, 10, 179
New York School, 12, 99
New York Times, 27, 53, 77, 80, 108,
 110, 141, 153, 158, 175, 180,
 188, 191, 199, 280, 283, 304,
 306, 311–12, 314, 315, 322, 328
New York Times Magazine, 131
Niarchos, Philip, 108
Nieuwe Revu, 234–35
Nine Nevada Depressions (Heizer), 35
Nissky, G. G., 316
Nitsch, Hermann, 43
Nochlin, Linda, 5
Nocturne in Black and Gold: The
 Falling Rocket (Whistler), 6
Noland, Cady, 218
Noland, Kenneth, 60
Nonas, Richard, 248
Norman, Geraldine, 53–54
North, East, South, West (Heizer), 34
Nosei, Annina, 97, 102, 128, 129,
 131, 136, 168, 309
Nue Allongée (Degas), 64
Numbers (Johns), 320
Nunez, Ramon, 265

Oakland Wedge, The (Oppenheim), 34
Observer, 114
Ocean Earth, 223, 224
Oehlen, Albert, 104
O.K. Harris, 8
Oldenburg, Claes, 23, 58, 244, 256,
 257, 258, 262, 294
Olitski, Jules, 60, 188–89, 306
Oliva, Achille Bonito, 100–01
Onassis, Jacqueline Kennedy, 315
One and Three Chairs (Kossuth), 25
One Wish (Bleckner), 167
Ono, Yoko, 276, 308
Opie, Julian, 289
Oppenheim, Dennis, 33–36, 38–40,
 42, 50, 64, 65, 69, 223, 227

Orgies, Mysteries, Theater (Nitsch), 43
Orlan (artist), 318–19
Ossorio, Alfonso, 95
OTTOshaft (Barney), 284
Out the Window (Johns), 143
Owens, Craig, 127
Oxidation Paintings (Warhol), 153

Pace Gallery, 8, 76, 164–65, 199, 306
Pace-Wildenstein Gallery, 308, 309
Paik, Nam June, 276
"Painted Word, The," 11
Painter, Patrick204
Paladino, Mimmo, 100, 104
Palermo, Blinky, 92, 103
Paley, Maureen, 292
Palley, Reese, 56
Pane, Gina, 42–43
Panorama, 153
Panza di Biumo, Count Giuseppe,
 62, 259–60, 304
Paolozzi, Eduardo, 99, 149
Parke-Benet, 1, 6, 170
Pattern & Decoration movement, 73–
 75, 95
Pauline, Mark, 227–28
Payson, John Whitney, 165
Pellizzi, Franco, 136
Penck, A. R., 106, 121, 213
People, 121, 164
Petzel, Friedrich, 309
Phase II (graffiti artist), 124
Phillips, Lisa, 165, 182
Photo-Realism, 71
Physical Impossibility of Death in the
 Mind of Someone Living, The
 (Hirst), 295–97
Picabia, Francis, 90, 101
Picasso, Pablo, 70, 78, 109, 160, 171,
 173–74, 177, 178–79, 183, 185,
 201, 204, 263, 309
Picasso, Sarah, 2
Pincus-Witten, Robert, 91–92, 151
Plagens, Peter, 311
Police Gazette (de Kooning), 14

Polke, Sigmar, 92, 103, 220, 274
Pollock, Jackson, 15, 26, 96, 99, 172,
 183, 247, 259
Pommes et biscuits (Cézanne), 53
Pop art, 3, 8, 11, 17, 70, 99, 129, 149,
 163, 249
Portrait of Dr. Gachet (van Gogh),
 202, 203
"Post Human" exhibition, 317, 320
Powers, Chimiko and John, 62
Pozzi, Lucio, 55
"Precession of Simulacra, The," 133
President's Committee on the Arts
 and Humanities, 167
Prince, Richard, 132, 214
Process art, 38
Protetch, Max, 149
Proudhon, Pierre-Joseph, 4
P.S. 1, 125, 128

Quattrocchi, Paul, 200–01
Quick, May, 253, 266
Quinn, Marc, 294, 296

Race Track (Morley), 71–72
Radji, Parviz, 64
Radziwill, Lee, 9
Rae, Fiona, 291
Rammellzee, 122–23, 129
Rat, The, 31
Ratcliff, Carter, 115
Rat King (Fritsch), 283
Rauschenberg, Robert, 8, 58, 60, 62, 63,
 90, 100, 173, 184, 274, 280, 316
 Rebus, 171, 174, 176
 Scull sale and, 10, 16, 17, 18
Ray, Charles, 312
Ray, Man, 321
Razor Gallery, 122
Read, Howard, 153–54
*Reading Position for Second Degree
 Burn* (Oppenheim), 39
Rebus (Rauschenberg), 171, 174, 176
Reif, Rita, 191

Reigning Queens (Warhol), 153
Reiring, Janelle, 132
Relics (Burden), 50
René, Denise, 9
Renoir, Pierre Auguste, 202, 203
Resale market, 169–70, 180
Rhoades, Jason, 311
Ribera, Jusepe, 12
Ricard, René, 126
Richardson, John, 163–64
Richter, Gerhard, 103, 226, 282, 321
Riley, Bridget, 58
Ripps, Rodney, 111–13
Rivers, Larry, 72
Robbins, Liz, 8
Robert Miller Gallery, 153
Robinson, Linda, 199
Robinson, Walter, 69
Roc Group, 190
Rockefeller, Nelson, 7, 65
Roden Crater, 252, 303–05
Rogers, Art, 151
Rollins, Tim, 67
Rome 78, 126
Ronald Feldman Gallery, 50
Roos, Fredrik, 108
Rose, Barbara, 246–47, 256
Rosen, Andrea, 191
Rosenberg, Harold, 24, 68
Rosenquist, James, 3, 16, 18, 62, 143–
 44, 151
Rosenthal, Norman, 109
Rosenthal, Sir Norman, 33, 320
Ross, David, 44
Rothko, Mark, 2, 9, 100, 321–22
Royal College of Art, 70
Rubell, Don and Miera, 127
Rubenstein, Perry, 191, 199, 202
Rubin, Larry, 8
Ruscha, Ed, 191
Ruskin, John, 6
Ruskin, Mickey, 89
Russell, John, 304
Ryman, Robert, 59, 69, 195

Saatchi, Charles, 74, 97, 109, 111,
114, 116, 144–45, 153, 164–65,
170, 176, 178, 187, 292–93, 294,
295, 296–97, 314
Saatchi, Doris, 114, 144, 187
Safer, Morley, 12–13
Saint-Simon, 4, 159
Saito, Ryoei, 203
Salander, Larry, 188, 306
Salander-O'Reilly, 188
Salle, David, 89–93, 95, 97–98, 103,
104, 106, 110, 115, 116, 130, 135,
137, 149, 180, 192, 314, 322
Boone and, *see* Boone, Mary, Salle
and
Gagosian and, 168, 185, 199, 306
Saltz, Jerry, 314
Samaras, Lucas, 256
Sandler, Irving, 17
Sandra Gering Gallery, 286
Scarborough, William, 308
Scharf, Kenny, 121, 124–25, 127,
129, 146, 147, 154
Schell, Orville, 19–20
Schellmann Éditions, 246
Schjeldahl, Peter, 56, 150–51, 159–
60, 214
Schnabel, Julian, 69, 74, 85–98, 102,
104, 107–11, 112, 113–17, 130,
141, 159, 191, 259, 294, 314,
322
Mary Boone and, *see* Boone, Mary,
Schnabel and
"plate" paintings, 96, 97, 102, 108,
115–16, 135–36, 204, 321
retrospective at the Whitney, 164–65
Schneemann, Carolee, 32, 46
Scholte, Micky (née Hoogendijk),
210–11, 219, 220–22, 224, 225,
234, 235, 236
Scholte, Rob, 210–37
Schubert, Karsten, 281, 291–92, 292,
293, 297, 298
Schuyff, Peter, 133, 215, 219, 237

Schwartz, Barbara and Eugene, 138
Schwartz, Estelle, 140, 141
Schwartz, Sarah, 311
Schwarzkogler, Rudolf, 43–44
Schwitters, Kurt, 247, 280, 290
Scott, William, 99
Scott Hanson Gallery, 176
Screw magazine, 125
Scull, Ethel, 2–3, 9, 10–11, 16, 142–
44, 154, 174
Scull, Robert, 1, 10–11, 36, 62, 249
death of, 142
divorce, 2–3, 142
sale of art collection, 1–4, 7–10,
14–18
Scull collection, sale of, 1–4, 7–10,
14–18
Seedbed (Acconci), 39
Seitz, William, 35
Sekkei, Nihon, 218
Self-Portrait (Quinn), 296
Self-Portrait (Scholte), 216
Serpentine Gallery, "Broken English"
show, 295–96
Serra, Richard, 36, 37, 38, 48, 49, 62,
68, 148, 258, 262, 282, 314
Seven Days, 150
Shadowman (Hambleton), 125
Shafrazi, Tony, 46–49, 65–66, 67,
121–23, 146, 148, 149, 191
Shafrazi Gallery, 125, 147–48
Shainman, Jack, 281–82
Shapiro, Joel, 67, 88
Sharp, Willoughby, 34
Sherman, Cindy, 131–32, 154–55,
322, 325
Shoot (Burden), 45
Shot Red Marilyn (Warhol), 184
Sidney Janis Gallery, 123, 322
"Post-Graffiti Show," 129–30
Siegelaub, Seth, 26
Silverman, Linda, 16–17
Singing Sculpture (Gilbert &
George), 41–42

Sironi, Mario, 101
Situationist International, 28, 30, 31,
 133
Situationist International Anthology,
 31
60 Minutes, 12–13
Smith, David, 191, 247
Smith, Kiki, 278, 279
Smith, Richard, 70
Smith, Roberta, 283, 321
Smith, Tony, 249
Smithson, Nancy, 47, 48
Smithson, Robert, 33–34, 36, 46–47,
 69, 223
SoHo, 54–57, 77, 126, 191, 249, 251,
 282–84, 308–09
Solanas, Valerie, 31, 184
Solano, Susana, 282
Solomon, Holly, 56, 73, 74, 91, 94,
 95, 111, 112, 166
*Some Comfort Gained from the
 Acceptance of the Inherent Lies in
 Everything* (Hirst), 313–14
Sonnabend, Ileana, 56, 94, 105, 106,
 135, 141–42, 150–51, 158, 205,
 282, 323, 326
Sonnabend Gallery, 39, 40
Sonnier, Keith, 61, 67
Sotheby's, 1, 2, 17, 53–54, 77–81,
 153, 167, 308, 314–15
 Boom period, 1987–1991, 164,
 166, 171, 173–75, 178–79, 183–
 84, 185–86, 190–91, 194, 200–
 05, 307
 escalation of prices at auctions held
 at, 1987–1991, 165
 expansion of, 77–78
 purchased by Taubman, 81
 Scull collection sale, 1–4, 7–10,
 14–18
Soulages, Pierre, 17
Soup Cans (Warhol), 181–82
Soutine, Chaim, 105, 290
Spectator, 114
Spellman, Lisa, 176

Spero, Nancy, 27, 69
Sperone, Gian Enzo, 101, 102, 116
Sperone Westwater, 104
Staehle, Wolfgang, 319
Stag magazine, 90
Staller, Ilona (La Cicciolina), 152–53,
 155–56, 157, 217, 326
Stansfield, Martin, 9
Stedelijk Museum, 114, 193, 215–16,
 217, 257, 267
Steinbach, Haim, 275
Steinberg, Saul, 78
Stelarc, 43
Stella, Frank, 24, 25, 97, 173, 195,
 228, 246, 247
Stelling, Bill, 126
Stephan, Gary, 94, 97, 98
Stern magazine, 86, 155
Stigter, Diana, 217, 219, 234
Stockebrand, Marianne, 263, 267,
 268–69
Storr, Robert, 311
String of Puppies (Koons), 151, 326
Studio International, 26
Studulski, John, 228, 237
Sunflowers (van Gogh), 165, 166
Surrealism, 31, 279
"Surrogate/Self-Portraits" show, 94
Survival Research Laboratories (SRL),
 227–28
Suzuki, Taro, 223
Suzy, aka Aileen Mehle, 165, 179
Sweeney, James Johnson, 28
Swid, Stephen, 79, 80–81
Swope, Tom, 187
Symes, Robin, 187

Taaffe, Philip, 133
Taki 183, 122, 123
Takis, 31
Tamenaga Gallery, 8
Tancock, John, 2, 3
Tansey, Mark, 324–26
Tàpies, Antoni, 17, 94, 275
Target paintings (Johns), 14, 15

Tate Gallery, 19
 Schnabel exhibition at, 114–15, 116
Taubman, A. Alfred, 81, 183, 186
Taylor, Elizabeth, 7, 167
Taylor, Paul, 69, 142, 145, 197
Taylor, Steed, 310
Teheran museum, 65, 66
Templon, Daniel, 104, 111, 178
Terner, Andrew, 15–16, 125
Thaw, Eugene, 8
Thaw (Rauschenberg), 16
Thousand Years, A (Hirst), 293
Three Flags (Johns), 76–77
Thulin, Hans, 171, 173, 175–76, 306
Tilton, Jack, 280, 281
Time, 55, 67, 86, 99, 121, 189
Time Out, 295
Times (London), 53, 58
Times-Sotheby Index, 53–54
"Times Square Show," 124–25, 128,
 291
Timing (Blanca), 232
Tinguely, Jean, 29
Tiravanija, Rirkrit, 323
Tobias, Richard, 252
TODT, 226
Toscani, Oliviero, 278
Toxic (graffiti artist), 124, 129
Tracy, Michael, 88
Transavanguardia, 100–01, 103–04,
 104
Transfixed (Burden), 46, 50
Transparancies (Picabia), 90
Tremaine, Burton and Emily, 9, 62,
 76, 77, 169, 172
Triple Elvis (Warhol), 153
Triumph of American Painting, The
 (Sandler), 16
Triumph of the New York School
 (Tansey), 325
Truitt, Anne, 249
Trump, Donald, 167
Tsurumaki, Tomonori, 204
Tuchman, Maurice, 316
Tucker, Marcia, 37, 38, 88

Tunick, David, 191
Turner, J. M. W., 6–7
Turrell, James, 36–37, 62, 252, 303–05
Tuttle, Richard, 63
Twombly, Cy, 3, 16, 128

Uccello, Paolo, 286
UCLA, Center for Digital Arts, 318
Uglow, Alan, 94, 98
Underground U.S.A., 126
United Graffiti Artists, 122–23
Untitled Film Stills (Sherman), 131
Up Against the Wall, Motherfuckers,
 30–31

Vaisman, Meyer, 133, 134, 141–42
van Bruggen, Coosje, 256–58, 262, 269
van der Rohe, Mies, 79
van Doesburg, Theo, 322
van Dongen, Kees, 90
Vaneigem, Raoul, 31
van Gogh, Vincent, 70, 166, 193,
 202, 203
 Irises, 165, 179, 193, 201, 203
 Sunflowers, 165, 166
Vanity Fair, 154
van Oss, Joost, 218, 265
van Rijn, Michel, 230
Vaughan, Geoff, 9, 16
Vautier, Ben, 41
Venice Biennale, 30, 104–05, 112,
 156, 217–18, 237, 273–80, 285,
 287, 298–99, 320
Vermeer, Jan, 193, 194
Victory Boogie-Woogie (Mondrian), 169
Vidal, Gore, 185
Village Voice, 128, 158
Villon, François, 233
Vinciarelli, Lauretta, 257–58, 259
Viola, Bill, 320
Virginia Dwan Gallery, 35
Virtual City, 318
Visiting Hours (Flanagan), 310
Vogel, Dorothy and Herb, 62–64
Vorticism, 24

Waddington, Lesley, 116, 262–63, 291, 292, 296–97, 305
Wagemans, Fred, 215, 237
Wall, Beriah, 124
Wallis, Henry, 5
Walter, Jean, 53
Warhol, Andy, 18, 50, 58, 63, 65, 128, 148, 170, 218, 268, 311, 315
 copyright problems, 152
 gunning down of, 31, 184, 210, 237
 revival of, in late 1980s, 153–54, 166
 sales of works by, 3, 16, 166, 174, 184
 Schnabel and, 109–10
 Soup Cans, 181–82
War Room, The (Taylor), 310
Waterlilies (Monet), 127
Waterman, George, 113, 138
Watts, G. F., 138
Wayne, John, 152
Wean (Antoni), 285–87
Wegman, William, 69
Weinberg, Daniel, 138
Weiner, Lawrence, 26–27, 40–41, 69, 222
Weiner, Rob, 260, 261–62, 265, 266, 267
Werner, Michael, 104–05, 106, 191
Wesselmann, Tom, 3, 72, 175
Westwater, Angela, 101, 102
Whistler, James McNeill, 5–7
White Fire II (Newman), 16
White Flag (Johns), 171, 172, 173, 175–76
Whitlam, Gough, 15
Whitney Independent Studies Program, 88
Whitney Museum, 76–77, 171, 280, 304
 "Anti-Illusion" show, 37–38
 Biennial, 112, 182–83, 280, 286

"New Image" show, 95, 111
 Rosenquist retrospective, 149
 Schnabel retrospective, 164–65
Wild Bunch, 103, 213
Wilde, Oscar, 5
Wild Style, 126
Wilson, Peter, 53–54, 77, 80, 81, 195
Wilson, Robert, 64, 277
Winder, Robert, 317
Winer, Helene, 132
Winter, Robert, 318
Winter Pool (Rauschenberg), 171, 174
Winters, Robin, 124
Wired, 317
Wolfe, Tom, 10–12
Wollen, Peter, 32
Wolman, Gil J., 28
Wolmer, Bruce, 88–89
Woman as a Landscape (de Kooning), 314–15
Woman at the Mandolin (Picasso), 179
Woolley, Robert, 77
World Flag Ant Farm, 279, 299
"Worship of Art, The," 11
Wortz, Ed, 37

Xavier Fourcade Gallery, 106, 168

Yao, John, 198
Yarber, Robert, 76, 322
Yarnell, Tim, 113
Yo Picasso (Picasso), 78, 185
Young, Donald, 150–51
Yours Sincerely (Scholte), 218

Zadikian, Zadik, 66
"Zeitgeist" show, 116
Zucker, Joe, 111